MICHELANGELO
and his Drawings

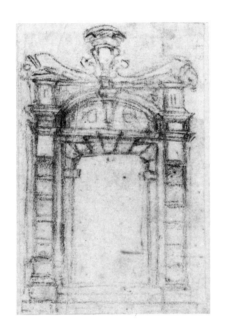

MICHELANGELO
and his Drawings

Michael Hirst

Yale University Press
New Haven & London

for Diane

Set in Linotron Bembo by Best-set Typesetter Ltd, Hong Kong
Printed in Great Britain by BAS Printers, Over Wallop

Library of Congress Catalog Number: 88-50431
ISBN 0-300-04391-0

Frontispiece: Study for a gate, Haarlem, Teylers Museum.

PREFACE

THIS ESSAY IS CONCERNED with Michelangelo's practice as a draughtsman. I have confined the evidence to substantially fewer than half of the drawings that survive, and a considerable number of the examples I have chosen reappear at intervals throughout the book, at each point considered in a different context. Notes have been kept to a minimum. Where drawings are referred to without being illustrated, I have indicated the appropriate reference in Tolnay's recent *Corpus* of the drawings. The attempt to survey the material within the limits here adopted may well be judged an act of temerity, and, having completed the task, I now appreciate all the more the justice of J.C. Robinson's observation that 'it is difficult to treat of the drawings of the great masters in an expeditious or summary manner...'.

It is not possible to describe here all I owe to the critics who have written about the subject in the past. Some acknowledgments will be found in the text and in the notes. And I have tried to express gratitude, as well as criticism, in my bibliographical note. I am indebted to the British Academy for a grant towards the costs of travel and of photography. For help and kindness that I have received whilst engaged on this study, I should like to thank Giovanni Agosti, Paola Barocchi, Richard Bösel, Antony Griffiths, Fabrizio Mancinelli, Rosanna Muzii, Nicholas Penny, Pina Ragionieri, Jane Roberts, Annamaria Petrioli Tofani, Nicholas Turner, J.H. van Borssum Buisman, Paolo Viti, Michael Warnes, and Matthias Winner.

A final thanks to John Nicoll and Gillian Malpass for their kind interest and patience.

CONTENTS

List of Plates ix

I Introduction 1

II The Concerns of the Artist 9

III Survival and Destruction 16

IV Chronology, Consistency, and Change 22

V Inventing the Motive 32

VI Composing the *Storia* 42

VII Copying, Studying, and Implementing the Design: Figures 59

VIII Demonstrations for the Patron 79

IX Copying, Inventing, and Implementing the Design: Buildings 91

X The Making of Presents 105

Select Bibliography 119

Index of Drawings 124

General Index 129

PLATES 133

All drawings in the Royal Library, Windsor Castle, are reproduced by gracious permission of Her Majesty the Queen. Those in the British Museum are reproduced by courtesy of the Trustees. I am grateful also for permission to publish drawings in the Casa Buonarroti, Florence, the Teylers Museum, Haarlem, and the Ashmolean Museum, Oxford. Drawings are reproduced also in the collections of the Louvre, Paris, the Uffizi, Florence, the Albertina, Vienna, the Pierpont Morgan Library, New York, the Metropolitan Museum, New York, the Fogg Art Museum, the Accademia, Venice, the Musée des Beaux-Arts, Lille, and the Courtauld Institute Galleries. I am grateful also for permission to publish two sheets from the Codex Coner, Soane Museum, and the copy of the Cascina cartoon belonging to the Earl of Leicester.

PLATES

All works illustrated are by Michelangelo unless they are otherwise described. Dimensions are in centimetres, height preceding width.

BLACK AND WHITE

1 Study for the bronze *David* (detail), pen and ink, Paris, Louvre.

2 Study for an Apostle, pen and ink, detail of pl. 32.

3 Study for the Tomb of Pope Julius II, pen and ink, 21.2 × 14.4 cm., Florence, Casa Buonarroti.

4 Studies of architecture and for a dead Christ, black chalk, 25.9 × 25.7 cm., Lille, Musée des Beaux-Arts.

5 Domenico Ghirlandaio, Two figures, pen and ink, 26 × 17 cm., Florence, Uffizi.

6 Fra Bartolommeo, *St Jerome*, pen and ink, 21.6 × 14.4 cm., Florence, Uffizi.

7 Figure studies, pen and ink, 26.9 × 19.4 cm., Haarlem, Teylers Museum.

8 Print after sheet of studies by Michelangelo, London, British Museum.

9 Leonardo da Vinci, Landscape, pen and ink, 19 × 28.5 cm., Florence, Uffizi.

10 Fra Bartolommeo, Landscape, pen and ink, 21.1 × 29 cm., London, Courtauld Institute Galleries.

11 Parmigianino, A woman seated at a table, red chalk, 18.3 × 11.9 cm., Budapest, Museum of Fine Arts.

12 Polidoro da Caravaggio, Two women in a landscape, red chalk, 28 × 20 cm., Montpellier, Musée Atger.

13 Aminadab lunette (detail), Vatican, Sistine Chapel.

14 Studies after the antique and of a monk, red chalk and pen and ink, 26.6 × 16.6 cm., Windsor, Royal Library.

15 Old woman and child, pen and ink, 32.9 × 19.2 cm., Oxford, Ashmolean Museum.

16 Three men conversing, pen and ink, 37.7 × 25 cm., Oxford, Ashmolean Museum.

17 Head of a satyr, pen and ink, drawn over a pupil's study, red chalk, 27.6 × 21.1 cm., Paris, Louvre.

18 After Michelangelo, Head of a girl, red chalk, New York, Private collection.

19 Michelangelo and pupil, Studies of a head and a skull, black chalk, verso of pl. 220.

20 Michelangelo and pupil, Studies of heads and eyes, red and black chalk, 25.4 × 33.8 cm., Oxford, Ashmolean Museum.

21 *Ecorché*, pen and ink, 28.3 × 19 cm., Windsor, Royal Library.

22 *Ecorché*, red chalk, 28.1 × 20.8 cm., Windsor, Royal Library.

23 *Ecorchés*, red chalk and pen and ink, 26.3 × 20.2 cm., Haarlem, Teylers Museum.

24 Self-portrait, black chalk and pen and ink, 36.5 × 25 cm., Paris, Louvre.

25 Portrait of Andrea Quaratesi, black chalk, 41.1 × 29.2 cm., London, British Museum.

26 *The Resurrection of Christ*, black chalk, 32.6 × 28.6 cm., London, British Museum.

27 *The Resurrection of Christ*, black chalk, 24 × 34.7 cm., Windsor, Royal Library.

28 Study for Adam, black chalk, 26.2 × 19.2 cm., Florence, Casa Buonarroti.

29 Study for a soldier, red chalk, 13.6 × 19.4 cm., Florence, Casa Buonarroti.

30 Study for a Slave, red chalk, 32.7 × 20 cm., Paris, Ecole des Beaux-Arts.

31 Titian, *St Sebastian*, oil on wood, Brescia, SS. Nazaro e Celso.

32 A male nude and studies for an *Apostle* and for a group of Virgin and Child, black chalk, lead-point and pen and ink, 27.2 × 26.2 cm., Florence, Uffizi.

33 Detail of pl. 32.

34 Copy after Donatello's marble *David*, black chalk and white heightening on a grey washed ground, 27.2 × 26.2 cm., Florence, Uffizi.

35 Studies for *Ignudi* and of an architectural detail, black chalk and pen and ink, 41.5 × 27 cm., Florence, Casa Buonarroti.

36 Detail of pl. 35.

37 Study of Madonna and Child, pen and ink over lead-point, detail of pl. 75.

38 Study of Venus and Cupid, pen and ink, 8.5 × 12.1 cm., London, British Museum.

39 *Madonna and Child*, marble, Notre Dame, Bruges.

40 Study of a Virgin and Child, pen and ink, 37.9 × 18.7 cm., Vienna, Albertina.

41 Studies of a Virgin and Child, pen and ink, 36 × 18.2 cm., Paris, Louvre.

42 Leonardo da Vinci, Studies for the *Battle of Anghiari*, pen and ink, 8.8 × 15.3 cm., Venice, Accademia.

43 Leonardo da Vinci, Studies for the *Battle of Anghiari*, pen and ink, 14.5 × 15.2 cm., Venice, Accademia.

44 Studies for the lunettes of the Sistine Chapel, pen and ink, 13.8 × 14.3 cm., Oxford, Ashmolean Museum.

45 Studies for the lunettes of the Sistine Chapel, pen and ink, 14.0 × 14.2 cm., Oxford, Ashmolean Museum.

46 Roboam-Abia lunette (detail), Vatican, Sistine Chapel.

47 Studies for the lunettes of the Sistine Chapel, pen and ink, 13.5 × 14.5 cm., Oxford, Ashmolean Museum.

48 Study of an old man with a dog, black chalk, 13.5 × 14.8 cm., Oxford, Ashmolean Museum.

49 Salmon-Booz-Obed lunette (detail), Vatican, Sistine Chapel.

50 Studies for the lunettes of the Sistine Chapel, pen and ink, 13.8 × 14.3 cm., Oxford, Ashmolean Museum.

51 Study for the Naasson lunette, black chalk, 14 × 14.5 cm., Oxford, Ashmolean Museum.

52 Naasson lunette (detail), Vatican,

Sistine Chapel.

53 Studies for the ceiling and lunettes of the Sistine Chapel, pen and ink, 14 × 14.2 cm., Oxford, Ashmolean Museum.

54 Engraving by William Young Ottley of the studies in pl. 53.

55 *God dividing Light from Darkness*, Vatican, Sistine Chapel.

56 Raphael, Studies for Prophets and Sibyls (detail), pen and ink, Oxford, Ashmolean Museum.

57 Studies for the Sistine ceiling and for Slaves for the Tomb of Pope Julius II, red chalk and pen and ink, 28.6 × 19.4 cm., Oxford, Ashmolean Museum.

58 Studies for the *Last Judgment*, black chalk, 27.7 × 41.9 cm., Windsor, Royal Library.

59 Study for St Lawrence, Codex Vaticanus Lat. 3211, fol. 88 verso (detail), Vatican Library.

60 Architectural and figure studies, black chalk, 19.2 × 19.7 cm., Florence, Casa Buonarroti.

61 Sketch of David and Goliath, black chalk, 7 × 11.1 cm., New York, Pierpont Morgan Library.

62 Sketch of David and Goliath, black chalk, 5.1 × 8.4 cm., New York, Pierpont Morgan Library.

63 Sketch of David and Goliath, black chalk, 4.9 × 6.6 cm., New York, Pierpont Morgan Library.

64 Sketch of David and Goliath, black chalk, 7.1 × 8.7 cm., New York, Pierpont Morgan Library.

65 Aeneas and a putto, black chalk, 10 × 7.5 cm., London, Courtauld Institute Galleries.

66 After Michelangelo, Aeneas and a putto, black chalk, tracing from the recto repr. in pl. 65.

67 Aeneas, Dido and a putto, black chalk, 13.6 × 18 cm., Haarlem, Teylers Museum.

68 Daniele da Volterra, Aeneas and a putto, black chalk, Vienna, Albertina.

69 Studies of sleeping Apostles, black chalk, 10.7 × 32.5 cm., Oxford, Ashmolean Museum.

70 Studies for a Pietà and an Entombment, black chalk, 10.8 × 28.1 cm., Oxford, Ashmolean Museum.

71 Compositional study for the *Battle of Cascina*, black chalk, partly over stylus, 23.5 × 35.6 cm., Florence, Uffizi.

72 Bastiano da Sangallo (?), Copy after the *Battle of Cascina* cartoon, grisaille on wood, 76.4 × 130.2 cm., Holkham Hall, Earl of Leicester.

73 Detail of pl. 71.

74 Detail of pl. 71.

75 Studies for the *Battle of Cascina* and the Bruges *Madonna*, black chalk and pen and ink over lead-point, 31.5 × 27.8 cm., London, British Museum.

76 Study for the *Battle of Cascina* and other studies, black chalk and pen and ink, verso of pl. 75.

77 Study for the *Battle of Cascina*, black chalk over stylus, 34 × 18 cm., Paris, Louvre.

78 Studies of a horse and sketch of a battle scene, pen and ink, 42.7 × 28.3 cm., Oxford, Ashmolean Museum.

79 A battle scene, pen and ink, 17.9 × 25.1 cm., Oxford, Ashmolean Museum.

80 Study for *Judith and Holofernes* fresco, black chalk, verso of pl. 122.

81 *Judith and Holofernes*, Vatican, Sistine Chapel.

82 *The Flagellation of Christ*, red chalk over stylus, 23.5 × 23.6 cm., London, British Museum.

83 After Michelangelo, *The Flagellation of Christ*, red and black chalk, 20 × 18.2 cm., Windsor, Royal Library.

84 *Christ before Pilate*, red chalk and pen and ink, 21 × 28.2 cm., London, Courtauld Institute Galleries.

85 Detail of pl. 169.

86 Detail of pl. 169.

87 Detail of pl. 169.

88 *The Three Crosses*, red chalk, 39.4 × 28.1 cm., London, British Museum.

89 Detail of pl. 88.

90 Domenico Ghirlandaio, Study for the *Birth of the Virgin*, pen and ink, 21 × 28 cm., London, British Museum.

91 Studies for the *Descent from the Cross*, red chalk, 27.3 × 19.1 cm., Haarlem, Teylers Museum.

92 Compositional study for the *Last Judgment*, black chalk, 34.4 × 29 cm., Bayonne, Musée Bonnat.

93 Compositional study for the *Last Judgment*, black chalk, 41.5 × 29.8 cm., Florence, Casa Buonarroti.

94 *The Last Judgment*, Vatican, Sistine Chapel.

95 Detail of pl. 93.

96 Detail of pl. 93.

97 *Christ and the Woman of Samaria*, black chalk and white heightening, 43.6 × 33.7 cm., Geneva, M. Bodmer Foundation.

98 Study for the Woman of Samaria, black chalk, 10.9 × 9.5 cm., Geneva, M. Bodmer Foundation.

99 Nicolas Beatrizet after Michelangelo, *Christ and the Woman of Samaria*.

100 *The Annunciation*, black chalk, 40.7 × 54.7 cm., Florence, Uffizi.

101 *The Annunciation*, black chalk, 38.3 × 29.6 cm., New York, Pierpont Morgan Library.

102 *The Annunciation*, black chalk, the left sheet 34.8 × 22.4 cm., the right 28.3 × 19.6 cm., London, British Museum.

103 Detail of pl. 102.

104 The Annunciate Virgin, black chalk, 28.3 × 19.6 cm., London, British Museum.

105 The Annunciate Virgin, black chalk, 34.8 × 22.4 cm., London, British Museum.

106 *Christ on the Cross with the Virgin and Nicodemus* (?), black chalk, bistre wash and white body colour, 43.3 × 29 cm., Paris, Louvre.

107 *Christ on the Cross with the Virgin and St John*, black chalk and white body colour, 41.2 × 27.9 cm., London, British Museum.

108 Study after Giotto, pen and ink, 31.5 × 20.5 cm., Paris, Louvre.

109 Giotto, *Ascension of St John* (detail), Florence, S. Croce, Peruzzi Chapel.

110 Florentine School, *Funeral of St Stephen* (detail), Prato, Cathedral.

111 Study, probably after Masaccio, pen and ink, 29 × 19.7 cm., Vienna, Albertina.

112 Study of an antique Venus, black chalk, 25.6 × 18 cm., London, British Museum.

113 Study of an antique Venus, black chalk, 20.2 × 11 cm., London, British Museum.

114 Studies of an antique Venus, black chalk, 20 × 14.7 cm., Florence, Casa Buonarroti.

115 Study of an antique Venus, black chalk, 14.7 × 10 cm., Florence, Casa Buonarroti.

116 A kneeling nude girl, black chalk, pen and ink and white heightening, on pink paper, 27 × 15 cm., Paris, Louvre.

117 *Christ carried to the Tomb*, panel,

London, National Gallery.

118 Study of a male nude, pen and ink, 36 × 18.2 cm., Paris, Louvre.

119 Study of a male nude, pen and ink, 39 × 19.5 cm., Vienna, Albertina.

120 Study of a male nude, black chalk and pen and ink, 40.9 × 28.5 cm., Florence, Casa Buonarroti.

121 Figure study for the *Battle of Cascina*, black chalk, 40.4 × 26 cm., Haarlem, Teylers Museum.

122 Figure study for the *Battle of Cascina*, black chalk and white heightening, 40.4 × 22.4 cm., Haarlem, Teylers Museum.

123 Figure study for the *Battle of Cascina*, pen and ink, wash, and white heightening, 42.1 × 28.7 cm., London, British Museum.

124 Figure study for the *Battle of Cascina*, black chalk and white heightening, 26.6 × 19.4 cm., Vienna, Albertina.

125 Study for an *Ignudo*, black chalk, 24.5 × 18.8 cm., London, British Museum.

126 Study for an *Ignudo*, black chalk over stylus, 30.5 × 21 cm., Paris, Louvre.

127 Study for an *Ignudo*, red chalk and white heightening, 26.8 × 18.8 cm., Vienna, Albertina.

128 *Ignudo*, Vatican, Sistine Chapel.

129 Studies for *Haman*, red chalk, 40.6 × 20.7 cm., London, British Museum.

130 Studies for *Haman*, black and red chalk, 25.2 × 20.5 cm., Haarlem, Teylers Museum.

131 Studies for Christ, red chalk and pen and ink, 23.8 × 20.8 cm., London, Collection Brinsley Ford.

132 *Christ*, marble, Rome, Santa Maria sopra Minerva.

133 *Christ*, marble, Rome, Santa Maria sopra Minerva.

134 Studies for the right arm of

Night, black and red chalk, 25.8 × 33.2 cm., Oxford, Ashmolean Museum.

135 *Night* (detail), marble, Florence, New Sacristy of San Lorenzo.

136 Study for *Day*, black chalk, 25.8 × 33.2 cm., Oxford, Ashmolean Museum.

137 *Day*, marble, Florence, New Sacristy of San Lorenzo.

138 Study for *Day*, black chalk, 19.2 × 25.7 cm., Haarlem, Teylers Museum.

139 *Day* (detail), marble, Florence, New Sacristy of San Lorenzo.

140 Studies for a Pietà, black chalk, 39.8 × 28.2 cm., Florence, Casa Buonarroti.

141 Study for a Pietà, black chalk, 25.4 × 31.8 cm., Paris, Louvre.

142 Study for St Lawrence, black chalk, 24.4 × 18.2 cm., Haarlem, Teylers Museum.

143 *St Lawrence*, Vatican, Sistine Chapel.

144 Studies of a male torso, black chalk, 24 × 17.5 cm., Switzerland, Private collection.

145 Study of a male torso, black chalk, 10.3 × 15 cm., Florence, Casa Buonarroti.

146 After Michelangelo, Studies of an Entombment.

147 Study for the Doni tondo, pen and ink, 16.3 × 9.2 cm., Florence, Casa Buonarroti.

148 Two studies of legs, red chalk over stylus, 21.4 × 16.1 cm., London, British Museum.

149 Study of a reclining figure, pen and ink, 15 × 19.3 cm., Florence, Casa Buonarroti.

150 Study of a reclining figure, pen and ink, 12.4 × 19.4 cm., Florence, Casa Buonarroti.

151 Study for the Doni tondo, red chalk, 19.9 × 17.2 cm., Florence,

Casa Buonarroti.

152 The Doni tondo, panel, Florence, Uffizi.

153 Study for the *Erythraean Sibyl*, black chalk, pen and ink and wash, 38.7 × 26 cm., London, British Museum.

154 *Creation of Adam* (detail), Vatican, Sistine Chapel.

155 Study for *Zechariah*, black chalk, 43.5 × 27.7 cm., Florence, Uffizi.

156 Studies for the Sistine ceiling, red chalk, 26.5 × 19.8 cm., Haarlem, Teylers Museum.

157 Cornelis Bos, Engraving (reversed) after Michelangelo's *Leda*.

158 Studies for the head of Leda, red chalk, 35.5 × 26.9 cm., Florence, Casa Buonarroti.

159 Grotesque head, black and red chalk, 24.8 × 11.9 cm., Windsor, Royal Library.

160 Grotesque heads (detail), red chalk, London, British Museum.

161 Design for a salt-cellar, black chalk, 21.7 × 15.5 cm., London, British Museum.

162 Drawings for the stone-cutters, pen and ink, 13.7 × 20.9 cm., London, British Museum.

163 Block drawings for the stone-cutters, pen and ink, 31.4 × 21.8 cm., Florence, Archivio Buonarroti.

164 Drawings of blocks for the San Lorenzo façade, pen and ink, 44.5 × 31.5 cm., Florence, Archivio Buonarroti.

165 Cartoon for the Pauline Chapel, black chalk, approx. 263 × 156 cm., Naples, Galleria Nazionale di Capodimonte.

166 Cartoon, black chalk, 232.7 × 165.6 cm., London, British Museum.

167 Detail of pl. 166.

168 Detail of pl. 166.

169 *Modello* for the San Lorenzo façade, black chalk, pen and ink

170 Giuliano da Sangallo, *Modello* for the San Lorenzo façade, black chalk, pen and ink and wash, 40 × 48 cm., Florence, Uffizi.

171 After Michelangelo, Design for the Tomb of Pope Julius II, pen and ink and wash, East Berlin, Staatliche Museum.

172 *Modello* for the Tomb of Pope Julius II (fragment), black chalk, pen and ink and wash, 29 × 36.1 cm., Florence, Uffizi.

173 *Modello* for the Tomb of Pope Julius II, black chalk, pen and ink and wash, 51 × 31.9 cm., New York, Metropolitan Museum.

174 Detail of pl. 173.

175 Detail of pl. 172.

176 Study for a door, black chalk, pen and ink and wash, 34.6 × 23.9 cm., Florence, Casa Buonarroti.

177 Study for a door, black chalk, pen and ink and wash, 40.5 × 25.3 cm., Florence, Casa Buonarroti.

178 Architectural elevation and part of a plan, black chalk, 39.8 × 24.3 cm., Florence, Casa Buonarroti.

179 *Modello* for a papal wall tomb, black chalk, pen and ink and wash, 33.7 × 22.8 cm., Florence, Casa Buonarroti.

180 Groundplan for a rare-book room at San Lorenzo, pen and ink and wash, 21.2 × 28 cm., Florence, Casa Buonarroti.

181 Groundplan for San Giovanni de'Fiorentini, black chalk, pen and ink and wash, 28.4 × 21.2 cm., Florence, Casa Buonarroti.

182 Groundplan for San Giovanni de'Fiorentini, stylus, black chalk, pen and ink and wash, white body colour, 42.8 × 38.6 cm., Florence, Casa Buonarroti.

183 Detail of pl. 182.

184 Study for the Porta Pia, black

chalk and wash, 39.9 × 26.9 cm., Florence, Casa Buonarroti.

185 Study for the Porta Pia, black chalk, wash and white body colour, 44.2 × 28.1 cm., Florence, Casa Buonarroti.

186 Bernardo della Volpaia, Study of antique architecture, pen and ink, Codex Coner, London, Soane Museum.

187 Copy after Bernardo della Volpaia, red chalk, 28.9 × 21.8 cm., London, British Museum.

188 Bernardo della Volpaia, Studies of antique architecture, pen and ink, Codex Coner, London, Soane Museum.

189 Copies after Bernardo della Volpaia, red chalk, 29 × 42.9 cm., Florence, Casa Buonarroti.

190 Site plan for the Library of San Lorenzo (left half), red chalk, 28.3 × 21.4 cm., Florence, Casa Buonarroti.

191 Site plan for the Library of San Lorenzo (right half), red chalk, 28.2 × 21.3 cm., Florence, Casa Buonarroti.

192 Site plan of St Peter's, black chalk, Codex Vaticanus Lat. 3211, fol 92 (detail), Vatican Library.

193 Sketch plan for the façade of San Lorenzo, pen and ink, 22 × 12.2 cm., Florence, Archivio Buonarroti.

194 Sketch plan for the façade of San Lorenzo (detail), pen and ink, Florence, Casa Buonarroti.

195 Plan and elevation of the San Lorenzo Library vestibule, pen and ink, 29.5 × 19.5 cm., Florence, Archivio Buonarroti.

196 Studies for attic of a ducal tomb, red chalk, 16.7 × 13.3 cm., Florence, Casa Buonarroti.

197 Attic of a ducal tomb (detail), Florence, New Sacristy of San Lorenzo.

198 Designs for tombs, black chalk, 14.5 × 12.1 cm., Florence, Casa Buonarroti.

199 Designs for tombs, black chalk, 10.5 × 15.7 cm., Florence, Casa Buonarroti.

200 Designs for tombs, black chalk, 21.9 × 20.8 cm., London, British Museum.

201 Reconstruction of the versos of pls 198–200.

202 Sketch for the façade of San Lorenzo (detail), red chalk, Florence, Casa Buonarroti.

203 Drawing for the façade of San Lorenzo (detail), black chalk and pen and ink, Florence, Casa Buonarroti.

204 Architectural studies, black chalk, 17.8 × 22.7 cm., Florence, Casa Buonarroti.

205 Architectural studies, black chalk, 28.3 × 25.5 cm., Florence, Casa Buonarroti.

206 Elevational design for a ducal tomb, black chalk, 29.7 × 21 cm., London, British Museum.

207 Study for the façade of San Lorenzo, red chalk and pen and ink, 15.7 × 13.6 cm., Florence, Casa Buonarroti.

208 Sketch for wall elevation, pen and ink, 24.6 × 22.6 cm., Florence, Casa Buonarroti.

209 Elevation and plan of a wall tomb, black chalk, pen and ink and wash, 39.7 × 27.4 cm., Florence, Casa Buonarroti.

210 Elevation of a wall tomb, black chalk, 27 × 38.5 cm., Florence, Casa Buonarroti.

211 Studies for St Peter's, black chalk, 25.9 × 25.7 cm, Lille, Musée des Beaux-Arts.

212 Design for a window frame, black chalk, 326 × 232 cm., Florence, New Sacristy of San Lorenzo.

213 Studies of base profiles and sec-

tion, red chalk, 28.2 × 21.3 cm.,
Florence, Casa Buonarroti.

214 Studies of base profiles, red chalk,
28.3 × 21.4 cm., Florence, Casa
Buonarroti.

215 Template for base moulding, 32.5
× 14.5 (at base), Florence, Casa
Buonarroti.

216 Sandro Botticelli, *Abundance*,
black chalk, pen and ink and wash,
white body colour, on pink paper,
31.7 × 25.5 cm., London, British
Museum.

217 Leonardo da Vinci, *Neptune with
Sea-Horses*, 25.1 × 39.2 cm.,
Windsor, Royal Library.

218 Three heads, black chalk, 34.3 ×
23.6 cm., Florence, Uffizi.

219 *Fury*, black chalk, 29.8 × 20.5
cm., Florence, Uffizi.

220 *Venus, Mars and Cupid*, black
chalk, 35.6 × 25.7 cm., Florence,
Uffizi.

221 Detail of pl. 220.

222 Marco Zoppo, Head, pen and ink
on parchment, 21.8 × 15.8 cm.,
London, British Museum.

223 *The Rape of Ganymede*, black
chalk, 38 × 27 cm., Cambridge,
Mass., Fogg Art Museum.

224 *Tityus*, black chalk, 19 × 33 cm.,
Windsor, Royal Library.

225 Resurrected Christ, black chalk,
verso of pl. 224.

226 *The Fall of Phaethon*, black chalk,
31.3 × 21.7 cm., London, British
Museum.

227 *The Fall of Phaethon*, black chalk,
41.3 × 23.4 cm., Windsor, Royal
Library.

228 Detail of pl. 227.

229 Detail of pl. 230.

230 *The Fall of Phaethon*, black chalk,
39.4 × 25.5 cm., Venice, Ac-
cademia.

231 *Children's Bacchanal*, red chalk,
27.4 × 38.8 cm., Windsor, Royal
Library.

232 Titian, *Worship of Venus* (detail),
oil on canvas, Madrid, Prado.

233 A reclining nude and putti around
a wine vat, red and black chalk,
20.7 × 30.6 cm., Bayonne, Musée
Bonnat.

234 Detail of pl. 231.

235 *Cleopatra*, black chalk, 23.2 × 18.2
cm., Florence, Casa Buonarroti.

236 *Christ on the Cross*, black chalk,
37 × 27 cm., London, British
Museum.

237 Macrophotographic detail of pl.
231.

238 Macrophotographic detail of pl.
227.

COLOUR

1 Study of a male nude, black chalk
and pen and ink, 40.9 × 28.5 cm.,
Florence, Casa Buonarroti.

2 Study for an *Ignudo*, red chalk and
white heightening, 26.8 × 18.8 cm.,
Vienna, Albertina.

3 Design for a cupola decoration, black
chalk and brush and brown wash,
26.6 × 21.5 cm., Florence, Casa
Buonarroti.

4 Elevation and plan of a wall tomb,
black chalk, pen and ink and wash,
39.7 × 27.4 cm., Florence, Casa
Buonarroti.

5 *The Labours of Hercules*, red chalk,
27.2 × 42.2 cm., Windsor, Royal
Library.

6 *Archers shooting at a Herm*, red chalk,
21.9 × 32.3 cm., Windsor, Royal
Library.

7 Detail of col. pl. 6.

8 Studies for the head of Leda, red
chalk, 35.5 × 26.9 cm., Florence,
Casa Buonarroti.

9 Study for the Porta Pia, black chalk,
wash and white body colour, 44.2 ×
28.1 cm., Florence, Casa Buonarroti.

I

INTRODUCTION

ALMOST EVERYTHING RELATING TO Michelangelo's drawings that appears in print today takes one of two forms. On the one hand, there is a ceaseless flow of specialized articles concerned with such topics as authenticity, dating, and context. And on the other, there are repeated attempts to assemble in book form all the authentic graphic work and so produce for us that elusive thing, the definitive catalogue of the master's drawings. The most recent of these is Tolnay's four-volume *Corpus*. What is, I believe, still lacking, is an analysis of how he drew, of the purposes that actuated the drawings, and of the reasons why the drawings look as they do. The only valuable general discussion of the subject is Berenson's essay on Michelangelo in the first volume of his *Drawings of the Florentine Painters*, published in 1903, which is replete with astonishing insights.[1]

Not all of these, however, were successfully applied in the catalogue volume of his great work. Berenson wrote his book at a moment that has now assumed a certain notoriety, when the number of drawings accepted as Michelangelo's was in the process of being drastically curtailed by a small number of well-known critics. Interesting as this period of critical reductionism is for the history of connoisseurship, it cannot be reviewed here. Some erroneous attributions were, it is true, discarded, but much more was lost than was gained. One consequence was a restriction in the sheer variety of drawings that Michelangelo was allowed to have made.

The leaves of the sketchbook with small studies for the Sistine ceiling, discussed below (pls 44–5, 47 8, 50–51, 53) may serve as an example. These sheets were analysed with sympathy and insight by J.C. Robinson in what is, perhaps, the most remarkable of books concerned with drawings published in the nineteenth century.[2] Whilst expressing his admiration of the author, Berenson lamented that the book had been written 'at the darkest moment before the dawn of systematic and accurate criticism'. He himself

[1] Berenson's first edition, in two volumes, appeared in 1903. All my citations are to the second edition, in three volumes, published by the University of Chicago in 1938. See my Select Bibliography, p. 120.

[2] J.C. Robinson, *A Critical Account of the Drawings by Michel Angelo and Raffaello in the University Galleries, Oxford*, Oxford, 1870.

rejected the drawings *in toto* and suggested as the artist one of Michelangelo's most obscure *garzoni*, on the grounds that his name had been written on one of the leaves by Michelangelo himself. The rehabilitation of the sheets took half a century.[3]

Many of the problems may be traced to the assumption that we can talk of a 'school of Michelangelo'. Drawings as diverse as the Oxford sketches for the Sistine ceiling, the Haarlem and British Museum studies for the *Haman* (pls 129–30), or a compositional drawing like the one reproduced in plate 84 can all be found under this rubric in Berenson's catalogue. (Other compositional drawings (pls 88 and 91) were there listed, for the first time, as by Sebastiano.) The belief in a 'school' assumed that the artist was surrounded by closely associated followers who could absorb and reproduce their master's graphic style, rather as Raphael's assistants could do in the last years of his lifetime. But facts belie this. The members of Michelangelo's workshop were, almost without exception, of negligible ability; the sheets on which master and pupil practised drawing lessons confirm this. Michelangelo had no Giulio.

Perhaps more serious was the reattribution to other artists of drawings long held to be Michelangelo's own, without a serious attempt to enquire how the former actually drew. This happened with the drawings moved from Michelangelo to Sebastiano. Such arbitrary procedures (method is a word best avoided here) are, unhappily, still with us; it is possible even now for a critic to assign to Marcello Venusti the drawings of the Annunciate Virgin reproduced in plates 103 and 104, with no attempt to establish how Venusti drew.[4] And many of the drawings have been denied the artist without any consideration of the treatment of the subject, that palpable *invenzione* so richly displayed in the drawings just mentioned.

These comments do not imply that attributional problems do not exist. It seems, however, true to say that the most real ones concern sheets that may (or may not) be close, even facsimile-like, copies of original drawings. Doubts already expressed by Berenson about the British Museum study for Adam (*Corpus* 134 recto) have recently re-emerged.[5] A large sheet like the one reproduced in plate 146 contains, in the chief motive, an invention that was certainly Michelangelo's; and the way different kinds of studies exist side by side, the delicate addition over the main group, are features characteristic of the master. But the drawings do not pass the qualitative test. Each time a hitherto unknown drawing appears, however, the critic has to make up his mind, and not all of them present a question as tractable as that posed in plate 97.

*　　　　*　　　　*

[3] Thode, 1913, pp. 118 ff., protested against this treatment of the drawings, but Berenson's authority was so great that he went unheeded.

[4] See Perrig, 1962, pp. 261 ff. For a serious study of Venusti as a draughtsman, see Davidson, 1973, pp. 3 ff.

[5] Gere and Turner, 1979, pp. 40–42.

Questions of interpretation as well as of attribution confront the critic. We may consider one of these here, raised by the fact that Michelangelo made figure studies for three-dimensional sculpture as well as for paintings. One of his best-known drawings in the Louvre has been rightly identified as a preliminary one for the bronze statue of *David* which he was asked to make in 1502 (pl. 1). What was required was a free replica of Donatello's bronze *David*. In this quick sketch, Michelangelo gave thought to a profile view of the figure, projected to be free-standing like Donatello's. Here, the situation seems unambiguous. If, however, we turn to a similar rapid pen sketch made about two years later for a different statue, we face a very real problem of interpretation. This sketch (pl. 2), along with two others (*Corpus 36 recto*), each representing a draped male figure turned to the right, his right foot resting on a block, has been associated with the series of twelve marble *Apostles* that Michelangelo was commissioned to carry out in 1503 for Florence Cathedral. Wilde believed that this and the two other drawings displaying the same motive show the projected main view of the statue, conceived, therefore, like the Sistine ceiling *Persian Sibyl*, in profile. Yet the marble *Apostles* were destined for pier niches in the Cathedral, and the head of this figure, turned away and partly obscured by the raised right hand, would have been well-nigh invisible from the nave. The suggestion that, in these studies, Michelangelo was thinking of a secondary profile view of a figure, as he had been when making the Louvre drawing of the *David*, seems more persuasive; even the vertical line of the back of the figure, appropriate for the back of the niche, favours this argument. Against this, we must recall that the *Apostles* were not conceived to be looked at from all sides, like the lost bronze *David*. And it must be conceded, further, that in at least one surviving drawing, Michelangelo contemplated a statue seen in profile for a niche (*Corpus* 280 recto). The fact that this *Apostle* was never carved along the lines laid down in the drawings means that we can never resolve the problem.[6]

There is plentiful evidence that Michelangelo paid great attention to the secondary views of his statues. In the case of the life studies, this can scarcely cause surprise; his attention to detail in preparing for his work on the marble block will be discussed later (pp. 62 ff.). Here, we may cite a red-chalk drawing, made from life, for one of the marble Slaves for the tomb of Julius II (pl. 30). This view of the figure is, manifestly, not the main one. Another drawing, made in connection with the same project, may serve as a further example (pl. 3). In this astonishing sketch, Michelangelo dashed down the briefest of profile views of the statue of the dead pope, projected, as the elaborate *modelli* confirm, for the tomb (pls 171 and 173). His needs were served by putting in just one of the two attendant bearers behind the pope. Michelangelo's concern with multiple views in these early stages of working

[6] For comments on this issue, see Wilde, 1953, p. 6, citing A.E. Popp who, I believe, is likelier to have been right.

on an invention must have been fortified by his concurrent practice of fashioning small-scale clay models, of which few survive.

As a final example, we may turn to a very late sketch, made on the back of the sheet at Lille more famous for the cupola study on the recto (pls 4 and 211). The contents on this verso are discussed more fully below (pp. 28 ff.). Here, it is enough for our purpose to note how the figure drawing, done for the Dead Christ in Michelangelo's last *Pietà*, is, once again, made in a near profile view.

<div align="center">* * *</div>

Michelangelo's almost exclusive employment of pen and ink in his early drawings, and the uses that he made of the medium, betray a particular debt to the artist to whom he was apprenticed in April 1488, Domenico Ghirlandaio. This fact, now a common-place, was already perceived by Berenson in 1903. He wrote: 'the pen-work in these early drawings, and indeed more than one trick of shorthand of later date, tell truthfully that Ghirlandaio was the man who first put a pen into Michelangelo's hand and taught him how to use it'.[7]

The pupil's early fidelity to pen and ink seems, however, to have been more complete than the master's. Indeed, when the old Michelangelo looked back at his youth, he informed his biographer Ascanio Condivi that chalk was not in use in that distant time. In an episode that he related to Condivi, he recounted that, to convince a doubtful witness of his authorship of the marble *Sleeping Cupid*, he took up a pen and made a rapid drawing of a hand; a pen, because chalk was not used at that time ('perciocchè in quel tempo il lapis non era in uso').[8] The episode may be apocryphal, and the generalization unreliable, but the remark tells us what Michelangelo remembered of his own practice. No significant number of figure studies in either red or black chalk survives from his hand before the period when he undertook the cartoon for the *Battle of Cascina* mural.

The extent of Michelangelo's debt to Ghirlandaio, the master who, he told Condivi, taught him nothing, requires a separate study, one that must now reckon with the transformed appearance of the Sistine Chapel lunettes. I have endeavoured to note some aspects of the debt in the course of this essay. Ghirlandaio's well-known Uffizi sheet (pl. 5) may serve to indicate the kind of drawing with which the youthful apprentice must have been familiar. It is a study for two figures in one of the Santa Maria Novella murals which were being carried out at the time of Michelangelo's apprenticeship. It displays the technique of pen cross-hatching that Michelangelo followed very closely in his earliest drawing, his copy after Giotto (pl. 108), and that

[7] Berenson, 1938, I, p. 187.

[8] Condivi, ed. 1746, p. 12. Meder believed that Michelangelo was here thinking of red rather than black chalk.

he would almost completely transform in later figure studies (pls 123 and 131). Even the way in which Ghirlandaio strengthened the contours was one that Michelangelo adopted in his early studies. And it was from the same kind of sheet that he picked up the habit of adding a few broad pen strokes alongside the figure drawing to lend a suggestion of depth (see pl. 111).

Michelangelo was not the only young artist connected with Ghirlandaio's workshop who set out in life with this kind of graphic equipment. It now seems clear that Fra Bartolommeo, more meaningfully than Michelangelo, was a student and associate of Ghirlandaio. Only three years Michelangelo's senior, his early drawings show a similar dependence on the older artist's pen style. To show this, we may take as an example a pen drawing of *St Jerome in Penitence*, now in the Uffizi (pl. 6). He probably made it at a time close to 1490, in the period when Michelangelo drew his copy after Giotto (pl. 108), and we can observe him using a very similar style of cross-hatching and reworked contours. This drawing by Fra Bartolommeo was for long attributed to Ghirlandaio himself.

* * *

Michelangelo's techniques of drawing are best revealed in a discussion of particular cases, and I have attempted to do this with selected examples in the following pages. But a few more general comments may be added here. Because so many of the early drawings have been lost, it is difficult to estimate how far he adopted the traditional media of the late fifteenth century. There appear to be, for example, no silver-point drawings, and while we cannot state categorically that he never made them, it is plausible to suggest that the delicacy, even daintiness, of the medium, never attracted him. The relative rarity of his use of lead-point, on the other hand, may well be exaggerated by the accidents of loss. In the early years of the sixteenth century, we find him employing it with a certain frequency, as an underdrawing to be reinforced by pen and ink. Examples are the little *pensieri* of a Madonna and Child group spread over sheet 233F in the Uffizi (pls 32–3), further described below. One of these groups, at the bottom of the sheet, he left without inking in, and it is now very difficult to make out. He still employed lead-point for small studies in the period of the Sistine ceiling and we can occasionally find them from as late as the 1520s (*Corpus* 252 bis recto). They easily elude the eye, are often interpreted as black chalk, and are frequently almost invisible in conventional photographs.

Another retrospective feature, a use of prepared coloured grounds, also appears in some early drawings. Michelangelo gave a slate-grey wash to the paper on which he drew his copy of Donatello's marble *David* (pl. 34). And he used crushed red chalk to make a pale pink ground for the pen study for the mourning Mary in the National Gallery *Entombment* (pl. 116). We find him spreading a pale grey wash over a sheet used for the Sistine ceiling (*Cor-*

pus 119 verso). But this aspect of drawing, so familiar from the workshops of the later fifteenth century, disappears after 1512. And in the cases we have just cited, we should note that it was the artist himself who laid in the ground. I have not found a single case of Michelangelo using true coloured paper, so favoured by his friend Sebastiano.

Michelangelo's adoption of chalk, eloquently revealed in his drawings for the *Bathers* cartoon, was not an act of pioneering. Apart from Leonardo, whose celebrated cartoon exhibited to the public at SS. Annunziata in 1501 must have revealed a complex and advanced use of black chalk, we have, for example, over fifty drawings in the same medium by Fra Bartolommeo for his *Last Judgment*, commissioned in 1499. Black chalk seems to have been the medium that Michelangelo most favoured for his drawings for the projected mural, for compositional sketches (pl. 71), for groups of several figures (pl. 77), and for single-figure studies (pl. 124), although it was not used to the exclusion of pen (pl. 123). And there is a precocious use of red chalk in at least one *Cascina* drawing (*Corpus* 68 verso).

Alongside this use of black chalk, we can note a much more prevalent use of stylus for exploratory underdrawing. In some sheets, the indented lines, which the subsequently applied chalk did not fill in, create a pattern recording the artist's rapid search for a solution that satisfied him (pl. 77). In other cases, the incidence of stylus on one part of a sheet and not on another can reveal important facts about the genesis of the design, as will appear in later comments on the Uffizi *Bathers* composition (pl. 71). Nowhere does the use of a stylus play a greater rôle than in drawings for the Sistine ceiling: in preliminary drawings such as the Detroit pen sketch for the overall plan of decoration (*Corpus* 120 recto), in single studies (pl. 126), and even in details (pl. 148). Drawings for projects following the ceiling reveal the same characteristics; stylus lies beneath the central chalk figures of the preliminary compositional draft made for Sebastiano del Piombo in 1516 (pl. 82). He seems to have used a stylus much more sparingly in the period after 1530, and in the very late figure drawings I have detected almost none.

We should not assume that the artist had not used both chalk and stylus before he set out to create his *Cascina* composition. The earliest of his drawings, the copy from Giotto (pl. 108), contains several unremarked stylus lines, but, because bistre is likelier than chalk to fill the indented lines, stylus is less easy to detect beneath pen and ink. And we can find a comprehensive, light, black-chalk drawing beneath the Louvre pen study mentioned above (pl. 116), probably executed two or three years before the *Cascina* studies.

As a broad generalization, it is true to state that the majority of Michelangelo's early chalk drawings are in black chalk. It is in the period of work on the Sistine ceiling that he begins to adopt red chalk extensively, and the life studies made at this time (col. pl. 2 and pls 129 and 130) are, perhaps, the most influential drawings ever made. An interesting question is

to what extent a younger artist such as Andrea del Sarto may have seen them. Some younger men do seem to have had access to drawings in his workshop, among them Rosso, and we have Vasari's word that, at a later date, Michelangelo allowed the brilliant young sculptor Pierino da Vinci to look at his drawings. Not long after the end of work on the ceiling, he employed red chalk for some of his earliest architectural drawings (pls 187 and 189).

In the early 1530s, his predilection for red chalk seems to have weakened, and his intensive employment of it appears to have lasted only just over two decades, from the beginning of work on the ceiling to about the time of his move to Rome in 1534. Its gradual displacement by black chalk follows the earlier disappearance of pen and ink for figure drawings. The presentation drawings of the early 1530s do not reveal a consistent pattern. Nevertheless, there is no large drawing made for the *Last Judgment* in red chalk, and although it occasionally makes a late appearance (*Corpus* 431 recto), his fidelity in old age to black chalk for both figurative drawings and architectural elevations is almost complete. Even in a design for tableware, a kind of drawing for which almost every sixteenth-century artist chose pen and wash, we find Michelangelo taking up his black chalk (pl. 161).

Leonardo had also turned to black chalk as he grew older, and it may be that both artists found in it a means of creating a subtly variegated range of tone which the more brittle medium of red chalk could not achieve. It is, we should recall, black chalk that is the medium traditionally employed for the drawings that come closest to painting—full-scale cartoons.

These generalizations will be supplemented—I hope adequately—in the following pages. More study is required of Michelangelo's use of media. To use the broad description of red or black chalk does no justice to the striking variations in the colour and texture of his chalks. Red chalk may be very light, as in the drawings made after the Coner sketchbook, or may assume a deep red, not so much purplish as earthy, and occasionally we find these different colours used in the same drawing. Likewise, his black chalk may be almost as soft as charcoal, or greasy, or very hard, akin in effect to modern graphite. Problems in interpreting these different appearances remain, for we cannot take a section of a drawing as we can of a painting.

Similarly, we still require a survey of the kinds of sheets of paper employed by artists of the period. Michelangelo's use of paper seems to have been exceptional only in his obsessive concern not to waste it, although paper was no longer a luxury article when the drawings discussed in this book were made. His frugality led him to put down sketches on any piece to hand, be it the back of a letter or, more remarkably, a page from a bank book of a Buonarroti active in 1405 (*Corpus* 26 verso). Relatively early, Michelangelo seems to have adopted very large pieces of paper. The sheet that makes a frequent appearance in the following pages, Uffizi 233F (pls 32–3), was, for example, originally almost twice its present size. We can

establish this, because Michelangelo's copy after Donatello's marble *David* on the verso (pl. 34) has been cut nearly in half. We can make a similar calculation about another sheet of the same period now in the British Museum, where, again, a verso study has been reduced in much the same way (pls 75–6). Copies of drawings can sometimes help us to reconstruct the earlier appearance of some sheets. A later record of one now at Haarlem shows, for example, that the drawing once had more figures (pls 7–8). We can find a substantial number of cases where such evidence has survived. Drawn copies or prints may, of course, record an original of Michelangelo that has disappeared altogether (see pl. 99).

Despite the losses, we can come close to Michelangelo as a draughtsman, closer, perhaps, than to any other of his time. We can glean purely anecdotal details from the drawings, such as the size of his inkwell when he was preparing for the Sistine ceiling. Or we can learn important biographical facts from the letters that have not yet been assembled in book form, those that discuss his activities but that were written neither by nor to him. From letters written to the Duke of Urbino by his Roman agent, we learn that, as early as 1537, when engaged on the *Last Judgment*, Michelangelo was no longer capable of carrying out very detailed work at close range. Such neglected evidence of his presbyopia (long-sightedness), I do not feel fully competent to discuss, but it may help explain some features of the late drawings, such as the near abandonment of stylus and the insistent repetition of contours.[9] Nor can I find a satisfactory explanation of how he scaled up his designs. It seems to have escaped comment that, among all the drawings that we still have, there are scarcely any that were squared for transfer by the artist.[10]

[9] Gronau, 1906, pp. 7–9. Michelangelo copied out a medical 'prescription' for eye treatment on a sheet now in the Codex Vaticanus.

[10] There is partial black squaring over an early nude study in the Louvre, inv. no. 1068 verso (*Corpus* 21 recto). And there is squaring over a rapid sketch of the Virgin and Child in the British Museum (Wilde 31 recto, *Corpus* 240 recto), but, here, the numerals written in suggest that Michelangelo did not do the squaring. So far as I can see, that is all.

II

THE CONCERNS OF THE ARTIST

THE DRAWINGS SELECTED FOR inclusion in this book constitute, I believe, a fair representation of what has survived. Architectural studies apart, and leaving aside also the sketches made to indicate to the stone-cutters at Carrara the shapes and dimensions of the blocks the artist required for building and for carving (pls 162–4 discussed below on pp. 74 and 104), the plates illustrate a remarkably single-minded devotion to drawing the human figure, chiefly the male figure. It has already been suggested that Michelangelo produced a much greater variety of types of drawings than would have been allowed by critics fifty years ago. Yet this variety in the different classes of drawings made by him only accentuates the exclusiveness of the artist's concerns. Different in appearance as the drawings may be, the great majority of them are concerned with creating figure inventions and the subsequent detailed studies he felt compelled to make to convert his inventions into painted or sculpted forms, that 'a fare le figure' which the artist declared to be his aim in the letter about the arts he addressed to Benedetto Varchi.[1]

We may see in this single-mindedness of purpose a reflection of the late-quattrocento Florentine tradition from which Michelangelo sprang and to which he remained remarkably faithful. It is also easy for us to exaggerate his singularity in his self-limitation. A comparable, nearly exclusive concern with the human figure appears in the works of later generations, if we consider the drawings of Andrea del Sarto or the younger Pontormo, or a non-Florentine like Correggio. Michelangelo was, however, active in a period that witnessed a new range of interest on the part of Italian artists in what might be drawn and in what was considered worthy of recording. Look where we may in Michelangelo's graphic work, we find no parallels for the landscape drawings of Leonardo or, to take a fellow artist much closer in age and upbringing, Fra Bartolommeo (pls 9 and 10). In all the months that Michelangelo spent in the wild and mountainous terrain above Carrara, supervising the search for marble, he seems never to have felt the

[1] Varchi, 1549, pp. 154–5.

impulse to record the appearance of his surroundings, as, we may suspect, Leonardo or Dürer would have done. No true landscape drawing by Michelangelo exists and there is no evidence that he ever made one. The landscapes in his paintings, panel and mural, are bleak and inhospitable backdrops rather than described surroundings.

This neglect of so much of the external world brings to mind the criticism that Leonardo levelled at the painter who failed to become an all-rounder. In his *Treatise on Painting* he wrote: 'He is not versatile who does not love equally all things contained in painting. For example, if he does not like landscape, he esteems it a matter of brief and simple investigation . . .'. Leonardo goes on to reproach Botticelli on this score, but the passage applies with even greater force to his younger rival.[2]

If we consider the figure drawings, we have to recognize that we meet hardly at all with the recording of anecdotal life, the portrayal of genre, of the kind we find in the drawings of a younger generation of artists active in the period of the 1520s. We find Parmigianino (admittedly a non-Florentine) describing everyday activities with an accuracy that anticipates the art of the Carracci or Rubens (pl. 11), or, to take an example from the Raphael workshop, Polidoro da Caravaggio sketching women drying clothes in a landscape (pl. 12). Such evocative glimpses of the common round of six-teenth-century life Michelangelo seems not to have felt warranted record-ing—or, if he did, he chose to destroy them. A chalk drawing in the British Museum of a girl seated in a chair holding a spindle (*Corpus* 315 recto) might be regarded as a parallel, but the ideal profile suggests that the drawing is not, in reality, a genre study made from life and was probably done as an exemplar for *garzoni* to copy.

It is, above all, in the depiction of family life in the recently cleaned lunettes of the Sistine Chapel that we may detect evidence that Michelangelo did make such descriptive records. A number of the lunette figures, most conspicuously the blond young woman in the Aminadab lunette depicted in the act of drying her hair (pl. 13), must have been based on observation that the artist had committed to paper. In the fragment of a sketchbook preserved at Oxford (discussed more fully below, pp. 35 ff.), in which Michelangelo jotted down ideas for figures in the lunettes, one sheet in particular stands out as a piece of observation committed to paper in the street. But even this brief, Rembrandt-like vignette of outdoor life (pl. 48) seems to have been made with the purpose of transcribing it into a monumental figure (pl. 49).

There are other hints of what we might call 'disinterested observation' here and there. On a sheet at Windsor, we find a very rapid pen sketch of a friar, sunk in sleep or meditation (pl. 14); Michelangelo may well have drawn him in the neighbourhood of Santa Croce, close to his own Florentine

[2] Leonardo, ed. McMahon, 1956, I, p. 59. Nevertheless, late in life, Michelangelo, through his biographer Condivi, did defen-sively claim an interest in landscape.

house. The sketch, made on top of chalk studies after an antique relief, can be matched by a few other pen drawings, one or two of which come close to caricature (pls 15–16). Like the Windsor friar, these drawings appear to date from the 1520s, in the period when the genre drawings of the kind produced by Parmigianino and others were becoming familiar, and perhaps it is possible to see in these sheets an influence of these younger artists on the older master. There is no hint of this kind of drawing in the surviving work of the later decades.

Some of the subjects that he embraced did demand studies of forms other than human ones. There is clear enough evidence that horsemen were envisaged for sections of the composition of the *Battle of Cascina* that never reached the stage of cartoon and, as a result, were not recorded in the Holkham Hall grisaille (pl. 72) or in engravings. One or two wonderful drawings of horses dating from the period of 1504-6 (pl. 78) have survived and show us that Michelangelo was here prepared to follow Leonardo's example in studying them from life. But their existence serves, of course, to illustrate the fact that Michelangelo made drawings for specific ends, and his later attempts to depict horses in his two Pauline Chapel murals scarcely look as if based on renewed horse studies at all. Yet the artist's professionalism must have led him to study a number of subjects of which we have only glimpses in the drawings surviving today. To give one example: the giant birds depicted in the *Punishment of Tityus* (pl. 224) or in the *Rape of Ganymede* cannot have been drawn without preliminary analytical studies.[3]

With Michelangelo's attitude to portraiture, the issues are more problematic. Drawings that may be considered portrait studies must be distinguished from studies of heads done from life that had no strictly portrait purpose, however vivid an evocation of life and individuality they may present. We know from Vasari that Michelangelo disliked making portraits, but the biographer also refers elsewhere in his life of the artist to a portrait drawing of the artist's intimate friend of the early 1530s, Tommaso de' Cavalieri, which he himself had clearly seen. A comparable portrait drawing, probably less ambitions in scale and finish than the lost Cavalieri, of Andrea Quaratesi, Michelangelo's youthful Florentine associate of the 1520s, is now in the British Museum (pl. 25). There are a few other drawings, less familiar than the portrait of Quaratesi, that seem also to be explicit portrait likenesses, including one of a young child, now at Haarlem (*Corpus* 330 recto), which is not, as has been alleged, a very late drawing, but a study of the 1520s.

Michelangelo also made his own likeness. Contemporaries were aware that the artist had introduced his own distorted face on the flayed skin held

[3] For a fine study of a bird of this period, see *Corpus* 588 verso.

out by St Bartholomew in the *Last Judgment*, and that he had portrayed himself as Nicodemus in the marble *Pietà* group now in Florence. These are self-portraits from Michelangelo's later years and were, undoubtedly, religious metaphors of great significance for the artist himself. There survives one drawing, now in the Louvre (pl. 24), that has strong claims to be regarded as another autograph exercise in self-portrayal. The drawing is in bad condition, which makes assessment difficult, but it was made first in black chalk and then the pen drawing was laid over the chalk. The Louvre sheet was traditionally regarded as by Michelangelo himself, and its autograph status was strongly defended by Berenson. The scale of the drawing suggests that the head is, in all probability, life-size—as was the lost drawn portrait of Cavalieri. It is an image of the artist that clearly enjoyed a considerable and early fame, for there are no less than four sixteenth-century paintings based on it. One of these is inscribed with the artist's name and records his age as forty-seven, establishing a date for the portrait image of not later than 1522. It seems to have been the case, therefore, that Michelangelo passed his own drawing on to another artist to be transcribed as a painting.

It is also likely that Michelangelo made the self-portrait drawing at someone else's request. And his incomplete correspondence gives us some idea of the daunting number and diversity of demands for drawings made upon him. As he grew older, these demands multiplied, not just because of his ever-increasing fame, but because requests for drawings took the place of requests for paintings or carvings which the artist's commitments precluded ever being made. Patrons would come to settle for a drawing, even a drawing not made *ad hoc* for them, rather than go without altogether. Requests of different kinds could come from the heads of ruling houses, such as Federico Gonzaga, or from a backwoods cleric in a provincial Tuscan town. Valerio Belli, a master of intaglio, could harass one of Michelangelo's closest friends in Rome in an effort to procure a design from the absent master. A Bolognese patrician might require a design for his chapel altarpiece which Sebastiano del Piombo could then carry out as a painting. A request might come from the Spanish royal envoy at the papal court for the design for a double tomb for his wife and himself; or, less easy to resist, Cardinal Lorenzo Pucci could press the artist to design the façade of his projected palace in the Roman Borgo.

These pressures on the artist could occasionally divert him from his current preoccupations, and we can look here at a documented case. Many of the foremost artists of the mid-sixteenth century (like their predecessors a hundred years earlier) were called upon to make designs for goldsmiths. Michelangelo responded to such requests with extreme reluctance. We know that, when in Bologna in 1507–8 to carry out an over-life-size bronze statue of Julius II, he undertook to design a dagger hilt for a Bolognese nobleman,

but there is no trace of what this looked like. But even later, when the artist had less time for such activities, there were occasions when he could not refuse, and he complied with the wish of the Duke of Urbino to design a salt-cellar; his own failure to complete the tomb of Pope Julius II, the long-dead Rovere pope, left him no choice. His drawn *modello* for the piece of tableware, made in 1537, is now in the British Museum (pl. 161). The design corresponds very closely to a description of the work given when it was being carried out in Rome, written by the Duke's Roman agent.

The drawing for the Rovere salt-cellar is not unique, but the extreme rarity with which Michelangelo accepted such commissions points to another feature of his personality, his distaste for making designs for others to execute. Close friendships, such as those with Sebastiano del Piombo or, later, Daniele da Volterra, might overcome this aversion. But it appears to have been his jealous regard for his own creations that was behind his refusal to make drawings for print-makers in a period when providing designs for prints had become a concern of many of the greatest artists of the age. A number of Michelangelo's drawings were engraved (chiefly the presentation drawings made for his friends), but this was without his sanction, and his rejection of the prospect of furnishing drawings for prints was violent. Just as he declined to enlist trusted assistants to help to carry out great projects (until advanced old age compelled him to do so), so he never sought out a Marcantonio Raimondi to bestow on his designs a wide dissemination. Such delegation impaired the uniqueness of his art.

The assistants whom Michelangelo did keep in his workshop were of notoriously poor ability. Late in life, he boasted of never having run a workshop, and although the remark was prompted by social snobbery, the lack of an effectively organized team of assistants confirms its truth. The presence of a few *garzoni* serves, however, to remind us of another kind of drawing that Michelangelo did produce, probably in quite large numbers, models or *exempli* for his youthful assistants to copy. There are several sheets where studies by Michelangelo and copies of these by an assistant cohabit side by side. On the back of a Uffizi drawing (discussed below, pp. 107 ff.) we find such a drawing lesson (pl. 19). Michelangelo's own drawing of a bearded profile on the left of the sheet was copied by the pupil on the right. Below, in the left corner, the master drew a skull which was then copied by the pupil above in the centre.

Sheets like these provide us with exercises in discrimination which act to keep us alert. In the past, a failure to discriminate between teacher and pupil led to a rejection of all the drawings on this Uffizi verso. Another example is on a verso now at Oxford (pl. 20). On the right of this sheet, there are two red-chalk profiles, the upper one by the master, that below by the copyist. Then, to the centre and left, we find no less than eleven studies—all of a human left eye. Discriminating here needs more care; of the eleven, I believe

three to be by Michelangelo and the rest to be slightly faltering copies by a pupil, who may have been Antonio Mini.

These eye studies are of a traditional kind in the history of masters teaching their students, and such sheets of eye studies were engraved in books of drawing instruction into the seventeenth century. We can even consider this Oxford verso in the light of remarks made by Cellini in the surviving fragment of a treatise he set out to write on drawing, his 'Discorso...sopra l'Arte del Disegno'. In his opening pages, Cellini deprecates this very exercise of setting the pupil the drawing of the human eye.[4] His remarks show that, on this Oxford verso, Michelangelo was displaying a characteristic devotion to Florentine tradition.

A somewhat different didacticism appears in another class of drawing, the *écorché*. Counting rectos and versos separately, there are over a dozen surviving sheets with *écorché* drawings on them. The majority are now divided between the Windsor Royal Library and the Teylers Museum at Haarlem and all these sheets may have come from the same collection (many share inscriptions and numbering in the same hand). Some are in pen and ink only, some in red chalk, and some in red chalk gone over in pen. Two of the red-chalk sheets at Windsor are clearly studies made with great care from the same plastic model (one is reproduced here, pl. 22). A further Windsor sheet, drawn in pen and ink, is of the same motive but explores it with an astonishing vigour (pl. 21). Others are drawn with almost pedantic delicacy, first done in red chalk, then drawn over in pen, and then marked out, with alphabet letters denoting the chief ligaments (pl. 23).

The *écorché* drawings are not, therefore, identical in purpose and style, but they all reveal a common preoccupation on the artist's part; and the fact that he went to the length of giving letters to individual features in a sheet like the Haarlem one suggests that he had publication in mind. Perhaps, then, these studies, all possibly fragments of the same large notebook, were steps toward the publication of the treatise on human anatomy that Michelangelo was still contemplating when Condivi published his life of the artist. They may not have been made at exactly the same time, but their appearance suggests a date close to 1520: the almost violent pen strokes of the Windsor sheet (pl. 21) closely anticipate those of the initial pen studies for the Medici Chapel statues (pl. 149).

In his drawing practice, Michelangelo was utilitarian. He was a ceaseless producer of drawings, and, even in very old age, he would sit shoeless, as his assistant Calcagni reported, drawing for three hours at a time. But the great majority of his drawings he made in order to carry out specific projects, and we rarely get the impression, as we do when looking at the drawings of Parmigianino, that the artist threw off drawings as a kind of daily exercise, like a pianist playing scales.

[4] Cellini, 1731, pp. 155 ff.

Compared with the multifarious art of Raphael or Titian, his own is confined within narrow—albeit self-imposed—limits. Yet within these limits we find powers of invention that cannot be equalled even by his greatest contemporaries. The series of drawings of the Resurrection of Christ, drawn in about 1532, are concerned with a theme undertaken and interpreted by many artists from the trecento onwards. Michelangelo's series displays an astonishing variety of response to a traditional subject. In some of the drawings, Christ stands on the edge of the tomb, banner in hand, as He had done in some of the familiar masterpieces of the quattrocento or earlier. In others, He breaks explosively from the tomb, scattering the soldiers on all sides (pl. 27). In another, He floats upwards from the tomb as if still wrapped in sleep, a conception of the Resurrection that seems to be without any precedent, but that may have been inspired, I believe, by memories of Ghiberti's floating Eve on the East Door of the Baptistry in Florence (pl. 26). This series is enough to demonstrate that we must turn to the drawings, after we have considered the completed and uncompleted carvings and paintings, if we wish to appreciate to the full the artist's incomparable play of imagination.

III

SURVIVAL AND DESTRUCTION

THAT ANY OBJECT OVER four hundred years old survives in the late twentieth century indicates that successive generations chose to preserve it. But the initial phase of conserving was certainly the least predictable in the case of Michelangelo's drawings, for the artist's own attitude to the preservation of his drawings seems to have been, at best, quixotic. The unpredictability of his behaviour can be illustrated by the fate that befell one of the most beautiful of his early figure drawings (col. pl. 1 and pl. 120). Michelangelo kept this drawing in his Florence workshop for a quarter of a century. Then, in the late summer of 1528, he took up the sheet again, folded it into four and used part of the folded verso to jot down *ricordi* of his expenses for one day in September and two in October; the shopping list includes the cost of a pair of slippers for his nephew Leonardo. Did he vandalize this wonderful and long-preserved sheet simply because he had run out of paper? Despite his brutal treatment of it, he refrained from throwing it away, although the verso *ricordi* were of little significance. It probably remained folded until rescued by the hands of others after his death.

The vicissitudes of survival and loss are such that it is often difficult to do more than record what they have been. If we turn to preparatory drawings for the four reclining Allegories of the Medici Chapel, we find that nine chalk studies have survived for the statue of *Day*, three for the *Night*, and none for *Dawn* or *Evening*. Here, it is surely nothing other than the operation of chance that we are encountering.[1]

A certain pattern can, however, be detected when we survey the whole body of existing drawings. The most recently published corpus, that by Tolnay, gives us a total of over six hundred sheets, some of which are double-sided. Tolnay's *Corpus* includes a small number of drawings that are certainly not autograph, but against this can be set a smaller number of autograph drawings that were unknown to him. Calculating, as we must, autograph rectos and versos as different drawings, we arrive at an ap-

[1] We find a somewhat similar imbalance in the case of Raphael's drawings for the Stanza della Segnatura.

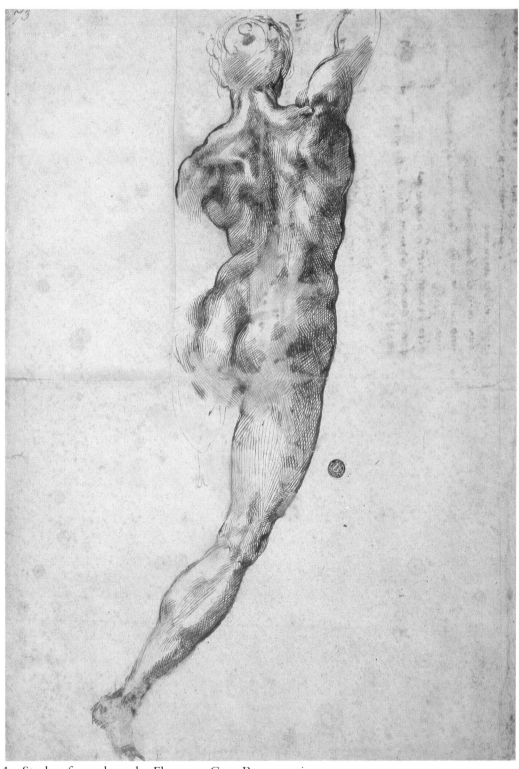

1 Study of a male nude, Florence, Casa Buonarroti.

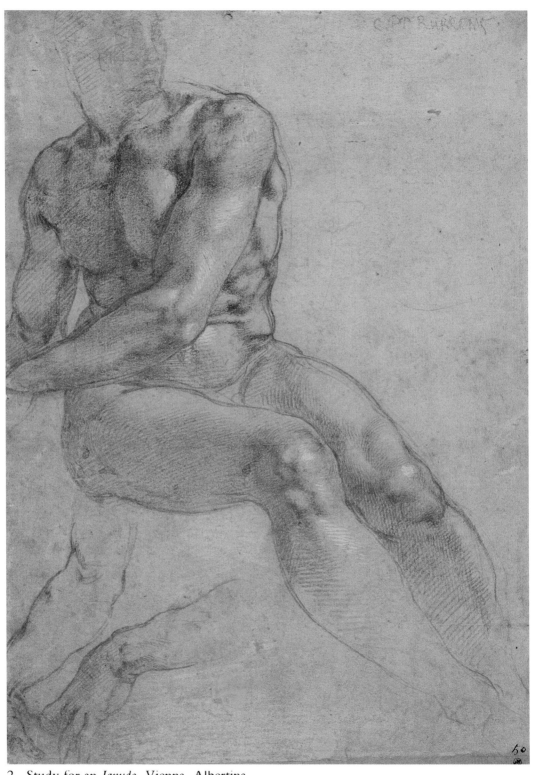

2 Study for an *Ignudo*, Vienna, Albertina.

proximate figure of about 785, although when we consider this total we must bear in mind that a considerable number of what we now consider different drawings were once parts of larger sheets, and that subsequent cutting up has increased the number (see, for example, pls 61–4).

Surveying this surviving material, the conclusion is inescapable that the most numerous block of drawings belongs to the period from 1501 to 1534, the year when Michelangelo, at the age of fifty-nine, left Florence for ever, to take up residence in Rome. In total, including the very few drawings that can be dated from the earliest years (prior, that is, to 1501), there seem to be about three hundred and sixty figurative drawings from the period to 1534, and only just over a hundred from that between 1534 and 1564. With architectural drawings the discrepancy is less marked, but even here we find that, from the last thirty years of Michelangelo's life, when most of his energies were devoted to architecture, we have a total of only about forty sheets; whereas, from the earlier period (and Michelangelo became seriously concerned with architecture only *circa* 1515) we have (including his copies of the drawings in the Coner sketchbook, pls 187 and 189) some ninety-six.

All calculations can be misleading, and with regard to the disparity in the number of figure drawings, one could point to the far greater number of projects for painting and sculpture in the artist's earlier years. Yet the gaps in the groups of late architectural drawings are striking. There is no group for any of the late building projects as numerous as that for the San Lorenzo Library vestibule and reading room, no series of elevational sketches comparable with that for the San Lorenzo façade; and this cannot be explained by the fact that these early projects required the dispatch of drawings to Rome for patronal approval (see below, pp. 83 ff.), for many of the San Lorenzo drawings are not of the kind made for the patron. We must conclude, I believe, that a great deal of the later graphic material, above all the drawings made in the years after 1541, perished at the hands of the artist himself. This would explain, for example, the almost complete absence of drawings made for the two murals in the Pauline Chapel.

The artist's periodic destruction of his drawings was well known to contemporaries. Pietro Aretino refers to such behaviour more than once in letters published in Michelangelo's lifetime. But such acts of destruction are recorded also in the artist's own correspondence. One of Michelangelo's most trusted associates wrote from Rome to the artist in Florence on 5 February 1518 about the instructions that had been received from the absent master. He reports that many 'chartoni' have been burnt. Although the term he uses could denote large drawings, it may well be that they were, precisely, cartoons that were destroyed at Michelangelo's wishes; if so, they must have been cartoons for the Sistine ceiling. Michelangelo's friend laments the decision even whilst reporting its implementation.[2]

[2] *Carteggio*, I, p. 318.

Vasari, the child of a different age, states that Michelangelo destroyed his preparatory work so that no one could witness the struggles he had gone through to create his masterpieces. Such considerations may have exercised Michelangelo's mind, although there seems little indication of this attitude in his own letters. What the correspondence does abundantly confirm is his self-protective privacy, so graphically evoked in a letter of 1527 to the Marquis of Mantua from his Florentine agent, in which he wrote that the artist would not show anything to anybody ('non mostra cosa alchuna ad alchuno').[3] This self-protectiveness seems to have sprung from, above all, a fear of plagiarism on the part of other artists. It manifests itself early, as Michelangelo's well-known letter to his father of January 1506, in which he asks him to hide his marble Madonna, amply shows. Michelangelo's references to drawings in his letters are frequently concerned and defensive, and events such as the theft of important drawings from his Florence workshop just before the siege of the city in 1529—about fifty sheets of figure drawings, including some for the Medici Chapel, were stolen—can only have contributed to his near paranoia.[4] This phobia communicated itself also to the artist's closest colleague, Sebastiano. When the Venetian writes to his absent friend concerning drawings that he is expecting from him, Sebastiano repeatedly expresses his anxiety lest these should fall into the wrong hands.

The artist's self-protectiveness about his drawings may have been provoked, in part, by the appearance of his inventions in the works of other artists. The subject is too large to be reviewed in all its implications here; yet it is a fact that ideas that had remained at the drawing stage, ones that the artist never executed himself, could be implemented in the works of others. A striking case is the figure of St Sebastian in Titian's polyptych in Brescia (pl. 31). The pose and ideal form of Titian's saint is invariably related by art historians to Michelangelo's *Rebellious Slave*, now in the Louvre, begun in 1513. Yet Titian's figure does not reflect the motive of the marble carving. Instead, it reflects, almost precisely in reverse, a red-chalk study by Michelangelo for one of the Slaves of the tomb that he never carried out (pl. 30): the hanging arm, the inclined head, even the high viewpoint of this—or an almost exactly comparable—study reappear in Titian's panel. Michelangelo never went to Brescia and was not in Venice when Titian painted his altarpiece; he could not have witnessed this particular 'borrowing'. But such ransacking of his own creations, usually on a far less inspired level, certainly contributed to the state of mind that led to the elimination of so many laboriously created drawings.

Aware of the imminence of his death, Michelangelo seems to have indulged in a final destruction of his drawings in the last weeks of his life.

[3] Frey, 1907, p. 138.
[4] *Ricordi*, 1970, pp. 371–2.

Friends and relatives, in the letters that they wrote just after he had died and the contents of his Rome workshop had been examined, explained the absence of drawings by the fact that Michelangelo had made two successive bonfires of them. His nephew, Leonardo, the closest member of his own family, is reported to have stated that Michelangelo had burnt everything ('lui stesso in due volte abruscio ogni cosa').[5] Michelangelo's most trusted Roman friend in his latter years, Daniele da Volterra, reported to Vasari that, of the smaller drawings in the Rome house, there were only two, an *Annunciation* (pl. 100) and a *Christ in the Garden of Gethsemane*. There can be no doubt that these intimate associates minimized the amount of graphic material that remained, especially when interrogated by Vasari who was anxious to procure everything he could lay his hands on for his master, Duke Cosimo. Nevertheless, a mass destruction had certainly taken place, and it is in this circumstance that we can explain the kind of imbalance in what has survived, outlined above. The destruction was reported back to the Medici court by Duke Cosimo's ambassador in Rome, and the news drew from Cosimo the aggrieved response that the action had been unworthy of the artist. It would have been truer to say that it was wholly characteristic.

Not all the drawings destroyed in Michelangelo's lifetime were destroyed by the artist himself. The most spectacular—and also the most mysterious— loss was that of the cartoon he had completed for the mural of the *Battle of Cascina*. Vasari gives conflicting accounts of its dismemberment, in one passage attributing its destruction to the much-disliked Baccio Bandinelli, in another suggesting it was torn to bits by copyists during the period in 1516 when the ruler of Florence, Duke Giuliano de' Medici, was fatally ill. Exactly what happened is obscure. Pieces of the cartoon did survive the initial dismemberment; Vasari tells us that there were some in a private collection in Mantua, and other evidence confirms this. There can be little doubt that he himself saw them when he visited the city to meet Giulio Romano in 1542—he mentions them already in the first edition of the *Lives of the Artists* of 1550. We owe to this Mantuan visit, therefore, Vasari's fine account of the actual technique of drawing employed in the original cartoon.[6]

The fate of these Mantuan *Cascina* fragments is unknown. The owners were considering selling them in 1575. Then, they disappear from all re- cords, although it is clear that Rubens studied them on his stay in Mantua in 1604. They cannot have been the two *Cascina* fragments that appear in inventories of the collection of the ruling family in Turin in the seventeenth century. These pieces are described in one of these inventories with sufficient detail to allow us to identify which figures of the cartoon were in question,

[5] Frey, 1930, p. 82.
[6] Vasari, ed. Milanesi, VII, pp. 160–61. It could have been the presence of these fragments in Mantua that provoked Federico Gonzaga's attempt to get hold of 'tre o quatri cartoni' of the artist in Rome in 1538; see Frey, 1907, p. 138.

and we also learn a fact of great importance, that the figures had been drawn by Michelangelo on a scale larger than life. These fragments seem to have perished in a fire in the middle of the seventeenth century.

A point that requires making, in a consideration of how much we still have of Michelangelo's graphic output, concerns his working method. Michelangelo must have been the readier to destroy his drawings because, unlike artists as diverse as Andrea del Sarto or Rubens, he did not reuse them. It is difficult to find a single case where we can point to his having picked up, for example, a study made from life, and re-employed it for a subsequent work. This has two conflicting implications. It means that he did not husband such studies for future use. But it also means that he made more drawings than would otherwise have been the case. For every invention, Michelangelo started, as it were, from scratch.

No example is more telling, in this regard, than that of his preparations for the panel painting of *Leda* (pl. 157) undertaken for Duke Alfonso d'Este in 1529. The pose of the *Leda* is similar to that of the Medici Chapel *Night* of a few years earlier; here, we do have a case where the artist's contemporary critics might have complained of repetition. Yet the drawings made in preparation for the painting show Michelangelo beginning anew; he did not pick up the drawings he had made so recently for his statue. In a study of how Michelangelo came to create his works, figurative or architectural, we find no short cuts.

Drawings are among the most vulnerable of all objects; even the leaves of manuscripts were usually protected by their covers. When we read of the travels of some of Michelangelo's drawings, we can appreciate at once the fragility of the sheets and the artist's concern for the safety of those he still needed. In the letter to his father of January 1506, the artist asked him to send on to him in Rome drawings he had left behind in his Florence workshop—they may have been studies for the first project of Pope Julius's tomb which he had had with him at Carrara the preceding year. Michelangelo's request is expressed in anxious terms: 'But see to it that it [the sack of drawings] is well packed in order to be waterproof, and take care, when packing it, that not the least sheet suffers...' ('no' ne vadi male una minima carta...').[7] Lodovico Buonarroti no doubt complied, and the drawings went down to Rome in the care of the carrier ('per uno vecturale'). In fact, the first leaf of Michelangelo's surviving *ricordi* has a note of the dispatch of just such a package of drawings (it is dated April 1508 and relates to preparations for the Sistine ceiling): 'per la vectura d'un fardello di disegni.'[8]

Michelangelo's drawings travelled more than most. When working on the Medicean projects in Florence, the San Lorenzo New Sacristy or the Library,

[7] *Carteggio*, I, p. 11.
[8] *Ricordi*, 1970, p. 1.

the artist was in one city and the patron in another; the letters show that about a dozen drawings connected with the Library reading room and vestibule went from Florence to Rome for inspection (see pp. 83 ff.). Michelangelo's drawings for San Giovanni de' Fiorentini, near the end of his life, may have travelled in the opposite direction (see p. 87).

The *peripatea* of some drawings can be reconstructed from the correspondence. In other cases, we can go some way towards reconstructing what happened to drawings from the evidence of the sheets themselves. As an example, we can take two now at Haarlem. On the recto of one, there is a fine black-chalk drawing for one of the more subordinate figures in the *Cascina* cartoon (pl. 122), whilst on the verso there is a summary compositional draft for the Sistine spandrel *Judith and Holofernes* (pls 80–81). The recto must have been drawn in the late summer or early autumn of 1504, the verso drawn in Rome in the early summer of 1508, but we cannot tell when the sheet left Florence for Rome; perhaps the artist took it with him when he went to Rome in the spring of 1505, or it moved at some date in early 1508, either taken by him or included in one of the bundles dispatched with the courier. The companion Haarlem sheet has a comparable *Cascina* study on the recto (pl. 121), but in this case, many years elapsed before Michelangelo used its verso; he employed it for a life study for the marble *Victory*, a work undertaken not earlier than the 1520s in Florence.

We cannot say whether this second sheet had remained in Florence for this long period of about twenty years. However, it can be shown that these two Haarlem sheets must have ended up in Michelangelo's Roman studio after 1534. Both the nude studies were used by a mid-century Roman painter for purposes of his own. One he employed in a painted frieze in the Palazzo de' Conservatori on the Capitoline Hill, the other, for the figure of the Baptist in an altarpiece of the *Baptism of Christ* in San Pietro in Montorio. The two sheets, subsequently owned by Queen Christina of Sweden, have remained together ever since.

Michelangelo's attitude to his drawings cannot be summarized. When he needed drawings he had made, he could express profound concern over their safety. At other times, he could treat them simply as convenient scrap paper on which to write, at one moment, humdrum notes, at another, drafts of poems involving his deepest feelings. They could be handled with wanton brutality, torn up or folded, in order to provide paper for other uses. Alternatively, drafts of his own letters, or letters written to him, could be picked up and used for drawing. Our approach to the drawings would have seemed baffling to their creator. Today, we respectfully lift them from their boxes in the calm security of a print room, or study them in a dim light in sealed and rigorously controlled cases. Such conditions do not make it easy to recapture those of their original use or bring home to us that they were objects subject to a wealth of contingencies in the artist's lifetime.

IV

CHRONOLOGY, CONSISTENCY, AND CHANGE

DESPITE HIS PASSION FOR recording and dating his expenses, Michelangelo rarely inscribed his works with either signature or date. He seems never to have dated a drawing in the way that Leonardo did his early landscape drawing in the Uffizi (pl. 9). However, Michelangelo disliked wasting paper, as the appearance of many of his sheets shows; and, as we have seen, this thriftiness led him very frequently to use the same sheets of paper both for making drawings and for writing things down. A very substantial number of his drawings are on sheets that, on recto or verso or both, contain writings by the artist. These writings are of different kinds, but are usually drafts of poems, or drafts of letters, or brief *ricordi*. Drafts of letters, if we can find the definitive text elsewhere, can frequently be dated. *Ricordi*, by their very nature, are commonly dated. Thus, because of Michelangelo's habits and his frugality, we find on drawings themselves a valuable aid to help us date them. But it is an aid that can fail us or lead us astray. To give an example of this, we need look no further than the Casa Buonarroti sheet already discussed (col. pl. 1 and pl. 120) and recall that the *ricordi* on the verso were jotted down about twenty-four years after the drawing on the recto had been made. The case is certainly unusual but serves to induce caution.

Again, we might be inclined to assume that autograph writing on sheets used for drawings was added after the drawings had been made. For the majority of cases, this rule holds good, but it does not always do so. We cannot rely absolutely on a piece of datable writing to serve as a secure *terminus ante quem* for the associated drawing, just as we cannot rely on drawings on recto and verso of the same sheet having been made at the same time. The situation with one or two sheets can be even more confusing, for we may occasionally meet with a case where one piece of writing precedes the drawing and another, unrelated piece of writing follows it.[1]

We may note here that some inscriptions are potentially misleading in

[1] See the early study for the *Leda* (*Corpus* 207 bis verso) and the analysis by Wilde, 1957, pp. 275 ff.

other ways. For example, on a British Museum sheet, for the most part covered with pen studies of children, a hand that is not Michelangelo's has twice written 'chosse de bruges . . .' ('things of Bruges').[2] These inscriptions must refer to Michelangelo's projected sculpture for Notre Dame in Bruges (pl. 39), but none of the drawings can be securely related to the marble group and most of them are demonstrably for the Taddei tondo. If neither carving had been carried out, this piece of 'documentation' might have led us badly astray about Michelangelo's intentions.

Drawings may contain other internal evidence of their date, apart from their general stylistic appearance. Of all Michelangelo's drawings, it is the figurative pen drawings that are the most difficult to date from their style. Sometimes, they contain other indications. For example, on a well-known sheet in the Louvre that was in Mariette's collection, there is a wonderfully animated pen-and-bistre drawing of a satyr's head (pl. 17). Beneath the pen drawing, there is a quite different head in red chalk, a female head which, unlike that of the super-imposed satyr's, has long, wavy hair. Mariette himself saw that this lower chalk drawing was of poor quality, 'par un pauvre ignorant.' Since the verso of this sheet contains the writings of Michelangelo's assistant Antonio Mini, as well as a number of feeble drawings consonant with Mini's modest capacities, there is little reason to doubt that the red-chalk head on the recto is Mini's, and that Michelangelo drew over it the remarkable creation we now see. Mini is recorded in Michelangelo's service only from 1522, and we can, therefore, conclude that the style of drawing of the satyr's head represents Michelangelo's pen-drawing style as it approached its last phase, before, that is, he abandoned using pen for figure drawings altogether. It seems, indeed, that Mini's submerged red-chalk head is the copy of one of Michelangelo's ideal head studies now lost, for a further copy of the same lost design, drawn by an abler hand on a somewhat smaller scale, has survived (pl. 18).[3]

For the great majority of Michelangelo's drawings, however, we must attempt a dating from external evidence, and this, because of the great wealth of documentation that survives, is extraordinarily abundant, richer than for any other sixteenth-century artist except Vasari. A substantial number of drawings can be related to references in documents and, above all, letters. We cannot, it is true, date any drawing of Michelangelo's to a particular day, for he seems never to have added drawings to the actual texts of letters in the way Filippo Lippi did when he wrote to a member of the Medici family in 1457. But we can come close enough to suggest, in some cases, a span of weeks, and in many cases, a span of months. We can, for example, state with near certainty that Michelangelo completed the most

[2] *Corpus* 48 verso.
[3] Tolnay's date (*Corpus* 95 recto) is, there-fore, too early.

highly finished version of the *Fall of Phaethon* in the last few days of August
or the early ones in September 1533, for Tommaso de' Cavalieri wrote his
letter of acknowledgment to him on the 6 September.[4] We can be almost as
certain that the artist presented two earlier drawings, the Windsor *Tityus*
(pl. 224) and the now lost final version of the *Ganymede* to Cavalieri at the
end of 1532 as some kind of Christmas gift, for the recipient wrote his thanks
for what are plausibly these drawings on New Year's Day of 1533.[5] The
letters do not, however, tell us when he began them; because of their intense
elaboration, they must have taken weeks to complete.

These are rather exceptional cases. Nevertheless, by correlating drawings
with written evidence, scholars in the past have succeeded in establishing
approximate dates for a remarkable number of drawings. To cite a specific if
modest case, we may turn to the black-chalk drawing for a salt-cellar re-
ferred to above in a different context (pl. 161). Michelangelo undertook this
uncharacteristic task for Francesco Maria delle Rovere, Duke of Urbino, on
the latter's request in early 1537, and, as we have seen, a letter dated 4 July
1537, discussing the goldsmith's progress, has survived.[6]

But many of the letters either from or to the artist himself provide
evidence for dating specific sheets. We know, for example, that Mich-
elangelo's definitive design for Sebastiano's Montorio *Flagellation of Christ*,
now preserved in a facsimile-like copy (pl. 83), was received in Rome
between 9 and 16 August 1516, and, as a consequence, we can date the
surviving autograph draft (pl. 82) in the immediately preceding period.

Many of Michelangelo's architectural drawings of the early 1520s can be
dated because of the large number of letters that went between patron and
artist. If a suggestion, made below, is accepted, we can conclude that the
'finished' drawing made for the internal articulation of the New Sacristy
cupola (col. pl. 3) was done in January 1524 and was returned from Rome to
the artist on 9 February (see pp. 84 ff.). We can find Michelangelo making a
drawing to meet a specific request which has survived in the correspondence;
the brief free-hand sketch of properties and their owners on the Piazza of San
Lorenzo was done as a response to a demand for information from Rome,
also dated in February 1524 (*Corpus* 543 recto).

A list of correspondences of this kind between written word and drawn
image would fill many pages. But at this point, it may be useful to turn to
drawings made for projects where such exactitude is missing. For most of
Michelangelo's large-scale pictorial commissions, for example, we have a
general chronological framework. This holds true of the never-painted *Battle
of Cascina*, the Sistine Chapel ceiling, and the *Last Judgment*. But it is more
difficult to pinpoint the specific date of a particular sheet.

[4] *Carteggio*, IV, p. 49.
[5] *Carteggio*, III, pp. 445–6.
[6] See Wilde, 1953, p. 105.

When we attempt to do this, it is important that we should appreciate the artist's working procedures. It has been rightly noted, with regard to Michelangelo's practice as an architect, that he never designed anything until the last moment, until he was literally compelled to do so. This is no less true of his practice as a painter. All the evidence points to the fact that Michelangelo did not set about designing the later part of the Sistine Chapel ceiling whilst he was engaged with the earlier part, and that he turned to the later only after the first part had been finished in 1510 and then unveiled in 1511.

This method of working has important consequences for dating. It implies, as I point out elsewhere in this book, that the small-scale drawings in the Oxford sketchbook (pls 44–5), which contain invention motives for late lunettes in the Chapel, but not for earlier ones at the Chapel's entrance end, were made not earlier than 1510, and probably not before Michelangelo was close to resuming work in 1511 (see pp. 35 ff.). Drawings such as large life studies (pls 127 and 129) must have been made immediately before he proceeded to draw the full-scale cartoon which, in turn, was prepared only when the relevant area of the vault was arrived at. Studies such as those for the Sistine figure of Haman, were, in other words, drawn only as the artist reached the close of his campaign of work in 1512.

Throughout his life, in preparing for sculpture as well as for painting, the act of drawing came just before the work had to be started; there is absolutely no evidence that a study made in one period of his life was ever retrieved and re-employed years later. Certain drawings remained, of course, close at hand after they had served their purpose; one such was the Oxford sheet with the red-chalk study for the *putto* who accompanies the Libyan Sibyl (pl. 57). It was because he had only recently used this piece of paper that Michelangelo picked it up again a few months later and with his pen jotted on it, around the chalk studies, ideas for the marble Slaves for the tomb of Pope Julius II.

We do not know when Michelangelo was commissioned to paint the *Battle of Cascina*, although it certainly followed the commissioning of Leonardo's mural of the *Battle of Anghiari* for the same room in the Palazzo Vecchio. The most important chronological fact regarding the ill-fated scheme is that the large sheets of paper that went to make up Michelangelo's cartoon for the Bathers section of his painting were being glued together in early October 1504.[7] Michelangelo's penultimate preparatory stage, the making of life studies, must have immediately preceded this. It follows that drawings such as those at Haarlem (pls 121–2), or in Vienna (pl. 124), or London (pl. 123) were probably made in the late summer of 1504. Similar observations apply to the series of drawings for the *Last Judgment*. Although, in this case and unlike that of the Sistine ceiling, Michelangelo had produced

[7] For the date, Hirst, 1986 (1), p. 46.

a drawn scheme for his patron to inspect, the evidence suggests that here, too, Michelangelo made cartoons for each section of the enormous fresco as work proceeded.

Nevertheless, where there is nothing to help anchor a drawing, when we are faced with the sheet and absolutely nothing else, dating can be an unnerving business. Traps may exist where there is near unanimity in the literature, as well as when there is conflict. The problem of the date of a famous drawing at Oxford, representing the Virgin and Child with St Anne (*Corpus* 17 recto), is a case in point. Its dating has, for the most part, been based on an incautious acceptance of a notional context, its dependence on a work of Leonardo's made in Florence in 1501. It also is commonly dated in the same year. But the source in Leonardo's art may have been invented earlier than 1501. And, even if it had been, we cannot rule out the possibility that Michelangelo was reverting to an aspect of the older artist's work several years later; the style of the Oxford drawing would not exclude a dating of around 1504–6.[8]

Generally, however, we find divergences rather than agreement. We can find an account of a number of these in Wilde's British Museum entries. Some of these differences of view involve datings that are decades apart. In my own opinion, the first drawing in Tolnay's recent *Corpus* is dated over twenty years too early. It would be presumptuous to assume that this record of conflicting opinions is one of human blindness, although it would not be arrogant to suggest that, the more we learn about the artist, the more such disparities of judgment will be ironed out. But we need to ask why dating some of the drawings can prove so difficult.

The primary cause is Michelangelo's own remarkable consistency as a draughtsman. We can appreciate this consistency by looking at a few examples. As has so often been pointed out and as we saw above, the figurative pen drawings of the early years of the sixteenth century show the final refinement and perfection of the fine cross-hatching technique that he had learned years earlier from Ghirlandaio. One example of this mastery is the Casa Buonarroti sheet to which I refer so frequently in these pages (pl. 120). Another is the British Museum study for one of the figures in the *Cascina Bathers* (pl. 123), made, as suggested above, in the late summer of 1504. It is revealing to compare the latter sheet with the study for the earlier of the two versions of the marble *Christ*, of which the second one is in Santa Maria sopra Minerva (pls 131–3). Work on the first discarded version of the statue began after the signing of the contract in June 1514. Thus, almost exactly a decade lies between the making of these two drawings. If we did not know their purpose, a precise dating would be almost impossible. Could we even be sure of the sequence, of which study came first?

We can find the same thread of consistency if we turn to drawings of other

[8] For this, see Wasserman, 1969, pp. 122 ff.

kinds. The British Museum study for the Bruges *Madonna and Child* marble group (pls 37 and 75) was probably made in late 1504. We may put alongside it a drawing of the same type, in the same collection (pl. 38). Both are invention sketches made at the early stages in the development of a figure motive. The latter drawing was probably made at the very outset of this creative process and is consequently smaller than the other. It is one of Michelangelo's earliest ideas for the design of a composition of Venus and Cupid which he subsequently carried out in a full-scale cartoon made for Jacopo Pontormo to turn into a painting. The little Venus and Cupid study dates from 1532 or 1533. It was made, therefore, almost exactly thirty years after the study for the marble group—the period of a normal working life for many sixteenth-century artists. Yet the appearance of these two drawings is remarkably similar, in the choice of medium, and even in the graphic shorthand. One can, indeed, say, that the style of drawing has scarcely changed more radically than the artist's handwriting. In each case, the chief figure is sketched as a male form, although one is for a Madonna, the other for a goddess. Their common style is a consequence of their similar function. And we can go further and add that the style does not vary radically on account of the fact that one is for a three-dimensional marble group, the other for a two-dimensional painting. These two sketches would aptly serve to illustrate the text of Michelangelo's letter to Benedetto Varchi on the identity of purpose of the two arts.

It is, above all, the figurative drawings in pen and ink that create such acute problems of dating. We can, however, run into difficulties almost as great with figure drawings made with chalk. Many years ago, I compared Michelangelo's chalk study for Adam in the Sistine *Expulsion* (pl. 28) with a study for a soldier in one of the compositions of the *Resurrection of Christ* (pl. 29). As with the invention drawings in pen, we are here confronted with comparable stylistic treatment, when, again, the drawings are about twenty years apart in date. Both drawings exhibit Michelangelo's approach to the problem of capturing human plasticity at a stage when the basic figure motive has been established and the artist's concern was to observe the broad lines of internal modelling under the stress of the movement he has chosen. In both, form is created with an economy of line (there is little or no hatching) that recalls a woodcut of Dürer.[9]

The dating of these two studies might be clarified by the change in the figure ideal, so much more slender in the earlier drawing. Yet even criteria of this kind can be misleading. If we turn to a sheet in the British Museum (pl. 125), we can appreciate this problem. This remarkable study was convincingly shown by Steinmann to be for the Sistine *Ignudo* above and to the right of the *Delphic Sibyl*. Other critics had believed it to date from the period of the *Last Judgment*, over twenty years later, and Berenson, modifying his opinion

[9] See Hirst, 1963, p. 170.

in the second edition of his *Florentine Drawings*, was only half persuaded that Steinmann was right. What, in fact, had led critics to date it late was the charcoal-like appearance of the *matière* which brings out the texture of the paper—Michelangelo had here used an eccentrically greasy chalk—and the heroic build of the figure. The body's proportions are more massive than those of the painted nude; making this study, Michelangelo did not, as he seems usually to have done in his Sistine *Ignudi* studies, select a youthful model. It is not surprising that critics went astray. And just how prophetic the Sistine study is of his later drawings can be shown if we compare it with a black-chalk study for a dead Christ, made much later than the *Last Judgment* (pl. 144)—it may be, indeed, one of the latest studies of its kind. The way in which the head is lightly indicated with a very personal kind of shorthand, and the way in which extremities are just touched on to the paper, is very similar. A space of about forty years separates these two drawings, and the confrontation is eloquent proof of the justice of Berenson's observation that 'in rapid and large chalk sketches Michelangelo differs little from epoch to epoch—too little, at all events, for ready distinction. . . '.[10]

With architectural drawings, the chances of serious misdatings are not so great. Even more strictly utilitarian than the figurative drawings, the identification of the projects for which they were made is usually an easier task. But where no project was carried out, we run into difficulties. A fine drawing in the Casa Buonarroti will illustrate some of these (pl. 178).

Opinions have differed sharply about this study. It has been interpreted as the project for a wall tomb or, more commonly, for an altar; one critic even connected it with the late Porta Pia. From the briefly sketched plan that Michelangelo drew in below, and from the volutes that frame the attic, there can be little doubt that the project was planned for a wall. But he has given us no indication of its scale. How should we date it? All that we have is the style of the design itself. The constituent elements, even the profiles, recall Michelangelo's drawings for the façade of San Lorenzo and the preceding drawings recording antique monuments (pls 189 and 203), but the whole conception is much more monumental—witness the massive attic—of a grandeur that anticipates a Palladio façade. A date before the middle of the 1520s seems impossible. But the fact remains that certainty about its purpose and its date is likely to elude us for ever.

Problems of dating can arise where a building project continued over many years, as happened with Michelangelo's involvement with the Campidoglio and with St Peter's. There is, here, the risk of a too simplistic interpretation of the context. The elevational drawing at Lille (pl. 211), made at some stage in Michelangelo's thinking about his cupola design, has often been connected with his written request in 1547 for the measurements of Brunelleschi's cupola in Florence to be forwarded to Rome. The connection between letter and drawing may look obvious. But other graphic evidence

[10] Berenson, 1938, II, p. 181.

suggests a substantially later date, in the following decade. On the verso of the Lille sheet (pl. 4), there is an autograph inscription datable to about 1556–7. It also contains a chalk study for a window tabernacle for the drum of St Peter's which Michelangelo would have had no call to make at the earlier date. And, as we saw above, within this architectural drawing, the artist sketched in a dead Christ which, it is important to note, was made for the second, revised, version of the Rondanini *Pietà*. Such evidence is not conclusive, but other drawings relating to the cupola can also be dated in the later 1550s.

We possess an astonishing variety of architectural drawings by Michelangelo, ranging from the hastiest indications of site plans (pl. 192) to large and much-worked plans to be presented to the patron (pls 181–2). Or, turning to elevational drawings, we can move from brief, free-hand sketches exploring novel architectural forms to the painstaking construction of profiles made to be translated into templates (pls 213–14) to guide the masons cutting the stone.

Yet running through this rich diversity of material we can find threads of continuity that, also here, link early with late. We might, for instance, compare two groundplans, both made for structures that were never built. The earlier (pl. 180), it has long been recognized, is the groundplan for a rare-book room that Pope Clement VII wished to incorporate into the complex of the San Lorenzo Library. This Casa Buonarroti sheet is the *modello* Michelangelo made to send to the pope in Rome (see p. 85). The other is one of several plans he prepared as designs for the church of San Giovanni de' Fiorentini in Rome near the end of his life (pl. 181). It, too, is a *modello*, prepared for inspection both by the Florentine community in the city and by Duke Cosimo I in Florence. Although the two were not drawn in an identical fashion, both plans were based on carefully ruled lines, in one case in pen, in the other in black chalk, and then, in both, blocks of bistre wash were superimposed with a brush. It does not seem to be pressing the argument of continuity too hard to claim that the overall appearance of the two sheets is very similar.

It would be absurd to close this discussion with an implied suggestion that, over the course of so many years, the appearance of Michelangelo's drawings did not change. As already noted, the very choice of drawing materials altered: from the period of the 1530s, Michelangelo seems to have abandoned red chalk for his figure drawings almost entirely. For some of the drawings reproduced in this book (see, for example, pl. 144) a late date has never been questioned, and no one would seriously suggest today that the series of three-figure Crucifixion sheets (pls 106–7) was done before 1550. Michelangelo's drawings do change in appearance, but it is important, when stating this obvious fact, to make a distinction between drawing *practice* and drawing *style*. The style changed, sometimes slightly, at other times radically, whilst the practice remained remarkably consistent.

A comparison of two life studies, both done for fresco painting, may help

illustrate this distinction. The earlier, made in red chalk with touches of
white body colour added, is for the *Ignudo* above and to the left of the *Persian
Sibyl*, painted in 1511 (col. pl. 2 and pl. 127). The other, in black chalk, is a
life study for the stooping figure of St Lawrence in the *Last Judgment*, and
was drawn almost a quarter of a century later (pl. 142). They are the same
kind of drawing. In both, the extremities are left out, or taken up and studied
separately in a spare area of the same sheet. Both illustrate with great
vividness Berenson's insight when he wrote that, for Michelangelo, every
figure study was a renewed exploration of anatomical form, which explains
'the deliberate elaboration of certain parts to the neglect of others, all
witnessing to an eternal preoccupation with anatomical structure...'.[11]

The drawings have even more in common than this. If we compare the
drawn forms with the painted ones (pls 128 and 143), we can immediately
perceive that the differences between the chalk studies and the related
frescoed figures are substantially the same: in both cases, the painted figures
have been made much bulkier and broader (compare the respective treat-
ment of the shoulders), so that the painted ideal is no longer the unqualified
reflection of the model drawn in the workshop. The painted figures in the
respective murals have, to an extent, become forms not of life but of
Michelangelo's imagination. The same holds true of the relation between
another *Ignudo* study and the corresponding painted figure.

Despite these common traits, we could scarcely conclude that the
Albertina *Ignudo* and the Haarlem *St Lawrence* were made at the same date.
There are, it is true, some striking divergencies between some of the
surviving studies for Sistine *Ignudi* (pls 125–6), but the differences are
explicable in terms of different functions, whereas the two drawings we are
concerned with here are the product, not of the same year or month, but of
the same moment in the design process. The differences are not difficult to
perceive. Put very crudely, the earlier drawing shows a more pronounced
disjunction between contours and internal modelling. All the lines are shar-
per and more brittle. The contrasts of light and shadow are much more
emphatic, as if the Albertina model had been placed in full sunlight, whilst
the Haarlem one had been studied in an ambience of suffused light only. The
effect of the powerful lighting in the earlier drawing leads to the almost
lapidary description of single physical elements such as shoulders, knees, and
the like, whereas the different areas of modelling in the later sheet fuse
together. The handling of chalk in the Vienna study still recalls that of the
anatomical pen drawings, and in a passage such as that of the lower left leg,
Michelangelo actually resorts to regular cross-hatching with the sharp point
of his chalk. He has also added white paint to strengthen some of the
highlights. In the Haarlem drawing, stresses are created not so much by the
emphasis on highlights, as by the deepening of darker accents by the artist's
moistening of his black chalk.

[11] *Ibid.*, I, p. 192.

Many similar observations apply to the architectural drawings. It may be helpful to compare, for example, the artist's elevational drawing for a doorway at the San Lorenzo Library, made in the mid 1520s (pl. 177), with his late and most complete study for the Porta Pia (col. pl. 9 and pl. 185). Both sheets are in the Casa Buonarroti and are of almost the same scale. Here, too, we encounter a greater contrast between the rather stark austerity of the earlier drawing and the rich colour of the later one. Paradoxically, the use of white body colour in the Porta Pia drawing does not disrupt the tonal unity, but, obliterating in some areas black-chalk drawing beneath and thereby assuming a greyish cast, binds the architectural forms together.

These differences are more extreme than those in the figure studies we have just considered, but they are not unrelated in kind. As regards the architectural drawings, however, we may make a further comment. The two figure drawings were planned to be carried out in the same medium, rapidly applied paint on fresh plaster. With the architectural drawings, the situation was different. The limpid and relatively unvariagated washes and sharp profiles of the reading-room design agree very well with the hard and clear forms of Tuscan *pietra serena*, whilst the softer, broader forms of the late drawing approximate to the textured building materials that Michelangelo employed in Rome, brick and travertine.

V

INVENTING THE MOTIVE

NOWHERE IS THE CONSISTENCY of drawing method already discussed more readily demonstrated than in the class of drawing that records Michelangelo's initial concern with a single motive, where the first germ of a form or forms appears on paper. Today, we can find examples of this kind of drawing only on sheets datable after his return from Rome to Florence in 1501. This may be no more than an accident, for few drawings of any kind have survived from the 1490s. It is a kind of drawing to which we may apply Vasari's characterization of initial sketches written in his Preface to Painting of 1568: 'Sketches...we call a certain kind of initial drawings made to establish the form of the poses and the first arrangement of the work' ('Gli schizzi...chiamiamo noi una prima sorte di disegni che si fanno per trovar il modo delle attitudini, ed il primo componimento dell' opra').[1] Less than a century later, the term 'primo pensiero'—the first thought—appeared in art-historical terminology in our context. Baldinucci, one of the greatest of seventeenth-century Italian authorities on drawings, used it as an alternative to 'schizzi'. And we find Rubens using the word 'pensiero' along with 'sketches' even earlier, in one of his many letters written in Italian.[2]

Michelangelo must have made almost innumerable drawings such as these, but they may have been of a kind that he himself had little inclination to keep and that did not attract the attention of early collectors. The most striking early examples are on the well-known sheet in the Uffizi (233F) which is remarkable both for its scale and for the variety of its contents (pls 32–3). On it, there are in all six tiny studies of a Madonna and Child, three disposed at right angles down the left margin (pl. 33), and a further three (one now almost invisible) drawn in the same direction as the larger studies. The black-chalk study in the centre, for a figure in the *Battle of Cascina* cartoon, was certainly the first drawing to be made (for a fuller discussion, see below, pp. 42 ff.). The little Madonna and Child sketches were the last to be made, hastily jotted down in the gaps available between and around the

[1] Vasari, ed. Milanesi, I, p. 174.
[2] Baldinucci, 1765, p. 10. For Rubens see

Held, 1959, I, p. 25. The term was later taken up by Mariette.

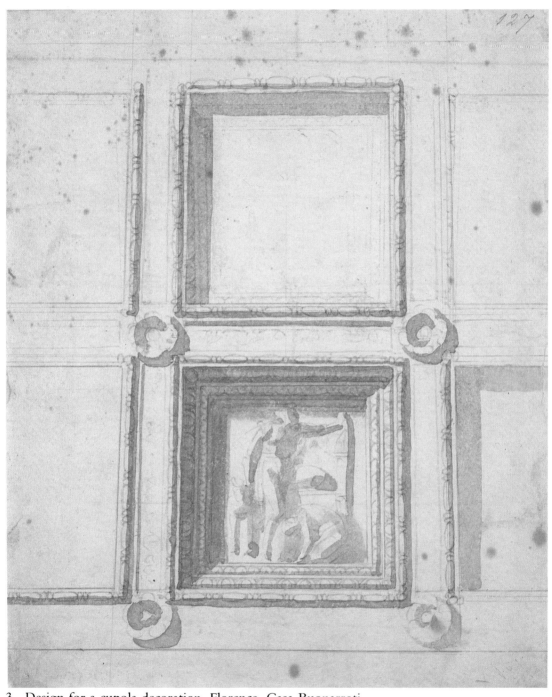

3 Design for a cupola decoration, Florence, Casa Buonarroti.

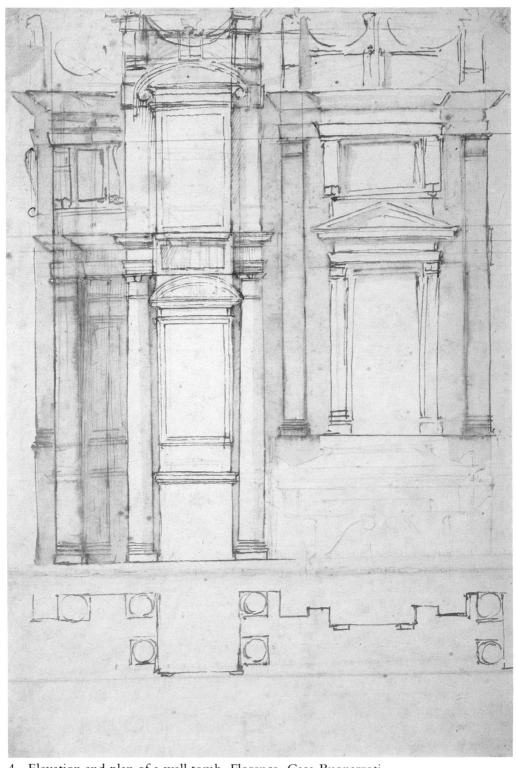

4 Elevation and plan of a wall tomb, Florence, Casa Buonarroti.

other studies. And they may, originally, have been more numerous for, as we saw above, this sheet is scarcely more that half its original size. The sheet is remarkable evidence of how many projects Michelangelo was concerned with at the time he used it—all the motives can be dated in late 1503 or 1504. It confirms, too, his consistent prediliction—perhaps springing from his innate frugality—for covering all areas of the paper with inventions.

Of these tiny drawings on the sheet, five of the six seem to be ideas for the marble group of *Madonna and Child* destined for the church of Notre Dame at Bruges, completed and dispatched to Flanders in 1506. These minute studies for the group—those drawn at right angles down the left edge measure between four and six centimetres—show alternative motives. In the top one, where only the Child has been drawn in in ink over the lead-point, He is already planned to stand in front of the Virgin, whereas in the centre study He sits astride her lap, turning to take her breast. The study in the middle of the sheet, drawn in the same direction as the larger studies, is essentially of the same kind, but shows yet another motive: the Mother's arms are flung up and wide and her body is turned in violent movement. This dramatic invention is in stark contrast with the near immobility of the Bruges work, and the idea could never have been transposed into a marble statue. Nevertheless, Michelangelo did not quickly abandon it; three rapid, large pen drawings, one on a sheet in Vienna (pl. 40), two on a second one in Paris (pl. 41), show Michelangelo carrying the idea further. It cannot be ruled out that the tiny initial Uffizi study and these larger drawings were ideas for one of the two carved relief tondi, both begun in the same period; in the Paris drawings, the Mother extends her right arm, a motive that re-appears in the Taddei marble tondo now in London.

A further step towards establishing the design of the Bruges marble group is the pen study (again over lead-point) in the British Museum, drawn, like the Uffizi studies, on a sheet with drawings for the *Battle of Cascina* (pls 37 and 75). Here too, it is clear that it followed the *Cascina* study. Over twice the scale of the Uffizi *pensieri*, it represents a somewhat later stage in the artist's design process, although the lead-point underdrawing took its departure from one of the Florence studies, with the Child's right arm extended over His Mother's lap. As drawn in ink, the Christ Child's action is now close to that of the sculpture; he is conceived as stepping downwards and away from His Mother's protection, although she has not yet been given the raised left leg that explains the Child's action in the marble. Her abstracted outward gaze is closer to that of the Virgin of the Pitti marble tondo than to the final solution of the Bruges group.

The economy of contour of the London sketch suggests a work to be hewn from a block, although had no work been carried out, we could not have excluded the possibility of a projected painting (one might compare the Madonna and Child in Parmigianino's London altarpiece, which owes so much to Michelangelo's drawings). The study also suggests that Michel-

angelo was thinking about his group with the knowledge of where the sculp-
ture would be placed in the church at Bruges. It stands on the altar at the
head of the right (south) aisle of Notre Dame, and it seems that, in this
sketch, he was considering what is one of the main views of the group from
the central nave (plate 39 shows the group from this viewpoint). Hence the
direction of the Virgin's gaze and of the movement of the Child (it is the
oblique view of the Virgin in this London drawing that reappears in
Raphael's *Madonna del Cardellino*). Michelangelo's final solution was diffe-
rent but still related to the view from the church's main axis. The whole
marble group was swung to (our) left, but his purpose has been jeopardized
because, as Wilde showed, the sculpture has been wrongly set up on its later
base.[3]

Michelangelo received a first payment (on account) for the Bruges group
in December 1503, at a moment when all his energies were directed to
completing the giant *David*, set up in front of Palazzo Vecchio in September
of the following year. It is not known when he received the commission to
paint the *Battle of Cascina*, the rival mural to Leonardo's *Battle of Anghiari* in
the Palazzo Vecchio, but there can be no doubt that it followed Leonardo's;
all we can be certain of is that his battle cartoon as we know it from the
Holkham grisaille (pl. 72) had been completed by the end of October 1504.
The *Cascina* studies on Uffizi 233F and on other sheets were in all probability
made in the late summer of 1504 and the Bruges sketches soon afterward.

This chronology is relevant when we turn to consider how close in
appearance the Bruges drawings on the Uffizi sheet are to Leonardo's
comparable small-scale pen studies of the very same moment (pls 42–3).
Indeed, those which come closest in scale and style to Michelangelo's on
Uffizi 233F are related to Leonardo's preparation for the cartoon of the *Battle
of Anghiari* and can be dated to 1503, the previous year. Much has been
written about the influence of the older artist on the younger in these four
years when both were in the same city and were creating competing works.
The assumption that borrowings were exclusively one-way is over-
prevalent. Nevertheless, in this case we have to recognize that drawings of
this *pensiero* class had been a part of Leonardo's drawing procedure for many
years, as a Windsor study for the *Last Supper* clearly shows.[4] And we have
none from Michelangelo himself (or by his master, Domenico Ghirlandaio)
prior to the moment we are here considering.

Similar as some of the drawings of this class by the two artists are,
Michelangelo seems always to have used the type in a more restricted way.
Leonardo employs them to create single motives—the repeated studies for
the two-figure group in the battle (pl. 42) are beautiful examples—and also
to compose with many figures, as another *Anghiari* drawing shows (pl. 43).

[3] Wilde, 1953, p. 13, no. 1.
[4] Popham, 1946, no. 161.

Michelangelo employs *pensieri* to establish single motives only; there seems to be no example of a many-figured composition drawn on this tiny scale. The observation appears to hold good even in those cases when he makes drawings to help other artists (compare pls 61–4).

The surviving drawings of this kind made for the Sistine ceiling seem to bear out these comments. On the lower half of a large sheet in the Casa Buonarroti (75F), we find seven small studies for *Ignudi*, larger than the Madonna and Child studies on Uffizi 233F but serving the same end, to establish 'attitudini' (pls 35–6). They were drawn very lightly in black chalk, and it was certainly the artist's original aim to go over each of them in pen and ink, just as he had gone over the lead-point studies with his pen on the Uffizi sheet. In the event, only one of them was drawn over in pale bistre. It has been suggested that the two studies in the upper right of the detail here reproduced (pl. 36) show Michelangelo initially planning the *Ignudi* as exact pendants, their designs reversed like those of the *putti* of the thrones of the Prophets and Sibyls. But this is not correct, for the figure studies on this sheet were not made at the commencement of the work, when issues of this kind could still have been in doubt. What Michelangelo was doing here was to draw a figure turned in one direction and then experiment with the pose in reverse. There are smaller black-chalk studies for *Ignudi*, almost submerged beneath red-chalk drawings from life made over them, on a sheet at Haarlem (*Corpus* 136 bis), their scale about the same as the Bruges Madonna studies on the Uffizi sheet.

Answering still more closely to Vasari's category of 'primi schizzi' are drawings on a series of double-sided leaves, now at Oxford. These eight sheets are all that have survived from a small sketchbook that must have measured just over fifteen centimetres square. All the sheets can be related to Michelangelo's work for the Sistine ceiling programme. Fifteen of the sixteen pages contain studies devoted to inventing or developing figure motives for the decoration, and the sixteenth (pl. 48) can also be related to the work in a slightly different way. Many of the small studies are of figure motives that the artist did not use in the frescos (there are two of these on the sheet reproduced in plate 44). But the drawn figures that can be matched convincingly with painted figures as carried out are ones relating to the area of the ceiling at the later, altar end of the Chapel, the part of the programme that, it has been convincingly argued, was painted after the pause of 1510 to 1511.[5] One sheet bears the beginning of a *ricordo* in the artist's hand: 'the fifteenth day of September' (di qui[n]dici di secte[m]bre'); and this, I believe, may signify that Michelangelo made these invention drawings only very shortly before he resumed work in the Chapel in the early autumn of 1511. So late a date may seem improbable, but a familiarity with Michelangelo's

[5] For a review of the chronology, see Hirst, 1986 (2), pp. 208 ff.

working habits leads to the conclusion that, when he was free to do so, he never made his designs until he had to.

The invention drawings are made mostly in pen and bistre ink and vary in scale from the smallest, which measure about three and a half centimetres or less (just over one inch), to those that are about four to six centimetres. Of those that relate to figures carried out, the majority are for the later lunettes, particularly those of Jesse-David-Solomon, Roboam-Abia (pls 44–6), Salmon-Booz-Obed (pls 47–9), Naasson (pls 50–52), and the two lunettes on the altar wall later destroyed to make way for the *Last Judgment*. In some cases, Michelangelo drew in the arched lines of the lunette frames and would experiment over the placing of a particular figure, sometimes reversing the motive before he was satisfied.

Some of the sheets contain both an invention drawing and a somewhat larger study of the same motive. The page reproduced in plate 44 is an example. The *pensiero* of the woman, seated and slumped forward in sleep or resignation, who would occupy the right-hand side of the Roboam-Abia lunette (pl. 46) was set down, with even the clothing already indicated, in the little drawing in the centre. Then the artist made the larger drawing in the upper left, considering the anatomical implications of the pose, now drawing the figure nude. He then returned to the motive on another sheet (pl. 45), inclining the figure further forward. These larger studies seem to have been made from life, for the studies of legs and right foot on this latter sheet were made for a different figure, the bent 'pilgrim' on the right of the Salmon-Booz-Obed lunette (pl. 49).

We can follow the development of this figure also in the Oxford leaves. On another sheet, we find a comparable invention drawing, accompanied by studies for his right hand and outstretched left arm, hand, and staff (pl. 47). And for the women on the left of the Naasson lunette, one of the last of the lunette figures in the whole Sistine series (pl. 52), we can trace the development from the most summary of studies (pl. 50) to one of the few chalk drawings in the sketchbook (pl. 51), where the self-contemplative pose has been established, and the mirror already included.

As we have seen above (p. 10), Michelangelo's apparent distaste for the portraying of everyday life did not exclude scenes of domesticity from some of the Chapel's lunettes. Whilst one or two of the figures, including the woman of the Naasson lunette, recall antique prototypes, others, like the woman drying her hair in the Aminadab lunette (pl. 13), were obviously the fruit of rapidly recorded observation. One sheet from the sketchbook is of a different kind, a black-chalk genre study of an old man with his dog, already referred to above (p. 10). It is likely, I believe, that Michelangelo made it at first hand with the needs of his lunettes in mind, and that this bent figure was transformed into the old man with a stick in the Salmon-Booz-Obed lunette who has already concerned us. Other pages, now lost, may well have contained similar examples of observation.

Not all these sketchbook drawings were made for lunette figures. On one of the pages now very difficult to read, Michelangelo drew three studies for the figure of God the Father in the last Genesis scene to be painted, that of *God dividing Light from Darkness* (pls 53–4). In the one in the upper right, there is a sketch, measuring about five and a half centimetres across, that is an astonishingly complete little draft for the mural scene as painted; even the framing lines are drawn in. Its character confirms what has been observed above, that these *pensiero* drawings, created to determine 'attitudini', are essentially studies of individual motives, for this last *Creation* scene, unlike the ones that had preceded it on the ceiling, comprises only one figure (pl. 55).

Whether Raphael may have learnt from Michelangelo's practice in making small *pensieri* drawings for the Chapel ceiling is an issue that may be debated but not resolved. It is, nevertheless, true that small-scale motive drawings seem to appear in Raphael's drawing *oeuvre* in about 1512. Some of the earliest we know today are the pen studies in Oxford for prophets and sibyls above the bay of the Chigi Chapel in Santa Maria della Pace (pl. 56). The parallel between these little studies and Michelangelo's (in the same collection) is striking. Raphael uses the sketches in similar fashion; like the studies for the lunette Ancestors, his also exemplify a search for appropriate 'attitudini'.

Many of the little studies on the Oxford leaves display a spontaneity of invention and speed of execution difficult to match among Michelangelo's other figurative drawings, of whichever kind we consider. If the suggestion made above, that they were drawn just before work on the ceiling was resumed in October 1511, is correct, they were the product of a moment when the artist was under unprecedented pressure, which would continue until the work was completed twelve months later.

If we turn to another sheet of examples from the same period of the artist's life, the six pen studies for bound Slaves planned for the tomb of Julius II (pl. 57), we can at once appreciate that these are drawn in a much less cursory style. These Slave studies signal Michelangelo's renewed concern with the tomb project after he had completed the ceiling. The pope had died in February 1513, an event that led to the making of a new contract between artist and executors in May. To make these little designs, Michelangelo picked up a sheet he had used less than a year earlier to prepare the composition of the Libyan Sibyl and her attendant *putti*, and drew them (and the architectural study) in the areas of the paper left unused —a repetition of the way he had inserted his little Bruges Madonna sketches on Uffizi 233F nearly ten years earlier. The degree of modelling that Michelangelo achieved in these studies, without recourse to any hatching, is remarkable. One of them is closely related to the *Rebellious Slave* in the Louvre, as was noted over a hundred years ago. The clearly conveyed contrasts in age, between youth and bearded middle age, anticipate those of the four unfinished Ac-

cademia Slaves, which Michelangelo would begin to carve seven or eight years later.

When we compare these six figures with the similarly scaled pen nude in the lower-left corner of Uffizi 233F (pl. 32), we can appreciate the new dynamism of Michelangelo's figure style. These little Oxford figures are conceived in the same spirit as the late *Ignudi* and the *Haman* of the Chapel ceiling, whereas the earlier sketch recalls the background nudes of the Doni tondo. The violent movement of the Oxford studies was reduced in the Slaves that Michelangelo drew in the 1513 *modello* for the tomb (pl. 172), but it reappears in the Slaves carved at the end of the decade, and in the earlier drawings made for Sebastiano's *Flagellation of Christ* in 1516. These Oxford studies, especially the uppermost, still reveal the influence of Leonardo's pen drawings of the 1480s, although the line is much more broken.

<p style="text-align:center">* * *</p>

Michelangelo seems never to have abandoned the practice of making these small initial studies for figure motives. But the examples we have from his later years seem, invariably, to be drawn in the black chalk that became his favourite medium in old age. We might turn forward to his drawings for the *Last Judgment*, planned for the altar wall of the Sistine Chapel just over twenty years after he had designed the later lunettes for the ceiling programme. On a very large sheet now at Windsor (pl. 58), we find a variegated wealth of figure studies, all made for a specific area low down in the composition, and almost all drawn on a relatively small scale. The right half of the sheet shows very clearly Michelangelo absorbed with a single motive, a resurrected figure carried by two angels, upside down, whilst a devil attempts to pull him into hell. The artist investigated this strange motive of an aerial tug-of-war eight times over the whole sheet. The staggering number of figures in the projected mural must have led him to make many single-figure invention drawings after the broad outline of his final scheme had been established. A fine example, almost isolated on a sheet that the artist subsequently employed to cover with drafts of poetry, is in the Codex now in the Vatican (pl. 59). The motive is intended for St Lawrence, stooping to raise his gridiron. In the mural, his position and action were completely changed, and the invention recorded on this Codex sheet was transferred, with a few changes, to St Catherine holding her spiked wheel.

This little study, measuring about four centimetres in height, anticipates remarkably closely the invention sketches made after 1550. We have a number of these. Some of the most striking were made by Michelangelo not for his own purposes, but to help his friend Daniele da Volterra. One such study (pl. 60), drawn to provide Daniele with the motive for a single-figure composition, the *Youthful Baptist in the Wilderness*, was once wrongly interpreted as a study for the *Last Judgment*, and, with the little Codex Vaticanus

drawing fresh in our minds, we can easily understand how the confusion arose.

Michelangelo's collaboration with Daniele has not yet received a detailed study, and has frequently been dated almost a decade too early.[6] It differed from his earlier collaboration with Sebastiano in being much more limited in scope; all the surviving drawings that can be related to Daniele's works are, broadly, of the kind that forms the subject of this chapter, sketches that could serve as a starting point for a painting or a sculpture. They are significantly smaller than most of the studies done for Sebastiano's paintings, and large anatomical sheets like that in the Louvre for his Ubeda *Pietà* (pl. 141) are conspicuously absent.

Some of them are, however, among the most beautiful of Michelangelo's late *pensieri*. We know from Vasari that Daniele undertook a number of works for Giovanni della Casa, author of the celebrated *Galateo*; there is some evidence that Michelangelo was involved in no less than three of them. One was the *Youthful Baptist*, for which Michelangelo made the drawing I have referred to, one of two he provided for his friend. Another was a plastic model of David slaying Goliath which Daniele then converted into a two-sided painting on slate. Four brilliantly animated little chalk studies by Michelangelo relating to Daniele's project are now in the Pierpont Morgan Library (pls 61–4). Full of *pentimenti*, they probably record Michelangelo's earliest thoughts about his colleague's subject. All were drawn on the same sheet (the versos confirm this) which was cut up at some date before the Morgan fragments were acquired by Sir Joshua Reynolds. This is a fate that has befallen almost all the drawings that Michelangelo made for Daniele, a fact suggesting that they remained in a block and were vandalized together. The David and Goliath sketches were probably drawn in 1555.

Another painting for della Casa is described by Vasari; it represented Mercury diverting Aeneas from the bed of Dido. Published earlier this century, the painting's whereabouts is unknown. Two preparatory drawings by Michelangelo exist. The smaller and earlier one now belongs to the Courtauld Institute Galleries (pl. 65). Aeneas is being helped out of his clothes by his attendant, his gaze already directed upwards towards the appearance of Mercury. Not much bigger than one of the Morgan studies, this too is clearly a fragment. The drawing has been recently lifted from its backing, and the verso has been revealed, displaying a rather lame tracing of the two-figure group of the recto (pl. 66). It is too heavy-handed to be by Michelangelo, although the practice of tracing suggests his inspiration; it may have been done by Daniele. And perhaps it was this experiment that led Michelangelo himself to try out a variant in his subsequent drawing of the subject now at Haarlem (pl. 67).

[6] See *Corpus* 368 recto and verso, 376 recto, and 377 recto.

In this, he elaborated the motive on a larger scale and then briefly sketched the *putto* on Aeneas' left, in turn cancelling this swiftly drawn alternative by sketching over him a nude, reclining Dido. This Haarlem sheet is also badly cut and it may well be that originally the study included a summary indication of Mercury as well.

Recent critics have proposed that the Haarlem drawing precedes the Courtauld one. This is not convincing. The suggestion ignores the fact that it is the motive on the Haarlem sheet that Daniele adopted, carefully transcribing it in a drawing of his own in Vienna (pl. 68) before beginning his painting. But the internal evidence of the two studies also indicates the priority of the smaller London one. In this, the two-figure group is conceived rather realistically; in the other, naturalism has been sacrificed to stylistic idealization. The two figures have been made into a single unit. Aeneas' pose is much more self-consciously beautiful, his massive figure falling into a carefully controlled contrapposto, the raised left leg poised on the base of Dido's bed as if on the sockle of a statue. The rhythms of projection and recession are far more complex, too complex for Daniele, whose drawn copy has petrified the movement. These two remarkable Aeneas studies are a vivid record of Michelangelo's inventive vitality at the age of eighty. It may be added that they are some of his very last interpretations of a profane subject.

Michelangelo did not give up making drawings of this kind for his own ends, and this rapid survey of one of the most appealing of his drawing types may conclude with examples made a few years later than those done for Daniele, perhaps close to 1560. Two broad and narrow sheets now at Oxford (pls 69–70) were, it has been convincingly shown, originally part of the same sheet (although they cannot have formed the whole of it). On one of them are five small sketches (there are traces of a sixth on the clipped left margin), all concerned with subjects that had engaged Michelangelo's attention for a lifetime. Three are for a Pietà in which Christ is supported by a single figure and, as has been recognized for over a century, relate to the Rondanini *Pietà* now in Milan. Each of them shows the group from a different viewpoint, confirming that they were made for sculpture. The two others are for an Entombment, with Christ's dead body carried shoulder high by two supporting figures. These sketches have been related to the Palestrina *Pietà*, and the stasis and frontality of the group in the drawings correspond, although the invention is not the same and neither of the two bearers in the Oxford sketches can be the Virgin. To some extent, the motive recalls another late invention of Michelangelo's, now preserved only in a facsimile-like copy (pl. 146). The frontality, however, is more closely echoed in yet another study, one of Michelangelo's last anatomical drawings (pl. 144) which is also almost certainly for a dead Christ.

The other Oxford fragment (pl. 69) was part, perhaps the upper part, of the original undivided sheet. Discernible to the left of its centre are the two vertical zigzag lines where Michelangelo tried out the point of his chalk

before he began to draw. There are thirteen sketches, some almost un-
decipherable, of sleeping apostles, all made in preparation for the group of
three apostles in the cartoon of *Christ in the Garden of Gethsemane* executed for
Marcello Venusti. The cartoon itself, comparable in scale with but later in
date than that for Venusti's *Annunciation*, is in the Uffizi in ruined condition.
None of these almost larva-like chalk forms corresponds to those in the
cartoon; none of them is a repetition, and only on the right does Michel-
angelo seem to have tried out the three in a group, as the iconography de-
manded. More shakily described than the forms made for Daniele, some of
these little bowed figures measure only three centimetres.

VI

COMPOSING THE *STORIA*

MICHELANGELO'S DRAWINGS THAT SHOW us an invention in the making are not confined to those that serve to create a single motive. At this point, we need to turn to his compositional drawings. But in so doing, we at once run into difficulties: few drawings of this kind exist. We may try to explain their rarity in a number of ways. Most obviously, throughout an exceptionally long life, Michelangelo was called upon to paint only on rare occasions. Nor, as a sculptor, did the kind of work he was most frequently engaged on call for compositional drawing. No marble relief survives from a date later than 1505–6. And there is only one narrative relief, the *Battle of the Centaurs*, in the whole sculpted *œuvre*.

This statistic is at least partly an accident. Michelangelo did envisage making narrative reliefs at later moments of his life; some were planned for the 1513 scheme for Julius II's tomb. And a substantial number of large narratives were projected for the never-realized façade of San Lorenzo, as the 1518 contract shows (see also pls 85–7). One or two remarkable compositional drawings which can be related very plausibly with unexecuted relief projects do survive (see pls 88 and 91). It must, however, be confessed that the lack of compositional drawings for the narrative scenes of the Sistine ceiling is the most conspicuous lacuna in the whole drawing *œuvre*. All we have is a rapid compositional study for the corner spandrel of *Judith and Holofernes* (pls 80–81). In the case of the planning of the *Last Judgment*, we are in a more favourable situation (pls 92–3). And the relatively few surviving compositional drawings that Michelangelo made for his own paintings can be supplemented by those of the same kind carried out to help other painters, notably Sebastiano del Piombo and then, much later, Marcello Venusti. Many of the presentation drawings are also, of course, elaborate compositions, and some, discarded or unfinished, reveal him in the act of composing (see pls 226 and 230). But the particular status of these drawings merits separate discussion (see below, pp. 105 ff.).

Michelangelo's most important early compositional drawing is now in the Uffizi (613E; pls 71, 73, 74). It was made to work out the main lines of the central part of his projected mural of the *Battle of Cascina*, the part of the

composition recorded in the Holkham Hall grisaille (pl. 72). The scene re-presented Florentine soldiers, bathing in the Arno, surprised by the approach-ing Pisans. Yet this sketch, fleeting as it is, cannot represent his earliest thoughts for the central episode of the *storia*. It was preceded by a scheme for the same subject which no longer exists but which included a remarkable motive of two nude soldiers holding up a third who gives the alarm to the Florentines (pls 75–7).

We find this invention on three different sheets. It first appears on the recto of a sheet in the British Museum (pl. 75, already discussed in the con-text of the Bruges Madonna). However, Michelangelo did not begin with the three-figure group in mind. He first drew the soldier with his back to us in the act of drawing his sword. Then, rapidly improvising, he added the two other figures and converted the action of the earlier one into that of holding up the youth. On the back of the same sheet (pl. 76), he quickly redrew the group on a larger scale, although the whole upper half was subsequently cut off and is lost. Finally, on a scale midway between those of the preceding drawings, he drew the group once more (pl. 77). Here the action is clear: the sword has been eliminated; the slenderer form of the boy is differentiated from the larger ones of his two companions who have lifted him up.

The design of the two supporting figures, one with his back turned, the other facing us, was clearly inspired by a group of Filippino Lippi's in the Brancacci Chapel, where Michelangelo had studied to such effect. Having spent time on the invention of the group (there is still another related draw-ing in London, *Corpus* 48 recto), the artist must have found it too bizarre and consequently abandoned it. But the soldier with his back to us survived. He reappears, slightly modified but still orientated to the left, on Uffizi 233F, discussed earlier (p. 32). His rôle is now undergoing a final change, from a supporting figure to that of the bather who hastily dresses himself. He appears again, thus engaged, in the centre of the compositional drawing (pl. 71) and, moved off centre, in the grisaille (pl. 72); in both, he is now turned to the right.

The three studies for the group, and the related figure on Uffizi 233F, all *preceded*, therefore, the compositional drawing (pl. 71), which was not the first fleeting draft for the cartoon which many of us (including the present writer) have too readily assumed it to have been. But we can state this only because the relevant drawings have survived; and there may have been many other cases of similar artistic osmosis that we can no longer even guess at.

That the Uffizi compositional drawing 613E was not the artist's first idea for the *Bathers* is confirmed by a close examination of the original. The drawing was executed throughout in a very soft, black chalk. But some figures were just indicated by a rapid preliminary sketch with a stylus. Stylus is used only on the left, specifically for four figures on that side of the sheet (in all, there are about fourteen fairly legible forms). These four figures,

underdrawn in stylus, are those least closely related to figures in the grisaille copy of the cartoon. By contrast, the figures on the right of the drawing do approximate much more closely to their counterparts in the grisaille and they are not drawn over stylus. I think we may conclude that Michelangelo began to draw this composition from the left (a normal procedure for a right-handed artist). He started with his stylus and then drew over the stylus lines with his chalk. Then he added the figures on the right which he had already developed elsewhere on another sheet and for which, therefore, no preliminary stylus drawing was needed.

A comparison of the compositional drawing (pl. 71) with the copy of the lost cartoon (pl. 72) is interesting. Some of the motives in the drawing were abandoned at the cartoon stage or even earlier. Some of the figures were moved. The soldier seen from behind, whose genesis we have traced from the earlier stage, was shifted off the central axis to the left. He was replaced by the figure who holds a lance with both hands. Now scarcely visible on Uffizi 613E, he is very faintly sketched in the left. This figure meant a great deal to the artist. The splendid study from life in Vienna (pl. 124), discussed elsewhere in this book, was the stage in the design process close to the drawing of the cartoon, but the germ of the invention lies in this faintly drawn figure on Uffizi 613E.

But of more significance than incidental displacement of some figures is something else: a consistent tendency, in the final design, towards an increased figurative abstraction and a less literal rendering of narrative. Another detail from the drawing shows this clearly (pl. 73). The seated figure in the foreground, designed in contrapposto, was first drawn in direct contact with the figure bending towards him; he is depicted communicating with his companion, who stoops to listen. Then, with a rapid *pentimento*, the artist changed the direction of the head of the seated soldier, who now looks away from us and his interlocutor (see the revised motive in the life study, pl. 123). The poses have not been changed radically, but the narrative link between the two has been broken. In other words, the much-noted semi-isolation of the figures in the grisaille is less marked in Michelangelo's preparatory compositional drawing, which has a more closely knit coherence, lacking in the celebrated 'forest of marble statues'. This figurative isolation was undoubtedly exaggerated in the grisaille. But the painting's obvious deficiencies do not dispose of Michelangelo's clearly evident changes of meaning between preliminary sketch and cartoon. Even in the cartoon, the stooping soldier (now shown looking into the water of the Arno) must have been more isolated than he would have been, had the earlier motive been retained.

This Uffizi drawing documents Michelangelo's concern with only the central episode of the mural, the episode of the Bathers, the one part taken as far as the full-scale cartoon. It has been calculated that this area of the fresco would have occupied less than half the width of wall at Michelangelo's

disposal.[1] Written sources and other drawings by Michelangelo prove that he did not ignore completely other, less prominent parts of the composition. These drawings are of different kinds (pls 78–9) but indicate his intention to include horsemen. They could have been made before he left Florence for Rome in the spring of 1505, by which time the Bathers section of the cartoon had been finished. Or they may date from after his return, nearly a year later, when he could have given further thought to other parts of the subject. The drawing at Oxford (pl. 79), takes up a theme sketched in the lower-left corner of the sheet devoted to horse studies in the same collection (pl. 78). The extreme rapidity and boldness of stroke in this drawing has led to its being dated twenty years later, but this is a misunderstanding. The drawing was made for a part of the fresco of secondary importance, for figures substantially distant from the front plane, and this fact explains its impressionistic style.

We find a striking parallel in the way Michelangelo painted the histories of the Sistine ceiling. In the *Drunkenness of Noah*, an early scene in the campaign of painting, the figure of Noah depicted at work in the background is carried out quite differently to the figures in the foreground. Noah is painted with large, summary brushstrokes, a technique far removed from the one creating the lapidary forms of the nudes. The style of this figure is a pictorial equivalent to that of the Oxford pen drawing. It can scarcely be doubted that stylistic adjustments of this kind, adopted to create depth, would have been employed had the entire *Battle of Cascina* been painted (a hint of the same device appears even in the Doni tondo). Recent examination of the Sistine fresco at close range has revealed, in fact, that for this distant figure of Noah digging, no cartoon was made; and in the light of this, we may question whether Michelangelo would have made cartoons for comparable subordinate details in the *Cascina* mural.

There is only one drawing that seems to relate to a narrative of the Sistine ceiling, on the back of a sheet used earlier for a *Cascina* study (pls 80–81). Its subject is that of one of the spandrels on the Chapel's entrance wall: Judith, having slain Holofernes, removes his decapitated head.

Doubts about its connection with the fresco have been expressed, prompted by the hastily drawn framing line, a lunette-shaped arc above the figures, which does not correspond with the frame that we now see in the Chapel. A possible explanation is that this arc in the drawing did correspond more closely to the framing line of the ceiling before Michelangelo's intervention, but this is an issue that cannot be discussed here. Unfortunately, this Haarlem drawing has been cut down, and the verso, containing the composition study, has lost about thirty-five centimetres of its height. If Michelangelo did draw the lower framing lines of the spandrel at the bottom, they would certainly have been lost. I believe the drawing was made for the span-

[1] Wilde, 1944, pp. 80–81.

drel. An alternative interpretation, that it is an early scheme for a lunette can be excluded, for the composition would have been broken by a window.

The scheme in the drawing reads like a triptych. The dead Holofernes is placed in the centre of the field, at the foot of a curved flight of steps, his body acutely foreshortened, his left leg raised, the severed stump of neck directly facing us. The artist was at pains to stress the central vertical axis. Overall, with its flanking figures on each side, the scheme looks forward to the later corner spandrel with the *Crucifixion of Haman*. Judith and her maid servant are on the left, the latter holding the dish. The action is too cursorily sketched to be entirely clear, but it seems that Judith does not yet look back at the stricken corpse. The two figures on the right are probably suggestions for two of Holofernes' soldiers (Michelangelo depicted one asleep in the mural); their proportions differ significantly from the slenderer ones of the two women on the left. All four figures are drawn with astonishing economy; a few chalk strokes are enough to capture form and movement. The idiosyncratic shorthand notation of the forms—we can note the curious cubism of the heads—leads us back to Michelangelo's teacher, Domenico Ghirlandaio, as do the broadly spaced, parallel hatching lines (compare pls 89 and 90).

<p style="text-align:center">* * *</p>

The years between the completion of the Sistine ceiling in 1512 and the start of work on the New Sacristy at San Lorenzo near the end of the decade, were among the least fruitful of Michelangelo's life. They did, it is true, witness his first serious engagement with architectural design (pls 202–3), but work on the project that occasioned this, the building of a façade for the church of San Lorenzo, was brought to a halt by the patrons in 1519. In these years, Michelangelo's concern with painting became a vicarious one, and found expression in designs made to help his friend Sebastiano del Piombo compose some of his most demanding projects. Almost immediately after finishing work on the ceiling, he provided Sebastiano with a full-scale cartoon for his celebrated *Pietà* for a church at Viterbo. And for a slightly later project, this time a mural altarpiece of the *Flagellation of Christ* for a Roman church, he made a more modest offering, a small-scale *modello*. By the time he designed this, he had left Rome for Florence to work on the façade project. We know from the artist's correspondence that the *modello* had arrived in Rome by mid-August of 1516.[2] Vasari refers to it as a 'little drawing', a 'piccolo disegno', and since the drawing was later acquired by Cavalieri, dedicatee of some of Michelangelo's greatest presentation sheets, we can be confident that he knew the original. This is now lost, but an

[2] *Carteggio*, I, p. 192.

almost facsimile-like copy survives at Windsor (pl. 83). Measuring twenty by just over eighteen centimetres, this copy may well reproduce the actual scale of Michelangelo's drawing as well as its appearance.

The scheme in the *modello* is a rigorously simple one, well suited to match the aims of Sebastiano's own art. He followed the *modello's* design very carefully in the mural, his chief modification being to clothe the figures, for in Michelangelo's drawing all the forms are completely naked (for a parallel for the nude Christ, see his contemporary marble statue, pls 132–3). Only the most minimal indication of space is suggested by the addition of the lower part of the column, around which the figure composition revolves; there is no description of setting. And this exclusive concern with the figures and neglect of their surroundings we find again in *modelli* that Michelangelo would make over thirty years later for another artist (compare pls 100–101, pp. 54 ff.).

One of Michelangelo's most beautiful compositional drawings is an earlier scheme for Sebastiano's project (pl. 82). It is unlikely that this drawing represents his first thoughts about the subject. Nevertheless, the composition is still a wonderfully flowing and expansive one, the invention not yet constricted by concerns about Sebastiano's powers of transcription or the requirements of the chapel site. Indeed, if we knew nothing about the drawing's purpose, we might have difficulty in deducing that is was made for a chapel altarpiece. The spread of figures, Pilate seated on the left, a casual onlooker with child on the right, recalls late-quattrocento representations of the subject. These more marginal figures were, however, afterthoughts, as were some additions to the architecture which Michelangelo sketched in a deeper red chalk. The central group was put in over a rather elaborate stylus underdrawing. Some of these stylus lines indicate internal modelling as well as contours, and there are others, which have been ruled, to mark the vertical lines of the foremost column. Perhaps it was Sebastiano who found these numerous figures and their complicated rhythms too elaborate for his requirements (there is evidence that he knew the sheet, for he used one of the figures in a different painting). Certainly, Christ is not here the passive sufferer of the final scheme but rather a youthful and almost Apollo-like hero who resists rather than accepts His fate. If we recall Michelangelo's pen inventions for marble Slaves of three years earlier, we can see that this conception sprang from those (pl. 57). Now, however, the ideal of form throughout is suppler and slenderer.

This compositional drawing was, for many years, ascribed to Sebastiano himself. The fact is mentioned here not to review an ageing controversy but to draw attention to a more general historiographical fact, that many, perhaps the majority, of Michelangelo's compositional drawings have been attributed to other artists during the last hundred years. In no part of the *œuvre* has the 'casualty rate' been more pronounced. This is true even in the case of drawings in no way related to works by other artists.

We can illustrate this phenomenon further by turning to another drawing which dates, in all probability, from the same period as the *Flagellation* one (pl. 84). Despite an attempt earlier this century to demonstrate its authenticity, its rehabilitation as an autograph compositional sheet is, even now, not complete. Yet many details of handling can be paralleled in other drawings of the same general class; the broad, slanted hatching strokes recall the much earlier drawing for the *Battle of Cascina* discussed above (compare pl. 79).

This drawing was begun in red chalk on the left; then the artist put his chalk aside and drew over the chalk lines in pen and ink, continuing the composition to the right in pen alone. Despite the difference in medium, a comparison with the *Flagellation* drawing is instructive: it brings out the artist's different concern here, to construct a scene with about twelve figures within a narrow band of depth. This, together with the insistently lateral narrative, suggests a relief rather than a painting, and it has been plausibly conjectured that the drawing could have been made for one of the reliefs of the unexecuted façade of San Lorenzo.

Michelangelo drew in two figurative reliefs on the large *modello* that he prepared at an early stage in his planning of the façade (pl. 169). The small judgment scene in this *modello* (pl. 85) undoubtedly depicts St Lawrence before the judge; his martyrdom is represented immediately below (pl. 87). Michelangelo put in these two scenes only to give some idea of decoration for the façade project to his patrons, and for the former scene he unashamedly paraphrased Ghiberti's *Baptist before Herod* on the Siena font; even Ghiberti's arcaded background is followed in this, one of Michelangelo's smallest compositional drawings (it measures a little over eleven by just over nine centimetres).

Views have differed about the subject of the large compositional drawing that is here our concern (pl. 84). It represents, I believe, Christ before Pilate. The captive is long haired and bearded and is iconographically appropriate for Christ. The female figure, so prominently placed next to the judge, is likely to represent Pilate's wife. And the coarse-featured supplicant before the judge, drawn more emphatically than any other figure, is almost certainly Barabas, the prisoner who would be released in place of Christ. Michelangelo has, therefore, if these suggestions are correct, treated the Gospel text very freely. With bold pen strokes, he has succeeded in including all the main participants and has succinctly characterized them; everything has been conveyed in the kind of lapidary style that Bandinelli strove to follow. The comment that Berenson passed on the drawing, which he did not accept, is, in the light of the remarks made about critical prejudice towards authentic compositions, worth quoting: 'The story is well told, too well for Michelangelo, who does not set out to be a narrator.'[3]

A rather similar question of purpose arises with two of Michelangelo's most beautiful chalk compositions, made, in all probability, several years

[3] Berenson, 1938, II, p. 233.

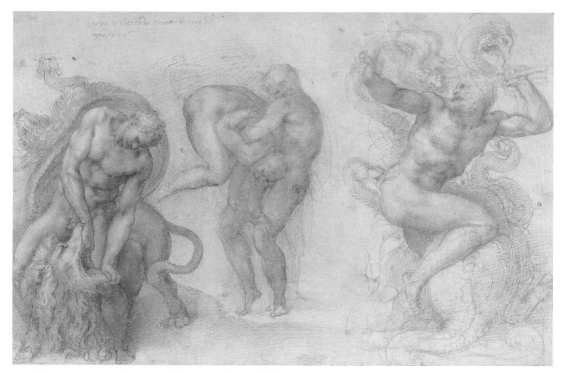

5 *The Labours of Hercules*, Windsor, Royal Library.

6 *Archers shooting at a Herm*, Windsor, Royal Library.

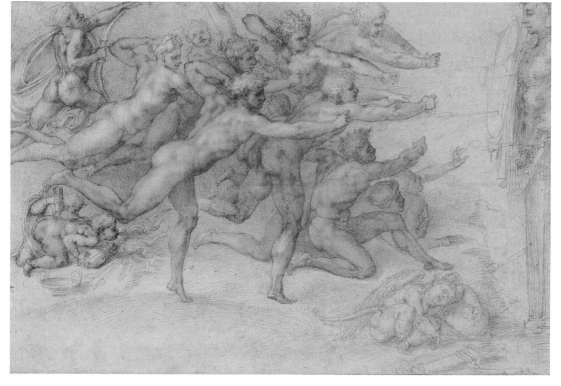

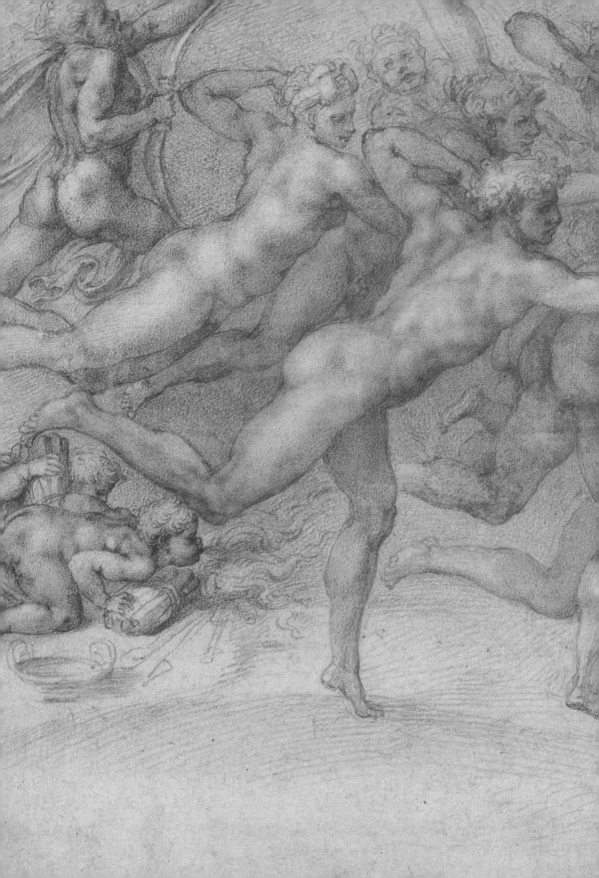

later, the *Descent from the Cross* in Haarlem and the *Three Crosses* in London (pls 91 and 88). These two sheets have shared a comparable critical fate. Both were, at one time, ascribed to Sebastiano, because of their stylistic congruity with drawings like the *Flagellation* study already discussed. The Haarlem *Descent* (pl. 91) has also been associated with Michelangelo's later protégé, Daniele da Volterra. Stylistically, they belong to the same period, and there is nothing to favour the view that the Haarlem drawing is many years later than the London one.

It has been suggested that the two drawings, representing related Passion subjects, could have been alternative designs for a small work of art, suitable for his study, requested in the summer of 1523 by Cardinal Domenico Grimani, a leading member of the curia and a passionate collector. As we have seen elsewhere, Michelangelo responded to such requests reluctantly, but we know that, on this occasion, he reacted positively. Grimani, anxious to have a 'quadretto' for his *studiolo*, left everything to the artist—price, subject, and medium. But his death soon after Michelangelo's involvement must have spelt the end of the project.

The connection of the drawings with Grimani's request is unlikely ever to be confirmed. However, that both drawings were made with a relief in mind is indicated by something they share with the *Christ before Pilate*, a confining of all the figures in a narrow band of depth. This feature is emphasized in the *Descent* by the rapid shading behind the main study, indicating a flat ground, a device Michelangelo adopted also in architectural elevational drawings (see pl. 208). Most conclusive is the fact that a wax relief, representing a more elaborate version of the main Haarlem study, once existed; a plaster cast, one of many records of the wax, survives in the Casa Buonarroti.

The existence of a wax model suggests that Michelangelo had in mind a bronze relief. Bronze had actually been mentioned as a possible medium in the letters exchanged about Grimani's request. Michelangelo's reluctance to use bronze is notorious; its choice here could have been dictated by lack of time to produce a painting or a marble carving. In his one letter about the commission, Michelangelo, occupied with the New Sacristy, characteristically lamented his burden of work, his age and ill-health, and his need to rest for four days if he worked for one.[4]

Whatever led to the making of these two drawings, we should note that they are not exactly comparable. The *Three Crosses*, drawn on an exceptionally large sheet, shows a complete narrative. There are marked differences of finish; most obviously, it is the figures of Christ Himself and of the thief on His right that were carried furthest. The lightness of drawing in other parts would have allowed these to be worked up also, however, and had this happened, the sheet would have looked very like a *modello* for a patron. Some of the lower figures are drawn with much the same summary swiftness as those in the *Judith and Holofernes* sheet (pl. 80). The central group

[4] *Carteggio*, II, p. 384.

7 (facing page) Detail of col. pl. 6.

at the foot of the cross, composed of nine mourners and the fainting Virgin, may serve as final demonstration of the fact that Michelangelo, even now, had not abandoned what he had picked up from Ghirlandaio—the master he went to such lengths to disparage in later life. To illustrate the extent of the debt, we may compare a detail from Michelangelo's drawing with a compositional drawing of Ghirlandaio made at the time when Michelangelo was briefly apprenticed to him (pls 89–90). Nearly forty years may separate the two. Yet despite the gap in time and the difference in medium, the morphology of Michelangelo's drawing relates directly to that in Ghirlandaio's. This is very clear if we compare the abbreviations of heads and hands, and the way the arms are drawn. And broad, parallel hatching strokes which travel right across the forms are conspicuous in both sheets.

The compositional drawing on the Haarlem sheet is much smaller. Although more densely drawn than anything in the other one, this is still very much a working drawing which would have been less easy for a patron to grasp, and it is surrounded by sketches, some on a slightly larger scale, which either elaborate the same motives or try out alternatives. At this point, it seems clear that the motive of the fainting Virgin, appearing as it does in both sheets, was preoccupying the artist; the sketch in the upper-right corner shows a variant of that in the main compositional study. In the end, Michelangelo abandoned the motive; in the Casa Buonarroti relief the Virgin is depicted standing, supported by companions, as in Rosso's *Descent from the Cross* in Volterra.

<p style="text-align:center">* * *</p>

Like the Uffizi sketch for the *Bathers* cartoon (pl. 71), the two compositional drawings for the *Last Judgment* (one in Bayonne, the other in the Casa Buonarroti), made exactly thirty years later, provide us with a similar insight into the artist's thinking (pls 92–3). But in this case the mural *was* carried out and may be compared with these early ideas (pl. 94). It was Pope Clement VII's last great commission. It seems that he was thinking of diverting Michelangelo to a new project, this time in Rome, by the mid-summer of 1533, and that Michelangelo resisted his proposal, only abandoning his opposition in early 1534. Clement's death in September of that year prevented his witnessing even the beginning of work in the Sistine Chapel; he did, however, live long enough to visit Michelangelo's workshop and examine the drawn *modello* for the work (see, further, p. 80). This visit must have taken place before Michelangelo returned to Florence for one last visit toward the end of the summer.

A contemporary source shows that the subject had been chosen by February 1534.[5] These two drawings may have been made soon afterwards. They

[5] Pastor, ed. Kerr, x, 1938, p. 363, n. 1.

demonstrate that the initial plan did not involve covering the Chapel's entire altar wall with the new fresco (and thereby the destruction of Michelangelo's own lunettes, the fifteenth-century frescos, and Perugino's altarpiece). There is no suggestion, in the Bayonne drawing, that the fresco would extend into the lunettes, and the groups of saved and damned, which Michelangelo has not drawn in below Christ and the elect around Him, would probably not have extended below the Chapel's first entablature (one figure to Christ's right looks down toward the saved). The circle of the elect around Christ reflects that in Fra Bartolommeo's *Last Judgment* in Florence, although as has been noted, Michelangelo changed it from a concave into a convex one.[6] The very high viewpoint with which these figures are designed is also in contrast to Fra Bartolommeo's work, designed with a low viewpoint. Christ's gaze is already turned to the left, towards the damned, in keeping with His gesture: with His left hand, He touches the wound in His side. He is seated on a cloud, and His pose is close to that of Zeus in the last version of the *Fall of Phaethon* (pl. 230), which may have been drawn at much the same time (see p. 114).

The drawing was made more carefully than either the early *Cascina* compositional sketch, or the later Casa Buonarroti sketch for the *Last Judgment* (pl. 93). Michelangelo made changes both to Christ's legs and the position of the head, and the drawing has been made lightly enough to have been elaborated further. The lower part of the sheet has been left unused.

Clearly, Michelangelo found the interpretation too static and discarded it. The brief sketch on the Casa Buonarroti sheet followed. More summary in execution, it shows much more of the subject, and, as a consequence, all the figures are drawn a smaller scale. The Last Day is no longer conceived in static terms; the whole interpretation has become dynamic, in important respects more dynamic than that of the mural. Although the design points toward the final composition, the drawing is not really a unity; the figures on Christ's left, for example, have been drawn on a substantially larger scale than those on His right. Christ's action is violent, more so than in the painting. In the Bayonne drawing, the Virgin had been placed on Christ's right as tradition prescribed, in the forefront of the circle of figures, her back turned to us, raising her arms towards Christ. In this drawing, she moves towards Him, actively interceding, both arms flung wide in an invocation of pity as graphic as that of the Heliades in the *Fall of Phaethon* drawings (pls 228–9). The emphasis given to her rôle (it reappears in another drawing, *Corpus* 349 recto) may have been at Clement's wish, for he had recently reaffirmed the Virgin's intercessory powers in response to the reformists' rejection of them. As we can see (pl. 94), the motive was abandoned in the mural, painted after Clement's death. The commanding figure on Christ's left, arms protecting others, may be that of the Baptist, the other chief

[6] Wilde, 1978, p. 161.

intercessor in the Last Judgment. Michelangelo broke with tradition in the fresco, by moving him to the other side. Already in this drawing, the elect are implicated in the ascent of the saved; instead of turning to look downwards, two now actively stoop to lift up the resurrected.

When Michelangelo made this drawing, he still did not envisage destroying the lunettes he had painted in 1512. And the unmistakable rectangle at the bottom of the sheet has been interpreted as a brief indication of Perugino's altarpiece, indicating that, at this point, the decision to remove it had not been made. Around this field, Michelangelo drew figures, including the angel at the top, turned to the left, combating a devil (pl. 96). That figures on both sides, a saved one on the left, a damned one to the right, are wrapped round the lower end of the field, suggests that the altar table stood a little way in front of the wall (their presence excludes the suggestion that what Michelangelo drew here was the door of the chapel's entrance wall). On the upper edge of the frame, Michelangelo's first thought was not the combative angel but a standing figure, both arms outstretched, looking toward the saved. This figure may have been St Michael.[7]

No drawings of this kind for the Pauline Chapel frescos have survived. To compensate for this, we can turn to other late compositional drawings. Many of these seem to have survived in distinct groups. One such group is composed of drawings of the Crucifixion (pls 106–7). Another one, less numerous, of the Annunciation, has survived from some years earlier. Michelangelo made these drawings to provide Marcello Venusti with designs for an altarpiece in the Roman church of Santa Maria della Pace. Some drawings of Christ expelling the Money Changers constitute a third, late group which escaped Michelangelo's destruction at the end of his life. And a number of isolated sheets can be added, all of devotional subjects.

It is impossible to discuss all of the late compositions here. But one exceptional drawing which has reappeared only in the last few years may be mentioned briefly.[8] It represents Christ and the Woman of Samaria at the Well (pls 97–8). We know that Michelangelo made a presentation drawing of this subject for Vittoria Colonna. It is one of three such gifts listed by Vasari in his 1568 life of the artist, and Vittoria herself refers to the gift in a letter that bears no date but that was written in either 1542 or 1543. The presentation drawing is lost, but its appearance is recorded in an engraving (pl. 99) which leaves no doubt about the subject of this preliminary compositional draft. Almost certainly made in 1542, it is an important link between the drawings made for the Last Judgment (completed in 1541) and those of the Annunciation, made to serve Marcello Venusti in the later years of the 1540s (pls 100–101).

[7] See the suggestion in Wilde, 1936, p. 10.
[8] Published by Annesley and Hirst, 1981, pp. 608 ff.

Like those, this one is a sacred *storia* of just two figures. This was a type of composition to which, in his later years, Michelangelo seems to have turned repeatedly for subjects from the life of Christ. Already essayed in the cartoon of the *Noli Me Tangere* made for Pontormo, it is here in the subject of the Samaritan Woman and in a still later drawing of *Christ appearing to His Mother* (*Corpus* 400), and it was doubtless a similar confrontation of two figures that was the subject of the cartoon of *Christ taking Leave of His Mother*, acquired by Cavalieri. Each lent itself to a dramatic interpretation. Here, the Samaritan Woman is represented moving away from the well and turning back, her startled attention caught by Christ's words and gesture. Seated on the well's edge, He holds out His hands, an action conveying with exceptional vividness His suppliant rôle in the passage in St John's Gospel (IV: 10): 'Jesus said unto her...Give me to drink....' We find a similar meditated response to the Gospel texts when we consider the *Annunciation* drawings.

This recent discovery shows that, at this advanced stage, Michelangelo would make large exploratory drawings whilst considering the treatment of the subject for a presentation sheet. This drawing has been cut at the top yet is still exceptionally large, measuring over forty centimetres high. It may have been preceded by smaller studies which, we have seen, Michelangelo did not abandon his practice of making in old age (pls 69–70). Yet the figure of Christ has been sketched in an entirely experimental way, the head first turned in profile (as in the engraved design); the expressive hands were drawn several times with the lightest-possible touch of black chalk.

The actual manner of drawing is different to anything hitherto considered and anticipates the artist's very late chalk style. Soft lines are drawn in different directions; they are no longer parallel as earlier (see the lines on the base of the well). Contours are drawn several times, and both contours and internal modelling are now achieved with loose, striated strokes. It is this repetition of line, rather than emphatic pressure of the chalk or cross-hatching, that now creates form.

The drapery style has also changed. It fits the figure very closely but breaks out into prominent isolated folds. In the way it falls, the dress of the Samaritan Woman anticipates that of the Virgin in the large *modello* Michelangelo would make for Venusti a few years later (pl. 100), but we find it already in the marble statue of *Leah* which the artist was completing in these years for the tomb of Julius II.

After having made the drawing, Michelangelo turned the sheet over and made a few sketches on the verso. In one, he rapidly redrew the inclined head of the Samaritan Woman (pl. 98), capturing her slightly fearful look with a few strokes. The vitality of expression, here dependent on no model, is extraordinary.

＊　　　＊　　　＊

Michelangelo's willingness to collaborate with the relatively unknown Marcello Venusti extended over many years. It seems to have begun with the project to paint an altarpiece of the *Annunciation* already mentioned. Unlike the help that Michelangelo gave to Daniele da Volterra (see above, pp. 39 ff.), this went much further than small sketches. Indeed, for the projected *Annunciation*, the drawings indicate that he went to exceptional lengths, perhaps because his devoted friend, Cavalieri, was involved in the commission. The subject itself seems to have come to engage him deeply, and he produced two highly finished *modelli*-like drawings, from which the patron, Cardinal Cesi, and Venusti, could make their choice. One of these two drawings was in Michelangelo's workshop at his death (pl. 100), as we saw above. Vasari knew both it and another, similar sheet, done for Venusti, representing Christ in the Garden of Gethsemane. He called them 'cartonetti', little cartoons. He acquired them for Duke Cosimo de' Medici, and both are now, as a consequence, in the Uffizi collection. The early history of the other *Annunciation* 'cartonetto' (pl. 101) is not known. It reappeared in the eighteenth century and is now in the Pierpont Morgan Library. It was this design that was chosen for the Pace altarpiece. The evidence of the drawings made in preparation for these two designs indicates that the Uffizi 'cartonetto' preceded the Morgan one.

Preparatory compositional drawings survive for both cartoons. The earliest, drawn laterally on a very large sheet, was cut up before being brought to completion. Parts of the sheet were lost altogether. But, as plate 102 shows, the design can be reconstructed; we can see that the out-stretched arm of the angel extends, with a loss in the middle, from one drawing to the other.

In this now dismembered study, it may well be that Michelangelo set out to make the definitive cartoon for Venusti. Favouring this conclusion is the very large size of the original sheet; in fact, the figure of the Virgin drawn here is on the same scale as that of the Virgin in the Morgan design. And her reading desk has been constructed very carefully; as in the two highly finished cartoons, all its main lines have been drawn with a ruler.

If this was Michelangelo's original intention, he soon abandoned it, and the sheet became, in effect, an exploratory drawing. *Pentimenti* abound. Even the present, ruled reading desk has been drawn over a smaller one, and the Virgin's right arm, the hand holding an open book, was first drawn in to rest on this lower support. Indeed, her whole figure was originally drawn further to the left, in the same movement of rising and turning to greet the angel. Michelangelo then moved her to the right, drawing the contours repeatedly; it is this that has created the kind of black–chalk aureole that has submerged the side of the desk. These lines were made to effect a *pentimento*, achieved here not, as it were, by a single leap, but by a succession of small steps. This whole passage points to analogous effects in still later drawings, in which Michelangelo pares down the figures by repeated *pentimenti* (see

pl. 107). The figure of Gabriel underwent more radical changes, first partially sketched floating in the air (the lines of the bed hanging are drawn in behind), and then redrawn closer to the Virgin.

Other drawings must have been made after this one and before the final Uffizi cartoon. Between the two, Michelangelo's treatment of the subject changed, from one that emphasized Mary's *humility* to one that underlined her surprise and alarm, that mental 'turbamento' depicted in so many Gothic renderings of the Annunciation (pl. 100).

But Michelangelo's concern with the subject did not end with the Uffizi cartoon. He embarked on another, quite different invention, its earliest surviving expression preserved in the compositional drawing made on the back of the right-hand part of the divided sheet we have just considered (pl. 104). This drawing was made much more rapidly than the other; the desk, for example, is drawn in with quick, free-hand strokes. Michelangelo's first intention here was to depict the Virgin in a much quieter rôle, sat close to the reading desk. Initially, her right hand was drawn resting on its top, holding an open book—an idea carried over from the drawing on the recto. Then, the arm and hand were drawn with the elbow resting on the desk, the right hand still holding a now diminutive prayer book. At the same time, with her left hand she holds the edge of her veil, a gesture taken from antique sculpture where it denotes 'pudicitia', that is, modesty or chastity. She listens, seemingly half abstracted, to the angel's message. Like the figure of Christ in the *Woman of Samaria* drawing (pl. 97), this heavenly being has been left by the artist in a state far less complete than the earthly one, as if to convey a divine radiance. The whole interpretation is monumental, drawing inspiration from a motive of Giovanni Pisano and from a figure of the artist's own like the Sistine *Isaiah*.

Then Michelangelo made a radical change. He redrew the Virgin's left arm in a gesture of astonishment and redrew her face turned upwards in profile to the right. Only the angel whose appearance provokes this violent reaction is missing; this is part of the sheet which has been lost (it formed the lower part of the angel drawn on the recto, pl. 102). The change points to the solution of the Morgan cartoon (pl. 101), and a further step in this direction has recently been identified, drawn on the back of the other part of the same divided sheet.[9] In a schematic sketch of a very few lines, Michelangelo partially redrew his revised idea (pl. 105). The drawing is little more than a jotting, although it has been made on a scale close to that of the finished figure in the Morgan cartoon. Drawn as it was on the other part of the sheet which was still close to hand, it shows Michelangelo composing very freely and on a large scale. That *all* the drawings we have just considered were made on either the once united recto or the subsequently divided verso of the same piece of paper is good evidence that all were made at the same time, actuated

[9] Gere and Turner, 1979, p. 100.

by the common purpose of producing designs for Venusti, and to propose, as has been done, that the verso composition was made at a later date than that on the recto is unconvincing.[10]

A modern public is likely to be disappointed by the appearance of the two *Annunciation* cartoons; their execution must seem laboured after the brilliant improvisations of the preparatory drawings. Both, together with the *Gethsemane* cartoon which was, as we saw, found with the Uffizi *Annunication* in the Rome workshop, have been attributed by most critics to Venusti. Yet there can be no serious doubt that the two cartoons in the Uffizi are those mentioned in the letters of 1564, where Michelangelo's authorship is confirmed. Vasari characterized them as 'reasonably well drawn' ('disegnatj ...assai ragionevolomente'), perhaps thereby striking a note of somewhat qualified admiration.[11] Given their history, one could state that these two Uffizi cartoons, together with the Casa Buonarroti *Cleopatra* (pl. 235), the drawing given to Duke Cosimo by Cavalieri, are the best documented of all Michelangelo's drawings. To compare them with the studies made in preparation for them is to compare the incompatible. The Uffizi *Annunciation* is closest in appearance to the presentation drawing of the *Pietà* made for Vittoria Colonna and now in Boston (*Corpus* 426 recto). And had the presentation drawing of *Christ and the Woman of Samaria* survived, the contrast between the preparatory drawing and the highly finished gift would, it is safe to suggest, have been similar in kind.

Michelangelo lavished great pains on these drawings. He made them on very large pieces of paper; the Uffizi sheet now measures 54.7 centimetres across and was originally a Florentine *braccio* (about 56.8 centimetres) long, as Vasari recorded. The verticals and horizontals of the reading desk are assiduously ruled (this is true also of the Morgan drawing), as are the main verticals of the door behind the angel. Every form was first drawn very lightly, and this underdrawing can be judged from features left at this stage, like the bed with its canopy and the domestic objects revealed by the open cupboard door. Only after this was every detail of the two figures elaborately worked up. This was achieved by repeated strokes of a very soft, black chalk on what was originally a heavily grained paper.[12] Some of Daniele da Volterra's figure studies reflect his attempt to emulate the style of these *Annunciation* cartoons (see pl. 68), just as he took up and imitated the kind of drapery style Michelangelo here worked on with such care.

As mentioned above, it was the Morgan cartoon, the later of the two, that Cardinal Cesi and Venusti chose for the Pace altarpiece. But the Uffizi composition did not go to waste, for, through the offices of Cavalieri, Venusti converted this design also into an altarpiece which still survives in the Lateran. The almost block-like form of Michelangelo's Virgin has been

[10] Suggested by Hartt, 1971, p. 304.
[11] Frey, 1930, p. 82.
[12] Wilde, 1959, p. 372, wrongly stated that the figures were stippled, but his article is fundamental.

elongated and the expression has come close to being trivialized in Venusti's painting.

<p style="text-align:center">* * *</p>

Michelangelo's latest series of compositional drawings is one of his most extraordinary and, at the same time, one of the most mysterious. There survive six large drawings of Christ on the Cross, accompanied by two attendant mourners below. Most of them were made on sheets measuring approximately forty-three by nearly thirty centimetres, about the original size of the *Crucifixion* made for Vittoria Colonna (pl. 236). That there was a seventh, drawn on the same large scale, is shown by two fragments of the Virgin and St John in the Louvre. And to the group can be added two sheets of Christ on the Cross, without other figures, and one or two preliminary sketches for Christ.

No early source refers to the group. A number of derivations show that other artists, including Marcello Venusti, had access to them, but this was not necessarily before the artist's death in 1564. Three of them were acquired from the Buonarroti family by the celebrated French collector of Michelangelo drawings, J.B. Wicar. But we know too little about the early history of the others to be certain that the whole group was still in the artist's possession when he died, as Wicar's three are likely to have been.

It has been suggested that the series was made in preparation for a Calvary group of three statues.[13] But the nature of the drawings does not support this. Such an explanation does not account for the fact that the drawings are made on sheets of the same size, which, in most cases, have no drawings on the verso. The figures have been drawn with only minor variations in scale from one drawing to another, which does not suggest that they are working drawings. There are no detailed life studies of the kind that Michelangelo made for his carvings, and that he produced even in very old age (see pl. 144), still less studies for views other than frontal ones. And an invention like that in plate 107 could scarcely have been carried out as a marble group.

The drawings were prepared with care. In all six the cross was drawn with a ruler, and changes to the shape and position of the cross, which we find on every sheet, were also ruled. In one drawing (pl. 107), Michelangelo actually drew a ruled horizontal base line, a feature recalling his architectural elevations. And the use of white-lead body colour both to model forms and effect changes by blocking out rejected solutions has been rightly likened by critics to the similar practice in one of the drawings for the Porta Pia (pl. 185). Such deliberate preparatory steps closely recall those for the *Crucifixion* drawing made for Vittoria Colonna (pl. 236). The likeliest explanation of

[13] Proposed by Tolnay, 1960, p. 80; see also his *Corpus*, no. 416 verso.

these drawings, unfinished as they are, is that Michelangelo made them for himself, and that, like his late religious poetry, they are confessional meditations, here given visual expression. In the mid-1550s, the artist composed a large number of sonnets concerned with the subject of these drawings, expressing a profound absorption in Christ's sacrifice and man's hope of redemption. In one of the greatest, composed between 1552 and 1554, he writes that his calling as an artist can no longer sustain him:

> Né pinger né scolpir sie più che quieti
> l' anima, volta a quell 'amor divino
> c' aperse, a prender noi, 'n croce le braccie[14]

The series shows Michelangelo repeatedly returning to the theme. In one of the drawings at Windsor (*Corpus* 418), which may be an early one in the sequence, the actions of the Virgin and St John recall those of figures in the Pauline Chapel *Crucifixion of St Peter*, completed in 1550. But it is unlikely that the series was made over a long period; motives in one drawing reappear in another, sometimes with the meaning changed. In the magnificent Louvre drawing reproduced here (pl. 106), the way in which Christ hangs from the cross reflects Michelangelo's adoption of a Y-shaped cross in two other drawings of the group (*Corpus* 416 and 417).

The two mourners are not invariably the same. In the drawing at Oxford (*Corpus* 415), the figures are male and female but they are clearly not the Virgin and St John. Although it is universally stated that the figure on Christ's left in the Louvre drawing is St John, this is not correct. This figure, with head bowed and both hands outstretched in submission to God's will, is that of a hooded, elderly, bearded man who may be identified more convincingly as Nicodemus. In what may be the last drawing of the series, Michelangelo returned to the traditional inclusion of the Virgin and St John (pl. 107). Both these figures are unfinished; the St John is only an underdrawing. The paring down of figures, already noted in the *Annunciation* drawings of the late 1540s (pl. 103), is especially evident in the figure of the Virgin here. Their rôles are remarkable, for they embrace the cross in a way more traditionally assigned to the Magdalen kneeling at its foot; and the Virgin now rests face and hand against her dead son as in a Pietà.

[14] As translated by Symonds: 'Painting nor sculpture now can lull to rest/My soul, that turns to His great love on high,/Whose arms to clasp us on the cross were spread.'

VII

COPYING, STUDYING, AND
IMPLEMENTING THE DESIGN: FIGURES

MICHELANGELO'S YOUTHFUL COPY AFTER Giotto (now in the Louvre, pl. 108) is his earliest surviving drawing. It may have been made as early as 1490, when he was no more than fifteen years old. And, as we have seen above, its pen-and-ink technique eloquently reveals a fact that he himself endeavoured many years later to suppress, that it had been from Domenico Ghirlandaio that he had learnt to draw.

Michelangelo here chose to study two of Giotto's monumental framing figures from the Peruzzi Chapel *Ascension of St John the Evangelist* at Santa Croce. He ignored the narrative story, and we find this same selectivity in comparable studies made a few years later (pl. 111). In these, also, he confined himself to a single figure or, at most, a group of three. His taste for copying specific forms can be found also in his copies of architecture, discussed below (pp. 92 ff.), or in his drawings after the antique (pl. 14). Michelangelo was not indifferent to the narrative power of Giotto's or Masaccio's murals, and that he remembered their compositions is clear from later works of his own. But he seems not to have needed compositional drawings as *aides-memoires*. His surviving copies (which must once have been much more numerous) are, with only one exception, self-educative explorations of forms and, at the same time, a critique of the prototypes.

The wish to amplify and improve is clear in the Louvre drawing. As has long been recognized, the youthful copyist's changes contrive to increase the sculptural, block-like forms of Giotto's foremost figure. After he had copied the latter in bistre ink, Michelangelo took up his pen again and, in a greyer tone of ink, added further modelling to the drapery and redrew the figure's left foot, making it more advanced and thereby distributing the weight more evenly than Giotto had done in the painting.

We find similar changes in a copy after Masaccio's figure of St Peter in the Brancacci Chapel *Tribute Money* (*Corpus* 4 recto). This drawing and the equally celebrated sheet of a three-figure group now in Vienna (pl. 111) are technically much more sophisticated than the Louvre copy, yet they cannot date from many years later; both, in all probability, date from before the young artist set off for Rome in 1496.

The prototype for the Vienna copy no longer exists. As we cannot securely identify it, we cannot compare Michelangelo's forms with those of his model. There has been considerable debate about the identity of the artist he here chose to study; it is probable that the drawing records a detail of Masaccio's lost mural of the *Consecration of the Carmine*, once in the cloister of the church. A copy of the same group by one of Michelangelo's *garzoni* exists in the Casa Buonarroti collection (*Corpus* 1 verso), probably dating from about 1530. Taken together with the evidence of other drawings by pupils which we need not discuss here, it strongly suggests that the middle-aged artist set his own workshop assistants to copy the very models he had selected to draw in his own youth.

This Vienna drawing, together with a study on the verso, is the most sophisticated of the copies of this early period. The density and degree of finish in modelling in the main figure shows how rapidly Michelangelo proceeded from the still relatively gauche use of Ghirlandaio's technique in the Louvre sheet. A much greater flexibility in transitions in cross-hatching lends the drapery a substantiality akin to sculpture; the use of pen in some areas of this drapery establishes a norm for modelling in ink to which, with remarkably little variation, Michelangelo would remain constant for nearly thirty years (compare pl. 131). As with with the Louvre drawing after Giotto, there were two steps in the making, for here, too, Michelangelo continued the drawing in a darker ink, reinforcing and amplifying the outline of the central figure and then adding his two companions. These other forms also present a remarkable contrast with the subordinate figure in the Louvre drawing. Already here, Michelangelo has devised a different style of drawing for figures in a further plane, consisting of light vertical strokes and hatching lines that are more widely spaced. This sophisticated effect of recession has not precluded the addition of some telling details; witness the pair of keys, pen–holder, and inkwell. But the new form of drawing here employed for the ancillary figures points toward remarkably subtle means of creating distance and nearness in figure groups which we find in later drawings and in the creation of painted groups in his frescoes.

Michelangelo's isolation in making such copies from trecento and quattrocento models in the 1490s can be exaggerated. Ghirlandaio's own frescos show how much Masaccio meant to him, and Giotto's works were never forgotten in the fifteenth century. One may illustrate this by pointing out that a minor Tuscan painter at work in the first third of the century inserted into his own mural at Prato the very group of Giotto's that attracted the young Michelangelo some fifty years later (pl. 110).

To judge from the depleted evidence, Michelangelo continued to make a few copies when he felt that they could teach him something. All these later copies seem to have been after sculptural rather than painted models.

At about the time he was requested to produce the replica of Donatello's bronze *David*, he drew the earlier master's marble *David*; the surviving lower

half of this very large copy we have already considered when noting the scale of his sheets of paper (pl. 34). Then, there is a group of small chalk copies of an antique torso of Venus, datable in the mid-1520s and made, therefore, at a time when he was confronted with carving female statues for the New Sacristy tombs. They are slight drawings, yet they reveal the instinctive response of the sculptor to a three-dimensional object, for the series shows Michelangelo studying the figure from all four main viewpoints (pls 112–15). And from about the same period, there are further chalk copies from the antique, two studies of the reclining male figure in the relief popularly called the *Bed of Polycletus*, a version of which belonged to a personal friend. We find them on the same Windsor sheet as the pen drawing of the drowsing friar referred to above (pl. 14), one of them almost submerged below the superimposed pen strokes. Here, too, the artist drew the prototype from different viewpoints. All these chalk drawings after antique models escape any hint of antiquarianism; in each, the forms seem to have been endowed with a palpability as if drawn from the living model.

These few figurative copies may have survived the artist's periodic destruction of drawings through sheer chance. Copies of the works of others do not seem the likeliest material to have escaped his notorious purges of workshop material, although it might be argued that copies from the antique could have had a more permanent value than life studies. Certainly, the motive of the sleeping youth in the relief took particular hold of Michelangelo's imagination, as the drawings made some years later for Sebastiano's Ubeda *Dead Christ* show (pls 140–41). Perhaps the early pen drawings held a special place in Michelangelo's heart, like the early marble *Battle of the Centaurs*, a work that we know he steadfastly refused to sell. Unfortunately, we have no information about their early provenance.

<center>* * *</center>

Of all the kinds of drawings that Michelangelo made, studies in pen or chalk from the living model are the most numerous. The fact is a true reflection of the reality of his activity as a draughtsman. Not all of these life studies are of the same kind. They range from the swiftly executed notation of structure so finely exemplified in the study for the Adam of the Sistine *Expulsion* (pl. 28) to studies of a richness of anatomical description that has never been equalled (pl. 138). They include also analytical studies of details (pl. 148). Many of the large-scale nude studies are now almost over-familiar from repeated anthologizing. Yet they set a standard for this class of drawing for over three hundred years; no one understood them better than Rubens, himself the owner of the Vienna *Ignudo* (col. pl. 2 and pl. 127). To attempt to discuss every deserving example would fill an entire book.

Nude studies for painting, like the Vienna *Ignudo*, the London *Haman* (pl. 129), or the Haarlem *St Lawrence* (pl. 142), or for sculpture, like the Oxford

and Haarlem studies for the *Day* (pls 136 and 138), imply an intensive preparation carried out beforehand. They are a stage in the evolution of a figure close to its realization. In the case of the three studies for painting, they mark the point just prior to the drawing of the cartoon, which would be prepared on a one-to-one scale. Between the stage that they constitute and the cartoon, there lay only one further step, that of defining anatomical details, heads, hands, feet, which Michelangelo almost invariably chose to study apart, sometimes on the same sheet (pl. 142), more frequently on a different one (pl. 130).

In the case of the studies for the New Sacristy statue of *Day*, the procedure was not very different. An analysis of details must have followed these drawings, leading, in this case, to the preparation of a full-scale clay model. A fine example of just such a sheet of detailed studies for the companion statue of *Night* is at Oxford (pl. 134). Michelangelo here drew the same sharply crooked arm from four viewpoints, each of them made in order to master the design of the *Night's* sharply bent right arm (pl. 135; even the falling strand of hair of the statue is lightly indicated, although not in its final position).

Of these four Oxford arm studies, it is the one in the upper left that was taken furthest, yet this is a view of the *Night's* arm that the visitor to the Chapel would never see. This remarkable fact may help us to appreciate with what unflagging attention Michelangelo prepared himself for the carving of these statues. The multiple viewpoints of these studies serves also to remind us of the fact that the making of carved figures in the round involved the artist in a far greater expenditure of time and effort than painting figures, not only in terms of the physical demands of carving, but also in the preparatory process of drawing.

The group of black-chalk life studies made for the New Sacristy *Day* show this clearly. A sheet at Oxford (pl. 136) is an early one in the series (Michelangelo subsequently used the back of the sheet for the *Night* arm studies we have considered). The general attitude of the statue has already been determined, but the drawn figure does not agree in all respects with the carved one (pl. 137); the study is concerned with the anatomical implications of the general disposition only. The model has been studied from a significantly further viewpoint than the one adopted for other *Day* sheets (compare pl. 138). This, and a fugitive notation of scale may indicate that Michelangelo was occupied here also with calculating the height of the block. (In fact, the *Day* was the only one of the Chapel Allegories cut from a block not prepared *ad hoc* for the project. We learn that it was carved from a piece to hand in the workshop.[1] This, I believe, explains the much-debated

[1] *Ricordi*, 1970, p. 124. It was correctly identified with the *Day* by Wilde, 1954, pp. 15–16, n. 3.

circumstance that the *Day* and *Night* have straight bases, as opposed to the curved ones of the *Dawn* and *Evening* of the other tomb.)

Another drawing for the *Day* (pl. 138), one of several at Haarlem, shows a different concern, the quest to analyse every form of the figure's back. For this study, Michelangelo chose a much softer black chalk, and in its delicate renderings of the muscles and evocation of the play of a subdued light over the surface, the drawing can scarcely be equalled in the history of draughtsmanship. Yet even here, the model's pose does not correspond exactly with that of the statue (pl. 139). Several of the surviving *Day* sheets show how pre-occupied Michelangelo was with this back view. Although not the Allegory's main view, it is an exceptionally important one, for it is what one actually sees from the altar, the point from which the whole Chapel programme was planned to be viewed.

The Oxford study for the *Day* has a further significance: it allows us to appreciate how intimately linked Michelangelo's drawing practice and carving practice were. In both drawing and statue it is the main form only which is his real concern. The neglect of the head in the Oxford *Day* drawing finds its parallel in the inchoate state of the head in the unfinished statue. Black chalk and chisel serve a common vision.

When Michelanglo made these chalk studies for the Sacristy statues, probably in early 1524, he was almost fifty. A career of unbroken activity already lay behind him, and the bad health that would soon assail him scarcely held promise of over thirty more years of life. Even within the long series of life studies prompted by his successive projects, the group for the *Day* holds a special place. But when and how did he begin to make drawings of this kind?

No studies for the sculpture of Michelangelo's first Roman residence, for the *Bacchus* and the *Pietà*, have survived; but that such ambitious works necessitated life studies cannot be doubted. All that we know of Michelangelo's early drawings suggests that they were in pen and ink; if we attempt to visualize their appearance, we have to turn to a study such as that for the Santa Maria sopra Minerva *Christ*, made nearly twenty years later (pl. 131). The earliest example that we can relate to a known work is a study in the Louvre for one of the Maries in the *Entombment* in the National Gallery, London (pls 116–17). It is likely, although not proven, that this altarpiece, left unfinished, was Michelangelo's response to a commission given to him in Rome in 1500, soon after he had finished the marble *Pietà* and a year before he returned to Florence.[2]

The Louvre study, one frequently and wrongly doubted, was unquestionably made from life, and the figure's elaborately plaited hair shows that here, exceptionally, Michelangelo employed a young girl as his model rather than a male *garzone*. The drawing was carried out with great care in

[2] Hirst, 1981, pp. 581 ff.

three stages. First, Michelangelo drew the figure very lightly in black chalk. Then, he worked over the chalk with pen and pale bistre and, after this, went over the whole figure again with a much finer pen and in a much darker ink. At this stage, he added the lateral strokes to denote the ground, a rare feature in his life studies. Finally, he added a few touches of white body colour on details like the hair, ear, right shoulder, and left hand.

The unfamiliar impression that this drawing makes is caused chiefly by the pink ground, a feature redolent of late-quattrocento Florentine practice and difficult to match among other surviving drawings. But we must again recall that very few drawings that we can plausibly suggest belong to this Roman visit survive. Michelangelo made this study when the whole composition of the altarpiece had been fixed, for there is a black-chalk line drawn vertically to the left of the figure, and this exactly marks the left edge of the panel. His inclusion of attributes, the sketched-in nails and crown of thorns, also strike a quattrocento note; such details he rarely introduced into the life studies of subsequent years.

Despite its constrained style, the study is important, for it reveals the still youthful artist studying from a nude model a figure planned to be clothed in the painting. There seems to be no evidence of Ghirlandaio having done this. Already, we find pen strokes that curve to enhance the convexities of the internal forms.

We are probably correct to associate another Louvre drawing with the abortive altarpiece (pl. 118). It has been proposed that this male figure was drawn for the figure of St John at a stage in the planning when Michelangelo was considering placing him on the dead Christ's left, rather than on His right as in the panel. The action of the figure in the drawing seems to confirm this. This study makes an impression of greater assurance than that for the Mary, but this need not mean that it was made later; its greater freedom can best be explained by the fact that it is earlier in the design process, hence the much bolder *pentimenti*. The cursory, yet expressively telling indication of the head already anticipates a practice that would last a lifetime.

A number of other pen drawings of male nudes on comparable large sheets of paper come close in appearance to this Louvre study. A fine example is now in Vienna (pl. 119). If, as seems probable, the drawings for the *Entombment* were made in 1500, a plausible case could be made for dating this Vienna one also at the end of Michelangelo's first Roman stay. An unremarked feature of the Vienna drawing is worth our notice. In effect, Michelangelo has treated the nude figure like an antique statue. Although sketching in head and feet, he has ceased to draw the arms at the point where we should expect a classical statue to be broken. This Vienna study is not from a plastic model (which would more easily explain the phenomenon), for we find the same moustached model in a relaxed pose in a pen drawing in the Louvre (*Corpus* 30 recto). And we could, if space allowed, trace a rather similar practice in much later drawings. Here, his adoption of it seems an

8 Studies for the head of Leda, Florence, Casa Buonarroti.

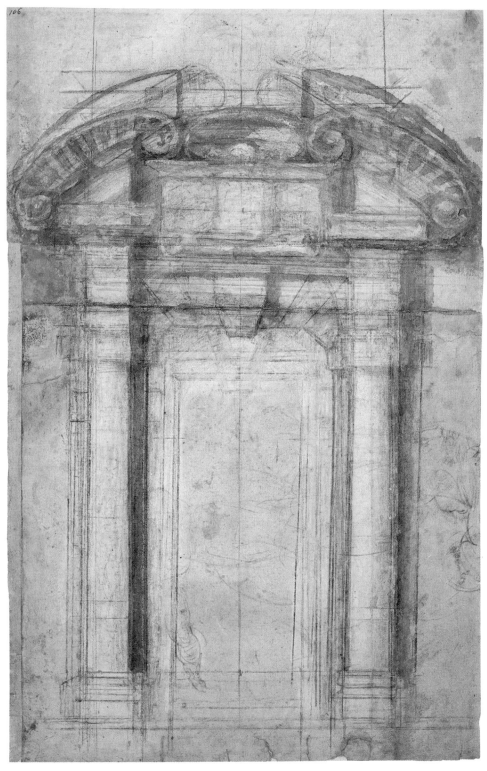

9 Study for the Porta Pia, Florence, Casa Buonarroti.

indication of his deep absorption in the study of antique sculpture, something that his long Roman stay from 1496 to 1501 at last allowed him, But Michelangelo's antiquarianism stopped here. He did not follow Tullio Lombardo, whose passionate commitment to antiquity led him to adopt the same convention in the carvings themselves.

It is, however, useful to turn to a famous drawing in the Casa Buonarroti (already referred to above) with these considerations in mind (pl. 120). Many years ago, it was shown that the figure is based on one of a Hercules in an antiqe sarcopahgus relief, of which a version still exists. Yet that the pen drawing was made directly from the classical prototype seems, I think, open to question. The proportions have been changed so completely that the pen drawing reads like a later paraphrase of a drawing done in front of the proto-type. The figure, it is true, 'stops' at the point where the carved figure of Hercules meets the relief field of the sarcophagus—Michelangelo has even briefly sketched in a kind of stump for the missing left leg. But, with the Vienna drawing in mind, this argument in favour of it being an on-site copy loses much of its force. It seems more likely that Michelangelo was here reworking the invention he had previously recorded—interestingly, from a diagonal view (see, for the same practice, pl. 14).[3]

Both this and the Vienna drawing reflect, I believe, a particular moment in the relation between Michelangelo's drawing practice and his study of the antique, but a comparison of the two suggests that the Casa Buonarroti sheet is the later. In it, the approach to form is more dynamic: muscles and sinews are caught up in a flow of movement. And to capture this greater unity of parts, Michelangelo has carried the technique of drawing a step further. Greater pools of shadow give a correspondingly sharper accent to the highlights created by the whites of the paper; but, more importantly for the total effect, the strokes of the pen are now much longer, and the lines of the modelling are at the same time both looser and denser, whichever corresponding part of each figure we choose to compare. Bunches of hatching strokes, some laid on others, curve, circle, and cross each other with an almost violent movement of the pen.

The motive of this Casa Buonarroti study appears in Michelangelo's Uffizi compositional drawing for the Battle of Cascina (pl. 71), in a figure placed inconspicuously in the background of the group, and the belief that the pen drawing was made in 1504 with the Bathers scene in mind is likely to be correct. In the end, Michelangelo abandoned the motive in his battle scene. But the figure study remained in his Florentine workshop, demon-strably studied by others, until the artist's impulse to vandalize it.

His participation, alongside Leonardo, in the decoration of the Sala del

[3] It is possible that this Casa Buonarroti drawing was made after a plastic model based on a study done in Rome.

Gran Consiglio in Palazzo Vecchio, may have had a great, even a decisive, effect on his development as a draughtsman. As we have seen above, the appearance of black chalk in his repertoire in this period may have been prompted by many things, and, as the Uffizi drawing for the Bathers scene shows, it was not confined to large studies from the model. Nevertheless, the appearance of drawings like those at Haarlem (pls 121–2) marks a remarkable step in his art, a step seemingly taken only now, at the age of nearly thirty. The example of drawings by Leonardo may have had an important part in this. Nevertheless, we have no drawings by Leonardo of this period that constitute a convincing parallel for drawings like the Haarlem ones. Closer in appearance, although smaller in scale, are the black-chalk nude studies that Signorelli was making in the same period.

These two Haarlem drawings, like that in the Casa Buonarroti, are very large (they were once even larger). In these chalk drawings, however, the model has been studied from a much closer viewpoint. We can notice also that the studies are for figures placed next to each other in the lost cartoon (see pl. 72); perhaps this is coincidence, or perhaps we have a hint here that the *Cascina* studies were once kept together in an orderly sequence in the studio. Both studies show the figures entire, with no regard for the fact that parts of them would be over-lapped by other figures. Each has been drawn with great freedom; there are striking *pentimenti*—for example, the raised right shoulder of the figure in plate 122, together with the raised right arm, was added as an afterthought. They show, in other words, Michelangelo working very rapidly at a stage where there was ample opportunity for major adjustments. In the cartoon, for example, he suppressed the raised left arm and left hand sketched in the companion sheet. Splendid as the drawings are, there is a certain bold coarseness about the handling of the slightly greasy black chalk.

The appearance of another *Cascina* chalk study, now in Vienna, is rather different (pl. 124), indicating that we should not assume that all his life studies for the *Bathers* were stylistically homogeneous. The drawing, later sadly cut down in order to make a coherent composition of the study on the other side, is for a figure in the furthest area of the cartoon as recorded in the grisaille (pl. 72). Yet it is a more painstaking record of appearances than the Haarlem studies. Itself a late stage in the evolution of the figure (an earlier drawing is in the Louvre, *Corpus* 54), it has been made in a much softer black chalk, in order to dwell on every rise and fall of the musculature. Then, not content to allow the white paper to serve for the highlights, the artist added a substantial number of touches of white body colour with the tip of a brush. These materials, black chalk and white lead (*biacca*), are precisely those that observers noted his use of in his celebrated full-scale cartoon. Beautiful as it is, this Vienna study has, therefore, an added importance. For, allowing for the greater constraint of a small, preparatory study, it is this drawing that can best help us to visualize the appearance of the lost cartoon.

It is instructive to compare this Vienna drawing, made in chalk and heightened with white, with the Casa Buonarroti study drawn in pen, probably of the same year. The range of tone, from dark to light, is about the same. But the comparison shows the advantages that chalk brought the artist. The range of descriptive possibilities it holds out cannot be matched by even the most sophisticated development of the late-quattrocento technique so wonderfully set out in the pen drawing.

* * *

By the time Michelangelo came to paint the Sistine ceiling, begun in 1508, he seems to have given up making many pen studies from life. But the chalk studies for this new enterprise do not neatly follow a pattern prescribed by the drawings made for the *Battle of Cascina*. It could be argued that the Vienna *Ignudo* study (col. pl. 2 and pl. 127), despite the medium, is in some ways closer to the *Cascina* pen drawing (pl. 123) than to the Vienna one for the *Bathers* (pl. 124). In it, we even find Michelangelo using some cross-hatching. The remaining life drawings for ceiling figures reveal an almost disconcertingly varied approach. Michelangelo seems to have favoured black chalk for the preliminary life drawings, and many were first underdrawn with a stylus. One of these, where in some passages he seems to have used the broad side of the chalk, shows a deep concern for establishing values of light and shadow (pl. 126). Another brief and 'non-definitive' life study he made in an uncharacteristically greasy chalk over stylus (pl. 125); it is confined to studying the main forms only, and, as we saw above, its similarity to very late drawings has led to serious confusion about its date.

Michelangelo resumed work on the ceiling in the early autumn of 1511. It was, in all probability, at this time that he drew the Vienna *Ignudo* study. The drawings of the same type that he seems to have made subsequently, for figures painted near the end of the programme, do, however, reveal a discernible change. Unfortunately, few drawings for 'late' figures have survived. But there is one incomparable example in the British Museum, the full-length red-chalk study for the figure of the crucified Haman, painted at a point near the completion of the whole work (pl. 129). The gradations of tone in the modelling are conspicuously finer and subtler than in the *Ignudo* sheet. Overt cross-hatching with the chalk point has been laid aside. And there is no trace here of the white heightening used for highlights in the other study. The enhanced unity of parts in the *Haman* drawing, already foreshadowed in a study for the *Libyan Sibyl* now in the Metropolitan Museum (*Corpus* 156 recto), is a graphic equivalent to the reduction in sharp local colour and greater unity in tone of the last painted figures of the ceiling, of which the *Jonah* is a conspicuous example. The now lost drawings for *Jonah* must have been very like this *Haman* one. Before leaving the sheet, it is worth adding that Michelangelo added little chalk circles on some of the forms. We

find them on the left thigh of the main study and, more clearly marked, on the 'repeat' study of the left leg to the right of the full-length drawing. These mark, I believe, the projected areas of most emphatic highlight in the painting, and are a kind of privately formulated substitute for the areas of white body colour used in earlier drawings. Serving the same purpose, we find them on many later life studies, especially on those made for the *Last Judgment* (they are very clear in the Haarlem drawing for St Lawrence, pl. 142), and they occasionally appear on studies for sculpture.[4]

One might assume that the experience of making studies such as these for the Sistine ceiling spelt the end of pen and ink as a medium for life drawings. Michelangelo did abandon it in this context, seemingly in the 1520s, but not before making drawings like the one from life for his marble *Christ*, destined for the church of Santa Maria sopra Minerva in Rome (pl. 131). However, it must be added that this pen study was made over a chalk underdrawing. It has already been referred to in order to show how difficult a task the dating of the pen studies can be (p. 26 above). But this Minerva study is important also in another way, for it shows us how Michelangelo wanted his statue to be seen. Designed for a niche, the marble *Christ* is very much a figure with a single view. But, like the *Madonna and Child* in Bruges, it has been wrongly set up on the free-standing pedestal on which it now, incongruously, stands.[5] Michelangelo carved the statue diagonally within the rectangle of the block. The front plane of the block is now canted to one side and, nullifying Michelangelo's desire for movement, has flattened out the figure. The drawing shows Michelangelo's intentions, for it is of the principal view of the figure as he planned it; it demonstrates the flattening effect of the statue's present installation (pls. 132–3).

<p style="text-align:center">* * *</p>

In the end, Michelangelo abandoned not only pen and ink but also red chalk for drawing from the model. All the known drawings of this kind made for figures in the *Last Judgment* are, like the Haarlem *St Lawrence* (pl. 142), in black chalk. As has already been suggested above, the potentially much softer substance answered better his wish to create very finely modulated ranges of tone. The *St Lawrence* sheet is a wonderful example of this style of black-chalk drawing.

The drawings made for the *Last Judgment* can be supplemented by two life studies of the same period which Michelangelo made to help Sebastiano paint an altarpiece of *Christ mourned by His Mother*, made as a present for the

[4] I find that one earlier writer has preceded me in observing these marks, the compiler of the Tenth Lawrence Gallery Exhibition (London, 1836), who, apropos the London *Haman* (p. 17), reached an identical conclusion.
[5] I owe this observation to Diane Zervas.

secretary of Charles V. These studies probably date from the autumn of 1533, when Michelangelo himself arrived in Rome for a long visit, and the earlier of the two, now in the Casa Buonarroti (pl. 140) has studies for the *Last Judgment* on the verso. The drawing is not unlike some of the more summary studies for the Sistine ceiling, but the handling is lighter, the strokes are more varied in direction, more broadly spaced, and more often repeated in the contours. In the second study for Sebastiano's dead Christ, now in the Louvre (pl. 141), we find a degree of finish scarcely equalled in any similar life study. The depth and variety of modelling can be compared only with that in some of the contemporary presentation drawings. The effect has been achieved by using an exceptionally soft chalk, which, in a few areas of shadow, may even have been stumped, or rubbed on the paper. For main accents, the point of the chalk was moistened, as in the *St Lawrence* sheet. In the area of the upper left arm, we still find cross-hatching, now carried out with very short strokes on top of lightly fused chalk.

Studies of this class dating from the period following the completion of the *Last Judgment* in 1541 are rare. Conspicuously missing is any significant group for either of the two narrative murals in the Pauline Chapel. Clearly, Michelangelo destroyed them. This does not exclude the possibility that he may have made fewer drawings of this kind after 1550 when Paul III's two frescos were completed. But that the practice of a lifetime was not abandoned completely in advanced old age is shown by the study reproduced in plate 144. A second sheet, really just a torn-off fragment, now in the Casa Buonarroti, has a closely related study on it, and the argument that the two were once part of the same sheet is entirely convincing (pl. 145). On the back of the Florence piece, there are two fragmentary drawings of bearers. And the presumption is strong that the two studies on these two rectos were made for the figure of a dead Christ, the lifeless head sunk forward, supported by a bearer figure on either side. This is one of the inventions that we find on the late sheet at Oxford (pl. 70). And the motive may also relate to the study of a supported dead Christ on the sheet of studies that has been discussed above as constituting a nearly facsimile copy of a lost sheet (pl. 146).

This drawing (pl. 144) was certainly made from life; beneath the main study, there are further ones of both shoulders. A working drawing, in purpose and scope it may be compared with the earlier of the two made for Sebastiano (pl. 140). The comparison brings out the tremulous handling of the chalk, now almost like charcoal, and a kind of translucence in the surface of the forms, all pointing to a date closer to 1560 than 1550.

* * *

The kind of life studies we have just considered are among Michelangelo's most famous creations. But they were not, of course, the only form of 'life drawing' made in preparation for painted or carved *figure*. They were both

preceded and followed by other studies made from the model, some done at a stage prior to the large, chalk nude drawings (pls 149–50), others following them (pls 130 and 134). These studies, all ancillary to the large sheets, are very much fewer in number than the latter. But this does not mean that Michelangelo made fewer of them; it reflects the fact that they were not sought after and preserved by early collectors in the same way.

The pen study reproduced in plate 147 was recognized as one made for the Christ Child in the Doni tondo as late as 1955.[6] Clearly, it is a fragment from a larger sheet. It was made from a fully mature male model and drawn with a very broad pen; the brevity of stroke can be compared with passages in some of the large studies already discussed. But this study was made specifically to analyse the physical implications of a choice of pose already determined.

Pen drawings made about twenty years later have some of the same characteristics (pls 149–50). These two were certainly done from life, but they were less exclusively conceived with the implications of a specific pose; they have been described as self-educative studies made by Michelangelo when planning the Medici Chapel Times of Day and River-gods. The purpose was to restudy the model in positions approximating in a general way to the motives already planned. Drawings such as these lay behind the incomparable capturing of visual appearance in the black-chalk drawings (pls 136 and 138). Executed with great economy, the few stabbing hatching lines continually shift direction, and this may cause confusion in the unwary (the drawing reproduced here in plate 150 as a reclining figure has recently come to be treated, wrongly, as a kneeling one). The rendering of muscles and tendons in the leg of the Casa Buonarroti drawing, 44F (pl. 149), is almost as analytical as an *écorché* (compare pl. 21). It was studies like these that helped form the drawing style of another sculptor who would, for a time, become one of Michelangelo's trusted associates, Raffaello da Montelupo.

Easier to understand, and more numerous, are the studies that followed the large life drawings, studies of details that the artist needed before he drew the cartoon or started work on the block. We frequently find these on the same sheet (pls 127 and 142). Sometimes the detail study is for the same figure as the main drawing, sometimes for a related one (pl. 140). In this last example, the right arm drawn on the *Pietà* sheet is for the mourning Virgin in Sebastiano's painting.

On other occasions, an entire sheet was given to studying such details. That at Haarlem, with studies for the *Haman*, is a fine example (pl. 130). The drawings range from one of the whole upper torso, arms, and head (painted subsequently in a somewhat different position), to one exclusively concerned with the right ear. A few black-chalk lines in the lower right are those of the tree from which Haman hangs. Yet even this series of studies, done to complement the British Museum drawings (pl. 129), seem not to have been

[6] Wilde, 1957, p. 279.

the last made before the cartoon. Many years ago, brilliant detection established that a rapid drawing on another British Museum sheet was made for Haman's sharply retracted left foot (pl. 148).[7] The second study, drawn the other way up, seems to be for one of the latest of the *Ignudi*. Both were drawn in a highly abbreviated style with astonishingly rapid strokes of hard red chalk (yet even here over traces of stylus).

This sheet helps us to appreciate another aspect of Michelangelo's practice when making such studies: how he would seize the opportunity to study the same anatomical detail in different positions for entirely different figures whilst he had the model in front of him. A drawing in Rotterdam shows his studying the same model's arm in different positions for the extended gestures of two of Noah's sons (*Corpus* 121 recto). Such economies, which were standard workshop practice in the period, clearly saved time and effort.

Some of these studies, especially those for the figure of Haman, have left critics wondering how the model held the pose. Michelangelo leaves us almost no clues as to how he achieved what he wanted; the lack of studio props in these drawings is wellnigh complete. Occasionally, we find a hint, as when we notice that the model held a ball to sustain the gesture in the hand and arm studies on the Sistine ceiling 'composition' sheet in London (*Corpus* 119 recto).

Not all the figures of the Sistine ceiling are nudes. How did Michelangelo study the draperies which are so integral a part of the forms of the Prophets and Sibyls, the largest figures of the programme? Drapery studies of the kind familiar to us from the Florentine studios of the late quattrocento are very few, even from Michelangelo's early career, when we might expect him to have made them frequently. The most significant example is one for the lower half of the drapery of the *Erythraean Sibyl*, a figure painted in Michelangelo's first campaign of work on the ceiling (pl. 153). The pose of the Sibyl has been defined in other drawings that we no longer have. Here, the figure was first drawn schematically from head to foot with a brush, the highlights left carefully untouched. Over this bistre wash Michelangelo drew a few black-chalk lines on the torso and then made the elaborate drapery study with pen and ink, working over the areas of dried wash. The hatching is elaborate and recalls that in his early copies after Giotto and Masaccio (pls 108 and 111); but it is similar also to that in some of the early drapery studies of Fra Bartolommeo. The curiously polished abstraction of the figure, really no more than a prop for the drapery, is unusual. It is, I think, likely that Michelangelo arranged the drapery over a model, not one of modelled clay of the kind familiar from Leonardo's practice, but a lay figure.

It may well be that Michelangelo turned from pen and ink to chalk for drapery studies at a later stage in painting the ceiling. But drawings of

[7] Thode, 1913, p. 133.

drapery of a later period scarcely exist at all, and nowhere in the surviving late *oeuvre* can we find equivalents for the chalk drapery studies made by Leonardo late in his career.[8]

As a postscript to this account of life studies, we may briefly turn to Michelangelo's studies of heads. It would be misleading to give an impression that Michelangelo had no interest in the human face; the great range of types we find in the series of the twelve Prophets and Sibyls of the ceiling is enough to dispel it. It does seem true that his concern with facial expression received a new stimulus from the commissions he received in Florence after his return from Rome in 1501; Ghirlandaio, although a fine cartographer of the human face, had not been interested in the varieties of expression that so absorbed Leonardo. This new interest is evident in the marble *David*. And even from the evidence of the grisaille copy of the *Bathers* composition, it is clear that a number of heads in the cartoon were powerfully individualized characterizations. There were fewer possibilities with the Doni *Holy Family* (pl. 152), although the bald and bearded St Joseph became a kind of iconographic paradigm, to which Fra Bartolommeo and Sarto reverted many times.

The celebrated study for the head of the Virgin in the Doni tondo (pl. 151) is the earliest of its kind directly linked to a surviving work, and it is also an early example of Michelangelo's use of red chalk. This is not a drawing made to capture an individual face which could then be transposed to a cartoon, as a number of Sistine studies are. It is very much a working drawing, done to study features very sharply foreshortened and to establish how the light would fall on these main accents. In the painting, the projection of the head is less extreme (in the drawing, the right eye is invisible); further drawings must have followed this one, probably culminating in a cartoon for the whole work (see p. 75, below).

The Uffizi drawing of the head of Zechariah (pl. 155) served a different purpose: to record a highly individualized face which Michelangelo must have sought out for one of his Prophets. This is not a study of forms as such; it is really closer to a portrait sketch, although it is not of any recorded 'sitter'. Summary as it is, it may have provided Michelangelo with enough indications to proceed directly to the preparation of the cartoon. Here, again, proportions underwent a marked change, from the vertical emphasis of the chalk head to a much more lateral spread of form in the mural.

An example of a small preliminary drawing is on a well-known sheet at Haarlem (pl. 156); the companion one for the whole figure, made in identical red chalk, is on another sheet in the same collection (*Corpus* 136 recto). This head sketch is about six and a half centimetres high, yet it already captures completely the element of 'furia' Michelangelo wanted for this figure (the expression vividly recalls that of the riders in Leonardo's *Anghiari*).

[8] See Popham, 1946, nos 186–8.

We may finally turn to the drawing for the head of Leda in the painting Michelangelo undertook for Duke Alfonso d'Este of Ferrara in 1529 (col. pl. 8 and pl. 158). Michelangelo's first step was to draw in faint schematic lines to mark out the area of the sheet destined for the study. These recall the lines drawn around some of the figure studies for the New Sacristy statues (compare pl. 136). Here, in a drawing made for a painting, the intention cannot have been the same, and these lines seem to have been made to establish the scale of the head drawing itself, perhaps in order to relate its size to that of other detailed drawings for the *Leda*. (The line above this head study may also have served to recall Leda's elaborate arched headdress, of which there is no trace here). The exact dimensions of Michelangelo's lost cartoon and painting are unknown. It has been suggested that a copy, now at the Royal Academy, is a fairly reliable guide to these. If this is correct, the scale of the Casa Buonarroti head, despite its exceptional size, is under half that of the head drawn in the cartoon and painted on the panel.

The fact that this was Michelangelo's first task in painting for over fifteen years, and the exalted rank of the patron, must have led the artist to prepare the work with great care. Many elaborate studies must have been made for details such as the complex play of folds of Leda's discarded dress, best recorded in Cornelis Bos's engraving (pl. 157). Of such studies, only that for the head survives; but we cannot complain, for it is not only one of the most beautiful of all Michelangelo's drawings, it is also one of the most perfectly preserved. Made about twenty-three years after the study in the same collection for the Madonna in the Doni tondo (pl. 151), it shows Michelangelo's art at a particular moment of idealization, now realized with a refinement in technique perhaps never equalled in the history of life drawing. For the study, Michelangelo chose the very dark red chalk he would employ for Cavalieri's *Bacchanal* of about four or five years later (pl. 231, p. 115). The head was first drawn very lightly—lines of an earlier profile contour are clearly visible. Then he embarked on the moulding of every form, achieved by the finest changes of emphasis of the chalk. It has been suggested that this process of modelling was completed by the process of stippling with the chalk point. This is not correct; the changes of tone in areas such as those above the eyelid and on the cheek were made by stroking a broad surface of a very soft chalk over the grained paper. Heavier accents were made with a moistened chalk. Finally, Michelangelo redrew the detail of the eye. He used the same chalk after sharpening the point (his two trial lines for this second study lie beneath it). The detail is now drawn from a close viewpoint, the eye is more nearly closed (as it seems to have been in the painting) and the long lashes were added.

Michelangelo used a *garzone* in the workshop as his model—even the collar of his jerkin is indicated. As has been the case with all the studies we have just considered, Michelangelo employs a male model, irrespective of the sex of the final image. This holds true for the drawing for the Madonna

in the Doni tondo, for this *Leda* study, and for other telling examples (for example, the New York sheet with a figure and head study for the *Libyan Sibyl* not discussed here). Where Michelangelo draws women, they seem, for the most part, not to be life studies, but drawings of his imagination, dating chiefly from the decade of the 1520s (see pls 218 and 220).

It would be misleading to leave this kind of drawing with the implication that all were made *ad hoc* for specific projects. We have already noticed studies of heads made as *exempla* for assistants to copy (pl. 19). The faun that Michelangelo so vigorously drew over a pupil's exercise was an essay in virtuoso fantasy (pl. 17). And we should not forget the half-beast, half-human heads that cover other sheets, still more exotic fantasies, some of which might appear later in a sculptural or architectural context, but which were not made directly for such transcriptions (pls 159–60).

<p style="text-align:center">* * *</p>

At this point, the graphic preparations for painting and for sculpture part company. In the context of mural painting, all the disparate life studies came to be united in the last major preparatory step before the act of painting, the preparation of the full-scale cartoon. For sculpture, the latest style of drawing may have been that of the anatomical studies exemplified in those for the New Sacristy statues considered above (pls 136 and 138), although, for some of these statues, Michelangelo also prepared full-scale clay models at the behest of his patron.

Before turning to cartoons for paintings, however, mention should be made of another kind of drawing engendered only in the process of making carvings. Michelangelo would rapidly sketch the blocks of marble he needed, together with the required measurements, for the men who would excavate the pieces at the quarries. These drawings might take slightly different forms. On a sheet in the British Museum (pl. 162), he made two rapid pen drawings of blocks with a male figure sketched within. It has been shown that, in fact, the figure is the same, seen from different angles, and the block, with its dimensions marked, is, consequently, a single piece. The figure is that of the recumbent River-god planned for the right side of the base of Duke Giuliano's tomb.

Slightly different drawings serving the same end cover many of the pages of a notebook preserved in the Archivio Buonarroti. Most of them contain block sketches either for the statues or for the wall-tomb fabric of the New Sacristy. The paper is of very poor quality, and the book may have been acquired for the purpose at Carrara, for these are the drawings of block measurements that Michelangelo himself refers to in a memorandum as having been made there, close to the quarries, in April 1521.[9] They served

[9] *Ricordi*, 1970, p. 106.

two purposes. The primary one was to indicate in Florentine *braccia* the length (*lunghezza*), breadth (*larghezza*), and depth (*grossezza*) of the pieces required. The other was to serve as a kind of legalized receipt, once the artist had taken delivery. Inscriptions on the first page of the book, one in Michelangelo's hand, the other in a notary's, show that the artist inscribed the initial of his supplier's name within his own symbol of three interlocking circles, once he had received the prescribed piece (pl. 163).

Such books of block drawings for statues and tomb fabric may have been quite numerous; we know that a 'quaderno' of the same kind was made in 1517 for the supply of marble for the tomb of Julius II. The drawings are similar in function to those that Michelangelo made for marble blocks for the San Lorenzo façade, discussed below (pl. 164). Having served their purpose, such books must usually have been thrown away. The sketches themselves are some of the most summary Michelangelo ever made. His only concern was clarity, and to achieve this all consideration of perspective in the drawings of the blocks might be disregarded: the orthogonals of the lowest block in plate 163, rather than converging, diverge as in a Dugento painting.

<p style="text-align:center">* * *</p>

Cartoons are the graphic product of Michelangelo that we are worst placed to discuss. Only two large ones survive. One, now in Naples, is for a group of three soldiers in the mural of the *Crucifixion of St Peter* in the Pauline Chapel (pl. 165). The other, in the British Museum, Michelangelo did not make for his own use at all. He drew it to be transcribed as a panel painting by his protégé and biographer, Ascanio Condivi (pls 166–8).

Making cartoons for panel paintings as well as for frescos may have been Michelangelo's chosen practice. We cannot be certain about this, for the evidence in the sources is almost exclusively concerned with cartoons that he made for other artists (including, apart from Condivi, Sebastiano del Piombo and Pontormo).[10] Two early panel paintings by Michelangelo himself, the London *Entombment* and the Doni tondo in the Uffizi, bear no indication of having been prepared with a cartoon; technical examination has revealed no traces of *spolveri*, the greyish or blackish dots left by the process of dusting chalk through the pricked lines of the drawn cartoon onto the panel. But this negative evidence is not decisive—much of the surface of the London painting is, in any case, in worn condition. That Michelangelo was in the habit of making cartoons for his panel paintings is strongly suggested by the fact that, much later in life, he made a full-scale cartoon for his painting of *Leda* . Vasari states that the cartoon, as well as the painting, were

[10] The large unfinished *Madonna and Child* in the Casa Buonarroti (*Corpus* 239 recto) is a kind of cartoon, almost certainly made for another artist.

given by Michelangelo to his *garzone*, Antonio Mini, who took them with him on his ill-fated move to France.

We can only speculate as to why the cartoon now in Naples escaped destruction. The likeliest explanation is that Michelangelo gave it away as a present in his lifetime, just as, much earlier, he had given the cartoon of the Sistine *Drunkenness of Noah* to a Florentine friend (see below, p. 105). The collecting of cartoons as works of art was firmly established by the middle of the century. And, in fact, both the Naples and London cartoons had been acquired by the same collector before 1600.

Ever since it was first published, the Naples cartoon has been described, understandably, as a cartoon for the fresco. But this traditional description may mislead us. Its recent restoration has revealed even more clearly than hitherto that it was never applied physically to the damp plaster of the Chapel wall. The area of the mural that corresponds to that of the Naples cartoon comprises many different patches of plaster (*giornate*), painted by the old artist in different sessions of work. It would have been totally impracticable to apply to the wall, and then remove, so large a drawing as this one on successive occasions. And, indeed, the piece of the composition preserved in the Naples cartoon bears no meaningful relation to the pattern of the *giornate* of the painting. Further, there is no sign whatever that the cartoon was cut up into appropriate smaller pieces and then reassembled. Even the holes that would have been left when the drawing was tacked to the wall are missing.

Made up of twenty pieces of paper of varying sizes, the cartoon is minutely and comprehensively pricked for transfer. But this laborious task must have been undertaken so that the design could be transferred to smaller and more manageable cartoons which were applied to the wall and which, no doubt, were destroyed in the act of transference.

The Naples cartoon, in other words, is a fragment of a master cartoon that had the same function as Raphael's more completely preserved cartoon for the *School of Athens*, now in Milan.[11] And this fact must lead us to speculate afresh about other cartoons by Michelangelo that are now lost. The Naples cartoon, containing three figures (with part of a fourth), cannot be very different from those fragments of the *Cascina* cartoon that escaped early destruction and are described in later inventories (see above p. 19). As we have seen, one of these comprised two figures that were over life-size, and this, also, was probably too large to have been used directly on the plaster. The character of the Pauline Chapel cartoon may, therefore, reflect that of the earlier work and indicate a longstanding practice of the artist's. The obvious *pentimento* in the Naples fragment, which may strike us as note-worthy in so late a stage in the design process, may also have been a feature of the pieces of the *Cascina* cartoon. It was, indeed, long ago suggested that

[11] Oberhuber and Vitali, 1972, pp. 8 ff.

discrepancies that we find between one engraving and another after *Cascina* figures could have been a consequence of *pentimenti* in the earlier cartoon.[12]

Current restoration in the Sistine Chapel is likely to provide more information about how Michelangelo employed cartoons for fresco painting. At the time of writing, it is clear that he used the technique of *spolvero* extensively in those parts of the ceiling that have been examined, but would sometimes also employ the sharp point of a stylus to go over the *spolvero* lines marked out by the dust brushed through the perforated cartoon. It may prove to be the case that, in later areas of the ceiling, he transferred his designs to the plaster by incising lines through the cartoon, in order to save time. It seems to be the case that this occurred with parts, although not all, of the *Creation of Adam*. The head of Adam, for example, seems to have been transferred from cartoon to *intonaco* in this way (pl. 154). This stylus passage in the plaster can be legitimately counted as one of the most astonishing of all Michelangelo's drawings.

The other large surviving cartoon, now in the British Museum, was, as we have seen, drawn to help Condivi paint an altarpiece. Exceptionally enigmatic in subject, it was, in all probability, drawn soon after 1550, some four or five years after the other.[13] Although a little less tall than the Naples one, it is broader, and the sheets of paper that compose it are much more regular in shape and size. It is listed among Michelangelo's workshop effects at his death, together with another late cartoon of *Christ taking Leave of His Mother*. This one, now lost, was acquired by Cavalieri and it, too, was probably for a panel altarpiece.

The London cartoon was drawn much more rapidly than the Naples one, and it contains many more *pentimenti*. The one relating to the head of the Virgin is radical. She was first drawn further to the right, looking to the left in profile. Then Michelangelo redrew the head to the left, preserving the original profile head but transforming the face into one seen in three-quarter view (pl. 167). The rest of the cartoon shows other indications of improvisation and speed. The degree of finish given to each figure is, in principle, governed by its distance from the front plane; the furthermost heads are little more than sketches. The approach, in other words, is similar to that in some of the early drawings and in the treatment of painted figure groups of the Sistine ceiling. But none of the figures has received the finish of those in the Pauline Chapel cartoon. Their more marked insubstantiality and the repetition of contours by the artist recall the figures in the series of Crucifixion drawings made at about the same time (pl. 107).

[12] See the point made by Wilde and recorded in Panofsky, 1927, p. 31.

[13] For its subject, see now the suggestion in Gombrich, 1986, pp. 175 ff. Gombrich's proposal to date the work later in the 1550s, thereby associating the project with San Giovanni de' Fiorentini, overlooks the fact that Condivi had by then left Rome to resettle in the Marche; see Settimo, 1975, pp. 39 ff.

These features must have created problems for Condivi, whose altarpiece, now in the Casa Buonarroti, has been well characterized as appallingly incompetent. There are no signs of pounced lines or stylus incisions on Michelangelo's cartoon, and we can only speculate as to how this ill-prepared associate transferred the design to panel. Despite his making of a drawing over seven feet high, Michelangelo did not change a lifetime's practice in his attempt to help Condivi; even this cartoon, made to assist someone without talent, was not squared to help with its conversion into paint.

VIII

DEMONSTRATIONS FOR THE PATRON

THE HISTORY OF THE finished drawing, made for inspection by the patron prior to the commencement of work, still remains to be written. It is, I believe, useful to retain the description *modello* for this kind of demonstration drawing, done expressly for patronal approval, criticism, or rejection. The word has the sanction of no less an authority than Alberti, who employs it in his *Della Pittura* for drawings made on paper to work out narrative compositions.[1] Its use avoids the confusion that may spring from adopting the term 'contract drawing' to categorize all drawings of this class.

That this latter term may mislead if used as a general description becomes apparent if we consider one of the largest of the few surviving *modelli* by Michelangelo, Casa Buonarroti 45A (pl. 169), a drawing much admired in the nineteenth century that later fell into critical neglect. It would be inaccurate to call this huge project a contract drawing. It is a design for the façade of the church of San Lorenzo made by Michelangelo at an early stage in his involvement with the project, drawn in all probability in the autumn of 1516, and its architectural language is still conservative. It cannot have had any contractual context, for the contract for Michelangelo to carry out the façade was not drawn up until January 1518 and was based on a completely transformed design. We shall see below that Michelangelo also made a different kind of *modello* in an architectural context, for specific features of his buildings such as doors and windows, relatively small-scale drawings, carried out, however, to a degree of finish that would convey the information required by his patron (pls 176–7). These, too, had no specifically contractual context.

Some *modelli* were, of course, made either in response to the preparation of a formal contract or as a basis for a subsequent contract. Although the

[1] Alberti, *De Pictura*, ed. Grayson, 1972, pp. 102–3: 'When we are about to paint a 'historia', we will always ponder at some length on the order and the means by which the composition might best be done. We will work out the whole 'historia' and each of its parts by making sketch models on paper, and take advice on it with all our friends.' ('Modulosque in chartis conicientes, tum totam historiam, tum singulas eiusdem historiae partes commentabimur, amicosque omnes in ea re consulemus.')

contract for the first scheme of 1505 is lost, we are well provided with formal agreements for the successive later projects for Pope Julius II's tomb. The 1513 contract, drawn up just after the pope had died, refers to a drawing or model by the sculptor ('secundum unum designum modellum seu figuram...').[2]

Some material survives to give us an idea of what this kind of drawing looked like, and this will be discussed in greater detail below. If, however, we turn from large-scale architectural or sculptural projects to *modelli* prepared for works in painting, we have little information to help us. It is a curious fact that we do not have a contractual text for any work in painting commissioned from Michelangelo. Nor do we have a true *modello*-type drawing for any of the pictorial projects, although we still have a faithful copy of a *modello* that Michelangelo gave to his friend Sebastiano for a mural altarpiece (pl. 83). With regard to the Sistine Chapel ceiling programme, the situation is obscure. It is not easy to believe that, in the context of so great an undertaking, Pope Julius II could have been satisfied with drawings as cursory as those now in the British Museum or at Detroit (*Corpus* 119 recto and 120 recto), and it seems plausible to assume that Michelangelo did prepare a *modello* for the initial programme, the one that was discarded. There may not have been a detailed finished drawing for the scheme subsequently planned and painted; indeed, everything indicates a contrary conclusion, that the artist designed the later part of his pictorial programme only after he had completed the earlier (see further comments on pp. 35ff.). Perhaps it was just such an independence from a *modello* in the creation of the final scheme that Michelangelo had in mind when he remarked that, after the first plan had been abandoned, the pope gave him a free hand to do as he wished ('che io facessi nella volta quello che io volevo...').[3]

The history of Michelangelo's earlier mural project, the *Battle of Cascina*, is also obscure. But in the case of Michelangelo's third great mural project, the *Last Judgment*, we do have good evidence that a *modello* was made for the patron of the work, Pope Clement VII, who died in September 1534 before painting had begun. This is stated explicitly in Condivi's life of the artist, when he describes the visit of Clement's successor, Paul III, to Michelangelo's studio. One of the works he saw there was 'the cartoon made under Clement for the wall of the chapel of Sixtus' ('il cartone fatto sotto Clemente per la facciata della Capella di Sisto...').[4] All this long preceded Condivi's own presence in Rome, and the information certainly came from the artist himself. Condivi is here using the word 'cartone' not in the sense of a full-scale cartoon to be applied to the wall, but in the more general sense of a large drawing. No further reference to this *modello* exists, and it may have

[2] Milanesi, 1875, p.635.
[3] *Carteggio*, III, p. 11.
[4] Condivi, 1756, p. 39.

been a victim of one of the artist's bonfires of 1564. There can be little doubt that it was drawn in black chalk; unfortunately, Condivi does not tell us its scale.

Michelangelo's *modelli* cannot have adhered to any prescribed and consistent size. The copy of the lost *modello* made in 1516 for Sebastiano's *Christ at the Column* (pl. 83) probably reproduces the scale of the original; it is a modest sheet measuring just under twenty centimetres square, and, in fact, the original drawing was described by Vasari as the 'little drawing', the 'piccolo disegno'.[5]

By contrast, the Casa Buonarroti *modello* for the San Lorenzo façade (pl. 169), referred to above, is, if we exclude cartoons, the largest extant drawing by Michelangelo, measuring over seventy by eighty-seven centimetres. It did not, however, begin on this scale, but grew as the artist worked on it. It is composed of at least four and probably six different sheets of paper glued together. The initial sheet contained the central four-columned bay up to the façade entablature. Then Michelangelo added pieces on either side to accommodate the two flanking lower-storey bays. After this, he added the top piece (or pieces) for the addition of the attic and pedimented central bay. Much of the drawing displays great care. Main verticals and horizontals are ruled, and beneath the pen and bistre there is underdrawing in black chalk. The top strip of the sheet has been drawn in a much more summary manner, although even here there is chalk under-drawing. But the bistre (a darker tone than that employed for the initial sheet) was put on with a brush; even the balletic figures poised on the attic are laid in with a brush, not with a pen.

The whole construction of this exceptional design was, therefore, additive, and there are other features of the scheme that could be interpreted as work in progress; there is, for example, no indication of how the façade would accommodate windows. Nevertheless, its whole character, above all its scale, suggests that is was made to demonstrate the artist's intentions to his patrons; such a purpose explains the delineation of sample statues and reliefs (pls 85–7), details not necessary if the drawing were made for the woodworker to carry out the wooden model. We do not know whether this large design was examined by Pope Leo X and Cardinal Giulio, but it is probably correct to suggest that it was dissatisfaction on the part of the artist rather than of his patrons that led to its rapid supersession by more radical solutions.

Surviving drawings that come closest in appearance to Casa Buonarroti 45A are those relating to the design of the tomb of Pope Julius II. Like the church façade drawing, they are elevational designs for an elaborate balance of architecture and statues. There are, I believe, three with good claim to be regarded as autograph. One of them, now in Berlin, is completely ruined, but that it is the ghost of Michelangelo's own design is suggested by

[5] Vasari, ed. Milanesi, v, p. 568–9.

drawings on the much better preserved verso, pen studies from the model for the *Rebellious Slave*, now in the Louvre, planned for the 1513 tomb project. What Michelangelo's recto drawing originally looked like can be appreciated from a faithfully traced copy, also in Berlin (pl. 171), made by an artist who had access to other drawings of Michelangelo's around 1550.

A second drawing, closely related to the Berlin drawing (although differing in details), is in the Uffizi (pls 172 and 175). Clearly, this is the lower half of a sheet similar to that in Berlin, and this Uffizi drawing also has autograph studies by Michelangelo on its verso, red-chalk studies for the right arm and hand of the other marble Slave begun for the 1513 project, the so-called *Dying Slave*.

The third drawing is more problematic. Acquired recently by the Metropolitan Museum as a school piece, it remained neglected until published by the present writer. This, too, is, I believe, an autograph *modello* by Michelangelo (pls 173–4).[6]

The condition of the Berlin elevation does not permit any comment on how it was made. But both the Uffizi drawing (itself a fragment) and the New York drawing are in good condition. Each of them was first drawn in black chalk before the draughtsman picked up his pen. In the Florence sheet, all the main horizontals of the entablature were drawn with a ruler; the guiding lines extend beyond the profiles. The figures were also drawn in black chalk. In the New York drawing, this black-chalk under-drawing is more elaborate. Details of the building lines for the construction of horizontals and the arcs of the niches are very clear, readable in a good photograph. The sheet displays more changes of mind than the Uffizi one; for example, the semicircles of the niches were lowered by the artist, after his initial idea had placed them on a higher level. A certain timidity in the drawing in New York, and the late-quattrocentesque character of the architectural forms, has led me to conclude that it may have been a design for the earliest tomb project, of 1505, rather than for that of 1513, the project to which the Berlin and Uffizi drawings belong. What concerns us more here, however, is the similarity of technique in these drawings, a technique actuated by the purpose of each sheet and one that was not subjected to great change over the passage of years.

Drawings such as Casa Buonarroti 45A and the Uffizi and New York drawings for Pope Julius's tomb have been neglected partly because of the unfamiliarity of their appearance. Few designs of this kind by Michelangelo have come down to us and comparable later examples do not exist. This does not mean they were not made; in the contract for the 1532 project for the papal tomb, the artist is once again bound to provide a model or drawing ('nuovo modello over disegno...').[7] There is, however, another cause of

[6] Hirst, 1976, pp. 375 ff.
[7] Milanesi, 1875, pp. 705–6.

their neglect; their pedantic appearance went against late-nineteenth-century conceptions of artistic spontaneity. A similar prejudice in favour of the rapid sketch contributed to the rejection of the minutely worked presentation drawings (see pp. 105 ff.). Berenson himself dismissed the Uffizi tomb drawing as 'beneath consideration'. The inability to appreciate these drawings sprang from a failure to consider what kind of drawing they are and in what tradition of drawing they may be placed. The Casa Buonarroti *modello* for the San Lorenzo façade, unique though it may be in Michelangelo's surviving work, can be seen to take its place in a tradition of draughtsmanship going back as far as the elevational *modelli*, made on vellum, of the late trecento. Close in date are the very large drawn *modelli* for the same project of the San Lorenzo façade made shortly before he died by Michelangelo's own friend, Giuliano da Sangallo (pl. 170), or those prepared only a few years later by Peruzzi for the façade of San Petronio in Bologna.[8]

<p style="text-align:center">* * *</p>

There is a more modestly scaled class of drawing that should also, I think, be included in this discussion of *modelli* for the patron. Drawings of this type were made by Michelangelo as demonstration pieces for specific architectural features, for details of a greater whole; they served as a kind of auxiliary *modello*. Many of those that survive date from the decade of the 1520s, when the artist was involved with the two San Lorenzo projects of the New Sacristy and the Library. He may have made such drawings earlier; it may, however, have been the circumstance that artist was in one city and patron in another that led to their making in relatively large numbers in this period. Cardinal Giulio de' Medici, elected pope as Clement VII in November 1523, was an exceptionally involved patron (as we have seen, it was for the same man that Michelangelo made his *Last Judgment modello* just before the pope's death in 1534). Taking an almost obsessive interest in every detail of his projects, the letters show that, whilst repeatedly expressing his complete faith in Michelangelo, he nevertheless continually solicited drawings for his inspection in Rome.

A considerable number of these drawings survive. One of them, Casa Buonarroti 98A (pl. 176) is the design for the outer side of the door at the head of the celebrated staircase that takes the visitor from the San Lorenzo Library vestibule into the reading room. There can be little doubt that this is the very drawing the arrival of which at the papal court is acknowledged in a letter to Michelangelo of 18 April 1526. The tablet over the door has been left blank in the drawing, and this letter relates how Pope Clement has asked Paolo Giovio for a suitable inscription of from a hundred to a hundred and

[8] Giuliano's San Lorenzo design reproduced here, Uffizi 277A, measures 40 by 48 cm. Another, Uffizi 281A, measures 69 by 90 cm. One of Peruzzi's San Petronio drawings is over 90 cm. high.

forty letters for it.[9] The drawing has been meticulously made, with ruled pen lines and a very careful application of wash. The base line of the pavement has been put in. A similar drawing for the internal, reading-room frame of the same doorway also exists, Casa Buonarroti 111A (pl. 177). This elevation is drawn a little more freely in pen and wash over a black-chalk underdrawing. At the foot of the sheet, Michelangelo has drawn in a single *braccio* unit to help Pope Clement to appreciate the scale. The other study for the outer frame probably carried a similar calibration, now lost, for unlike the study for the inner frame of the reading room, this sheet has been cut substantially.

Another demonstration drawing, technically comparable with those for the door tabernacles, survives for the coffering of the interior of the cupola of the New Sacristy at San Lorenzo (col. pl. 3). I believe that it can be identified with another drawing referred to in the correspondence. Pope Clement had asked for a drawing of the projected coffering in January 1524, and the arrival of the requested drawing was acknowledged on 9 February.[10] This sheet, Casa Buonarroti 127A, is likely to be the drawing in question. The complaint was made in Rome that there was no indication of the scale of the largest coffered rectangles that Michelangelo was planning. There is no indication of scale on this drawing; perhaps some suggestion did once exist, for this sheet, too, has been cut on all sides. But another complaint to the artist, that the drawing sent to Rome did not explain how many coffered rectangles were planned for each radial axis, seems to confirm that we have here the very drawing discussed, for this particular sheet could never have answered this query.

Whatever its shortcomings in the eyes of the patron, the sheet is a very beautiful example of Michelangelo's *modello* style. It was first drawn throughout with black chalk, the main converging verticals drawn with a ruler. Michelangelo then picked up not a pen but a brush and with great delicacy accented specific forms with wash, working up sufficient detail of bead-and-roll mouldings, rosettes, and other features, to show Pope Clement what he had in mind. He added also the 'sample' two-figure *storia* in the central *quadro*. His concern to bring out projection and recession, light and shadow, can be matched in other *modelli*, but there are few that can rival this one in its economy and delicacy.

That drawings today in the Casa Buonarroti can be identified with drawings referred to in the letters implies that they were returned to the artist. We know that this did happen.[11] We can note a further feature of the three drawings just discussed. None has been laid down on a backing, and we can, therefore, see that the verso was left blank and unworked by

[9] *Carteggio*, III, p. 220. Michelangelo seems to have indicated how many letters he wanted in his own accompanying letter.
[10] *Carteggio*, III, p. 35.

[11] For example, Michelangelo's drawing for both internal and external windows of the reading room were returned to him with the pope's approval; *Carteggio*, III, p. 141–2.

the artist, a rare feature with Michelangelo's drawings and one that adds further support to the view that we are here concerned with special *modelli* dispatched to the distant patron. Other designs for doorways, comparable to those looked at here, present us with similar blank versos (these include Casa Buonarroti 65A and 95A, *Corpus* 548 and 549). In another case, Michelangelo began a comparable *modello* drawing which he then abandoned; here, he did turn the sheet over and use the verso.[12]

We may conclude this brief survey of these elevational *modelli* of the 1520s with another, for a never-executed papal tomb (pl. 179). The appearance of this fine design must have been like that of the *modello* for the Chapel coffering, but it has faded very badly. It was drawn in the same way, the design first laid out in black chalk and then touched in certain areas with bistre wash. This drawing's survival is important, for it shows that Michelangelo made these small demonstration drawings not only for architectural 'wholes' and architectural details but for his tomb projects as well.

<center>* * *</center>

Modelli were not confined to elevational drawings; they included also groundplans. To illustrate these, I have chosen an example from this same period of Michelangelo's activity at San Lorenzo, and two others from a series made late in his life.

The example from the 1520s is a plan for the rare-book room that Pope Clement wished to add to the Library at San Lorenzo (pl. 180). A number of drawings for this addition ('certi disegni della pichola libreria') had arrived in Rome by 10 November 1525, and this one, Casa Buonarroti 80A, was, there is good reason to believe, one of them. Involving a highly inventive triangular plan, the drawing is the fruit of a number of earlier, exploratory sketches, one of which (Casa Buonarroti 79A) also survives. It shows us very clearly how anxious Michelangelo was to make everything clear to his exigent patron. He has written in the identification of a neighbouring property, has indicated his idea to have three overhead skylights ('lume di sopra') and, once again, has put in a one *braccio* scale. Yet the plan, unprecedented in the novelty of its form, the response to the exigencies of the site, is drawn in a traditional way: the main lines are ruled and then blocks of bistre wash were put in to denote the solid forms. We find the same basic approach to groundplan construction in sheets dated thirty-five years later.

In the autumn of 1559, at the age of eighty-four, Michelangelo was asked to submit designs for a national church of the Florentines in Rome, San Giovanni de' Fiorentini. Vasari tells us that he prepared in all five groundplans to be submitted to the Florentines in charge of the project. Three plans

[12] *Corpus* 551 recto and verso.

relating to the commission survive in Florence, Casa Buonarroti nos 120A, 121A, and 124A. Casa Buonarroti 121A (pl. 181) is the most tentative. The lack of homogeneity in the plan (the columns of the hemicycle, for example, are not distributed equally) and the seemingly provisional nature of the drawing when compared with its companions are features that have been adduced as militating against its function as a demonstration *modello*. But these objections seem mistaken. The whole plan was carefully prepared with a black-chalk underdrawing which involved the use of ruler and compass, and only in the upper, chancel end of the plan did the artist stray from his chalk drawing, expanding the two corner areas of the rectangular block and adding the chancel and oval sacristies (all drawn in a lighter ink). As with the sheet for the rare-book library at San Lorenzo of over thirty year's earlier, the verso of Casa Buonarroti 121A is unused. And the use of white body colour to erase the two intruding piers at the upper end of the drawing also suggests that the design was one not to be discarded as work in progress but to be conserved and presented to the commissioners.

Pentimenti appear also in Casa Buonarroti 120A (not reproduced here) and are even more obtrusive in Casa Buonarroti 124A (pl. 182). Here, heavy white body colour was used to blot out features about which the artist changed his mind, in particular the placing of piers without, and the arrangement of altars within the four corner chapels (see the detail, pl. 183). The blackish appearance of these areas, so different from the limpid bistre pools of Michelangelo's plans of the 1520s, is a consequence of his having drawn over the still damp biacca with more chalk, pen, and brush. (The pale tones of the central altar and three steps remain to show how the whole plan began on top of the preliminary black chalk.)

This drawing was made on a substantially larger scale than the two companion plans, and, contrary to his usual practice when making a *modello* of this kind, Michelangelo used part of a very large sheet, the verso of which he had already employed for a different purpose (see *Corpus* 612 verso). He carried it out in a much more complex way; for it has gone unnoticed that the whole plan was constructed over an elaborate series of circles drawn with compass and stylus, made before any of the preliminary chalk drawing was carried out. There are two concentric circles around the central altar, and no less than six to guide the designing of the inner ring of paired columns and the responding outer walls, all made with the compass point in the centre of the three-stepped altar area (some of these outer circles may be visible in the detail of the upper-right chapel, pl. 183). Michelangelo followed a similar procedure for the four large radial chapels which are drawn over smaller circles, in some cases three, in others four (see the detail reproduced in pl. 183). Here also, the compass points are easily read in the original. In this plan, the most majestic from the artist's hand we now have, we can observe Michelangelo constructing in a way that we associate with Borromini.

The master's final intentions for the planning of altars in Casa Buonarroti

124A, the design the commissioners selected, is clearly readable only in Calcagni's amended fair copy which survives in the Uffizi. The artist, in his own letter of 1 November 1559 (which provides a *terminus ante quem* for the drawings we are considering), had informed Duke Cosimo that Calcagni would perform this function ('*el quale si farà ritrare e disegniare più nectamente ch'io non ò potuto per la vechiezza . . .*').[13] The letters exchanged between Rome and Florence are not entirely clear as to whether it was Michelangelo's own drawing or Calcagni's that was dispatched to the Duke for his endorsement. Perhaps both were sent to Florence.

It is tempting to read the group of three surviving San Giovanni groundplans as a sequential development, from Casa Buonarroti 121A, through 120A, to the accepted solution of Casa Buonarroti 124A, which is physically the largest and, as we have seen, technically the most complex. But, whilst we have Michelangelo's own word for it that he regarded Casa Buonarroti 124A, the choice of the commissioners, as the most fitting ('el più honorevole'), there can be little doubt that for him the designs were true variants. Casa Buonarroti 121 A (pl. 181) is a radically different project from the other two in that the central element is not, as often stated, an altar, but a font crowned by a *baldacchino*—hence the appropriate dependence of the plan of that of the old Lateran baptistery. What may also have weighed with the commissioners in choosing Casa Buonarroti 124A was the plan's provision for a multiplicity of altars. The sale of patronal rights to these altars would have constituted an important source for the funding of the project.

It was long ago observed, in the context of Michelangelo's San Giovanni groundplans, how few of his architectural drawings bear detailed measurements. The *modelli* just considered amply confirm the truth of this comment. None of the San Giovanni drawings (or others that are comparable in type and technique, like Casa Buonarroti 123A, *Corpus* 608) has any indications of scale at all. We might compare this with the practice of two architects who had preceded Michelangelo in preparing drawings for San Giovanni, Baldassare Peruzzi and Antonio da Sangallo the Younger, many of whose plans are scored with detailed measurements. Even in an elevational sheet like that for the San Lorenzo Library doorway (pl. 177), on which an indication of scale has been added for the patron's benefit, we find it exiled, as it were, to the foot of the sheet, not placed on the drawing proper. Michelangelo seems to have confined his writing in of detailed measurements to working drawings only, made to show workmen and assistants precisely what was required, be they for a column base or to indicate the exact scale of marble blocks to be excavated at the quarries (pl. 164). And, as we shall see, when he copied the copies of antique architecture of another

[13] Calcagni, Michelangelo writes, 'will copy and draw more cleanly than I can because of my old age'; *Carteggio*, v, p. 183.

draughtsman, he eliminated all the painstaking recording of measurements of his graphic prototypes (pls 186–9). For Michelangelo, it seems to have been an expectation that the patron as well as the artist should carry the compass in his eyes, 'le seste negli occhi.'

<p style="text-align:center">* * *</p>

Michelangelo's San Giovanni groundplans are not the latest drawings that have a claim to be included in this discussion of *modelli*: less than two years after his involvement with the church project, he was approached by the recently elected Pope Pius IV to design a city gate, the Porta Pia, the name still serving to immortalize its patron. At work on the project in the late summer of 1561, the artist became deeply involved with it. A considerable number of drawings have survived, ranging from small-scale invention sketches (pl. 205) (all now drawn in black chalk) to monumental elevational designs drawn on very large sheets. There are three of these in the Casa Buonarroti, nos 73A bis (pl. 184, *Corpus* 615), 102A, and 106A recto (col. pl. 9 and pl. 185).

Vasari tells us that Michelangelo made three designs from which the pope could make his final choice; all three were, in his view 'extravagant and beautiful' ('tre, tutti stravaganti e bellissimi').[14] Like the five plans for San Giovanni, these also must have been true variants. And, just as economic considerations may have influenced the choice of the Florentine building commissioners, so here too finance evidently played a part, for Vasari adds that Pope Pius chose the least expensive ('quello di minore spesa').

The three large Casa Buonarroti sheets were undoubtedly connected with the preparation of the demonstration drawings presented to the pope but for a number of reasons it is unlikely that any of them were the actual sheets themselves; none of the three corresponds with the building as we see it. However, there are grounds for suspecting that two of them, Casa Buonarroti 73A bis (pl. 184) and 102A, were begun as *modelli* for the patron, only to be put on one side by the artist before he had carried them to completion. In support of this, one may cite the very large scale of the drawings— even 73A bis, the smallest, is nearly forty centimetres high—the way the designs are laid out on the sheet (compare, for example, pl. 177 of just under forty years' earlier) and, in the case of these two sheets the unworked versos.

Casa Buonarroti 73A bis (pl. 184) is of exceptional value in allowing us to examine how Michelangelo began the process of constructing an elaborate architectural project at this late moment in his life. The ruled black-chalk construction lines denote the chief horizontals and verticals, but they were preceded by the lighter line ruled down the very centre of the sheet (now cut a little on the left). A number of the main lines of the architectural forms

[14] Vasari, ed. Milanesi, VII, p. 260.

were also ruled. Because the study has been put aside at an early stage, we can see that the design began with an arched segmental pediment; this, and other initial motives were put in with the lightest touches of the chalk, as was the lower profile of the arch itself, which was subsequently raised. Changes such as these are (quite apart from other considerations) enough to show that the repeated suggestions in the literature that the drawing is mainly the work of an assistant are groundless; we can observe the artist feeling his way. None of the chalk lines is heavily accented; plastic substance is created entirely by the addition of the bistre wash, and there is no use of pen and ink on either this or the other two related Casa Buonarroti studies. The overall effect of 73A bis is one of great delicacy; the technique recalls that of the drawing for the New Sacristy coffering (col. pl. 3), although the handling of the wash (see, for example, the vertical shadow cast by the left-hand column) reveals unmistakeably the unsteadiness of the old artist's hand.

Casa Buonarroti 106A recto (col. pl. 9 and pl. 185) is, by contrast, densely worked; it is the most elaborated architectural drawing by Michelangelo that exists. This does not mean that it is necessarily the latest of the three Casa Buonarroti sheets; on the contrary, Casa Buonarroti 102A (not reproduced here) is closer to the solution chosen for the Porta Pia. Casa Buonarroti 106A recto, despite the unique *matière*, is also the sheet that least appears to have begun as a *modello* to be presented. The architectural forms are drawn over figure studies, and the sheet itself is made up of five pieces of paper glued together. Its verso has also been used extensively, and some of these verso drawings preceded the Porta drawing on the recto.

Despite these *ad hoc* features, it is one of the most extraordinary documents in the history of architectural design. It is, also, the most eloquent evidence of all of Michelangelo's reluctance in old age (exemplified, as we have seen, in the San Giovanni groundplans) to discard an ambitious drawing once begun. Unfortunately, we know much less about the procedures behind the designing of the Porta Pia, and there is no evidence as to whether Calcagni was once again expected to make fair copies of Michelangelo's designs. The appearance of Casa Buonarroti 106A recto would surely have proved an insuperable obstacle to such a procedure. The drawing began with the same initial guiding lines so clearly readable in 73A bis, but the artist added layer upon layer, covering (or partially covering) the rejected solution with white-lead body colour. We can observe this very clearly with the actual Porta opening, which the artist decided to widen: he deleted the horizontal lintel with its keystone and substituted the drafted arch with its rusticated voussoirs in the jambs. At the top of the Porta, there are three different pediment solutions: the first, in black chalk, was of relatively traditional volutes with scroll ends; this was superseded by a broken triangular pediment, again in chalk; the third, which dominates the entire design, consisting of broken segments supported on shell-like volute forms, was laid in on top with very broad brush-strokes of bistre wash. The overall effect of

the drawing is close to that of a grisaille painting, and the technique of the Porta Pia drawing has, indeed, been called 'impressionistic' and likened to Titian's contemporary style. The consistent use of a brush to the exclusion of a pen points, it is true, to Michelangelo's search for broad effects of light and shade. But it was not Michelangelo's intention to produce 'blurs of light and shadow'; the appearance of the sheet is a consequence of successive *pentimenti*, carried out by an artist too old to discard work begun. For a parallel, we may recall the artist's near destructive changes to his last *Pietà*.

IX

COPYING, INVENTING, AND
IMPLEMENTING THE DESIGN:
BUILDINGS

DESPITE THE EXCEPTIONAL NUMBER of studies devoted to Michelangelo's architecture, we still need a detailed analysis of his working practice. Once made, this would allow us to compare his design procedures with those of his immediate predecessors and his contemporaries. Enough drawings have survived to permit the attempt. But such a study is beyond the scope of this book and the competence of its author. The aim of the following pages is much more modest: to give a brief survey of the kinds of drawings that Michelangelo made in response to his building assignments.

The surviving architectural drawings are, like those for painting and sculpture, remarkably varied. Their range has, indeed, been extended recently by the discovery of very large autograph drawings on the walls of the choir of the New Sacristy at San Lorenzo (pl. 212). We cannot, it is true, follow the design procedure for any one project from beginning to end. But the material allows us, notwithstanding, to catch a glimpse of almost every stage in Michelangelo's preparatory processes, from his free-hand site plan sketches (pls 190–91) to the templates he drew and cut out for the masons to follow in executing specific architectural members (pl. 215).

Michelangelo's career as an architect effectively began when he was given the commission to build the façade of the church of San Lorenzo in Florence by Pope Leo X and Cardinal Giulio de' Medici. But this did not signal the beginning of his concern with architectural forms; the painted framework of the Sistine ceiling is enough to show that this was not the case. It is an accident of survival that has robbed us of architectural studies relating to the ceiling more significant than the drawings of details on sheets celebrated for their figure studies (pl. 35).

Although we cannot reconstruct Michelangelo's definitive design of 1505 for the tomb of Pope Julius II, it is clear from Condivi's description that this free-standing project must have called for architectural designing skills. If, as I now believe, the careful *modello* in New York is a design of 1505 made for a more modest wall tomb for the pope, we may conclude that in architectural terms, especially in the form of his profiles, Michelangelo at this date followed readily accessible, late-quattrocento Florentine prototypes

(pls 173–4). Yet, even in the timid lowest order of this project, he introduced a volute bracket beneath the column and pilaster bases, a remarkable anticipation of his incomparably bolder use of the same motive in the vestibule of the San Lorenzo Library.

That Michelangelo was already regarded as a practising architect by 1507 is shown by a recently discovered letter from the Florence Cathedral *operai*, inviting him to submit a model or drawing ('un modello o disegnio') for a conspicuous feature of the building still lacking, the gallery (*ballatoio*) for the area at the top of the drum beneath the cupola. At that time, Michelangelo was in Bologna, at work on a monumental bronze sculpture of Pope Julius II. He would be involved with the same project again ten years later. Of this involvement of 1507, nothing more is known, although two cautious red-chalk drawings, of which the context has always been puzzling, may be sketches done at this time for the *ballatoio*.[1]

Despite these concerns with architectural design, and despite the fact that Michelangelo seems to have carried out a modest architectural assignment for Leo X in Rome before his involvement with the San Lorenzo façade, the pope's decision to entrust the Florentine project to him may have struck contemporaries as a very bold one. It was, however, the firm intention of the patrons that Michelangelo should undertake it in association with an experienced architect and they were compelled to abandon their aim only because of Michelangelo's subsequent behaviour towards his collaborator, the ill-treated Baccio d'Agnolo.

How did Michelangelo seek to confront the problems that the façade project brought him? He seems to have set out to supplement his knowledge of architectural forms by a self-prescribed course of study, and his first substantial group of architectural drawings belongs to this self-educative course.

These drawings (pls 187 and 189) deserve a word of explanation. They were made on sheets now divided between the Casa Buonarroti and the British Museum, five in Florence and one, now cut into two halves, in London. They are all in red chalk and were drawn on sheets of the same size, measuring about forty-five by thirty-one and a half centimetres. Before using the sheets, Michelangelo, taking them lengthwise, folded them vertically down the centre (the fold in the Casa Buonarroti sheet here reproduced is clear in plate 189). These folds are not the result of the sheets having been bound in a sketchbook as we might suppose, for there is no trace of stitching holes.

Michelangelo seems to have chosen to fold the sheets, giving himself pages of half their scale, in order to emulate his prototype. For these drawings, are, with few exceptions, copies of another draughtsman's renderings

[1] For the letter, Marchini, 1977, p. 47, and Ristori, 1983, pp. 167 ff. The drawings are on Uffizi 1872F recto, *Corpus* 317 recto.

of Roman buildings, and the latter really were part of the contents of a sketchbook. Known as the Codex Coner from the name of a later owner, the book, amplified with later additions, still survives (pls 186 and 188). The puzzle as to who the draughtsman was has recently been solved; he was a Florentine, something of a specialist in drawings after the antique, a member of the Sangallo family's Roman circle and probably known to Michelangelo personally. His elaborate drawings, mostly of antique buildings, wholes and details, were almost certainly made to serve as exemplars, for the practice of copying from such books was widespread in the period.[2]

In all probability, Michelangelo made his drawings when his involvement with the façade project was certain, shortly before he left Rome for Florence in the summer of 1516. They constitute no less an autodidactic exercise than the drawings he had made many years earlier after Giotto and Masaccio. Yet no more than the earlier drawings, are these faithful redactions of the prototypes. It was, indeed, the evidence of tangible, and seemingly arbitrary, changes that led to doubts about his authorship of the copies.

Whereas most of the drawings in the Codex Coner were carefully made, using compass and ruler as required, Michelangelo's are, with two exceptions, drawn free-hand. For the pen and bistre of the prototypes he substituted red chalk. He ignored the written inscriptions, made to identify the buildings, and he omitted all the carefully recorded measurements on the Codex drawings. He did not respect the sequence of his prototypes (compare pls 189–9) and frequently changed the proportions of details. Most of the drawings evidently held little interest for him. He did not copy a single groundplan and drew only two elevations, neither of which he completed (see pl. 189). The series shows, in fact, a preoccupation with specific architectural forms rather than with whole buildings, just as, years earlier, he had selected single figures, or groups of figures, from Giotto's and Masaccio's frescos rather than a whole scene. Michelangelo's treatment of the sheets he copied emphasizes, in other words, his complete disregard for antiquarian studies at a moment when these were being pursued with unprecedented energy and sophistication in Rome.

Some of these features can be illustrated by two examples. The half sheet in the British Museum is a copy of a similar folio in the Codex Coner (pls 186–7), which, as the inscription shows, is a study of the Doric order and entablature of the Theatre of Marcellus. Droplines and measurements have been excluded. Michelangelo draws in only one triplyph, for that is all he needs, and confines his recording of the dentils to a minimum. Where a form interests him, he adds a detail missing in the original; here he introduces a mutule in the upper-right corner. Every line is drawn free-hand in his copy, and his adoption of chalk has allowed a far richer and livelier contrast of light

[2] For these copies, see Wilde, 1953, pp. 31 ff., Buddensieg, 1975, pp. 89 ff., and Agosti and Farinella, 1987, *passim*.

and shadow. The drawing's freedom suggests that it may have been done late in the surviving series.

The other example, a double sheet in the Casa Buonarroti, is different. The left 'page' copies a sheet in the Codex recording the elevations of door and *cella* window in the Temple of Vesta at Tivoli. Michelangelo here drew all of the door (exceptionally, using a ruler) and half of the window, which, in a similar canted form, diminishing at the top, would reappear in the windows of the lunette level of the San Lorenzo New Sacristy. On the right 'page', he took further liberties. His copy after the Codex study of the Arch of Constantine is one of two elevational drawings that he permitted himself (both, we should notice, of exterior façades). It is made completely free-hand. But in the attic, Michelangelo suddenly switched prototypes, and for the attic corner substituted the form of the Arch of Severus attic, which had been drawn on the following page of the Codex.

It is unlikely that Michelangelo ever again had recourse to copying buildings or other artist's drawings of them. And in the drawings he made for his own projects, he only rarely reverted to drawing architectural wholes or details in perspectival view, a feature so evident in the Codex Coner drawings and in his copies after them. (Still less did he adopt the kind of bird's-eye view in making sketches for projects most familiar to us from sheets by Leonardo.) Michelangelo's rejection of a perspectival convention for architectural drawing came relatively early, and its importance has been neglected. His grasp of designing an elevation in orthogonal projection is clear from Rocchetti's faithful copy of his design for the 1513 project for the tomb of Julius II (pl. 171); it can, indeed, be recognized even in the damaged original. The approach is used consistently throughout the design, with no foreshortening of architectural forms. In the New York design for the tomb, on the other hand, this is not the case (pl. 173). The uppermost moulding of the main niche (the *cappelletta*, as it is called in the documents), has been drawn in perspectival foreshortening, and the volutes beneath the columns have also been designed with a concession to 'pictorialism'. These features suggest an earlier date for the New York *modello*, which, as we have already seen (pp. 91–2), is likely on grounds of its architectural style as well.

Only rarely did Michelangelo revert to a perspectival treatment in an elevational drawing, although this could happen, as his design of the drum of St Peter's in a much later drawing clearly shows (pl. 211). And it is characteristic that, unlike many artists of the period who produced perspectival drawings for tableware, he made his own design for the Duke of Urbino's salt-cellar in an unqualified orthogonal projection, like the elevation of a building (pl. 161).

<p align="center">* * *</p>

Every architect works under constraints of one kind or another, but those with which Michelangelo had to contend were exceptional, for almost all his

building assignments comprised the completing, altering, or supplementing of the works of others. At San Lorenzo, the façade project, monumental as the undertaking was, meant the completion of someone else's church (even the internal ordering of nave and aisles determined the positioning of the doors). The New Sacristy was envisaged, at least in plan, and possibly in elevation also, as a pendant to the Old. The Library, built to house the Medici collection of books, had to be situated within the existing complex of church and monastery. Even his planning of the Roman Campidoglio was conditione by the decision to conserve a fifteenth-century palace. It seems, in fact, true to say that only with the projects of San Giovanni de' Fiorentini (destined not to be built in accordance with Michelangelo's intentions) and with the Porta Pia, was he able to work with a relatively free hand, and even in the former of these, foundations had already been laid. Constraints seem, in Michelangelo's career, to have served to kindle his artistic *fantasia*. Nevertheless, we need to remember them when we consider the character of the drawings.

It was the problem of situating a library in the monastic complex at San Lorenzo that led Michelangelo to make what is his most extensive surviving site plan (pls 190–91). Made in red chalk, it is entirely free-hand, although drawn with some care. It was done on a large sheet that was subsequently cut in two, as the illustration shows. The loss in the centre is insignificant, but that below is substantial and serious. Michelangelo clearly drew the plan not on site but back in the workshop, for his memory failed him over the precise number of bays in the main cloister. Nevertheless, it is a very clear record of the whole complex, with the church's left flank drawn in on the right. Michelangelo wrote in descriptions of individual areas, such as 'chiostro', 'chamera', and 'orto', recording the situation at first floor level.[3] He drew in two alternative sites for the projected library, inscribing both of them 'libreria'. We know that such a site plan, offering alternatives, reached Rome in January 1524. This drawing is a draft for the one that went to the pope. It remained in Florence, and Michelangelo, a short time after, used the sheet again, folding it down the centre and using the two verso leaves for detailed studies of base profiles for the Medici Chapel, turning the sheet from top to bottom whilst so doing (pls 213–14). They were drawn in preparation for the making of metal templates to guide the masons, some of which were paid for in the following March.

From this site plan, drawn in order to prepare a more finished one to be sent to the patron, we may turn to another from the latter years of the artist's life (pl. 192). Badly cut, it is the most summary of sketches, hastily drawn in black chalk to serve as a kind of starting point for thoughts about the east end of St Peter's. Michelangelo drew the basilica as a Greek cross, with four equal apsidal arms (only half of the drawing has survived), and then drew over the apse the rectangular block of the east end, adding in front a portico

[3] As observed by Caroline Elam.

carried, in all, by nine columns. To the right, he drew in adjacent buildings of the Vatican palace; staircases are briefly indicated. And in front of the portico, there is a single line with suggestions of columns which, it has been suggested, could denote the still surviving atrium of the old basilica. These adjacent structures are drawn so freely as to impede precise identification; but it was the relation between new church and existing buildings that was here exercising his mind. This is not, in other words, a project drawing for the façade (the scale of the columns is utterly unreal), but a notation of given topography, made for himself alone. Whilst letters allow a close dating of the San Lorenzo site plan, with this one we are in the dark. Specialists have dated the sonnet fragment *circa* 1550, and there can be little doubt that Michelangelo added the drawing subsequently, but where we should place it, in the 1550s or early 1560s, is speculative; it cannot be excluded that he drew it in the last years of his life.

Michelangelo must have made numerous site plans, but few have survived, for they were of negligible interest to collectors. Characteristically, the San Lorenzo site-plan sheet was cut up, with serious losses at its foot, whilst the detailed architectural studies on the verso were preserved intact. On this much later sheet, the eight lines of poetry were preserved and the drawing mutilated.

The elaborate groundplan *modelli* we have already considered were the end product of a complex gestation (pls 180–82). We may turn to two examples of how Michelangelo began the planning of his projects. The earlier of these is one of the most cursory of all Michelangelo's architectural drawings, made, as long recognized, for the façade of San Lorenzo (pl. 193). It is simply a sketch, made on a sheet that has been cut down the middle, and this, the surviving right-hand half, is now bound into a volume of the Archivio Buonarroti. The brief suggestion of columns is no more than a kind of recorded note. The projection of the façade's right-hand bay beyond the line of the basilica's right flank is a diagrammatic rendering of Michelangelo's intention to extend the bay systems of the façade by one bay around the side of Brunelleschi's church. This was a late decision in the planning of the façade, made in the spring of 1517, and the sketch may signal Michelangelo's initial jotting, the first step towards the definitive scheme. Very soon after, he drew another groundplan for the façade which, whilst less summary than the other, is still no more than a rapid, free-hand rendering (pl. 194). Here, Michelangelo was really concerned only with the problem of the corner bays with their columns; selecting the left side of the façade, he drew in the rest in a purely diagrammatic way with no attention to scale.

Another initial sketch that may go alongside that for the façade is one relating to the staircase leading from the vestibule of the San Lorenzo Library to the reading room (pl. 195). Groundplan and elevation have been rapidly sketched on very poor quality, absorbent paper (they are frequently reproduced the wrong way up; see, for example, *Corpus* 523.) The groundplan,

drawn first, is Michelangelo's earliest surviving solution for the staircase problem, about which he was subjected to requests for information from the papal court. His initial response was to design two flights of steps, abutting the side walls of the vestibule, rising to a landing before the door. Above this groundplan, he hastily added a schematic elevation, choosing, as he generally did, the west wall of the vestibule, the wall the visitor sees on entering the space. The profile of the rising staircase is indicated by a single line, the door in the wall of the vestibule facing the entrance just suggested. The artist has used the upper horizontal line of his groundplan as the base line of the elevation. Even in this minimal sketch, Michelangelo's intention to align the top of the staircases with the upper line of the side wall's lowest storey, the *basamento*, is clear.

Combinations of plan and elevation on the same sheet are not common (for a fine example, see pl. 209, discussed below.) They may appear in unfamiliar contexts. We find one on a sheet in the Casa Buonarroti, on which Michelangelo explored the forms of the thrones he had decided to include at attic level on the New Sacristy ducal tombs (pls 196–7). He drew two elevations of a throne in the upper half of the sheet. Beneath the more finished one, in the upper left, he drew a detail of the cornice and paired pilasters in elevation, and, then, below these, the throne in plan, indicating his balusters as small columns. If we had only this plan, without the explanatory elevation above it, any commentator would be hard pressed to establish its meaning. In the end, with a sovereign disregard for the original meaning of the motive, Michelangelo eliminated the backs of the thrones entirely, as plate 197 shows.

The appearance of this sheet is typical of many from the period of the 1520s. Relatively small-scale studies, now for the most part in chalk, are spread over much of the available space. A number of surviving sheets, containing 'invention' studies for the tombs in the New Sacristy, offer a similar appearance. But the very nature of the studies on this scale was an encouragement to owners and collectors to cut up the sheets, thereby multiplying the number of the drawings. The sheet with the throne studies has clearly suffered in this way. And it can be shown that this well-known group of sheets with designs for the Medici tombs has been created by cutting up one very large sheet (pls 198–200). The now divided versos can be put together again, to reconstitute an architectural drawing that will be discussed below (pl. 201, p. 103).

The sketches for the Medici tombs vary in scale but none is large; some are no bigger than the attic throne (pl. 198). For only one of them, on the left of plate 200, did Michelangelo indicate a scale; the black-chalk line put in below is a *braccio* unit. All are drawn free-hand. Other tomb studies, made several years before for a project planned for a Roman church, show Michelangelo adopting an even smaller scale for his 'invention' sketches (*Corpus* 176 verso). And that, for his earliest thoughts for architectural projects, Michel-

angelo adopted the same small-scale kind of drawing that he employed for figure motives seems clear from the surviving *primo pensiero* studies for the San Lorenzo façade elevation. One of these, in red chalk (pl. 202), measures six and a half centimetres across, drawn for an elevation of about sixty *braccia* wide (which equal thirty-five metres). These little sketches are evidence of Michelangelo's thinking anew about the façade project after he had abandoned the design of the elaborate *modello* discussed in the previous chapter (pl. 169). Another *modello* may not have been prepared for the definitive scheme, for the wooden model was itself presented to the pope in Rome. The surviving drawing that approximates most closely to this final scheme (pl. 203) is of modest size, drawn free-hand without any strict concern for the scale of individual features.

The artist's persistence in old age in making these little invention drawings for architectural projects matches that in producing them for figure studies; this, despite the deterioration in his eyesight which has been referred to above (see p. 8). On the sheet containing a figure study connected with a painting by Daniele da Volterra discussed above (p. 38), we find also small-scale sketches for a tomb elevation (pl. 60). If we turn the sheet the other way up, we can note the study for a double-ramped staircase, again on a small and exploratory scale. This was an initial idea for the design of the staircase of the Belvedere courtyard in the Vatican. A still later sheet, reproduced in plate 204, shows a characteristic alliance of small-scale plans and elevations. It has been proposed that they relate to the project of the Sforza chapel in Santa Maria Maggiore, and whilst the connection is not certain, they clearly date from around 1560. The spread of the sketches across the page may be compared with those for the Medici Chapel (pls 198–200). And Michelangelo's persistence in making these small drawings for elevations can be further illustrated by late examples of the same type for the design of gates.

There are a number of these. The smallest is on a tiny piece of paper at Haarlem which measures no more than seven and a half by less than four centimetres, the diminutive survivor of a dismembered sheet (see the illustration on the half-title page). The design shares features with the *modelli* for the Porta Pia (pls 184–5) but was intended for a much smaller project, perhaps, as been suggested, for a villa gate.[4] Despite the tiny scale, the details are wonderfully clear: dolphins, rather than reversed volutes, flank the central coat of arms, and the gate has been given an anthropomorphic character by the introduction of eyes in the tympanum, a foretaste of later-sixteenth-century architectural fantasy. Another somewhat larger study shows the same conceit (pl. 205). The gate is more monumental in design, with entablature and heavy attic, closer to a civic monument. The artist here ruled the main vertical and horizontal lines and the drawing is, in fact, al-

[4] Tolnay, 1930, pp. 42 ff.

most certainly later than the other. Yet even this study measures no more than seven centimetres high.

Some of the ideas committed to paper at this initial stage in the design process would be taken no further. Others would be developed before being abandoned, and yet others would be taken up, reconsidered, and elaborated or recast. Most of the sketches for the Medici tombs reproduced in plates 198–200 were made for a single four-sided monument in the centre of the Chapel, an idea finally relinquished for lack of space. Plate 206 is a black-chalk elevation for the wall tomb of one of the Medici dukes after the final disposition of wall monuments in the Chapel had been decided. It is drawn entirely free-hand and is still exploratory. As so often in the artist's elevational drawings, the left-hand side of the project is drawn more carefully than the right (compare pl. 169). The motive of the centrally placed, seated duke is still missing. The double pilaster order of the final scheme has been drawn in but there is still uncertainty over its height. The cluttered attic would be radically simplified and cut down beyond what was planned in the later drawing for the attic thrones which we have already con-sidered (pl. 196).

Elevational drawings could be more or less carefully drawn than this British Museum tomb elevation, depending on the stage of realization the artist had reached. Rather carefully made is a very beautiful red-chalk elevation for one of the lower storey tabernacle bays of the façade of San Lorenzo (pl. 207). This was made after Michelangelo had arrived at his final composition of the façade but before he had settled the scale of each part in relation to every other. He also drew two different groundplans below this elevation. The latter is not only a very careful description of architectural forms, it is, as well, a delicate study of the light and shadow intended for the façade, something much in his mind but easy to overlook when we contemplate diagrammatic reconstructions and the wooden model of his aborted masterpiece.

Much freer is a spirited pen drawing for a wall of the San Lorenzo Library vestibule (pl. 208). Michelangelo first drew a smaller idea to the left, and then proceeded to the larger central study, adding the right-hand bay as a rapid supplement. This large elevation on Casa Buonarroti 89A has fre-quently been considered one for the south wall of the vestibule, the two 'blank' lower bays being interpreted as paired doors leading to the reading room. But this is certainly mistaken; two doors do not appear on any of the groundplans and could never have been related to the single broad walk between the reading-room desks, axiomatic from the start.[5] This elevation, like the others for the vestibule (compare pl. 195) is for the west wall. The

[5] Wittkower's proposal, 1934, pp. 156 ff., which misled Ackerman, has been rightly rejected by Tolnay (see *Corpus* 524 recto).

lowest *basamento* level of the vestibule has been hastily sketched beneath the articulated wall area; the artist left out the staircase. There are retrospective features in the design, like the Brunelleschian corbel and the round-headed niches which recall those of the San Lorenzo façade, suggesting that this is an early idea for the vestibule. The sheer speed of Michelangelo's pen is astonishing, but the lack of more detail and of a groundplan is frustrating. We can infer, but cannot state as a fact, that Michelangelo was here contemplating a giant pilaster order and a smaller one of columns, a combination he discarded at the Library but which he later revived for the façade of the palaces on the Campidoglio in Rome.

 Another elevation in the Casa Buonarroti, made not much later, probably in 1526, presents a very different appearance (col. pl. 4 and pl. 209). It is the most ambitious and elaborate of a series of drawings connected with Pope Clement VII's wish to have wall tombs erected for Leo X and himself on either side of the choir of San Lorenzo behind the high altar. This elevation is for a three-bay monument, of which Michelangelo has drawn the left and central bays, subsequently adding a plan below. The whole drawing has been made with considerable care. Much of the design was first drawn in very lightly in black chalk, with the intention that it should be drawn over in pen and ink. However, the pen design does not always follow the chalk one—Michelangelo first drew a shallow gable pediment over the centre bay, an idea he had entertained in earlier drawings for the project. The one element the artist left in black chalk, the sarcophagus at the foot of the central bay, is a feature no longer easy to read in a photograph but nevertheless important, for it allows us to reckon the approximate scale of the whole monument. Despite the seemingly expository charactor of this large sheet, the whole pen drawing, apart from a very few horizontal lines, has been drawn free-hand (as has the plan), a striking indication of Michelangelo's sureness of hand at the age of fifty-one. His aim, easily appreciated in the plan, was an exceptionally rich play of projection and recession, and this led him to pick up a brush and apply bistre wash. He has used it here with exceptional subtlety, varying the strength of tone to correspond with the depth of recession of the planes.

 Planned to be about thirty feet across, the design, apparently conceived to have only one statue in the central bay, reads like a façade rather than a tomb, its vocabulary a step beyond that of the Library vestibule, one element of the centre bay even anticipating motives of the Porta Pia. Yet, clear as most of the forms are, this was probably not the drawing meant to be sent to the pope in Rome. The attic composition has not been resolved fully. There is no real indication of the order Michelangelo intended, which, if the tombs had been executed, would surely have been Corinthian, in conformity with Brunelleschi's in the nave and crossing. And there survives another sheet, likewise in the Casa Buonarroti, which certainly followed this one (pl. 210). Never referred to at all until 1959, its relation to the previous drawing is not

in doubt, although it has been drawn on a slightly smaller scale. This painstakingly ruled drawing is, I believe, the first stage in the preparation of the carefully worked *modello* planned to be sent to Pope Clement in Rome, and was probably laid aside by the artist when the project fell through in 1527. These seemingly inert lines are, in fact, Michelangelo's construction lines, comparable to those in a *modello* like that reproduced in plate 184 for the Porta Pia. The sheet, in other words, shows us what a drawing of this kind looked like at its earliest stage.

These examples of elevational drawings have been taken from a rather restricted period of Michelangelo's career as an architect. This is difficult to avoid, for as we have seen earlier (pp. 17 ff.), architectural drawings for the later Roman projects are few, and elevational studies very rare. A brief survey such as this may close with a few words about one of them, a design, now in Lille, for the cupola of St Peter's (pl. 211).

This drawing, well-known for many decades, has provoked much discussion. Once unequivocally considered to be autograph, its status was subsequently downgraded. Even lately, when the variety of Michelangelo's drawing practice has come some way to being reappreciated, doubts have persisted, and, in the most recent careful study to discuss it, the execution of the design of the drum has been regarded as too mechanical to be Michelangelo's.[6] This kind of judgment seems based on a conviction that Michelangelo did not pick up a ruler and make carefully executed architectural drawings, a belief that could scarcely survive an examination of all the graphic material left to us. It also ignores Michelangelo's notorious distaste for workshop collaboration, which he would have recourse to only very late in life for the execution of a 'clean' *modello*, which the Lille elevation is clearly not.[7] In the case of this Lille sheet, there is no need to conclude that cupola and drum drawing are by different hands or represent different stages in the artist's thinking about his greatest late project.

As in so many of his architectural drawings, Michelangelo's first step was to draw a vertical line down the centre of the sheet. Then he proceeded to his drawings of the profile of the cupola, but we should note that these are for a section, not an elevation proper. Some of these profiles were drawn with a compass and others, which probably followed, were made free-hand. Then the artist turned to the drum, first ruling in the many horizontal lines as his guide. The drum drawing is an elevation but it is not drawn in orthogonal projection. Its articulation of round windows and coupled columns, and the free-hand sketches of features like the statues on the attic, were all drawn in perspectival, 'pictorial' recession, like, it may be added, the drum elevation in the woodcut of Bramante's cupola reproduced in Serlio's Third Book, published in 1544. The free-hand sketch of the lantern, probably the last

[6] See Saalman, 1975, p. 398.
[7] For this case, see above, p. 87.

detail of the main study to be added, is also drawn in the same way, as, indeed, are more elaborate studies for the lantern on a related subsequent sheet at Haarlem (*Corpus* 596 recto). In the top-right corner, Michelangelo drew in plan one of the double-column drum buttresses with the convex wall of the drum behind. And in the upper-left corner, there is a rapid free-hand sketch, made a little later, for the elevation of the church's attic as we know it today.[8] As we have seen earlier, the evidence points to the conclusion that both this Lille elevation and the related one at Haarlem were made not long before Michelangelo prepared a clay model of the cupola in the summer of 1557 (see p. 28).

<center>* * *</center>

We may, finally, add a few words about Michelangelo's drawings of architectural details. Two sheets containing examples of these we have already noted briefly in their rôle as the divided reverse sides of the San Lorenzo groundplan (pls 213–14). Made for the base mouldings of the double-pilaster order of the tombs of Dukes Giuliano and Lorenzo in the New Sacristy, they illustrate Michelangelo's quest for the perfect profile, the most personal signature of the cinquecento architect (the study at the bottom of plate 213 shows not a profile, but the whole section of the base). They were drawn entirely free-hand and demonstrate a sureness of touch and fluency of chalk stroke that would be difficult to equal in the period. Above the profiles in plate 214, Michelangelo wrote his celebrated meditative gloss on the mortality of Duke Giuliano, but even in the architectural studies below he has exercised his *fantasia*, for, by the addition of an eye, he has turned the profile in the lower right into a face, with open mouth and beard. There are similar examples of anthropomorphizing in other architectural details of the same period.

These studies were drawn on a scale less than half that of the bases as carved and put up; they are, therefore, Michelangelo's exploration of shapes made for himself alone, as were the studies of head and hands on sheets like that at Haarlem (pl. 130). But Michelangelo's architecture had to be executed by others, an act of delegation with which even he had to come to terms. The profile of a base moulding reproduced in plate 215 is a response to such delegation. It is the model, first drawn in pen on paper and then carefully cut out, that would serve for the templates made from sheets of tin, used by the masons in their work. Michelangelo has himself boldly written the purpose of this one down its length: 'el modano delle colonne della sepoltura doppia di sagrestia' ('the model of the columns of the double tomb of the sacristy'). Many of these sheets were, inevitably, destined to perish, but this one was

[8] See Hirst, 1974, pp. 66 ff., and the dissent
of Millon and Smyth, 1975, pp. 162 ff.

made for the tomb of the two Magnifici on the Sacristy's entrance wall which was never carried out, and it was, therefore, never used.

It was not only for the work of actual construction that such detailed guides were required. They were needed also for the making of the large wooden models that, in accordance with Renaissance practice, constituted a late and highly significant stage in the development of the projects. The kind of drawings made by Michelangelo to guide the carpenter in constructing the model seem to have eluded any enquiry. But some light can be shed on this stage in Michelangelo's design process.

My example involves the verso of the three sheets containing sketches for the Medici Chapel tombs already discussed, which are now split up between the Casa Buonarroti and the British Museum (p. 97 above, pls 198–200). Aided by the recent publication of Michelangelo's drawings to scale, it is not difficult to appreciate the fact that the three versos once formed a single very large sheet with one red-chalk drawing on it. The character of the drawing, the section of a Corinthian column, allows us to compute how much is now missing between each sheet—the amount is not great—and leaves us with a question mark only about the base (pl. 201). Michelangelo drew the section with great care and on an exceptionally large scale; in fact, he first drew in three vertical ruled lines as a guide, one of which runs down the centre of the section. These features point to a specific purpose. We find that the measurements of this red-chalk section agree almost exactly with those of the lower order Corinthian columns of the wooden model of the San Lorenzo façade now in the Casa Buonarroti. This is, in other words, Michelangelo's working drawing for the maker of the model to follow. And, once the identification is made, we can, *vice versa*, complete the missing base of the drawing from the evidence of the model.[9] Unquestionably drawn before the tomb sketches on what we now misleadingly call the rectos, the section had no further use for the artist after the completion of the model in late 1517, and he used its blank side for his next great undertaking at San Lorenzo, the designing of the New Sacristy.

Michelangelo's largest architectural drawings were discovered as recently as 1976, made not on paper but on the two lateral walls of the choir (or altar chapel) of the New Sacristy. Almost fifty architectural drawings have been found there, not all by the artist himself, together with some autograph written inscriptions. The drawings are on different scales and were made for different purposes. Two, without doubt by Michelangelo himself, are of particular interest in any survey of his drawing practice. They are full-scale orthogonal elevations, drawn in black chalk, for the interior and exterior

[9] The height of the wooden model columns, including capitals and bases, is 60 cm., and without them, 45 cm. The bases are 7 cm. high and the capitals 8 cm. (compare these measurements with those in plate 201). The artist would have added a detailed drawing of the capital for the model maker.

windows of the reading room of the San Lorenzo Library. Although semi-definitive, made exactly to the scale of the windows as executed, both show minor *pentimenti* in the design of the cornices. The drawing on the left wall, for the exterior windows of the reading room (pl. 212), despite the losses at the bottom, can be read more easily than the other—even the central vertical construction line is visible, recalling those on the *modelli* we considered earlier. Despite its enormous scale, the lines of this drawing were also ruled. Its making no doubt followed the dispatch of *modelli* to the pope in Rome; indeed, Michelangelo's drawings for the reading-room windows, both inside and outside ('le finestre di drento e di fuora') were returned to him in a letter of April 1525 with Pope Clement's approval.[10]

These to-scale wall drawings were made for Michelangelo's masons, his chosen team of *scarpellini*, to follow in constructing the windows. We know, from a contract of 1533, that he must have made others at San Lorenzo, for this later document refers to drawings in the cloister, done for the doors and staircase of the Library. In making these scaled wall drawings, it seems to be the case that Michelangelo was, once more, asserting his traditionalism with regard to means, while pursuing his radically novel stylistic ends. Nearly two hundred years before, at SS. Annunziata in Florence, a similar procedure had been followed over work for the Cathedral; a wall was to be plastered and drawings of a column and capitals, made to scale, were ordered to be carried out on it.[11]

We may end this survey with one other kind of drawing. The supply of materials for Michelangelo's building projects was no less a concern than that for his carvings; indeed, the financial implications were very much greater. A group of block drawings, indicating his specification for marble for the lower story of the San Lorenzo façade, predating that with similar drawings for the New Sacristy referred to above, has survived, now bound into volumes in the Archivio Buonarroti. The double sheet illustrated here is one of the finest examples of the San Lorenzo group (pl. 164). All the drawings have been made free-hand and with great rapidity; then they have been inscribed by the artist with the prescribed measurements in *braccia*, with, in a few cases, identifications of the pieces, for example, cornice, frieze, and column. Most of the pieces that feature on this sheet are for the membering of the lateral bays of the front façade, but where one item was required to a uniform scale for all the lower storey of the façade, front and side wall bays, the total number was written in. This is the case with the column, where Michelangelo requested twelve to be supplied, and the piece to the right, the pedestal block for the lower storey statues, of which he needed six. The sheet is an important source for attempting a reconstruction of Michelangelo's final design; but it is also a vivid record of his practical concerns and the way in which he conveyed them.

[10] *Carteggio*, III, p. 141.
[11] Guasti, 1884, p. 116–17.

X

THE MAKING OF PRESENTS

THE BESTOWAL OF WORKS OF ART as presents is an extensive subject, for present-giving has embraced many different kinds of gifts, ranging from formal diplomatic presents to the most intimate expressions of attachment and gratitude. Artists have given works to fellow artists or to friends throughout history, but motives might be as various as the recipients. In 1456, Donatello gave the small, round, bronze relief now in London to Giovanni Chellini, his friend and the doctor who had saved his life.[1] Similar gratitude lay behind Michelangelo's present of the two over-life-size marble Slaves now in the Louvre to Ruberto degli Strozzi nearly a century later, for it was in Strozzi's Roman house that Michelangelo had recovered from the two serious illnesses in 1544 and 1546; he himself felt that Strozzi's house had kept him alive. There is, nevertheless, a significant difference between the two cases. Donatello's little relief was purpose-made, done *ad hoc* for Chellini, whilst Michelangelo's far bigger gift to Strozzi was not. If we turn to a similar case concerning a drawing, albeit a very large one, we find that Michelangelo gave to his Florentine banker friend, Bindo Altoviti, his preparatory cartoon for the Sistine ceiling *Drunkenness of Noah*. How soon after the completion of the mural this happened we do not know; evidently, the cartoon had remained in fair condition. The gift, mentioned by Vasari, who certainly knew it, had, once again, not been purpose-made for Altoviti. Nor, to take a nearly contemporary case, had the red-chalk drawing that Raphael sent to Dürer as a present in 1515.[2]

There are indications that drawings, carried out as ends in themselves, planned as gifts, were made before the end of the fifteenth century. Evidence of this kind exists in the case of Andrea Mantegna. His Uffizi *Judith* (404E), dated 1490, and, still more plausibly, an unfinished coloured mythological drawing now in London, bear signs of having been conceived as presentation drawings. It is possible that he himself was inspired by Tuscan examples. Many years ago, Herbert Horne, without explicitly using the

[1] For an account, see now Darr and Bonsanti, 1986, pp. 161–2.

[2] Knab, Mitch, and Oberhuber, 1983, no. 504.

terminology of presentation drawing that Wilde adopted for Michelangelo's gift drawings, saw in Botticelli's *Abundance* (pl. 216) a drawing made as an end in itself. To judge from its style, Botticelli's drawing must predate those by Mantegna.[3]

Vasari, who owned a drawing of Judith by Mantegna gives us a description of it that implies that it was a finished drawing.[4] But for a more explicit reference to the making of a presentation sheet, we should turn to his remarks about the now lost drawing of Neptune by Leonardo. Vasari knew this drawing, for he was a friend of the son of the original owner. He states that Leonardo made the drawing as a present for Antonio Segni.[5] This probably happened soon after Leonardo's return to Florence in 1501, in, therefore, the period when Michelangelo and Leonardo were at work in the same city. He does not tell us about the medium, but there cannot be much doubt that the drawing was made in black chalk, like the surviving preliminary draft for it now at Windsor (pl. 217). This drawing shows that, at an early date in the sixteenth century, a presentation drawing of Leonardo's would be preceded by preparatory studies, for the Windsor *Neptune* is not a projected presentation sheet left unfinished. Segni's drawing is unlikely to have been the only one of its kind that Leonardo made; a highly finished, red- chalk *Allegory*, also now at Windsor, probably constitutes another.[6] And other artists associated with Leonardo's Florentine studio may also have produced drawings as presents, including Bandinelli.

The evidence that we have suggests, therefore, that Michelangelo adopted the genre; he did not invent it. His contribution to this class of drawing is, however, unique, in terms of both meditated invention and painstaking application, a fact recognized by his contemporaries. Nevertheless, he seems to have taken up the making of this kind of drawing only at certain periods; the drawings do not constitute a long and consistent series spread over many decades. Nor does their production coincide with stretches of leisure in his life. There seems, in fact, to have been three periods during which Michelangelo devoted effort and time to the making of presentation drawings: in the 1520s; in the early 1530s; followed by a brief resumption in the 1540s.

We have to explain this pattern not by a lack of other commitments, but by the workings of profound personal attachment. And although we cannot exclude the possibility that he made drawings of this kind in other periods, there is no evidence that he did so. All Michelangelo's 'documented' presentation drawings are in either black or red chalk, and, as we have noted, chalk had been the medium adopted by Leonardo for his drawing for Segni.

[3] Horne, 1908, p. 124; he concluded that Botticelli's drawing, which is also unfinished, 'was evidently intended to exist for its own sake'.

[4] Vasari, ed. Milanesi, III, p. 402. The Uffizi drawing does not exactly answer to Vasari's description.

[5] Vasari, ed. Milanesi, IV, p. 25.

[6] Popham, 1946, no. 125.

The real parallel for these drawings of Michelangelo is love poetry, above all sonnets, works actuated by profound personal feeling. They testify to his attachment for Gherardo Perini, Andrea Quaratesi, Tommaso de' Cavalieri, and Vittoria Colonna. There is no known case where Michelangelo made a drawing of this kind for an *ottimato*, a distinguished patron, because of the latter's rank. They were carried out for love rather than duty, to use words of the artist's own: 'per amore e non per obrigo.'

Vasari already refers to drawings given to others by Michelangelo in his First Edition of 1550. In the Second, of 1568, his account is greatly amplified, and he provides us with information that has led to the identification of sheets made for Michelangelo's earliest attested recipient of drawings, Gherardo Perini. Vasari states that Perini received three sheets from Michelangelo. These contained 'some heads in black chalk which are divine and which, after Perini's death, have come into the possession of the illustrious Don Francesco, prince of Florence, who treats them like jewels, which they are'.[7]

Vasari's information would lead us to expect that we should find the Perini drawings in the Uffizi collection, and this is indeed the case, although critics for long refused to accept that so simple a situation could be true. Two of the three black-chalk sheets of heads listed by Vasari can be identified by inscriptions on the sheets themselves. The so-called *Fury* (pl. 219) is inscribed with Perini's name along the top and with the artist's name and personal sign of three interlocking circles in the lower-right corner. A second Uffizi sheet of *Three Heads* (pl. 218) is inscribed with an autograph message by Michelangelo himself at the bottom. It reads: 'Gherardo, I have not been able to come today' ('Gherardo io non o potuto oggi ve[nire]'). The third sheet's identification is not quite so certain, but from the evidence provided by early Medici inventories, we can deduce that it was an exceptionally celebrated drawing that later came to bear the title of *Zenobia*, but that may represent Venus, Mars, and Cupid (pls 220–21).[8]

Two of these drawings, the *Fury* and the *Venus*, were destined to become famous and were widely copied. The *Three Heads* enjoyed less celebrity, and the message that Michelangelo wrote along the bottom implies that it was no more than the draft for a more finished but never-realized sheet. We shall encounter another draft presentation drawing below, on which Michelangelo wrote a message (see p. 113). Certainly, none of them can rival the presentation drawings that Michelangelo would produce some years later. They are not narrative drawings; rather, they are exactly what Vasari said they were, 'teste'. If we turn from them to drawings such as the Windsor *Labours of Hercules* (col. pl. 5) or those that would be made for Cavalieri, we

[7] Vasari, ed. Milanesi, VII, pp. 276–7.
[8] Archivio di Stato, Florence, Guardaroba 65, fol. 164A and Guardaroba 69.

can appreciate that, in making this kind of drawing, Michelangelo proceeded from relatively simple forms to more complex ones, from single images to narratives. The modest scope of the Perini drawings emerges clearly if we compare them with Leonardo's study for his lost *Neptune* (pl. 217). These considerations go far to suggest that, when he made these drawings, Michelangelo was not carrying out a kind of drawing with which he had been long familiar. If earlier examples have survived, the presumption is that they are of the same kind. The strongest candidate to be included is, it seems to me, a red-chalk head now at Oxford (*Corpus* 323 recto).

Vasari called the Perini drawings 'teste divine', but this is a qualitative characterization, not a definition of their subjects. The *Fury* (pl. 219) is an allegorical image and may well have been inspired by a work of Leonardo; an invention of his, either an original or a copy, was actually listed in a sixteenth-century inventory as a 'Furia infernale', and the flying coils of hair of Michelangelo's head may well reflect the coiffeur of live snakes in Leonardo's painting that so deeply impressed Vasari.

Least clearly characterized is the sheet of *Three Heads* (pl. 218). Recent suggestions as to the identities of these heads have overlooked the fact that Michelangelo gave halos to two of them—the two orientated to our left— and probably failed to add one to the third simply for lack of space. The two younger heads probably represent differing characterizations of the Virgin and the third, old, one either St Anne or St Elizabeth (the type is close to that invented for St Elizabeth by Mantegna).

Perhaps most challenging as a subject is the so-called *Zenobia* (pls 220–21). The early inventories referring to the drawing do not provide a solution. In the earlier, drawn up sometime after 1560, we find the sheet described as 'a head of a woman and part of the bust, with antique hairdressing, with two other sketched heads'. In the other, we find it referred to as 'the portrait [or depiction] of the Gipsy...'. Perhaps it was the word 'Zinghana' employed here that, over the passage of time, became corrupted to the fanciful later appellation of Zenobia.

The opulent central image of this Uffizi drawing with her exposed breasts, fantastic hair arrangement, and helmet, has no true parallel in Michelangelo's long series of ideal heads; none exhibits quite this alliance of sullen sensuality and elaborate coiffure. It is easy to invoke the names of legatees of such an invention—Fuseli is one—but for our purposes it may be more important to recall that comparable drawn images had been made in the later fifteenth century. The drawing reproducd in plate 222, made by an artist from the same antiquarian circle as Mantegna, constitutes a remarkable anticipation of Michelangelo's Uffizi image.[9] Those critics who have recognized the authenticity of the drawing seem to be agreed that this image indeed represents

[9] It is contained in a bound volume now in the British Museum, attributed to Marco Zoppo; see Popham and Pouncey, 1950, pp. 162–3.

Venus. It is probable that the *putto* is Cupid and that the bearded head, also helmeted, is Mars.

There are indications, however, that Michelangelo started out with the aim of a single image only. The arrangement on the sheet suggests this. And the two subordinate heads are drawn in the broad and summary style that Michelangelo employed for rapid compositional drafts or for afterthoughts. In other words, they are not unfinished parts of the drawing awaiting an elaboration similar to that of the main image, for their broad handling could never have allowed the technical finish of the Venus. Beneath her head in its delicately wrought state there is a tentative underdrawing completely different to the bold diagonal strokes of her companions, surpassing in delicacy any of the lightly drawn passages of the *Three Heads*.

All of the Perini drawings are in a worn condition. They show considerable chalk losses, and all three sheets are discoloured through excessive exposure to sunlight. But the *Venus* sheet is at once the best preserved and the most elaborately finished of the group. A detail of the head (pl. 221) reveals the exceptional nuances in the black–chalk modelling, gradations that seem to be softer and subtler than those in the *Fury*. In both drawings, Michelangelo used a very soft black chalk, but in the *Venus* he exploited the grain of the paper to greater effect; the fused tonality is close to that in the later presentation drawings.

Perini's drawings are rightly dated by the majority of critics to the 1520s, and it is probable that they were made early in the decade. There is, indeed, a very brief surviving exchange of letters between Perini and Michelangelo in 1522, and the drawings could have been made at about this time. The influence of the ideal profile type—the *all' antica* hairstyle, and the headdress of the *Three Heads* (and Michelangelo may well have made more drawings for Perini than the three itemized by Vasari)—seems clear in Rosso's San Lorenzo *Marriage of the Virgin*, which is dated 1523; and these heads were to reappear in ever more fantastic guises in later inventions of Rosso. Similarly, the head of Michelangelo's Furia reappears in Rosso's own design of a full-length *Fury* engraved in the period after he had left Florence for Rome.

The later presentation sheets are far more ambitious than those given to Perini. They also signal Michelangelo's renewed concern with antique mythology. This concern, only hinted at in the *Venus* sheet, had been kept alive in the 1520s by the project for a marble group of *Hercules and Cacus* and found its most spectacular expression in the commission in 1529 to paint a large panel of *Leda and the Swan* for Duke Alfonso d'Este of Ferrara. In agreeing to undertake the painting, Michelangelo was, in effect, offering to compete with Titian, whose recently delivered mythologies he certainly saw on a tour that we know he made of the Este collection in that year. We have an anecdote of how Michelangelo reacted to Titian's art in the 1540s when the latter visited Rome, but there is no record of his reaction in 1529 to the *Worship of Venus*, *Andrians*, and *Bacchus and Ariadne*. Yet Titian's astonishing

evocations of antique myth may well have contributed not only to the decision to paint the *Leda*, but also to Michelangelo's renewed interest in mythological narrative, exemplified in the drawings for Cavalieri of a few years later.

The Windsor *Labours of Hercules* (col. pl. 5) may have been the earliest of these more ambitious drawings. Elaborate if compared with the Perini sheets, it is, nevertheless, more modest and a less successful unity than most of the presentation drawings of the early 1530s. Michelangelo selected three of Hercules' exploits, and his choice of episodes reflects works of the Florentine quattrocento exceptionally familiar to him. For it has escaped notice that he adopted precisely the scenes depicted by Antonio Pollaiuolo in his monumental paintings owned by Lorenzo il Magnifico and hung in Palazzo Medici: the killing of the Nemean lion, the conflict with Antaeus, and the struggle with the many-headed Hydra.

It has been shown that Michelangelo's three groups are inspired by earlier Renaissance designs, by other drawings of his own, and by the antique. For the drawing's central group, the artist adapted an antique motive that had shown Hercules killing the lion; in a characteristic act of improvisation, Michelangelo preserved the antique profile design but changed the meaning. The right-hand group is the most assured in composition. The debt to the *Laocoon* group is obvious and profound. Even the way in which the snake-like head of the Hydra bites at the hero's flesh is derived from the Hellenistic group; in fact, Michelangelo had already used the idea in his Sistine Chapel *Worship of the Brazen Serpent*.

The debt to antique art is, however, more fundamental than one of isolated borrowings. For the whole scheme of this sheet, with its narrative constructed by the multiplication of single groups, comes from antique sarcophagi. This kind of solution is, in fact, a feature especially common in sarcophagus reliefs that illustrate different exploits in the story of Hercules.

The artist sought to avoid flatness by varying the depths of the groups, and, as has been noted, he represented Hercules frontally, in profile, and in three-quarter view. The difference in the density of modelling in the three groups points, however, to the conclusion that this Windsor sheet was never fully finished. In the left-hand group, Michelangelo achieved a high degree of finish. The right-hand group, compositionally the most ambitious, is much less worked up and is, I believe, unfinished. The drawing of the hero and the Hydra show what Michelangelo's underdrawing for a presentation sheet looked like at this point in his development of the type. The contours are unemphatic and the modelling is achieved by delicate parallel hatching; features such as the Hydra's tail are barely indicated. The delicacy of the underdrawing has allowed Michelangelo, indeed, to affect a *pentimento* in the position of Hercules' left arm that does not disturb the unity of the group. All three groups must have been 'laid in' like this one, and then, as a right-handed artist, Michelangelo concentrated on finishing the left-hand group,

prior to working towards the right. There are indications of the same procedure in the Windsor *Archers shooting at a Herm* (col. pls 6–7).

Unfortunately, we do not know for whom either the *Hercules* or the *Archers* sheet was made. To judge from its more episodic treatment of narrative and its less accomplished technique, the *Hercules* is likely to be the earlier. Whilst the *Archers* enjoyed great fame in the sixteenth century, the *Hercules* seems to have been less well known, although copies of it do exist. These seem to be the work of Florence-rather then Rome-based artists, and it is possible that it was made for Andrea Quaratesi, the young member of the Florentine banking family, whose drawn portrait, again a presentation drawing, Michelanglo made soon after the end of the siege of Florence (pl. 25). The *Archers*, on the other hand, was in Rome in the later sixteenth century. The enigmatic character of its moral allegory appears to make it a kind of natural companion sheet to the Windsor *Children's Bacchanal* (pls 231 and 234), which Vasari tells us was made for Cavalieri. But it does not appear in his list of Cavalieri drawings, which comprises, apart from the *Bacchanal*, the *Rape of Ganymede* (see pl. 223), the *Tityus* (pl. 224), and the *Fall of Phaethon* (pl. 227). Perhaps we should not attach too much authority to the exclusiveness of this brief list, which he introduced into the Second Edition 'Life of Michelangelo'. Elsewhere in his 1568 book, Vasari lets drop the information that the *Cleopatra* (pl. 235), now in the Casa Buonarroti, was also made for Cavalieri.

What the *Archers shooting at a Herm* (col. pls 6–7) shares with the *Hercules* is a still rather obvious formal debt to antique art, in this case a stucco relief in the Golden House of Nero. But records of the subsequently lost prototype show how radically Michelangelo transformed his source. He reversed the group, changed it into a flying or semi-flying one, and dynamized the static composition of the stucco. The arcane details on the sheet are his alone. These include the prevailing left-handed-ness of the figures (a moralizing feature), and the absence of the bows, a detail that a later engraver attempted to revise.[10]

As in the *Hercules*, the figures were first drawn in very lightly, and then the artist proceeded with laborious small strokes to model them. To a degree hitherto unparalleled in Michelangelo's surviving drawings, he exploited the white ground of the paper to form the highlights; the physical basis of the drawing constitutes the point of greatest concave plasticity, an approach that achieves a final perfection in the *Bacchanal*.

Although Vasari's list of Cavalieri's presentation drawings cannot be complete, he seems to have listed the four sheets that he does mention in the order in which they were made. The lost *Rape of Ganymede* and the Windsor

[10] A similar shooting gesture without bow reappears in the *Last Judgment*, in the figure of St Sebastian.

Tityus (pl. 224) were probably the two drawings that Cavalieri acknowledged in a letter written to the artist on New Year's Day, 1533. Both achieved instant fame, as would the Windsor *Fall of Phaethon* (pls 227–8) which was to follow in September. The reception of this last sheet in Rome provoked an excitement described in Cavalieri's letter to Michelangelo, now back in Florence.[11] Pope Clement VII, Cardinal Ippolito de' Medici and 'everyone else' ('ugnono') had hastened to inspect it. Cavalieri had been compelled to lend the *Tityus* to Cardinal Ippolito so that it might be copied in crystal; he had held on to the *Ganymede* with the greatest difficulty. Drawings had come to assume an importance never before accorded to them in the history of art.

The *Ganymede* and the *Tityus* seem to have been created as a mythological diptych, a pair in which each drawing consists of a giant bird and a single naked form. They were linked in a more fundamental sense, in their shared, scarcely veiled, autobiographical allusion to the artist's love for the young Roman. But a diptych may not have been Michelangelo's first intention. A drawing of *Ganymede* now in the Fogg Museum (pl. 223) bears, I believe, indications of being by the artist himself. This vertical composition, in its representation of landscape and the shepherd boy's dog, is more elaborate than the lateral drawing familiar to us from copies. It, too, however, was recorded in an engraving. The re-emergence of the Fogg sheet supports Berenson's conjecture that Michelangelo originally envisaged his Ganymede composition in a more extensive form. It seems to have been the case that Michelangelo reduced his Ganymede design to the more familiar form surviving in the many 'repeats', the better to harmonize it with the inescapably lateral composition of the *Tityus*. This final version remains lost. Nevertheless, the Fogg drawing, worn and incised as it now is, gives us some idea of the beauty of this, Michelangelo's first invention for his beloved friend. The scale of boy and eagle may even be the same as that in the lost second version, and even in this sheet it is possible to appreciate the range of expression, from the cupidity of the giant bird to the half-bemused compliance of the curly haired boy.

The *Tityus* (pl. 224) is more stylized, the design of the recumbent victim more explicitly based on antique motives. What it does reveal is an exceptionally rich diversity of graphic techniques. The differences in finish between the figure of Tityus and the setting is deliberate and is not, as has been proposed, evidence that the drawing was left unfinished. These ancillary forms of rock and tree are constructed by firm, parallel chalk strokes which the artist spaces more broadly when he wishes to achieve recession.

Wilde saw in the main forms of the *Archers*, the *Tityus*, and the Windsor *Phaethon* and *Children's Bacchanal*, evidence that Michelangelo used a technique of stippling with the sharpened end of his chalk to create plasticity. In so doing, he seems to have followed a comment first made by Symonds in

[11] See *Carteggio*, IV, p. 49.

his account of the *Archers*.[12] A recent examination of the Windsor draw-ings under the microscope does not bear out the argument. The granular shadings are not made by stippling, but by a technique of applying the most minute strokes of chalk, and, paradoxically, it is the untouched points of white paper rather than the chalk touches themselves that give the passages the deceptive appearance of stippling. In these Windsor drawings, what Michelangelo's chalk has left on the granulated surface of the paper is not so much strokes as what is best described as touches that leave a minute, wedge-shaped mark. This laborious way of modelling is, from the evidence of microscopic examination, at its most developed in the *Childrens' Baccha-nal*, which, we have already noted, is the last sheet in the list of Cavalieri drawings that Vasari enumerates. Some of the marks appear to have been laid on paper which Michelangelo has dampened. The detail in plate 237 is a macrophotograph of the right leg of the *putto* who stands next to the fire. And plate 238 is a more magnified detail from the Windsor *Phaethon* which may give some idea of the kind of modelling that Michelangelo adopted.

Before he parted with the *Tityus*, Michelangelo held it up to the light and traced a Resurrected Christ on its verso, using the recumbent figure of the recto as the basis for his new invention (pl. 225). Despite the labour spent on his presentation drawings, it is clear that he did not treat them with the veneration accorded them by their recipients or by ourselves. On some, he would even write messages, as we have seen. This tracing, with its as-tonishing improvisation, also allows us to appreciate that Sebastiano was not simply frivolous when he suggested that Michelangelo might convert his *Ganymede* into a St John the Evangelist ascending into Heaven. He himself must have witnessed the kind of metamorphosis of subject to startlingly exemplified on this Windsor sheet.

That Michelangelo would go to the length of making more than one version of an invention for Cavalieri is demonstrated by the existence of no less than three compositions of the *Fall of Phaethon* (pls 226–7 and 230). Clearly, Michelangelo became deeply absorbed with this episode from Ovid's *Metamorphoses*, one no less open to an autobiographical interpretation than the *Ganymede* and the *Tityus*. His preoccupation with the subject found its first expression in the British Museum sheet (pl. 226). Michelangelo made this drawing before he left Rome for Florence in the summer of 1533. It bears along the bottom a three-line inscription with a message to Cavalieri in the artist's hand in which he offers to make another drawing if his friend does not like it. Michelangelo himself refers to the drawing as a 'schizzo', and it is clearly unfinished.

The drawing is not entirely successful in the attempt to unite different, successive episodes of the story. It is, however, the most faithful of the three to Ovid's text; it is, for example, the only rendering that shows Phaethon's

[12] Popham and Wilde, 1949, p. 248.

lamenting sisters being turned into trees. It is also the version closest to what was Michelangelo's chief pictorial stimulus, an antique sarcophagus of the *Fall of Phaethon* which, in the late fifteenth century, and probably still in the sixteenth, stood outside the church of the Aracoeli in Rome, close to where Cavalieri lived. In the British Museum drawing, the motive of the falling Phaethon really does no more than reproduce the antique figure in reverse; and if we compare the disposition of the horses with that in the two other versions, we can recognize how the lateral composition of the relief still makes itself felt in this one.

It is generally assumed that the version in Venice (pls 229–30), now so worn that Michelangelo's autograph message to Cavalieri is scarcely legible, followed the London sheet and preceded the completely finished drawing at Windsor (pl. 227). A comparison of all three drawings does not, however, confirm this hypothetical sequence. The slightly inchoate design of the London drawing has been subjected to greater order in the Windsor one, especially in the lowest group of figures. Phaethon himself, nevertheless, is still placed to the left of the falling group, above and on the same axis as the recumbent Eridanus.

Formal and iconographic considerations suggest that the Venice sheet is the latest of the three. It is the version least faithful to the antique sculptural prototype. All the figures are more monumental than their Windsor counterparts. In particular, Michelangelo has given to Eridanus, the river-god, and the three Heliades a quite new grandeur of scale, and all four now act out the tragedy with a greater violence of gesture; echoes of the Eve of the Sistine ceiling *Expulsion*, evident in the other two drawings, have disappeared. Other details set the Venice sheet apart; it is, for example, the only one in which Zeus is middle-aged and bearded, and in which his eagle has been omitted.

That the Venice drawing was begun in Rome is proved by the message to Cavalieri written on it. Michelangelo made it, I believe, after his definitive move back to the city in 1534. The recent discovery of small studies for the *Last Judgment* on the verso does not weaken this suggestion. One can, indeed, go farther, and in the light of the consideration that this is the latest version, suggest that the dramatization of the subject was prompted by the artist's design for the *Last Judgment*, finished, as we have seen, in its general form before Pope Clement VII's death in September 1534 (see p. 80). In other words, Michelangelo was here taking up the subject for the third time, and, corresponding to the British Museum drawing in both bearing a message and being incomplete, the Venice drawing is a demonstration trial drawing, one which the artist abandoned.[13]

Scarred as it is, the Venice drawing can still offer us an example of the kind

[13] Brinckmann, 1925, p. 47, argued that the Venice drawing followed the Windsor one.

of underdrawing Michelangelo employed at this date. The very tentative strokes of the river-god and three Heliades convey energy and plasticity with a minimum of line; it is a kind of underdrawing we find in the study of the *Resurrected Christ* that Michelangelo traced through from the *Tityus* onto the Windsor verso (compare pls 225 and 229) two or three years earlier. Only in the paired horses, locked together as if in some phantasmagoric mating, is there any extensive modelling.

It is in the Windsor version, a drawing completed in every detail, that we can appreciate to the full Michelangelo's ideal of presentation sheet (pls 227–8). He probably began the drawing in Rome and took it with him when he went to Florence in June 1533, completing it there in a period when he felt deeply depressed by his distance from Cavalieri. As we have seen, it was the arrival of this drawing in Rome that prompted a mass visit of *cognoscenti* to Cavalieri's house. More regularized in composition than the British Museum design, it has a poise in its design that gives it a particular place in the presentation series. Its assimilation of antique sources (for example in the figure of the *putto*) is much greater than in the trial 'schizzo'. The extreme idealizing of pose has not, however, been achieved at the expense of narrative fidelity. There are signs here, also, of Michelangelo's meditation on his text. The swan with its emphatically outstretched neck is a vivid illustration of Ovid's description of the fate of Cycnus. And Zeus hurls his thunderbolt from a position close to his right ear, as the text prescribed.

The human figures and the four horses are elaborately worked, whilst landscape forms and clouds are drawn in the same way as the setting in the *Tityus*. But the balance of the Windsor drawing was not achieved without a struggle. One sister was first drawn with arms raised; Michelangelo then lowered them, but traces of the earlier forms survive. (pl. 228).

On the Windsor *Phaethon*, the artist must have spent a great deal of time in the late summer of 1533. Yet on the *Children's Bacchanal* (pls 231 and 234) he must have spent even longer. We have a preliminary compositional draft for this drawing (pl. 233). Its subject is not precisely the same, or rather, more accurately, its subject is really one part only of the finished work. The development from one to the other seems to preclude Michelangelo's having here set out to illustrate a given text; the subject of the Windsor sheet is likely to have been his own invention. Its precise meaning has eluded commentators, and the central motive of the 'entombment' of the dead deer is more baffling to interpret than any motive in the Bayonne study. All the groups have been placed within a cave. Its mouth is partially closed by the broad expanse of curtain; this explains why the many figures in the drawing are evenly lit. It is, in fact, the evenness of tonality over the entire sheet that is the drawing's most astonishing aspect. The sheet is more consistently and comprehensively worked than any other of its kind, how intensively modelled, we have just seen (see pl. 237). In no comparable drawing has the use of the white paper to create plasticity been used to equal effect. In some

areas of the bodies, the white has been left untouched in the highlights and then surrounded by the subtlest variations of tone. In other areas, such as the broad folds of the curtain, the white has been modified by a few strokes where the artist may have used the broad side of his chalk, creating a soft, granular texture. Tonal gradations in the *Bacchanal* have attained a pitch of delicacy that led Wilde to comment that the drawing 'shows to a high degree the consistency and transparent texture of an engraving...'.[14] And Vasari singled out this sheet for special praise when he wrote of it in his First Edition of 1550: 'not with the fineness of breath could you have achieved greater unity'.[15]

Michelangelo's preparation for this drawing must have been elaborate. The rich diversity of movement and variegation of morphological expression is unique in the presentation series; emotion ranges from the intense concern of the children around the cauldron (pl. 234) to the more abstracted melancholy of those who carry the deer. The turbaned child on the right of this group has been given a haunting, animated pathos that has no precedent in the *putti* of Donatello's *Judith* reliefs or in Titian's *Worship of Venus* (pl. 232). Michelangelo's children are both male and female, and he has divested them of the *all' antica* wings that both Donatello and Titian chose to preserve. To compare a detail of Michelangelo's drawing with one from Titian's painting, which Michelangelo must have seen about four years earlier at Ferrara, is startling. Torpor, melancholy, a drunken sleep, and death dominate the later invention, in a setting deprived of sun or sky.

The *Bacchanal*, the most complex of the presentation drawings discussed in this chapter, was probably the latest of the narrative drawings that Michelangelo made for Cavalieri. This does not imply that it must have been the last of all the drawings that he made for him. Vasari writes of drawings of heads that were given to him, sometimes as models for the young patrician to copy. The Casa Buonarroti *Cleopatra* (pl. 235), modest as it must seem after what we have just considered, could have been one of these. It has its own peculiar fame in being a drawing of Michelangelo's that Cavalieri was compelled to part with even at a date before the artist's death. It may have been the first of Michelangelo's drawings to enter the Florence Granducal collection. In surrendering it to Duke Cosimo, Cavalieri himself reported that he felt as if he were losing one of his children. It is in only fair condition, but it is worth noting how Michelangelo chose to fashion this image, as if it were an antique bust with the arms lost, constituting a formal expression of that kind of *all' antica* evocation of figures we have met with in studies made from life (pl. 119; pp. 64 ff.) This kind of approach to the subject was also, undoubtedly, in keeping with Cavalieri's own taste, for the family owned a substantial collection of antique sculpture.

[14] Popham and Wilde, 1949, p. 254.
[15] Vasari, ed. Barocchi, 1962, I, pp. 121–2.

Without Vasari's stray reference to the *Cleopatra* and without Cavalieri's own letter deploring its loss, we would have no clue about its origin. Other drawings of heads may well have been made for him. One likely candidate is the *Ideal Head of a Woman* now in the British Museum (*Corpus* 316 recto).

* * *

Michelangelo's few surviving presentation drawings of a later period share neither the secular subject matter nor the sensuous beauty of those just considered. Once again, however, they were the reflection of a profound attachment which, as earlier, found expression in poetry as well as drawings. Vittoria Colonna, whose intimate friendship with the artist was formed in the period of the *Last Judgment*, may have been the exclusive recipient of these later drawings, although there is evidence that she would give away a drawing to as close a confident from her own circle as Reginald Pole, no doubt with Michelangelo's own sanction.

It is a striking but unremarked fact that, of all the presentation drawings made by Michelangelo over three decades or more, it is only those given to Vittoria Colonna that Condivi mentions in his life of the artist of 1553. This certainly reflects the old Michelangelo's own attitude towards them. And the omission of the pagan drawings done earlier for Cavalieri indicates the artist's defensive attitude by the time his associate set out to write his highly protective biography. In the meantime, Pietro Aretino had alluded to the fact that only 'Gherardi' and 'Tommasi' could hope to obtain drawings by the master, a charge that the gifts to Vittoria Colonna could serve to rebut.

In all, Michelangelo seems to have made three drawings for her. Condivi mentions the *Christ on the Cross* (pl. 236), done, he states, spontaneously for her, 'per amor di lei', and a *Pietà* which he carried out at her request and which survives in bad condition (*Corpus* 426 recto). A third, mentioned by Vasari, of *Christ and the Woman of Samaria at the Well* has disappeared, but its appearance is recorded in an engraving, and a remarkable preparatory study, discussed earlier, has recently reappeared (pl. 97).

Michelangelo and Vittoria Colonna exchanged letters frequently, even when in the same city. Few have come down to us, but of the five addressed by her to Michelangelo, three refer to work that he was carrying out for her. Their language is difficult to interpret, and they are not dated; but several of the references seem to relate to a single sheet, the British Museum *Christ on the Cross* (pl. 236). In one letter, Vittoria requests the drawing as a kind of anticipatory loan, even if unfinished, so that she may show it to others. In another, she expresses her rapt admiration for the drawing, a Crucifixion which has crucified in her memory every other work she has ever seen. She has examined it in good light, with a magnifying glass, and in a mirror, and declares she has never seen a more perfectly finished object. And in a third passage, which again, I believe, refers to this drawing, she writes of her

delight in finding the angel on Christ's right more beautiful than that on his left, for St Michael will place Michelangelo himself on Christ's right on the Last Day. She will address her prayers to this sweet Christ, 'questo dolce Christo'.[16]

The demands of the subject clearly led the artist to plan the drawing very carefully. The vertical and horizontal lines of the cross are ruled, and these lines end exactly where they meet the contours of Christ's form, which, therefore, were 'laid in' before the cross could be drawn. There is a significant but unnoticed *pentimento*. Michelangelo first drew the vertical stem of the cross to reach the bottom of the sheet—the ruled lines are clearly visible. Then he decided to add the skull and drew it (and the supporting ground) over the unreinforced ruled lines of the cross. An iconographic addition of this kind may have been made at Vittoria Colonna's request, who, as letters show, had the loan of the drawing when still unfinished.

Condivi, writing at Michelangelo's instance, stressed the singularity of the invention. It shows Christ, he wrote, 'not in the semblance of death as commonly adopted but alive, lifting his face to the Father, seeming to say "Eli, Eli"; and one sees this body not collapsed and fallen, but as if alive, contorted and suffering in bitter torment'.[17] Vasari differed in his interpretation, seeing in the sheet Christ's very last moment alive, his head raised recommending his spirit to God. Whichever source is correct, the significant fact remains that Michelangelo here portrayed a living Christ on the Cross, the upturned head the artist's final tribute to the *Laocoon*.

Perhaps Michelangelo reached this conception with Vittoria Colonna's counsel. It was of profound importance for the future, for the adoption of a dramatized 'Cristo vivo' would mark many of the finest representations of the subject by subsequent artists, whether we turn to the bronzes of Giambologna or the paintings of El Greco, Barocci, Reni, and Rubens. What recalls the past is the inclusion of the two mourning angels, placed on either side of Christ, as we find them so frequently in trecento painting; their half-length form has precedents in mid-quattrocento Florentine art. That on the left raises his head in grief, a motive recalling Giotto's angels, whilst that on the right points to the wound in Christ's side.

From the evidence, it seems to be the case that these drawings made for Vittoria Colonna were the last of their kind. Yet we should probably be mistaken in assuming that it was the physical impairment of old age that led to the ending of the series begun some twenty years earlier. The explanation lies rather in the circumstance that no one would henceforth appear in Michelangelo's life to inspire new creations of the same kind.

[16] For Vittoria's letters, see *Carteggio*, IV, pp. 101, 104, and 105.
[17] Condivi, 1746, p. 53.

SELECT BIBLIOGRAPHY

A BIBLIOGRAPHICAL NOTE

The foundations of scholarship concerned with Michelangelo's drawings were laid early in the present century. What may justly be called the first stone was Bernard Berenson's *The Drawings of the Florentine Painters*, published in two volumes in 1903. It contained a long essay on Michelangelo as a draughtsman and a catalogue of just over two hundred and twenty sheets accepted as autograph. In the 1938 second edition, issued in three volumes, the essay remained substantially unchanged, although new footnotes were added. The catalogue was greatly expanded and several appendices relevant for the subject were introduced. Berenson's characterization of Michelangelo as a draughtsman is unlikely to be superseded. I feel the more an obligation to express my esteem for it, in that on a number of significant issues my own views differ from his. His essay remains the text to which every student approaching the subject should first turn. And the reader of this book may note that, where quotations are introduced, these are, almost without exception, from Berenson.

Two more detailed attempts to survey the material followed. One was by Karl Frey, whose book appeared from 1909 to 1911. His catalogue was unfinished, but a supplement dealing with the Haarlem drawings appeared, edited by F. Knapp, in 1925. The other catalogue was made by Henry Thode. It is contained in the third volume of his *Michelangelo, Kritische Untersuchungen über seine Werke*, published in 1913. Thode is little consulted today; nevertheless, of the early critics, he showed a truer understanding of the varieties of Michelangelo's drawing styles than any of his contemporaries. Brinckmann's essay of 1925 was more modest in scope, but the text contains valuable insights.

My own greatest debt in writing this book has been to the studies by Johannes Wilde. His catalogues of the Windsor and British Museum collections reveal an unprecedented understanding of the graphic material, and the drawings are often discussed in a wider context because of his unrivalled knowledge of the written sources. His insights published in these two catalogues can be supplemented by others in a series of articles, many of which are acknowledged in my notes. Without Wilde's writings, much of my discussion would have been the poorer and some features of it impossible.

More recent attempts to study all the material include Dussler's catalogue of 1959, and Hartt's book of 1971. Dussler's text is laborious and contains few useful per-

ceptions. The book contains, however, a serviceable essay on provenance and the history of collecting of Michelangelo's drawings. Hartt's book is lively but frequently misleading in its conclusions, not least in matters of chronology. Tolnay's recent four-volume *Corpus* is of much more value. Its greatest service lies in the fact that, with few exceptions, the drawings are reproduced not only in colour but also to scale. For this, all future students of the subject will be profoundly grateful.

Students of drawings should avoid confining themselves to the study of a single artist or even a single period. No general book on Michelangelo's drawings can compare with that by Julius Held on those of Rubens. But this does not mean that the Michelangelo specialist cannot gain great profit from reading Held's acute and eloquent text.

B. Berenson, *The Drawings of the Florentine Painters*, 2 vols, London, 1903.

B. Berenson, *The Drawings of the Florentine Painters*, 3 vols, Chicago and London, 1938.

A.E. Brinckmann, *Michelangelo-Zeichnungen*, Munich, 1925.

L. Dussler, *Die Zeichnungen des Michelangelo*, Berlin, 1959.

K. Frey, *Die Handzeichnungen Michelagniolos Buonarroti*, 3 vols, Berlin, 1909–11.

F. Hartt, *The Drawings of Michelangelo*, London, 1971.

F. Knapp, *Die Handzeichnungen Michelagniolos Buonarroti*, Berlin, 1925.

A.E. Popham and J. Wilde, *The Italian Drawings of the XV and XVI Centuries ... at Windsor Castle*, London, 1949.

H. Thode, *Michelangelo, Kritische Untersuchungen über seine Werke*, III, Berlin, 1913.

C. de Tolnay, *Corpus dei Disegni di Michelangelo*, 4 vols, Novara, 1975–1980.

J. Wilde, *Italian Drawings in the Department of Prints and Drawings in the British Museum. Michelangelo and his Studio*, London, 1953.

WORKS REFERRED TO IN THE NOTES
IN ABBREVIATED FORM

Agosti and Farinella, 1987: G. Agosti and V. Farinella, *Michelangelo, Studi di antichità dal Codice Coner*, Turin, 1987.

Alberti, *De Pictura*, ed. Grayson, 1972: Leon Battista Alberti, *On Painting and On Sculpture*, ed. C. Grayson, London, 1972.

Annesley and Hirst, 1981: N. Annesley and M. Hirst, ' "Christ and the woman of Samaria" by Michelangelo', *Burlington Magazine*, CXXIII, (1981), pp. 608–14.

Baldinucci, 1765: F. Baldinucci, *Raccolta di alcuni Opuscoli*, Florence, 1765.

Berenson, 1938: B. Berenson, *The Drawings of the Florentine Painters*, 3 vols, Chicago and London, 1938.

Brinckmann, 1925: A.E. Brinckmann, *Michelangelo-Zeichnungen*, Munich, 1925.

Buddensieg, 1975: T. Buddensieg, 'Bernardo della Volpaia und Giovanni Francesco da Sangallo. Der Autor des Codex Coner', *Römisches Jahrbuch für Kunstgeschichte*, XV, (1975), pp. 89–108.

Carteggio, I: *Il Carteggio di Michelangelo*, ed. P. Barocchi and R. Ristori, I. Florence, 1965.

Carteggio, II: *Il Carteggio di Michelangelo*, ed. P. Barocchi and R. Ristori, II, Florence, 1967.

Carteggio, III: *Il Carteggio di Michelangelo*, ed. P. Barocchi and R. Ristori, III, Florence, 1973.

Carteggio, IV: *Il Carteggio di Michelangelo*, ed. P. Barocchi and R. Ristori, IV, Florence, 1979.

Carteggio, V: *Il Carteggio di Michelangelo*, ed. P. Barocchi and R. Ristori, V, Florence, 1983.

Cellini, 1731: B. Cellini, *Due Trattati di Benvenuto Cellini*, Florence, 1731.

Condivi, ed. 1746: A. Condivi, *Vita di Michelagnolo Buonarroti*, ed. A.F. Gori, Florence, 1746.

Corpus: See Tolnay, *Corpus*.

Darr and Bonsanti, 1986: A.P. Darr and G. Bonsanti, *Donatello e i Suoi*, Florence, 1986.

Davidson, 1973: B. Davidson, 'Drawings by Marcello Venusti', *Master Drawings*, XI, (1973), pp. 3–19.

Frey, 1907: K. Frey, *Michelagniolo Buonarroti, Quellen und Forschungen zu seiner Geschichte und Kunst*, I, Berlin, 1907.

Frey, 1930: K. Frey, *Der literarische Nachlass Giorgio Vasaris*, II, Munich, 1930.

Gere and Turner, 1979: J.A. Gere and N. Turner, *Drawings by Michelangelo from the British Museum*, New York, 1979.

Gombrich, 1986: E.H. Gombrich, *New Light on Old Masters*, Oxford, 1986.

Gronau, 1906: G. Gronau, 'Die Kunstbestrebungen der Herzöge von Urbino. II. Michelangelo', *Jahrbuch der Kgl. Preussischen Kunstsammlungen*, XXVII, (1906), Beiheft, pp. 1–11.

Guasti, 1887: C. Guasti, *Santa Maria del Fiore, La Costruzione della Chiesa e del Campanile*, Florence, 1887.

Hartt, 1971: F. Hartt, *The Drawings of Michelangelo*, London, 1971.

Held, 1959: J.S. Held, *Rubens, Selected Drawings*, 2 vols, London, 1959.

Hirst, 1963: M. Hirst, 'Michelangelo Drawings in Florence', *Burlington Magazine*, CV, (1963), pp. 166–71.

Hirst, 1974: M. Hirst, 'A Note on Michelangelo and the Attic of St. Peter's', *Burlington Magazine*, CXVI, (1974), pp. 662–4.

Hirst, 1976: M. Hirst, 'A Project of Michelangelo's for the Tomb of Julius II', *Master Drawings*, XIV, (1976), pp. 375–82.

Hirst, 1981: M. Hirst, Michelangelo in Rome: an altar-piece and the Bacchus', *Burlington Magazine*, CXXIII, (1981), pp. 581–93.

Hirst, 1986 (1): M. Hirst, 'I Disegni di Michelangelo per la Battaglia di Cascina', *Tecnica e Stile*, ed. E. Borsook and F. Superbi Gioffredi, 2 vols, Milan, 1986, pp. 43–58.

Hirst, 1986 (2): M. Hirst, ' "Il Modo delle Attitudini", Michelangelo's Oxford sketchbook for the Ceiling', *The Sistine Chapel, Michelangelo Rediscovered*, London, 1986, pp. 208–17.

Horne, 1908: H.P. Horne, *Alessandro Filipepi, Commonly called Sandro Botticelli, painter of Florence*, London, 1908, (reprinted, Princeton, 1980).

Knab, Mitsch and Oberhuber, 1983: E. Knab, E. Mitsch, and K. Oberhuber, *Raphael, Die Zeichnungen*, Stuttgart, 1983.

Leonardo, ed. McMahon, 1956: *Treatise on Painting (Codex Urbinas Latinus 1270) by*

Leonardo da Vinci, ed. A.P. McMahon, 2 vols, Princeton, 1956.

Marchini, 1977: G. Marchini, 'Il Ballatoio della Cupola di Santa Maria del Fiore', *Antichità Viva*, XVI, (1977), pp. 36–48.

Milanesi, 1875: G. Milanesi, *Le Lettere di Michelangelo Buonarroti pubblicate coi Ricordi ed i Contratti Artistici*, Florence, 1875.

Millon and Smyth, 1975: H. Millon and C.H. Smyth, 'A Design by Michelangelo for a City Gate', *Burlington Magazine*, CXVII, (1975), pp. 162–6.

Oberhuber and Vitali, 1972: K. Oberhuber and L. Vitali, *Raffaello, Il Cartone per la Scuola di Atene*, Milan, 1972.

Panofsky, 1927: E. Panofsky, 'Bemerkungen zu der Neuherausgabe der Haarlemer Michelangelo-Zeichnungen, *Repertorium für Kunstwissenschaft*, XLVIII, (1927), pp. 25 ff.

Pastor, ed. Kerr: L. Pastor, *The History of the Popes from the Close of the Middle Ages*, ed. R.F. Kerr, X, 1938.

Perrig, 1962: A. Perrig, Michelangelo und Marcello Venusti. 'Das Problem der Verkündigungs-und Ölbergs-Konzeption Michelangelos', *Wallraf-Richartz-Jahrbuch*, XXIV, (1962), pp. 261–94.

Popham, 1946: A.E. Popham, *The Drawings of Leonardo da Vinci*, London, 1946.

Popham and Pouncey, 1950: A.E. Popham and P. Pouncey, *Italian Drawings in the Department of Prints and Drawings in the British Museum, The Fourteenth and Fifteenth Centuries*, London, 1953.

Ricordi, 1970: *I Ricordi di Michelangelo*, ed. L. Bardeschi Ciulich and P. Barocchi, Florence, 1970.

Ristori, 1983: R. Ristori, 'Una Lettera a Michelangelo degli Operai di S. Maria del Fiore, 31 luglio 1507', *Rinascimento*, XXIII, (1983), pp. 167–71.

Robinson, 1870: J.C. Robinson, *A Critical Account of the Drawings by Michel Angelo and Raffaello in the University Galleries, Oxford*, Oxford, 1870.

Saalman, 1975: H. Saalman, 'Michelangelo: S. Maria del Fiore and St. Peter's', *Art Bulletin*, LVII, pp. 374–409.

Settimo, 1975: G. Settimo, *Ascanio Condivi, biografo di Michelangelo*, Ascoli Piceno, 1975.

Thode, 1913: H. Thode, *Michelangelo, Kritische Untersuchungen über seine Werke, III, Verzeichniss der Zeichnungen, Kartons und Modelle*, Berlin, 1913.

Tolnay, 1930: C. de Tolnay, 'Zu den späten architektonischen Projekten Michelangelos, I', *Jahrbuch der Preuszischen Kunstsammlungen*, LI, (1930), pp. 1–48.

Tolnay, 1960: C. de Tolnay, *The Final Period*, Princeton, 1960.

Tolnay, *Corpus* I: C. de Tolnay, *Corpus dei Disegni di Michelangelo*, I, Novara, 1975.

Tolnay, *Corpus* II: C. de Tolnay, *Corpus dei Disegni di Michelangelo*, II, Novara, 1976.

Tolnay, *Corpus* III: C. de Tolnay, *Corpus dei Disegni di Michelangelo*, III, Novara, 1978.

Tolnay, *Corpus* IV: C. de Tolnay, *Corpus dei Disegni di Michelangelo*, IV, Novara, 1980.

Varchi, 1549: *Due Lezzioni di M. Benedetto Varchi*, Florence, 1549.

Vasari, ed. Barocchi, 1962: G. Vasari, *La Vita di Michelangelo nelle redazioni del 1550 e del 1568*, ed. P. Barocchi, 5 vols, Milan-Naples, 1962.

Vasari, ed. Milanesi: G. Vasari, *Le vite de'piu eccellenti pittori, scultori ed architettori*, ed. G. Milanesi, 9 vols, Florence, 1878–1885.

Wasserman, 1969: J. Wasserman, 'Michelangelo's Virgin and Child with St. Anne at Oxford', *Burlington Magazine*, CXI, (1969), pp. 122 ff.

Wilde, 1936: J. Wilde, 'Der ursprüngliche Plan Michelangelos zum Jüngsten Gericht', *Die Graphischen Kunst*, N.F.I., (1936), pp. 7 ff.

Wilde, 1944: J. Wilde, 'The Hall of the Great Council of Florence', *Journal of the Warburg and Courtauld Institutes*, VII, (1944), pp. 65–81.

Wilde, 1953: J. Wilde, *Italian Drawings in the Department of Prints and Drawings in the British Museum, Michelangelo and his Studio*, London, 1953.

Wilde, 1954: J. Wilde, *Michelangelo's 'Victory'*, Oxford, 1954.

Wilde, 1957: J. Wilde, 'Notes on the Genesis of Michelangelo's "Leda"', in *Fritz Saxl, Memorial Essays*, London, 1957.

Wilde, 1959: J. Wilde, 'Cartonetti by Michelangelo', *Burlington Magazine*, CI, (1959), pp. 370–81.

Wittkower, 1934: R. Wittkower, 'Michelangelo's Biblioteca Laurenziana', *Art Bulletin*, XVI, (1934), pp. 123–218 (reprinted in R. Wittkower, *Idea and Image, Studies in the Italian Renaissance*, London, 1978, pp. 11–71.

INDEX OF DRAWINGS BY
MICHELANGELO MENTIONED IN
THIS BOOK

OLD TESTAMENT

Studies of David and Goliath, New York,
Pierpont Morgan Library 132a–d, *Corpus* 370r.,
371r., 372r., 373r., 39
Study for the bronze *David*, Paris, Louvre 714r.,
Corpus 19r. 3

NEW TESTAMENT

Annunciation, Florence, Uffizi 229F, *Corpus*
393r. 19, 47, 53, 54 ff.
Annunciation, London, British Museum, Wilde
71r., *Corpus* 394r. 2, 54 ff., 58
Annunciation, London, British Museum, Wilde
71v., *Corpus* 394v. 55
Annunciation, London, British Museum, Wilde
72r., *Corpus* 395r. 2, 55 ff., 58
Angel of *Annunciation*, London, British Museum,
Wilde 72v., *Corpus* 395v. 54–5
Annunciation, New York, Pierpont Morgan
Library IV, 7, *Corpus* 399r. 54 ff.
Study for the Doni *Holy Family* Christ Child,
Florence, Casa Buonarroti 23F, *Corpus* 29r. 70
Cartoon, called *Epiphania*, London, British
Museum, Wilde 75, *Corpus* 389r. 75, 77–8
Christ and the Woman of Samaria, Geneva, M.
Bodmer Foundation 2, 52–3, 55, 117
Christ in the Garden of Gethsemane, Florence, Uffizi
230F, *Corpus* 409r. 19, 41, 47
Studies of sleeping Apostles, Oxford, Ashmolean
Museum, Parker 340, *Corpus* 404r. 40–1
Christ before Pilate, London, Courtauld Institute
Galleries, *Corpus* 101r. 2, 48, 49
The Flagellation of Christ, London, British
Museum, Wilde 15, *Corpus* 73r. 6, 24, 47
The Flagellation of Christ (copy), Windsor, Royal
Library, Popham-Wilde 451 24, 46–7, 80–1
The Three Crosses, London, British Museum,
Wilde 32, *Corpus* 87r. 48–50
Christ on the Cross with the Virgin and St John,
London, British Museum, Wilde 82, *Corpus*
419r. 58
Christ on the Cross with two mourners, Oxford,
Ashmolean Museum, Parker 343, *Corpus*
415r. 58
Christ on the Cross with the Virgin and Nicodemus (?),
Paris, Louvre 700, *Corpus* 414r. 58
Christ on the Cross with the Virgin and St John,

Windsor, Royal Library, Popham-Wilde 436r.,
Corpus 418r. 58
Studies for a Descent from the Cross, Haarlem,
Teylers Museum A25r., *Corpus* 89r. 48–50,
Descent from the Cross, Oxford, Ashmolean
Museum, Parker 342r., *Corpus* 431r. 7
Study for Sebastiano's Ubeda *Pietà*, Florence,
Casa Buonarroti 69Fr., *Corpus* 91r. 39, 61,
69, 70
Study for Sebastiano's Ubeda *Pietà*, Paris, Louvre
716, *Corpus* 92r. 39, 61, 69
Study for a dead Christ, Florence, Casa Buonarroti
46F, *Corpus* 378r. 69
Study for a dead Christ, Switzerland, Private
collection, *Corpus* 382r. 28, 40, 69
Study for the Rondanini *Pietà*, Lille, Musée des
Beaux-Arts, *Corpus* 595v. 4
Studies for the Rondanini *Pietà* and an
Entombment, Oxford, Ashmolean Museum,
Parker 339, *Corpus* 433r. 40
Study for a Mary in the London *Entombment*,
Paris, Louvre 726r., *Corpus* 31r. 5, 6, 63–4
Study for a figure in the London *Entombment*,
Paris, Louvre 689r., *Corpus* 23r. 64
Studies for an Entombment (copy), Private
collection 2, 40, 69
The Resurrection of Christ, London, British
Museum, Wilde 52, *Corpus* 258r. 15
Study for a soldier in the Windsor *Resurrection*,
Florence, Casa Buonarroti 32F, *Corpus*
254r. 27
The Resurrection of Christ, Windsor, Royal Library,
Popham-Wilde 427r., *Corpus* 255r. 15
Study of a Resurrected Christ, (verso of the
Tityus), Windsor, Royal Library, Popham-
Wilde 429v., *Corpus* 345v. 113, 115
Studies for the Sopra Minerva marble *Christ*,
London, Coll. Brinsley Ford, *Corpus* 94r. 26,
63, 68
Christ appearing to His Mother, Oxford, Ashmolean
Museum, Parker 345, *Corpus* 400r. 53
Study of the Baptist in the wilderness, Florence,
Casa Buonarroti 19Fr., *Corpus* 368r. 38–9
Study for a marble *Apostle*, Florence, Uffizi
233Fr., *Corpus* 37r. 3
Studies for a marble *Apostle*, London, British
Museum, Wilde 3r., *Corpus* 36r. 3
Cartoon for the *Crucifixion of St Peter*, Naples,

Galleria Nazionale di Capodimonte, Inv. 398, *Corpus* 384r. 75–7

VIRGIN AND CHILD

Cartoon of the *Madonna and Child*, Florence, Casa Buonarroti 71F, *Corpus* 239r. 75 n.10

Head study for the Virgin (Doni tondo), Florence, Casa Buonarroti 1Fr., *Corpus* 158r. 72–3

Studies of a Virgin and Child, Florence, Uffizi 233Fr., *Corpus* 37r. 5, 32–5, 37

Study for the Bruges *Madonna and Child*, London, British Museum, Wilde 5r., *Corpus* 46r. 27, 33–4

Sketch of a Virgin and Child, London, British Museum, Wilde 31r., *Corpus* 240r. 8 n.10

The Virgin, Child and St Anne, Oxford, Ashmolean Museum, Parker 291r., *Corpus* 17r. 26

Studies of a Virgin and Child, Paris, Louvre 689v., *Corpus* 23v. 33

Study of a Virgin and Child, Vienna, Albertina Inv. 118, R. 152v., *Corpus* 22v. 33

SISTINE CEILING

Sketch for the general scheme, London, British Museum, Wilde 7r., *Corpus* 119r. 71, 80

Sketch for the general scheme, Detroit, Institute of Arts 27.2r., *Corpus* 120r. 6, 80

Studies for the *Creation of Adam*, London, British Museum, Wilde 11r., *Corpus* 134r. 2

Study for Adam in the *Expulsion*, Florence, Casa Buonarroti 45F, *Corpus* 131r. 27, 61

Studies for the *Drunkenness of Noah*, Rotterdam, Boymans Museum I, 513v., *Corpus* 121r. 71

Studies for *Haman*, Haarlem, Teylers Museum A16r., *Corpus* 164r. 2, 25, 70–1, 102

Studies for *Haman*, London, British Museum, Wilde 13r., *Corpus* 163r. 2, 25, 61, 67–8,

Study for Haman's left foot, London, British Museum, Wilde 14, *Corpus* 165r. 71

Study for *Judith and Holofernes*, Haarlem, Teylers Museum A18v., *Corpus* 51v. 21, 42, 45–6, 49

Drapery study for the *Erythraean Sybil*, London, British Museum, Wilde 10r., *Corpus* 154r. 71

Study for putto of the *Libyan Sibyl*, Oxford, Ashmolean Museum, Parker 297r., *Corpus* 157r. 25

Study for the head of Zechariah, Florence, Uffizi 18718Fr., *Corpus* 153r. 72

Studies for *Ignudi* and of an architectural detail, Florence, Casa Buonarroti 75F, *Corpus* 145r. 35, 91

Study of an *Ignudo*'s head and of other details, Haarlem, Teylers Museum A20r., *Corpus* 135r. 72

Study for an *Ignudo*, Haarlem, Teylers Museum A27r., *Corpus* 136r. 72

Studies for *Ignudi*, Haarlem, Teylers Museum A27v., *Corpus* 136v. 35

Study for an *Ignudo*, London, British Museum, Wilde 8r., *Corpus* 139r. 27–8, 67

Study for an *Ignudo*, Paris, Louvre 860v., *Corpus* 143r. 67

Study for an *Ignudo*, Vienna, Albertina Inv. 120, R. 142r., *Corpus* 144r. 30, 61, 67

Studies for lunettes, Oxford, Ashmolean Museum, Parker 300r., *Corpus* 167r. 36

Studies for lunettes, Oxford, Ashmolean Museum, Parker 300v., *Corpus* 167v. 36

Studies for lunettes and *God Dividing Light from Darkness*, Oxford, Ashmolean Museum, Parker 301r., *Corpus* 168r. 37

Studies for lunettes, Oxford, Ashmolean Museum, Parker 302r., *Corpus* 169r. 36

Studies for lunettes, Oxford, Ashmolean Museum, Parker 303v., *Corpus* 170v. 36

Study for the Naasson lunette, Oxford, Ashmolean Museum, Parker 305r., *Corpus* 172v. 36

LAST JUDGMENT

Compositional study, Bayonne, Musée Bonnat 1217, *Corpus* 346r. 50–1

Compositional study, Florence, Casa Buonarroti 65Fr., *Corpus* 347r. 50–2

Study for St Lawrence, Haarlem, Teylers Museum A23r., *Corpus* 357r. 30, 61, 68–9

Sketch for St Lawrence, Vatican, Codex Vat. Lat. 3211, fol. 88v., *Corpus* 356v. 38–9

Studies for lower part of the fresco, Windsor, Royal Library, Popham-Wilde 432r., *Corpus* 351r. 38

BATTLE OF CASCINA

Compositional drawing, Florence, Uffizi 613Er., *Corpus* 45r. 6, 42–5, 50, 51, 65–6

Studies for the cartoon, London, British Museum, Wilde 5r., *Corpus* 46r. 8, 33, 43

Studies for the cartoon, London, British Museum, Wilde 5v., *Corpus* 46v. 8, 43

Figure study for the cartoon, Florence, Casa Buonarroti 73Fr., *Corpus* 49r. 16, 22, 26, 65–7

Figure study for the cartoon, Florence, Uffizi 233Fr., *Corpus* 37r. 34, 43

Figure study for the cartoon, Haarlem, Teylers Museum A19r., *Corpus* 50r. 21, 66

Figure study for the cartoon, Haarlem, Teylers Museum A18r., *Corpus* 51r. 21, 45, 66

Figure study for the cartoon, London, British Museum, Wilde 6r., *Corpus* 52r. 25, 26, 67,

Figure study for the cartoon, Paris, Louvre 713r., *Corpus* 54r. 66

Figure study for the cartoon, Paris, Louvre 718r., *Corpus* 47r. 43

Figure study for the cartoon, Vienna, Albertina Inv.123, R.157v., *Corpus* 53v. 25, 44, 66–7

Studies of a horse, Oxford, Ashmolean Museum, Parker 293r., *Corpus* 102r. 11

A battle scene, Oxford, Ashmolean Museum, Parker 294, *Corpus* 103r. 45, 48

TOMB OF POPE JULIUS II

Modello for the tomb, East Berlin, Staatliche Museum 81–2, 94

Modello for the tomb (copy), East Berlin, Staatliche Museum 3, 38, 82, 94

Sketch for effigy of the Pope, Florence, Casa Buonarroti 43Av., *Corpus* 501v. 3

Modello for the tomb (fragment), Florence, Uffizi 608Er., *Corpus* 56r. 82–3

Studies for the Victory group, Haarlem, Teylers
 Museum A19v., *Corpus* 50v. 21
Modello for the tomb, New York, Metropolitan
 Museum 62–931, *Corpus* 489r. 3, 82, 91–2, 94
Small studies for Slaves, Oxford, Ashmolean
 Museum, Parker 297r., *Corpus* 157r. 25, 37–8
Study for a Slave, Paris, Ecole des Beaux-Arts
 197r., *Corpus* 62r. 3, 18

SAN LORENZO FACADE

Groundplan of the façade, Florence, Archivio
 Buonarroti I, 157, fol.280, *Corpus* 502r. 96
Groundplan of the façade, Florence, Casa Buonar-
 roti 77Av., *Corpus* 505v. 96
Study for the façade, Florence, Casa Buonarroti
 43Ar., *Corpus* 501r. 98
Study for the façade, Florence, Casa Buonarroti
 91Ar., *Corpus* 499r. 98
Elevation study for lower storey bay, Florence,
 Casa Buonarroti 100A, *Corpus* 560r. 99
Modello for the façade, Florence, Casa Buonarroti
 45A, *Corpus* 497r. 48, 79, 81, 83
Drawing for the wooden model of the façade,
 versos of Casa Buonarroti 71Ar., 49Ar., and
 British Museum, Wilde 25r. 97, 103
Drawings of blocks for the façade, Florence,
 Archivio Buonarroti I, 144–5, fols 260v.–261r.,
 Corpus 450–1 75, 104

SAN LORENZO NEW SACRISTY

Study for the interior of the cupola, Florence,
 Casa Buonarroti 127A, *Corpus* 206r. 24, 84
Studies of tombs, Florence, Casa Buonarroti
 71Ar., *Corpus* 183r. 97, 99, 103
Studies of tombs, Florence, Casa Buonarroti
 49Ar., *Corpus* 182r. 97, 99, 103
Studies of tombs, London, British Museum,
 Wilde 25r., *Corpus* 184r. 97, 99, 103
Elevation design for a ducal tomb, London,
 British Museum, Wilde 27r., *Corpus* 185r. 99
Plans and elevations for the attic of the ducal
 tombs, Florence, Casa Buonarroti 72A, *Corpus*
 199r. 97
Studies of base profiles for the ducal tombs,
 Florence, Casa Buonarroti 9Ar. and 10Ar.,
 Corpus 202r. and 201r. 95–6, 102
Template for base profile of the Magnifici tomb,
 Florence, Casa Buonarroti 59Ar., *Corpus*
 204r. 90, 102
Study for *Day*, Haarlem, Teylers Museum A30r.,
 Corpus 216r. 62–3
Study for *Day*, Oxford, Ashmolean Museum,
 Parker 309r., *Corpus* 213r. 61–3
Studies for the right arm of *Night*, Oxford,
 Ashmolean Museum, Parker 309v., *Corpus*
 213v. 62
Drawings of blocks for the New Sacristy, Florence,
 Archivio Buonarroti I, 82, fol. 223, *Corpus*
 467r. 74–5
Drawings of block for a River-god, London,
 British Museum, Wilde 35r., *Corpus* 227r. 74

SAN LORENZO LIBRARY

Site plan drawing for the location of the Library,
 Florence, Casa Buonarroti 9Av. and 10Av.,
Corpus 202v. and 201v. 90, 95, 96
Sketch of properties in the neighbourhood of San
 Lorenzo, Florence, Casa Buonarotti 81A,
 Corpus 543r. 24
Plan and elevation of the vestibule, Florence,
 Archivio Buonarroti I, 80, fol. 219, *Corpus*
 523r. 96–7
Elevational study for the vestibule, Florence, Casa
 Buonarroti 89Ar., *Corpus* 524r. 99–100
Study for the reading-room exterior door,
 Florence, Casa Buonarroti 98A, *Corpus*
 550r. 83
Study for the reading-room interior door,
 Florence, Casa Buonarroti 111A, *Corpus*
 555r. 31, 84, 87
Groundplan of rare-book room, Florence, Casa
 Buonarroti 80A, *Corpus* 560r. 29, 85–6
Full-scale drawings for the reading-room
 windows, San Lorenzo, New Sacristy 91,
 103–4

OTHER ARCHITECTURAL PROJECTS

Study for an altar, Oxford, Christchurch Inv.
 0992r., *Corpus* 280r. 28
Studies, perhaps for the *ballatoio* of Florence
 Cathedral, Florence, Uffizi 1872Fr., *Corpus*
 317r. 92
Sketches for a wall tomb, Florence, Casa
 Buonarroti 114Av., *Corpus* 176v. 97
Study for an unidentified wall elevation, Florence,
 Casa Buonarroti 40Ar., *Corpus* 177Ar. 28
Elevational design for the tombs of Popes Leo X
 and Clement VII, Florence, Casa Buonarroti
 128A, *Corpus* 279r. 100
Unfinished *modello* for the tombs of Popes Leo X
 and Clement VII, Florence, Casa Buonarroti
 116A, *Corpus* 190r. 100–1
Study for a papal wall tomb, Florence, Casa
 Buonarroti 52A, *Corpus* 188r. 85
Groundplan of San Giovanni de'Fiorentini,
 Florence, Casa Buonarroti 120A, *Corpus*
 610r. 86–8
Groundplan of San Giovanni de'Fiorentini,
 Florence, Casa Buonarroti 121A, *Corpus*
 609r. 29, 86–8
Groundplan of San Giovanni de'Fiorentini,
 Florence, Casa Buonarroti 124Ar., *Corpus*
 612r. 86–8
Site plan of St Peter's, Vatican, Codex Vat. Lat.
 3211, fol. 92, *Corpus* 592r. 95–6
Studies for the cupola of St Peter's, Haarlem,
 Teylers Museum A29r., *Corpus* 596r. 102
Studies for the drum and cupola of St Peter's, Lille,
 Musée des Beaux-Arts Inv. 93–4, *Corpus*
 595r. 28–9, 94, 101–2
Studies for St Peter's, Lille, Musée des Beaux-Arts
 Inv. 93–4, *Corpus* 595v. 28–9, 101–2
Study for the Porta Pia, Florence, Casa Buonarroti
 73A bis, *Corpus* 615r. 88–90
Study for the Porta Pia, Florence, Casa Buonarroti
 97Ar., *Corpus* 616r. 88
Study for the Porta Pia, Florence, Casa Buonarroti
 102A, *Corpus* 618Ar. 88–90
Study for the Porta Pia, Florence, Casa Buonarroti
 106A, *Corpus* 619r. 31, 88–90

Studies, probably for the Porta Pia, Florence, Casa Buonarroti 97Ar., *Corpus* 616r. 98–9
Small study for gate, Haarlem, Teylers Museum A29 bis, *Corpus* 621r. 98
Sheet of studies, perhaps for the Sforza Chapel, Casa Buonarroti 109A, *Corpus* 625r. 98
Study for the Vatican Belvedere staircase, Casa Buonarroti 19Fr., *Corpus* 368r. 98

PRESENTATION DRAWINGS

Archers shooting at a Herm, Windsor, Royal Library, Popham-Wilde 424, *Corpus* 336r. 111–13
Childrens' Bacchanal, Windsor, Royal Library, Popham-Wilde 431, *Corpus* 338r. 73, 111, 115–16
Christ on the Cross, London, British Museum, Wilde 67, *Corpus* 411r. 117–18
Cleopatra, Florence, Casa Buonarroti 2F, *Corpus* 327r. 56, 111, 116–17
The Fall of Phaethon, London, British Museum, Wilde 55, *Corpus* 340r. 113–14
The Fall of Phaethon, Venice, Accademia 177r., *Corpus* 342r. 51, 114–15
The Fall of Phaethon, Windsor, Royal Library, Popham-Wilde 430r., *Corpus* 343r. 23–4, 111 ff.
Fury, Florence, Uffizi 601E, *Corpus* 306r. 107–9
Head of a Young Man, Oxford, Ashmolean Museum, Parker 315, *Corpus* 323r. 108
Ideal Head of a Woman, London, British Museum, Wilde 42r., *Corpus* 316r. 117
Pietà, Boston, Isabella Stewart Gardner Museum, *Corpus* 426r. 56, 117
The Rape of Ganymede, Cambridge, Mass., Fogg Art Museum 1955:75, *Corpus* 344r. 11, 112
Three Heads, Florence, Uffizi 599Er., *Corpus* 308r. 107–9
The Labours of Hercules, Windsor, Royal Library, Popham-Wilde 423r., *Corpus* 335r. 107, 110–11
Tityus, Windsor, Royal Library, Popham-Wilde 429r., *Corpus* 345r. 11, 24, 111, 112–13, 115
Venus, Mars and Cupid (the so-called *Zenobia*), Florence, Uffizi 598Er., *Corpus* 370r. 107–9

MYTHOLOGY AND ALLEGORY

Study for *Aeneas and Dido*, Haarlem, Teylers Museum A32r., *Corpus* 376r. 39–40
Study for *Aeneas and Dido*, London, Courtauld Institute Galleries, *Corpus* 377r. 39–40
Study for the *Childrens' Bacchanal*, Bayonne, Musée Bonnat 650v., *Corpus* 337v. 115
Grotesque heads, London, British Museum, Wilde 33r., *Corpus* 236r. 74
Grotesque head, Windsor, Royal Library, Popham-Wilde 425r., *Corpus* 236 bis r. 74
Study for the *Leda*, Florence, Archivio Buonarroti XIII, fols 150–1, *Corpus* 207 bis v. 22 n.1
Studies for the head of Leda, Florence, Casa Buonarroti 7F, *Corpus* 301r. 73–4
Head of a satyr, Paris, Louvre 684r., *Corpus* 95r. 23, 74
Venus and Cupid, London, British Museum, Wilde 56, *Corpus* 302r. 27

FIGURE STUDIES

Study of a reclining figure, Florence, Casa Buonarroti 44F, *Corpus* 299r. 14, 70
Study of a reclining figure, Florence, Casa Buonarroti 48F, *Corpus* 28r. 70
Study of a seated man, Paris, Louvre 722, *Corpus* 30r. 64
Study of a nude man, Vienna, Albertina Inv. 118, R.132v., *Corpus* 22r. 64–5
Male nude, Paris, Louvre 1068v., *Corpus* 21r. 8 n.10
Ecorché studies, Haarlem, Teylers Museum A39v., *Corpus* 111v. 14
Ecorché, Windsor, Royal Library, Popham-Wilde 440, *Corpus* 113r. 14
Ecorché, Windsor, Royal Library, Popham-Wilde 442, *Corpus* 106r. 14

GENRE STUDIES

Figure studies, Haarlem, Teylers Museum A22r., *Corpus* 10r. 8
Girl seated in a chair, London, British Museum, Wilde 40, *Corpus* 315r. 10
An old woman and a child, Oxford, Ashmolean Museum, Parker 324, *Corpus* 100r. 11
Three men conversing, Oxford, Ashmolean Museum, Parker 326, *Corpus* 9r. 11
Study of an old man with dog, leaf of Sistine notebook, Oxford, Ashmolean Museum, Parker 304r., *Corpus* 171r. 10, 36
Study of a sleeping monk, Windsor, Royal Library, Popham-Wilde 422r., *Corpus* 99r. 10–11

PORTRAIT DRAWINGS

Portrait of a young child, Haarlem, Teylers Museum K153r., *Corpus* 330r. 11
Portrait of Andrea Quaratesi, London, British Museum, Wilde 59, *Corpus* 329r. 11, 111
Self-portrait, Paris, Louvre 2715, *Corpus* 118r. 12

COPIES AFTER OTHER WORKS

Studies of an antique relief, Windsor, Royal Library, Popham-Wilde 422r., *Corpus* 99r. 11, 61
Study of an antique Venus, Florence, Casa Buonarroti 16F, *Corpus* 234r. 61
Study of an antique Venus, Florence, Casa Buonarroti 41F, *Corpus* 231r. 61
Study of an antique Venus, London, British Museum, Wilde 43, *Corpus* 232r. 61
Study of an antique Venus, London, British Museum, Wilde 44, *Corpus* 233r. 61
Copies from the Codex Coner, Florence, Casa Buonarroti 8A, *Corpus* 512r. 7, 88, 92–4
Copy from the Codex Coner, London, British Museum, Wilde 18r., *Corpus* 561r. 7, 88, 92–4
Study after Donatello's marble *David*, Florence, Uffizi 233Fv., *Corpus* 37v. 5, 7, 60–1
Study after Giotto's *Ascension of St John the Evangelist*, Paris, Louvre 706r., *Corpus* 3r. 4–5, 59–60, 71
Study after Masaccio's *Tribute Money*, Munich, Graphische Sammlung 2191, *Corpus* 4r. 59

Study, probably after Masaccio's *Consecration of
the Carmine*, Vienna, Albertina Inv. 116,
R.150r., *Corpus* 5r. 59–60, 71

DRAWING LESSONS

Drawing lesson, Florence, Uffizi 598Ev., *Corpus*
307v. 13–14

Drawings of head and eyes, Oxford, Ashmolean
Museum, Parker 323v., *Corpus* 96v. 13–14

DRAWING FOR TABLEWARE

Design for a salt-cellar, London, British Museum,
Wilde 66, *Corpus* 437r. 7, 13, 24, 94

GENERAL INDEX

Ackerman, J.S. 99 n.5
Agosti, G. 93 n.2
Alberti, Leon Battista 78
 De pictura 78 n.1
Altoviti, Bindo 105
Annesley, N. 52 n.8
Aretino, Pietro 17, 117

Baccio d'Agnolo 92
Baldinucci, Filippo 32
Bandinelli, Baccio 19, 48, 106
Barocci, Federico 118
Beatrizet, Nicholas 8
Belli, Valerio 12
Berenson, B. 1, 2, 4, 12, 27, 28, 30, 48, 83, 112
Bologna 92
 San Petronio 83
Bonsanti, G. 105 n.1
Borromeo G., agent of Federico Gonzaga 18
Borromini, Francesco 86
Bos, Cornelis
 engraving after Michelangelo's *Leda* 73
Botticelli, Sandro 10
 drawing of *Abundance* 106
Bramante, Donato
 design for St Peter's cupola recorded by
 Serlio 101
Brinckmann, A.E. 114 n.13
Bruges, Notre-Dame 33
Brunelleschi, Filippo 96, 100
Buddensieg, T. 93 n.2
Buonarroti, Leonardo 16, 19
Buonarroti, Lodovico 18, 20
Buonarroti, Michelangelo, see Michelangelo

Calcagni, Tiberio 14, 87
Carrara 9, 20, 74
Casa, Giovanni della 39
Cavalieri, Tommaso de' 24, 46, 53, 54, 56, 77,
 107, 111–17
 lost portrait of 11–12
Cellini, Benvenuto 14
Cesi, Cardinal Federico 54
Chellini, Giovanni 105
Christina, Queen of Sweden 21
Codex Coner, see London, Soane Museum
Colonna, Vittoria 52, 56, 107, 117–18
 drawing of *Christ on the Cross*, 57, 117–18

Condivi, Ascanio 4, 10 n.2, 14, 75, 77–8, 80–1,
 91, 117–18
Correggio, Antonio da 9

Daniele Ricciarelli da Volterra 13, 19, 38ff., 41,
 49, 54, 56
Darr, A.P. 105 n.1
Davidson, B. 2 n.4
Donatello
 bronze *David* 3, 60
 Judith pedestal reliefs 116
 marble *David* 5, 60
 roundel for G. Chellini 105
Dürer, Albrecht 10, 27, 104

Elam, C. 95 n.3
El Greco 118
Este, Alfonso d', Duke of Ferrara 20, 109

Farinelli, V. 93 n.2
Ferrara 109, 116
Florence 17, 20
 Cathedral 104
 Cathedral Operai 92
 SS. Annunziata 104
Fra Bartolommeo
 early drapery studies 71
 landscape drawings 9
 Last Judgment studies 6
 St Jerome study (Uffizi) 5
Frey, K. 56 n.11
Fuseli, J.H. 108

Gere, J.A. 2 n.5, 55 n.9
Ghiberti, Lorenzo
 Baptist before Herod (Siena Font) 48
 Creation of Eve (Florence Baptistry) 15
Ghirlandaio, Domenico 4, 5, 26, 34, 46, 59, 60,
 64, 72
 Study for *Birth of the Virgin* 50
 Study of Two Figures 4
Giambologna 118
Giotto 60, 93, 118
 Ascension of St John the Evangelist,
 (S. Croce) 59
Giovio, Paolo 83
Giulio Romano 2, 19
Gombrich, E.H. 77 n.13

Gonzaga, Federico, Marquis, later Duke, of
 Mantua 12, 18, 19 n.6
Grimani, Domenico 49
Gronau, G. 8 n.9
Guasti, C. 104 n.11

Hartt, F. 56 n.10
Held, J.S. 32 n.2
Hirst, M. 25 n.7, 27 n.9, 35 n.5, 52 n.8, 63 n.2,
 102 n.8
Horne, H. 104–5

Julius II, Pope 80

Knab, E. 105 n.2

Leo X, Pope 81, 91, 92, 98, 100
Leonardo da Vinci
 architectural drawings 94
 Battle of Anghiari 25, 34, 65–6, 72
 Battle of Anghiari drawings 34
 cartoon at SS. Annunziata 6, 26
 chalk drapery studies 72
 chalk drawing style 66
 landscape drawing (Uffizi) 9, 22
 Neptune drawing for Segni 106
 Neptune drawing at Windsor 106, 108
 painting of *Furia* 108
 use of black chalk 7
 views on landscape 10
 Windsor study for *Last Supper* 34
Lippi, Filippino 43
Lippi, Filippo 23
Lombardo, Tullio 65
London
 National Gallery *Entombment* 63–4
 Soane Museum, Codex Coner 92ff.

Mantegna, Andrea 105, 108
 presentation drawings 105–6
Mantua 19
Marchini, G. 92 n.1
Mariette, P.-J. 23, 32 n.2
Masaccio 93
 Consecration of the Carmine 60
 Tribute Money (Brancacci Chapel) 59
Meder, J. 4 n.8
Medici, Cosimo de', Duke of Florence 19, 29,
 54, 56, 87, 116
Medici, Francesco de' 107
Medici, Giuliano de', Duke of Nemours 102
Medici, Giulio de' (from 1523, Pope Clement
 VII) 29, 50ff., 80–1, 83ff., 91, 100–1, 104,
 112, 114
Medici, Ippolito de' 112
Michelangelo *passim*
 assistants 2, 13
 cartoons 17, 46, 53, 54ff., 75ff.
 clay models 4, 76
 collaboration with Daniele da Volterra
 38ff., 54
 collaboration with Marcello Venusti 54ff.,
 56
 collaboration with Sebastiano del Piombo
 39, 46ff.
 drawing lessons 13–14

drawings lost through theft 18
drawing media 5ff.
drawings on the wall 103–4
destruction of drawings 17ff.
écorché drawings 14–15
Florence workshop 16
genre subjects 10–11
landscape, neglect of 10
long-sightedness 8
male models 73–4
modelli (demonstration drawings) 29, 50,
 79ff.
movement of drawings during lifetime
 20–1, 84
poetry 58
problems in dating drawings 23ff., 27ff.
rarity in use of squaring 8
rarity of portraiture 11–12
ricordi 16, 20, 22, 35, 62
Rome workshop 17, 54, 56
self-portraiture 11ff.
self-protectiveness 18
survival of drawings 17ff.
technique of 'presentation drawings'
 112–13
use of orthogonal projection 94, 103
use of stylus 43ff., 47, 86
Michelangelo works
 Apostles (for Florence Cathedral) 3
 Bacchus 63
 Battle of Cascina (cartoon, destroyed) 4, 76
 destruction of 19
 Mantuan and Turin fragments 19–20
 scale of figures 20
 Holkham Hall copy of 11, 34, 43ff., 66,
 72
 Battle of Cascina (mural, unexecuted) 24, 25,
 34, 42ff., 80
 Battle of the Centaurs 42, 61
 bronze statue of Pope Julius II (destroyed)
 12, 92
 Christ with Instruments of the Passion (Rome,
 S. Maria sopra Minerva) 26, 47, 63, 68
 Christ taking leave of his Mother (cartoon,
 lost) 53, 77
 David (bronze, destroyed) 3
 David (marble) 34, 72
 Dawn (Medici Chapel) 16
 Day (Medici Chapel) 16, 62–3
 Descent from the Cross (stucco relief, Casa
 Buonarroti) 49–50
 Doni tondo 38, 45, 72, 75
 Dying Slave (Louvre) 82, 104
 Entombment (London, National Gallery)
 5, 63–4, 75
 Evening (Medici Chapel) 16
 façade, San Lorenzo, Florence (unexecuted)
 28, 42, 46, 75, 79, 92ff., 95, 100, 103, 104.
 four Slaves (Florence, Accademia) 37–8
 Hercules and Cacus (unexecuted marble group)
 109
 Leah 53
 Leda and the Swan (destroyed) 20, 73, 75,
 109–10
 Library, San Lorenzo, Florence 92, 95ff.,
 100, 103–4

Last Judgment 7, 8, 12, 24, 25–7, 36, 38, 42, 69, 80, 114
 modello for fresco 80, 83
 St Catherine 38
 St Lawrence 30, 38
 St Sebastian 111 n.10
Madonna and Child (Bruges) 23, 27, 33–4, 68
Medici Chapel (New Sacristy), San Lorenzo, Florence 91, 94, 102–3
Night (Medici Chapel) 16, 20, 62–3
Noli Me Tangere (cartoon, lost) 53
Palestrina *Pietà* 40
Pauline Chapel murals 11, 17, 52, 69
 Crucifixion of St Peter 58, 75
Pietà (St Peter's) 63
Pitti tondo 33
Porta Pia 28, 88ff., 98ff., 101
Rape of Ganymede (drawing, lost) 111, 112–13
Rebellious Slave (Louvre) 18, 37, 82, 104
Rondanini *Pietà* 4, 12, 29, 40, 90
San Giovanni de' Fiorentini (unexecuted) 85–8
Sforza Chapel, Santa Maria Maggiore 98
Sistine ceiling 24–5, 46, 67ff.
 Aminadab lunette 36
 architectural framework 91
 Creation of Adam 77
 chronology 35ff.
 current restoration 77
 Delphic Sibyl 27
 Drunkenness of Noah 45
 Haman 38, 46
 Ignudi 27–8
 Isaiah 55
 Jesse-David-Solomon lunette 36
 Judith and Holofernes 45ff.
 Naasson lunette 36
 Persian Sibyl 30
 programme 80
 Roboam-Abia lunette 36
 Salmon-Booz-Obed lunette 36
 Worship of Brazen Serpent 110
 Zechariah 72
Sleeping Cupid (marble, lost) 4
Taddei tondo 33
Tomb of Pope Julius II 3, 13, 20, 25, 37, 42, 53, 75, 80–2, 91, 94
Millon, H. 102 n.8
Mini, Antonio 14, 23, 76
Mitsch, E. 105 n.2
Montelupo, Raffaello da 70

Oberhuber, K. 76 n.11, 105 n.2
Ovid
 Metamorphoses 113–15

Panofsky, E. 77 n.12
Parmigianino 11, 15
 Altarpiece with the Baptist and St Jerome (London) 33
 Woman seated at a table (drawing in Budapest) 10
Pastor, L. 50 n.5
Paul III, Pope 69, 80
Perini, Gherardo 107ff.

Perrig, A. 2 n.4
Perugino, Pietro
 Sistine Chapel altarpiece 51–2
Peruzzi, Baldassare 83, 87
Pierino da Vinci 7
Pius IV, Pope 88
Pisano, Giovanni 55
Pole, R. (Cardinal) 117
Polidoro da Caravaggio
 Two women in a landscape (drawing, Montpellier, Musée Atger) 10
Pollaiuolo, Antonio
 paintings of Hercules in Palazzo Medici 110
Pontormo, Jacopo 9, 27, 53, 75
Popham, A.E. 106 n.6, 108, n.9
Popp, A.E. 3 n.6
Pouncey, P. 108 n.9
Pucci, Lorenzo (Cardinal) 12

Quaratesi, Andrea 11, 107, 111

Raphael 2, 15, 37
 assistants 2
 cartoon for the *School of Athens* (Milan) 76
 drawings for Stanza della Segnatura 16 n.1
 Madonna del Cardellino 34
 present for Dürer 105
 sketches of prophets and sibyls (Oxford) 37
Raimondi, Marcantonio 13
Reni, Guido 118
Reynolds, Joshua 39
Ristori, R. 92 n.1
Robinson, J.C. 1
Rocchetti, Jacopo 94
Rome
 Arch of Constantine 94
 Arch of Septimius Severus 94
 Belvedere court staircase (Vatican) 98
 Campidoglio 21, 95, 100
 Golden House of Nero 111
 San Giovanni in Laterano 56, 87
 Santa Maria della Pace 37, 52, 56
 San Pietro in Montorio 21
 Sistine Chapel (Vatican) 51–2
 St Peter's (Vatican) 28, 95–6, 101–2
 Theatre of Marcellus 93
Rosso Fiorentino 7
 Descent from the Cross (Volterra) 50
 Fury (engraving) 109
 Marriage of the Virgin (Florence, San Lorenzo) 109
Rovere, Francesco Maria della, Duke of Urbino 8, 13, 24
Rubens, Peter Paul 10, 19, 20, 32, 118

Saalman, H. 101 n.6
Sangallo family 93
Sangallo, Antonio da (the younger) 87
Sangallo, Giuliano da
 modello for the San Lorenzo façade 83
Sarto, Andrea del 6, 9, 20
Sebastiano del Piombo 2, 6, 12, 13, 18, 24, 42, 49, 75, 113
 Flagellation of Christ 38, 46–7
 Pietà (Ubeda) 39, 61, 68–9

Pietà (Viterbo) 46
Segni, Antonio 106
Serlio, Sebastiano 101
Settimo, G. 77 n.13
Signorelli, Luca 66
Smyth, H.C. 102 n.8
Steinmann, E. 27–8
Strozzi, Ruberto degli 105
Symonds, J.A. 58 n.14, 113

Thode, H. 2 n.3, 71 n.7
Titian 15, 90, 109
 Andrians 109
 Bacchus and Ariadne 109
 St Sebastian (Brescia) 18
 Worship of Venus 109, 116
Tivoli
 Temple of Vesta 94
Tolnay, C. de 1, 16, 26, 57 n.13, 98 n.4, 99 n.5

Turner, N. 2 n.5, 55 n.9

Varchi, Benedetto 9, 27
Vasari, Giorgio 7, 11, 18, 19, 23, 39, 46, 52,
 56, 75, 81, 85, 88, 105, 106–8, 109, 111, 113,
 116, 117–18
 1568 Preface to Painting 32
Venusti, Marcello 2, 41, 42, 52, 56, 57
Vitali, L. 76 n.11

Wasserman, J. 26 n.8
Wicar, J.B. 57
Wilde, J. 3, 22 n.1, 26, 34, 45 n.1, 52 n.7,
 56 n.12, 62 n.1, 70 n.6, 77 n.12, 93 n.2, 106,
 112, 116
Wittkower, R. 99 n.5

Zervas, D. 68 n.5
Zoppo, Marco 108 n.9

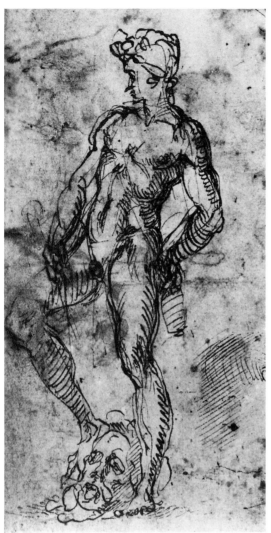

1 Study for the bronze *David* (detail), Paris, Louvre.

2 Study for an *Apostle*, detail of pl. 32.

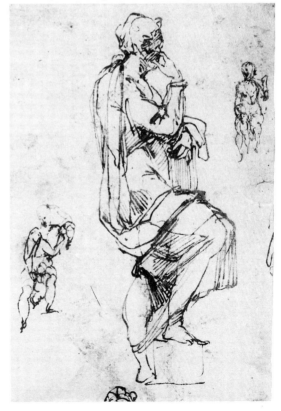

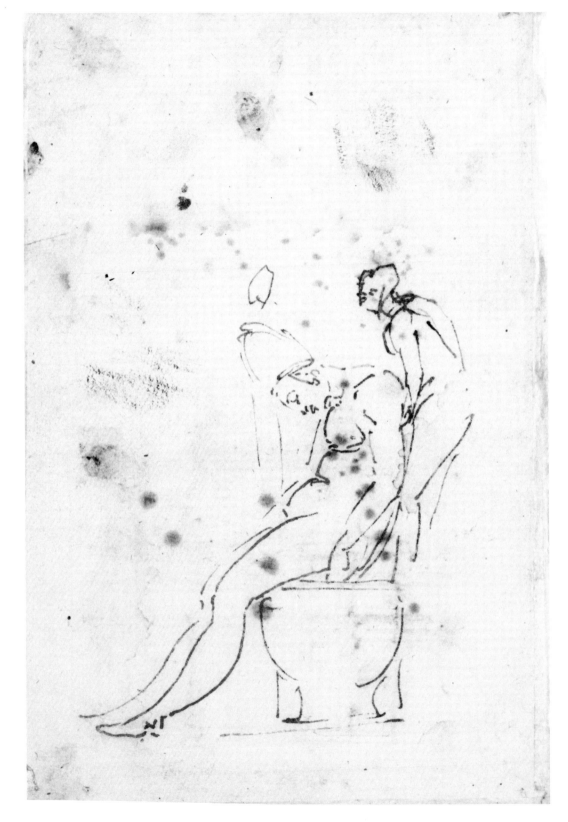

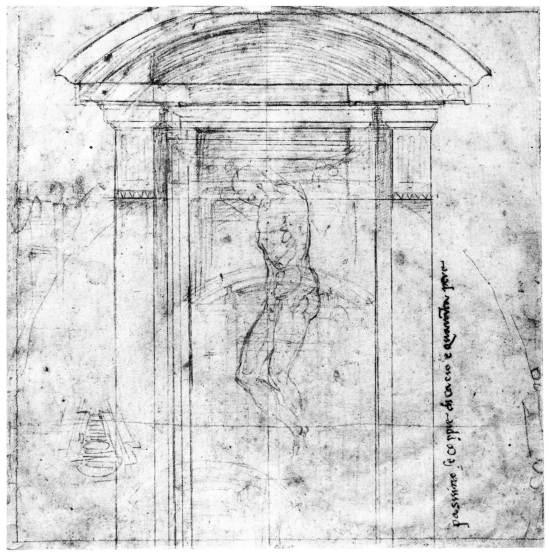

4 Studies of architecture and for a dead Christ, Lille, Musée des Beaux-Arts.

3 Study for the Tomb of Pope Julius II, Florence, Casa Buonarroti.

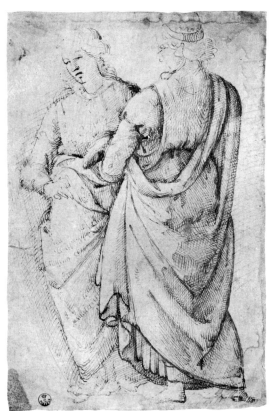

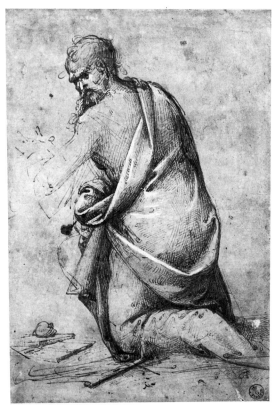

5 Domenico Ghirlandaio, Two figures, Florence, Uffizi.

6 Fra Bartolommeo, *St Jerome*, Florence, Uffizi.

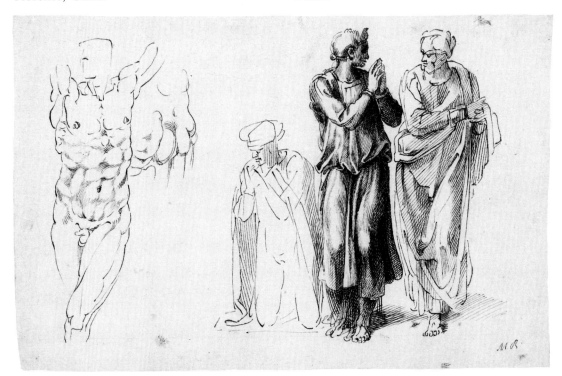

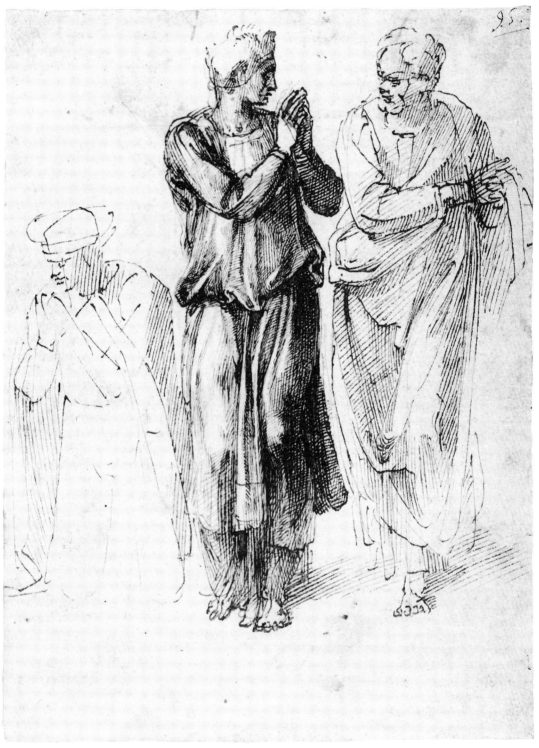

8 Figure studies, Haarlem, Teylers Museum.

7 (facing page bottom) Print after sheet of studies by Michelangelo, London, British Museum.

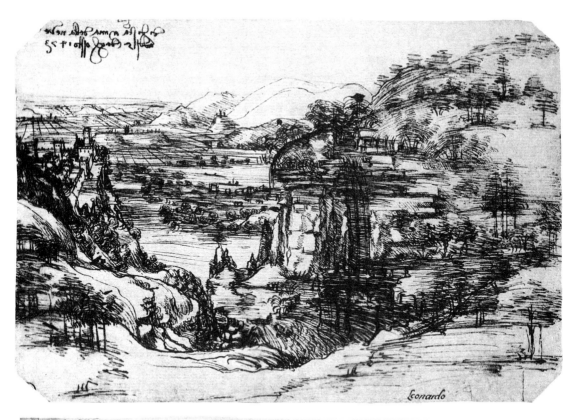

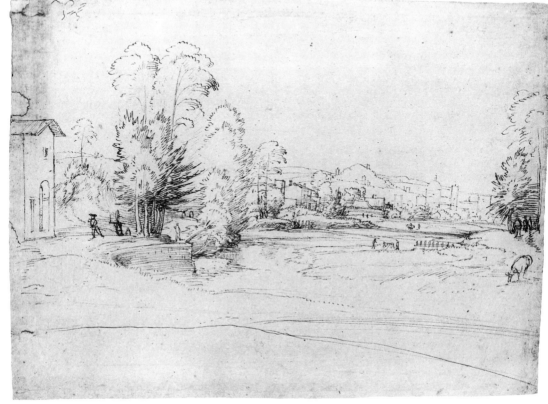

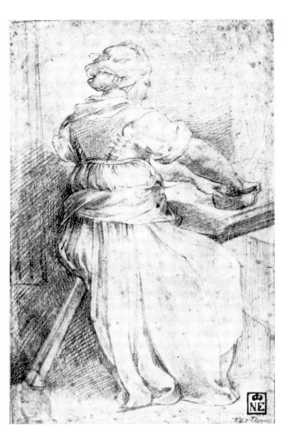

9 (facing page top) Leonardo da Vinci, Land-scape, Florence, Uffizi.

11 Parmigianino, A woman seated at a table, Budapest, Museum of Fine Arts.

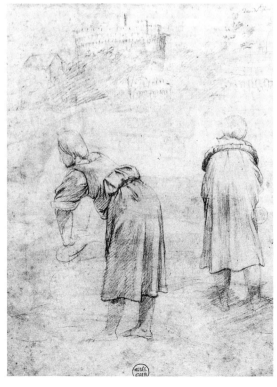

10 (facing page bottom) Fra Bartolommeo, Landscape, London, Courtauld Institute Galleries.

12 Polidoro da Caravaggio, Two women in a landscape, Montpellier, Musée Atger.

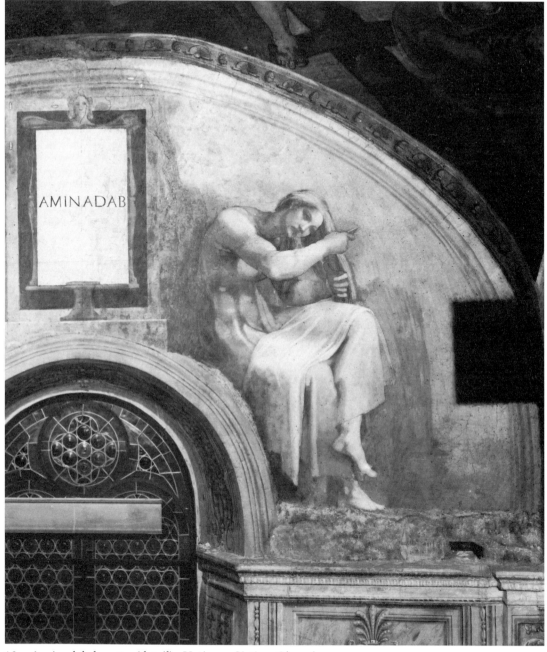

13　Aminadab lunette (detail), Vatican, Sistine Chapel.

14 (facing page top)　Studies after the antique and of a monk, Windsor, Royal Library.

15 (facing page bottom left)　Old woman and child, Oxford, Ashmolean Museum.

16 (facing page bottom right)　Three men conversing, Oxford, Ashmolean Museum.

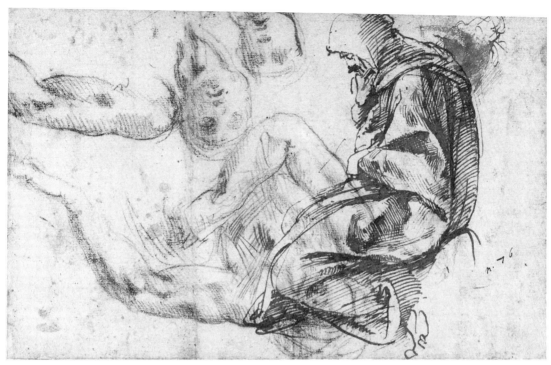

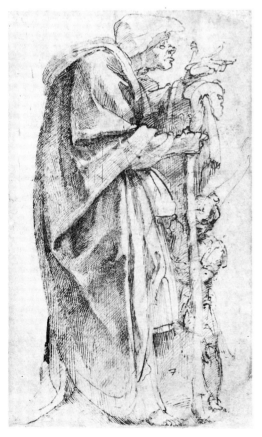

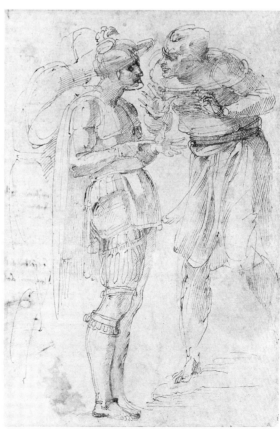

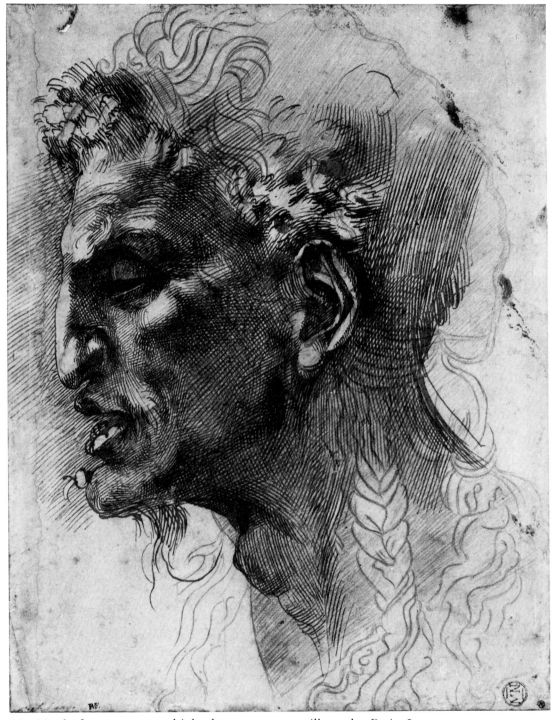

17 Head of a satyr, pen and ink, drawn over a pupil's study, Paris, Louvre.

20 (facing page bottom) Michelangelo and pupil, Studies of heads and eyes, Oxford, Ashmolean Museum.

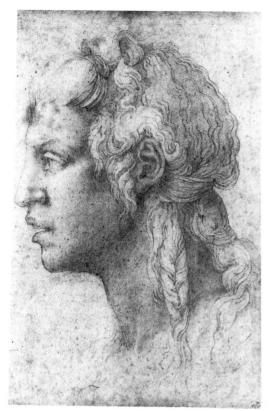

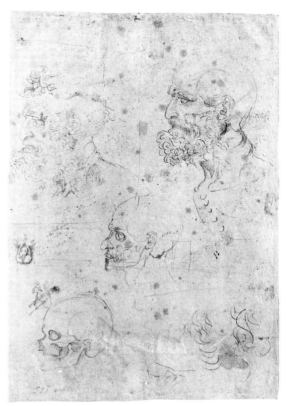

18 After Michelangelo, Head of a girl, New York, Private collection.

19 Michelangelo and pupil, Studies of a head and a skull (verso of pl. 220), Florence, Uffizi.

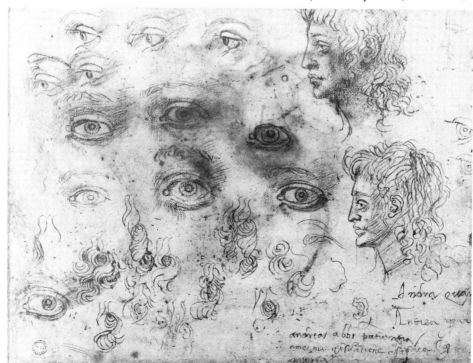

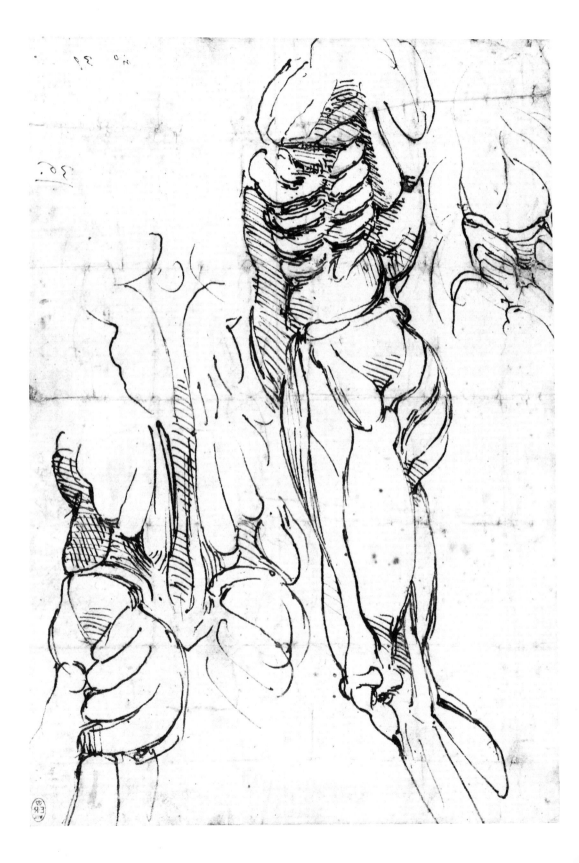

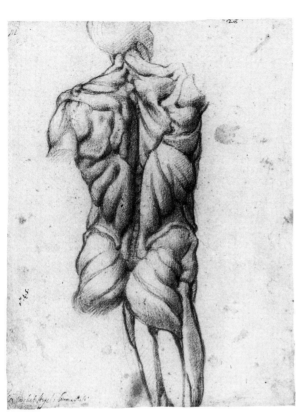

21 (facing page) *Ecorché*,
Windsor, Royal Library.

22 *Ecorché*, Windsor, Royal
Library.

23 *Ecorchés*, Haarlem,
Teylers Museum.

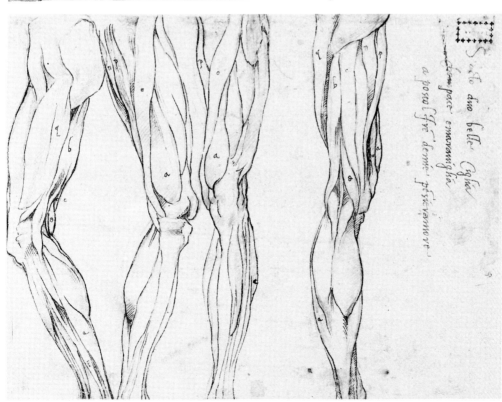

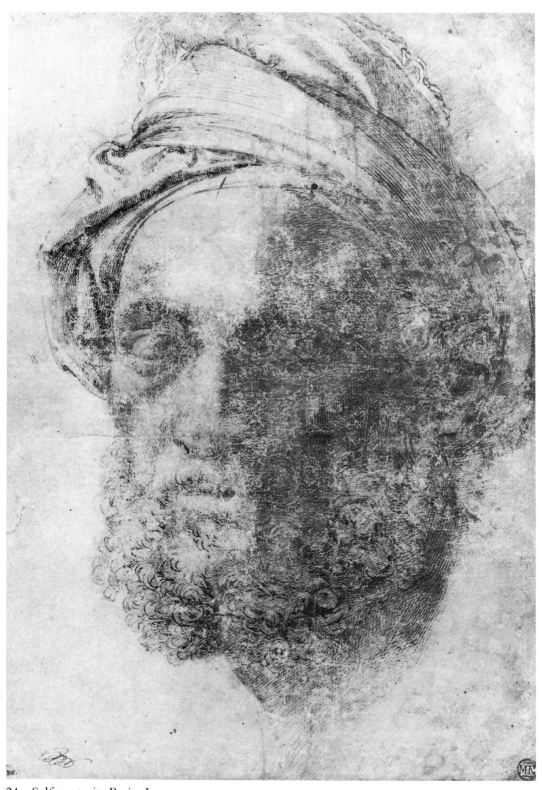

24 Self-portrait, Paris, Louvre.

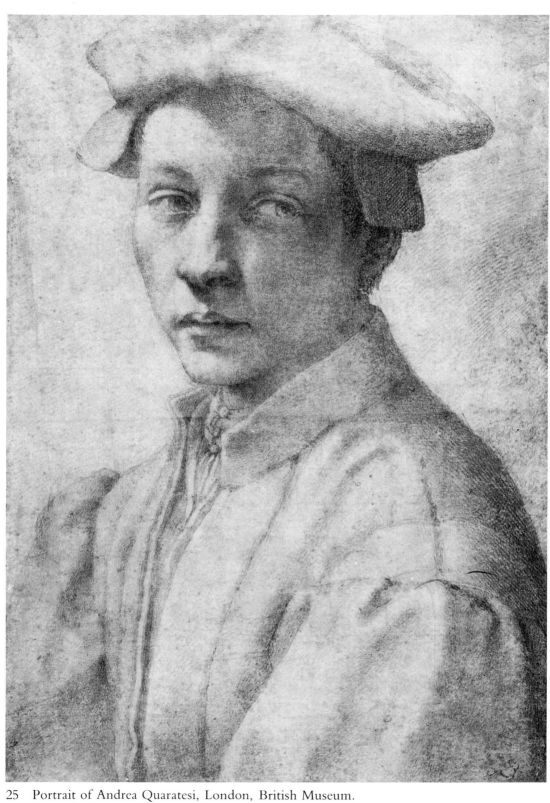

25 Portrait of Andrea Quaratesi, London, British Museum.

26 *The Resurrection of Christ,*
London, British Museum.

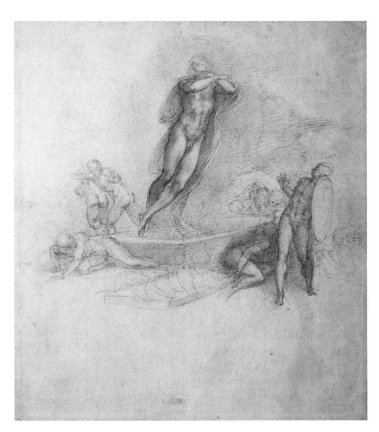

27 *The Resurrection of Christ,*
Windsor, Royal Library.

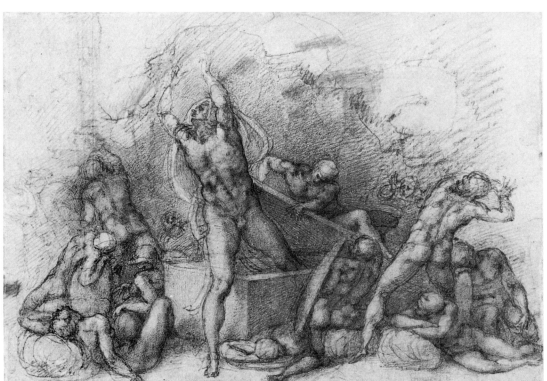

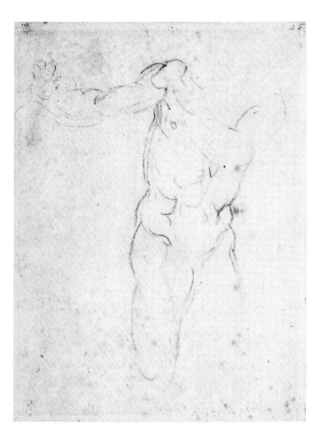

28 Study for Adam, Florence, Casa
Buonarroti.

29 Study for a soldier, Florence, Casa
Buonarroti.

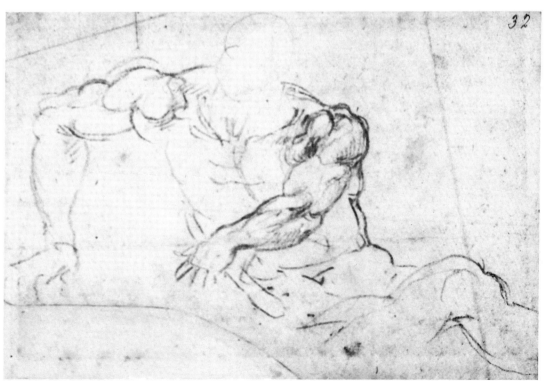

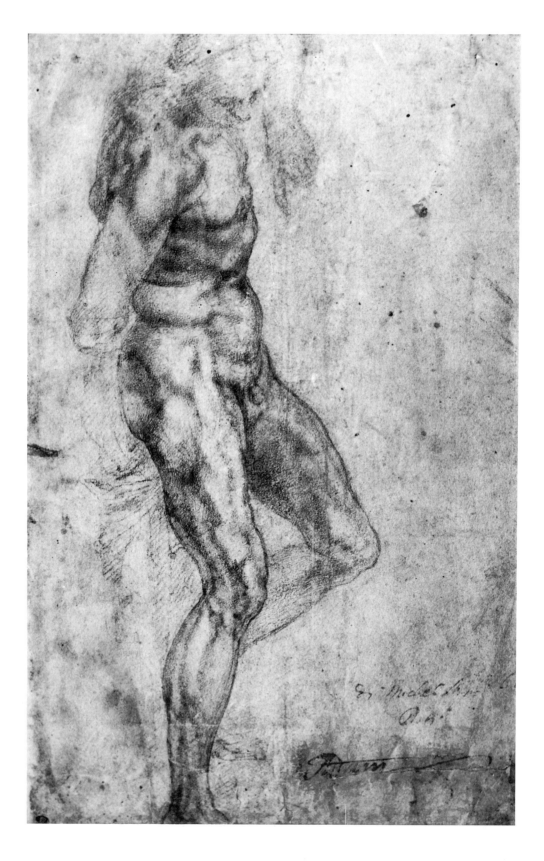

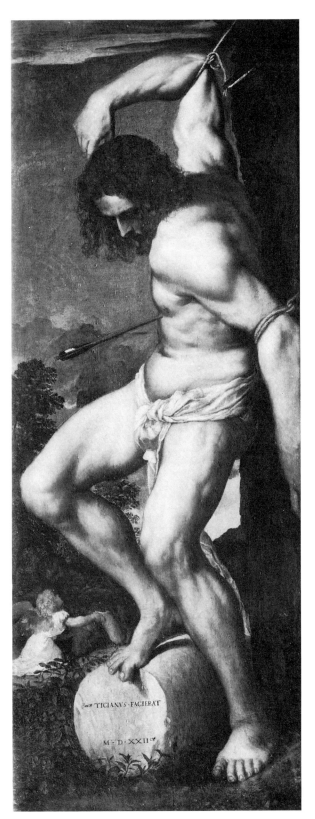

30 (facing page) Study for a
Slave, Paris, École des Beaux-
Arts.

31 Titian, *St Sebastian*, Brescia,
SS. Nazaro e Celso.

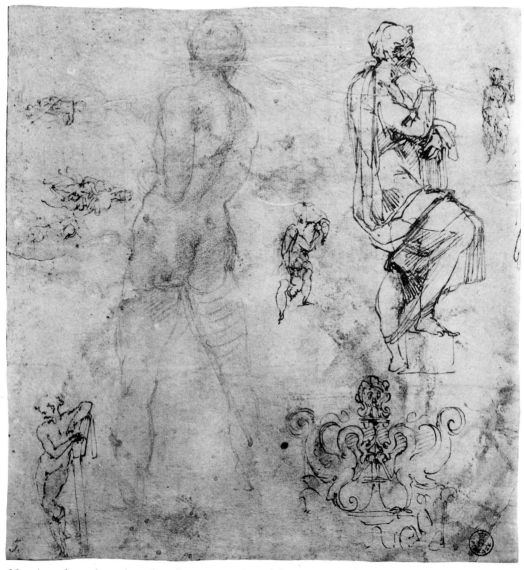

32 A male nude and studies for an *Apostle* and for a group of Virgin and Child, Florence, Uffizi.

33 Detail of pl. 32.

34 Copy after Donatello's marble *David*, Florence, Uffizi.

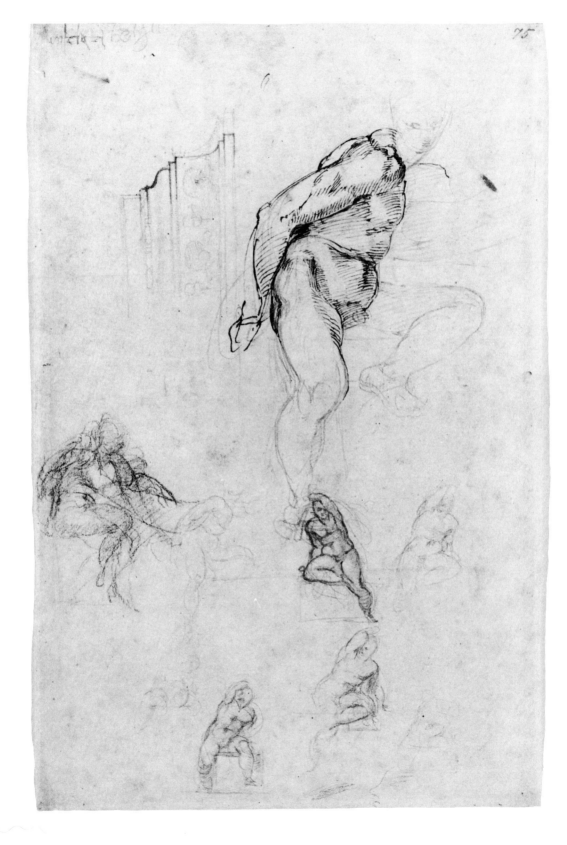

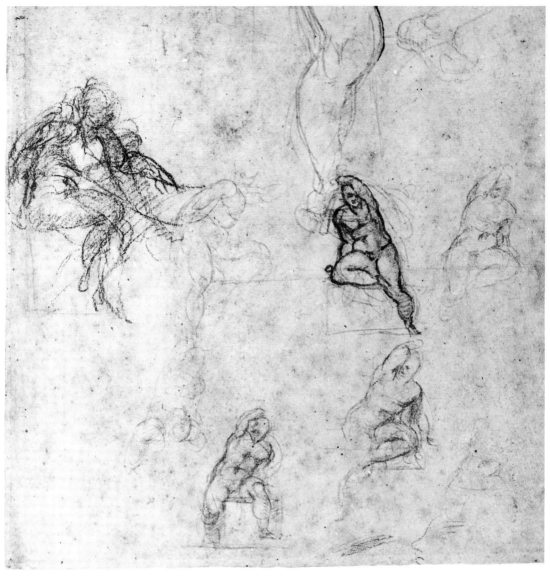

36 Detail of pl. 35.

35 Studies for *Ignudi* and of an architectural detail, Florence, Casa Buonarroti.

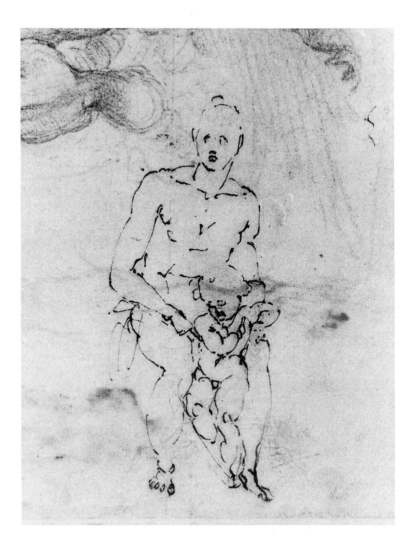

37 Study of Madonna
and Child, (detail of pl.
75).

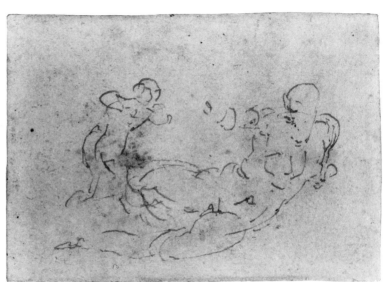

38 Study of Venus and
Cupid, London, British
Museum.

39 *Madonna and Child*, Notre Dame, Bruges.

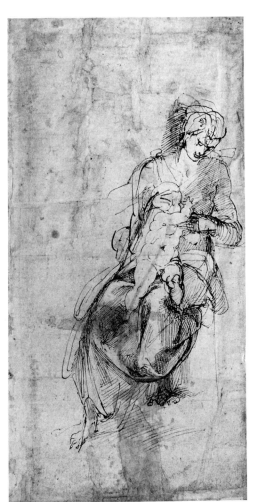

40 (left) Study of a Virgin and Child, Vienna, Albertina.

42 (facing page top) Leonardo da Vinci, Studies for the *Battle of Anghiari*, Venice, Accademia.

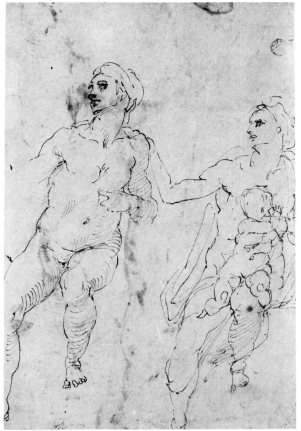

43 (facing page bottom) Leonardo da Vinci, Studies for the *Battle of Anghiari*, Venice, Accademia.

41 (right) Studies of a Virgin and Child, Paris, Louvre.

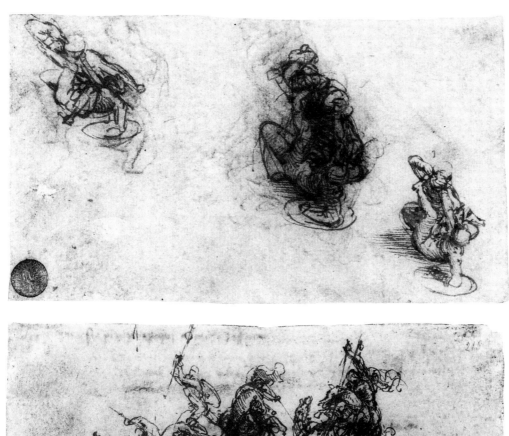

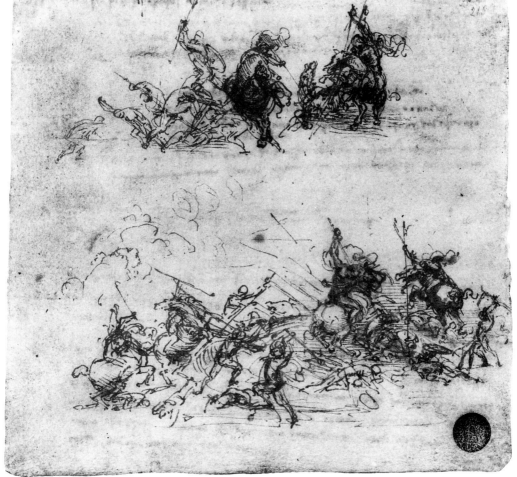

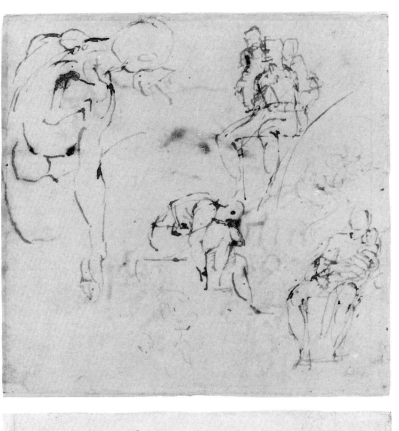

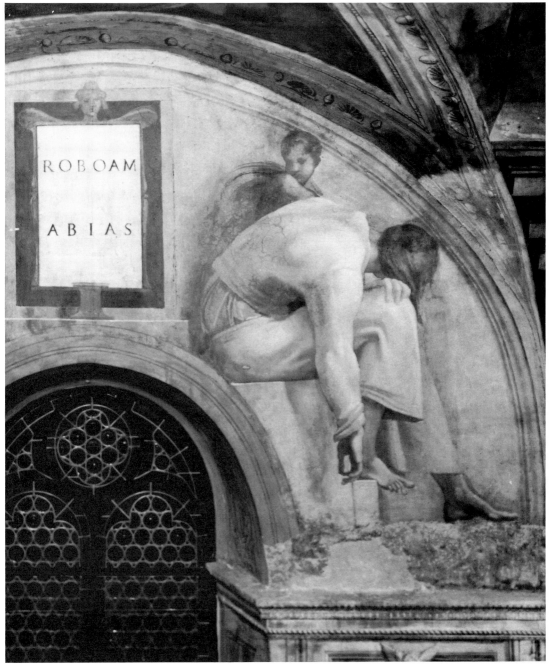

46 Roboam-Abia lunette (detail), Vatican, Sistine Chapel.

44 (facing page top) Studies for the lunettes of the Sistine Chapel, Oxford, Ashmolean Museum.

45 (facing page bottom) Studies for the lunettes of the Sistine Chapel, Oxford, Ashmolean Museum.

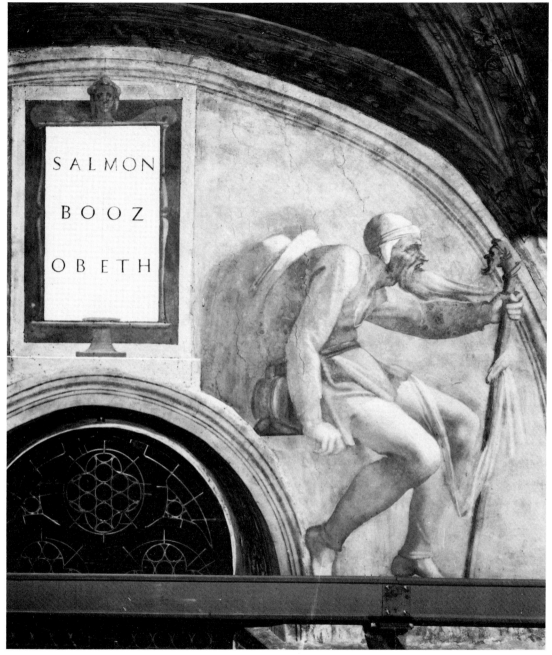

The inscription in the panel reads:

SALMON

BOOZ

OBETH

49 Salmon-Booz-Obed lunette (detail), Vatican, Sistine Chapel.

47 (facing page top) Studies for the lunettes of the Sistine Chapel, Oxford, Ashmolean Museum.

48 (facing page bottom) Study of an old man with a dog, Oxford, Ashmolean Museum.

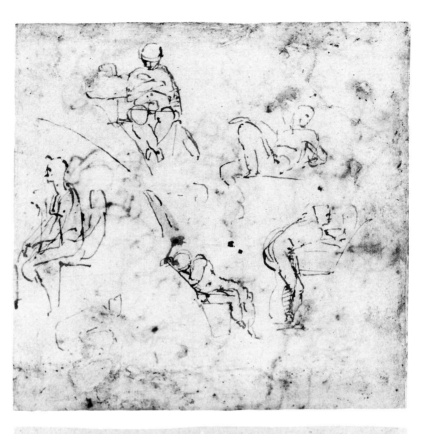

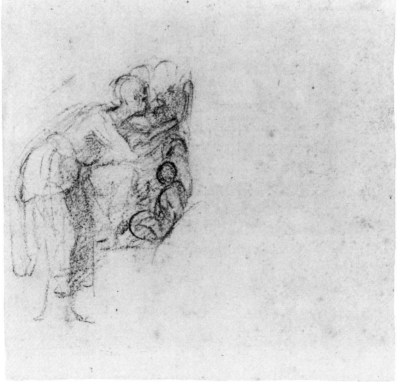

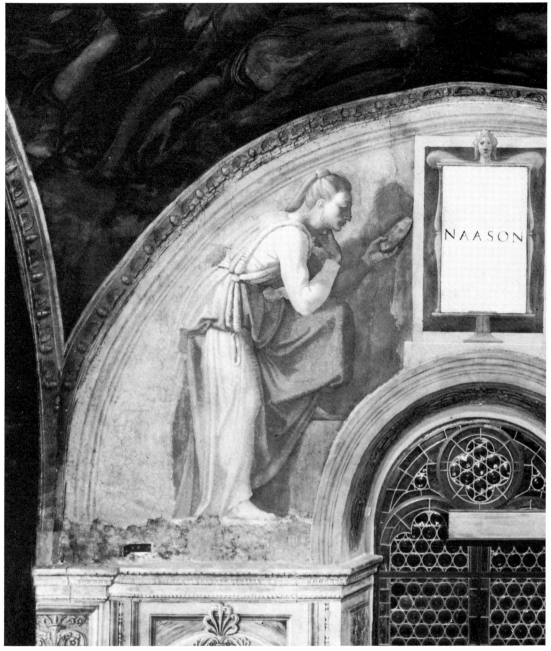

52 Naasson lunette (detail), Vatican, Sistine Chapel.

50 (facing page top) Studies for the lunettes of the Sistine Chapel, Oxford, Ashmolean Museum.

51 (facing page bottom) Study for the Naasson lunette, Oxford, Ashmolean Museum.

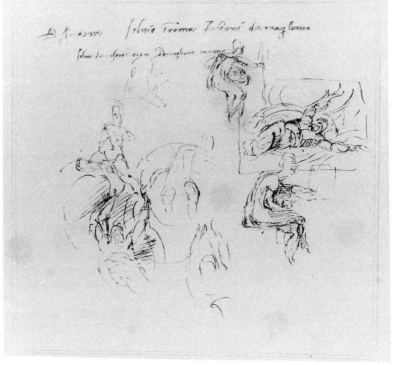

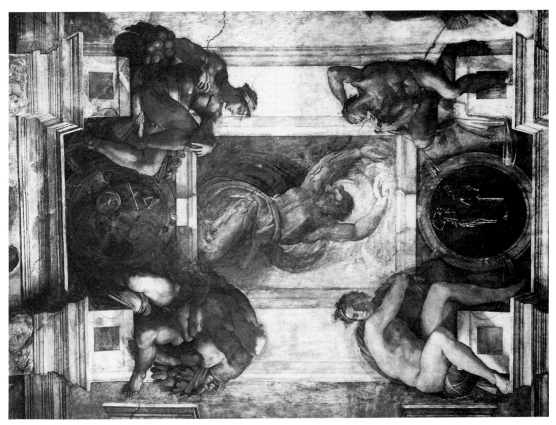

55 *God dividing Light from Darkness*, Vatican, Sistine Chapel.

53 (facing page top) Studies for the ceiling and lunettes of the Sistine Chapel, Oxford, Ashmolean Museum.

54 (facing page bottom) Engraving by Ottley of the studies in pl. 53.

56 Raphael, Studies for
Prophets and Sibyls
(detail), Oxford,
Ashmolean Museum.

57 (facing page)
Studies for the Sistine
ceiling and for Slaves for
the Tomb of Pope Julius
II, Oxford, Ashmolean
Museum.

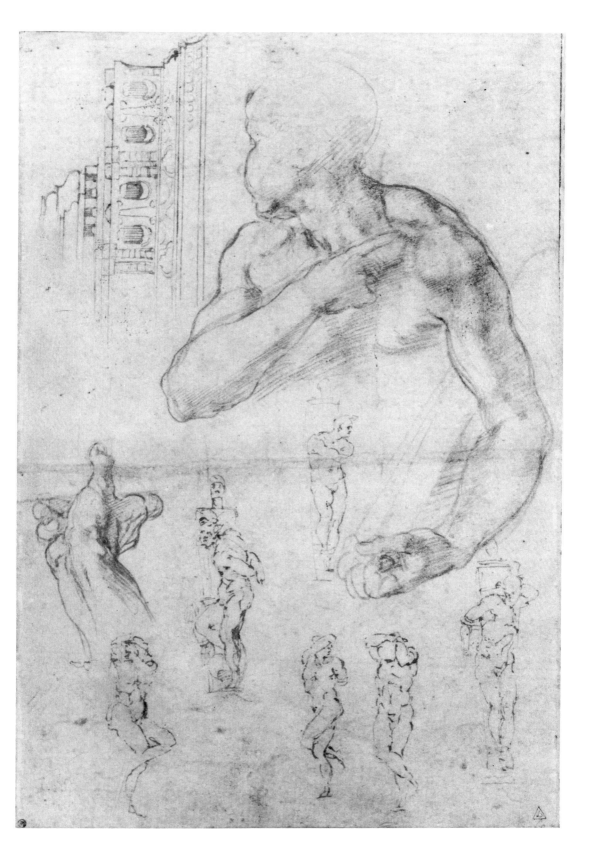

58 Studies for the *Last Judgment*, Windsor, Royal Library.

59 (facing page top) Study for St Lawrence, Codex Vaticanus Lat. 3211, fol. 88 verso (detail), Vatican Library.

60 (facing page bottom) Architectural and figure studies, Florence, Casa Buonarroti.

quel ch'io 'n veggio e più se pur tornoro
se poi mi squarci do m'avi
ciascun me di se stesso

Spirito d'acqua o di foco
supedio e l'tuo consiglio
se più ne duo amo più m'ita somiglio
e si me chezza, e presso a le tuo porte
che mal resto fra noi spaza da morte

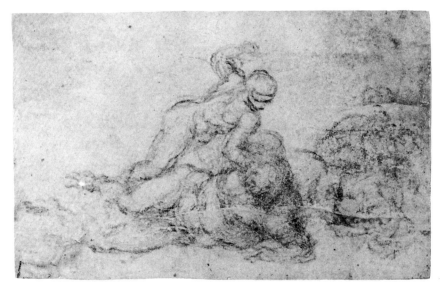

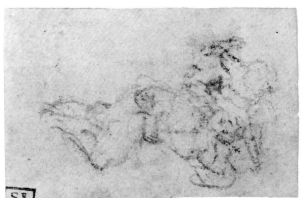

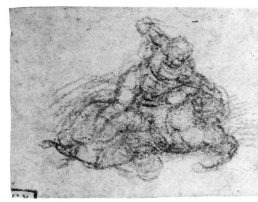

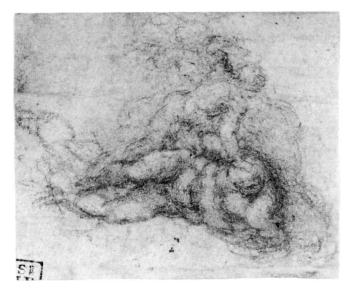

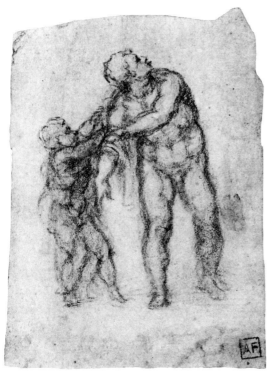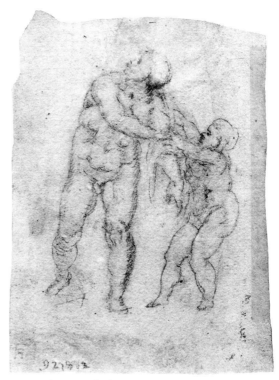

65 Aeneas and a putto, London, Courtauld Institute Galleries.

66 After Michelangelo, Aeneas and a putto, tracing from the recto repr. in pl. 65.

61–4 (facing page) Sketches of David and Goliath, New York, Pierpont Morgan Library.

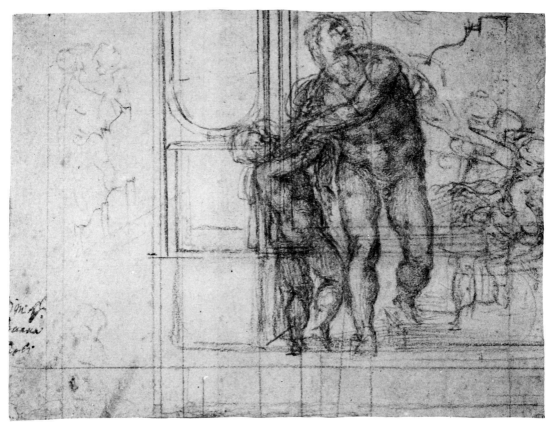

67 Aeneas, Dido and a putto, Haarlem,
Teylers Museum.

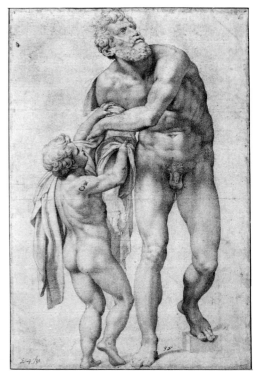

68 Daniele da Volterra, Aeneas and a putto,
Vienna, Albertina.

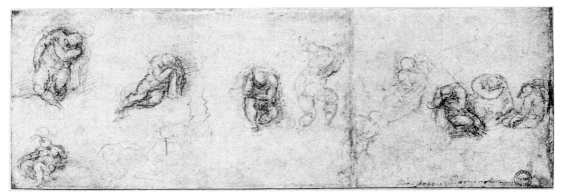

69 Studies of sleeping Apostles, Oxford, Ashmolean Museum.

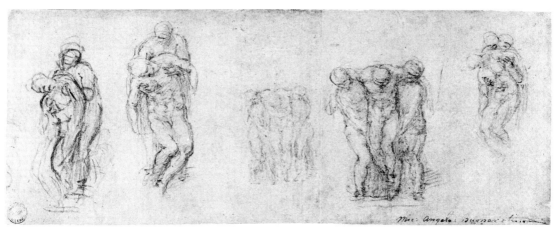

70 Studies for a Pietà and an Entombment, Oxford, Ashmolean Museum.

71 Compositional study for the *Battle of Cascina*, Florence, Uffizi.

73 (facing page top) Detail of pl. 71.

74 (facing page bottom) Detail of pl. 71.

72 Bastiano da Sangallo (?), Copy after the *Battle of Cascina* cartoon, Holkham Hall, Earl of Leicester.

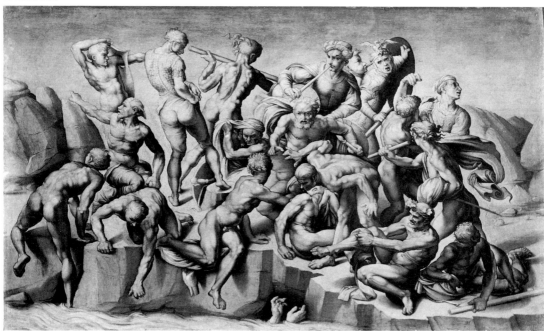

75 Studies for the *Battle of Cascina* and the Bruges *Madonna*, London, British Museum.

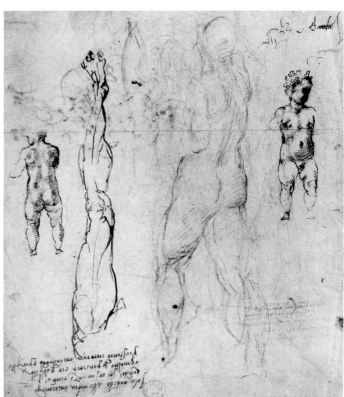

76 Study for the *Battle of Cascina* and other studies (verso of pl. 75).

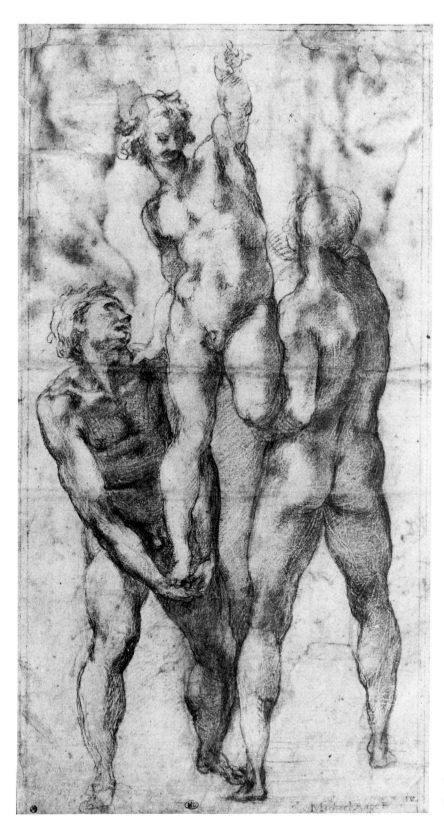

77 Study for the
Battle of Cascina,
Paris, Louvre.

78 Studies of a horse and sketch
of a battle scene, Oxford,
Ashmolean Museum.

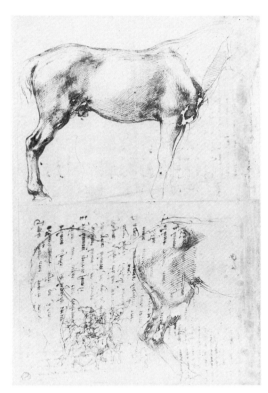

79 A battle scene, Oxford,
Ashmolean Museum.

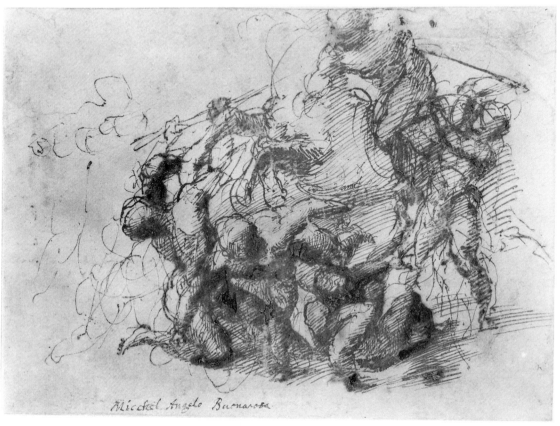

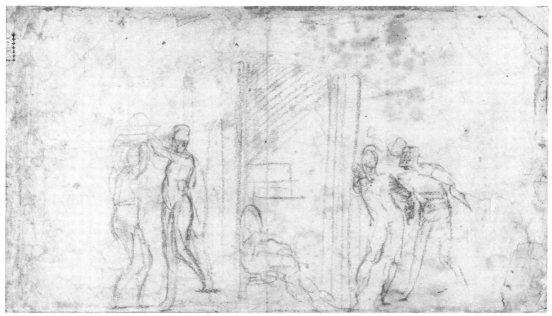

80 Study for *Judith and Holofernes* fresco (verso of pl. 122).

81 *Judith and Holofernes*, Vatican, Sistine Chapel.

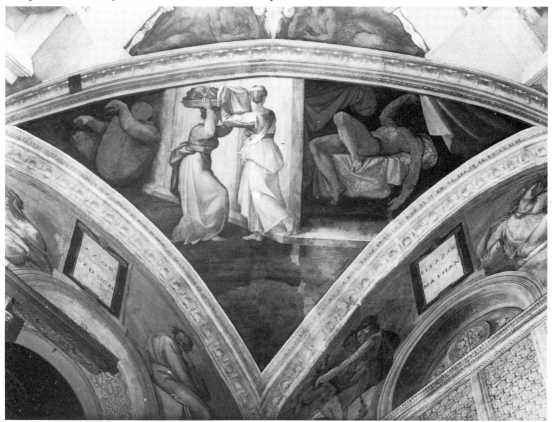

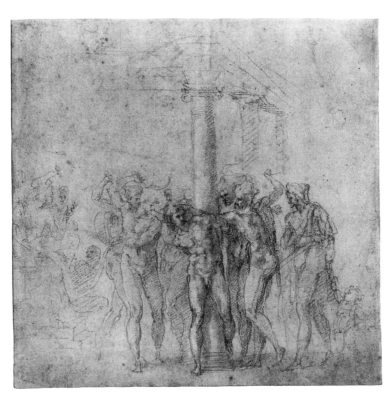

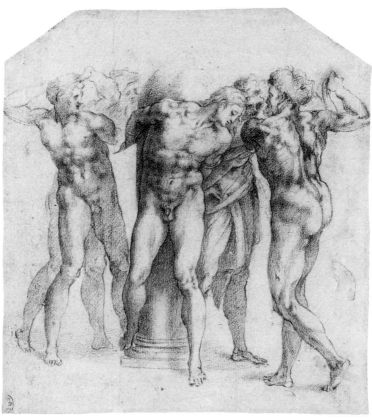

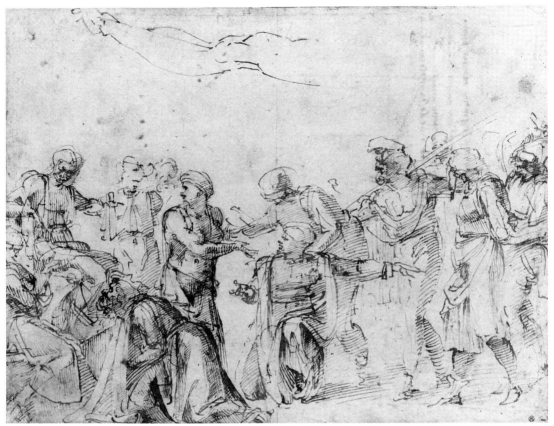

84 *Christ before Pilate*, London, Courtauld Institute Galleries.

82 (facing page top) *The Flagellation of Christ*, London, British Museum.

83 (facing page bottom) After Michelangelo, *The Flagellation of Christ*, Windsor, Royal Library.

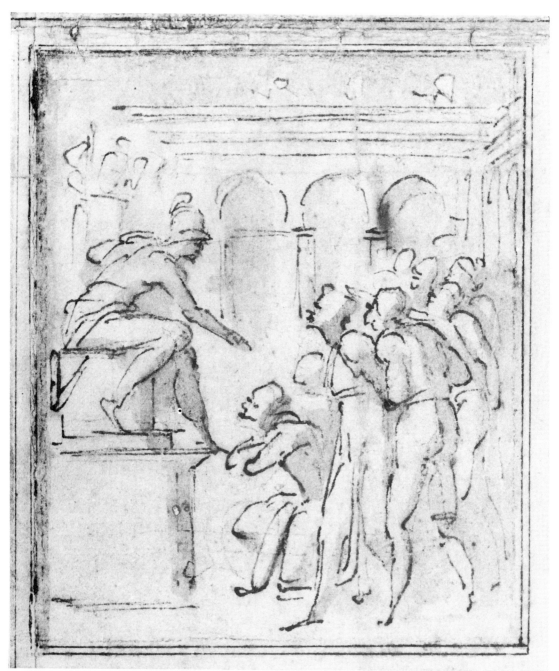

85 Detail of pl. 169.

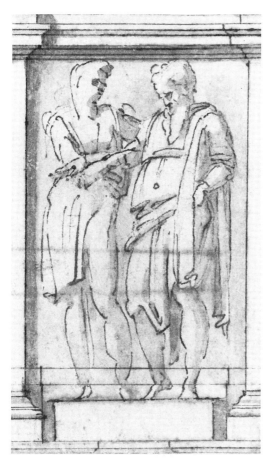

86 Detail of pl. 169.

87 Detail of pl. 169.

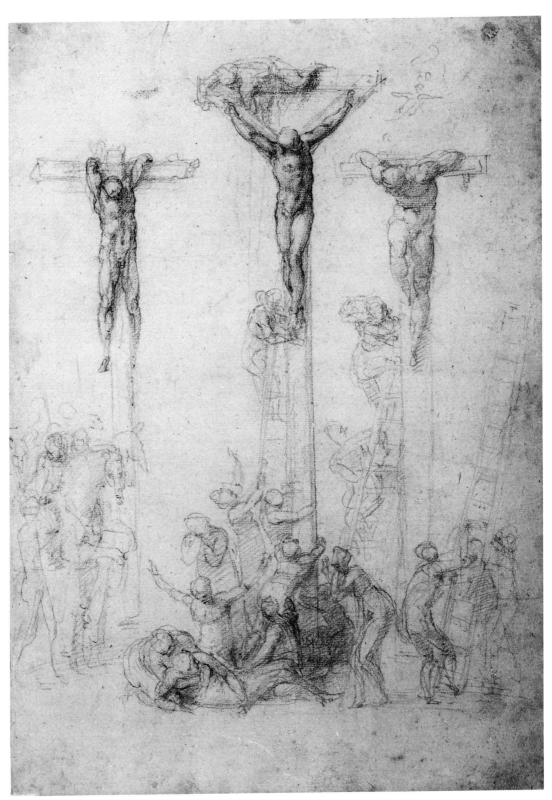

88　*The Three Crosses*, London, British Museum.

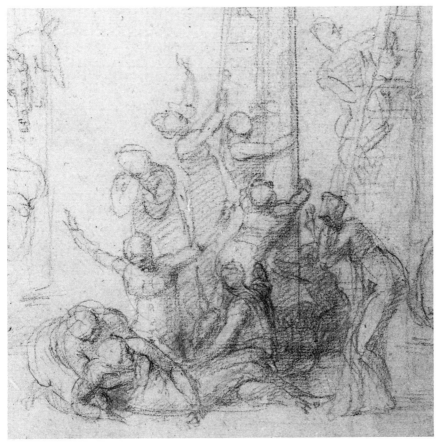

89 Detail of pl. 88.

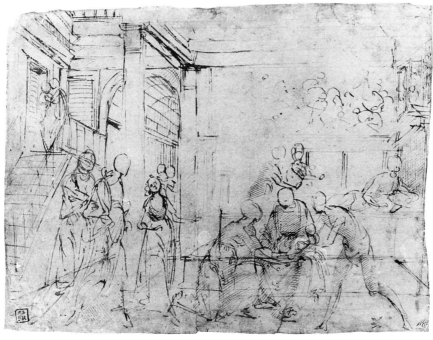

90 Domenico
Ghirlandaio,
Study for the
Birth of the Virgin,
London, British
Museum.

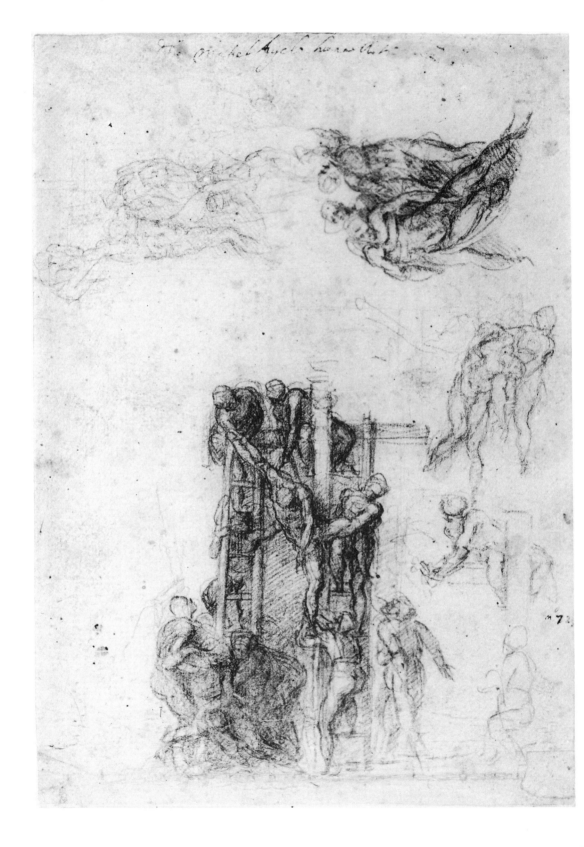

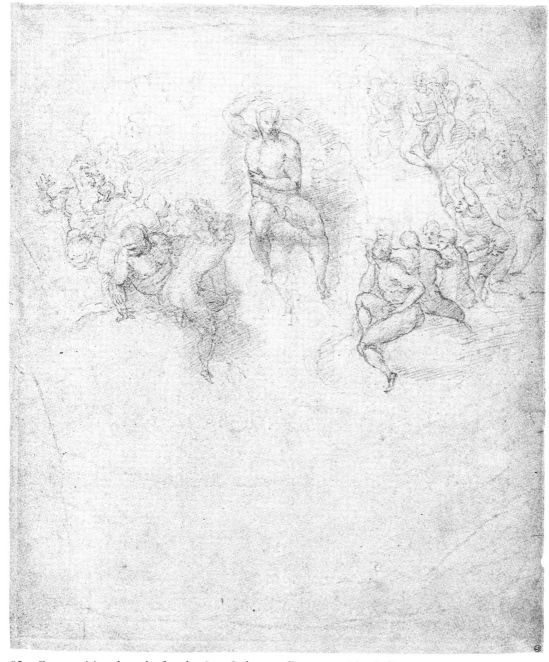

92 Compositional study for the *Last Judgment*, Bayonne, Musée Bonnat.

91 Studies for the *Descent from the Cross*, Haarlem, Teylers Museum.

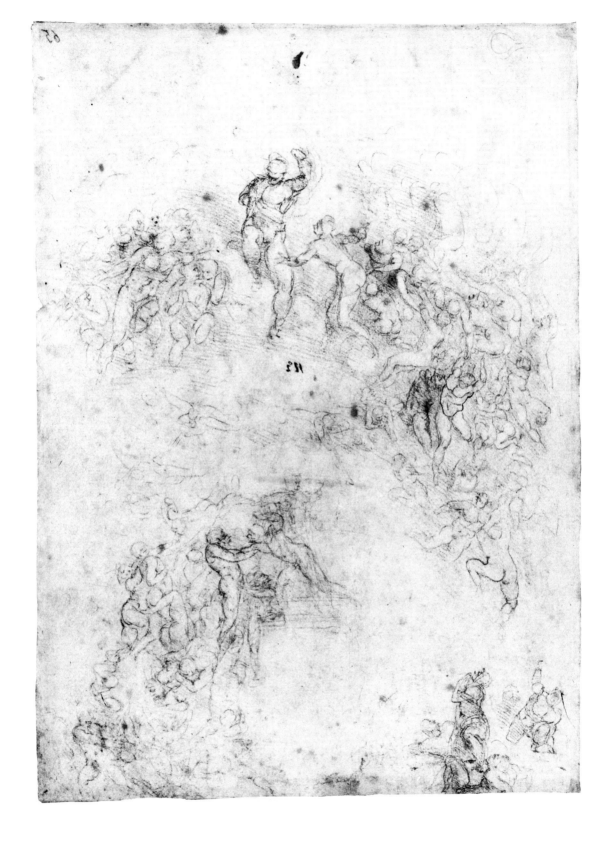

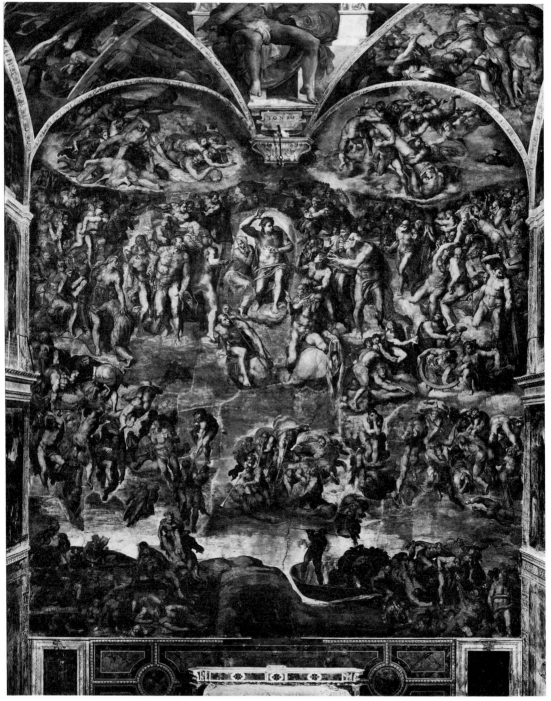

94 *The Last Judgment*, Vatican, Sistine Chapel.

93 Compositional study for the *Last Judgment*, Florence, Casa Buonarroti.

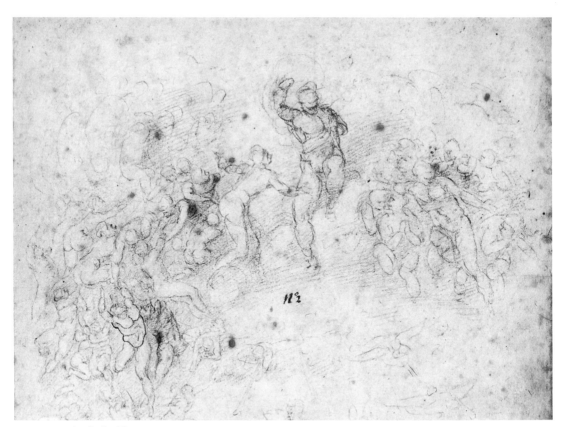

95 Detail of pl. 93.

96 Detail of pl. 93.

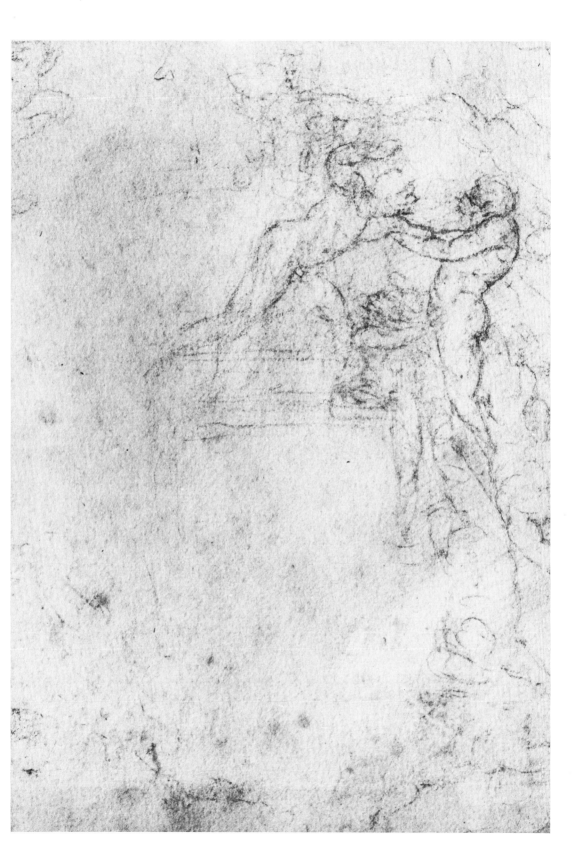

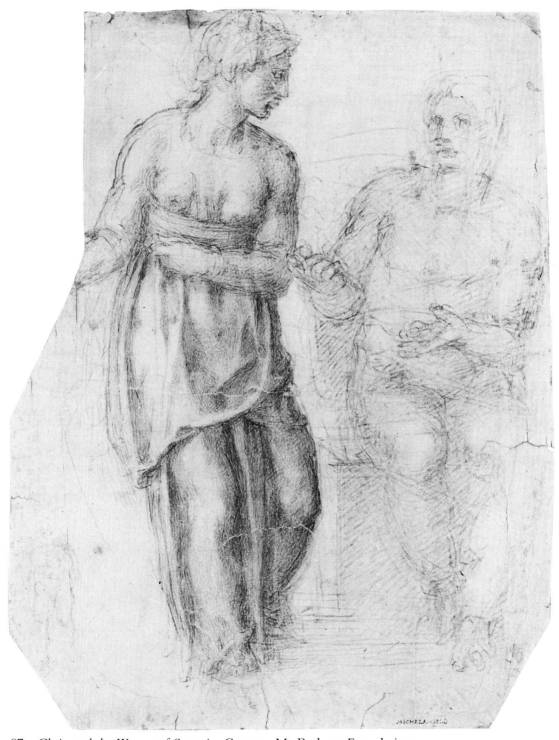

97 *Christ and the Woman of Samaria*, Geneva, M. Bodmer Foundation.

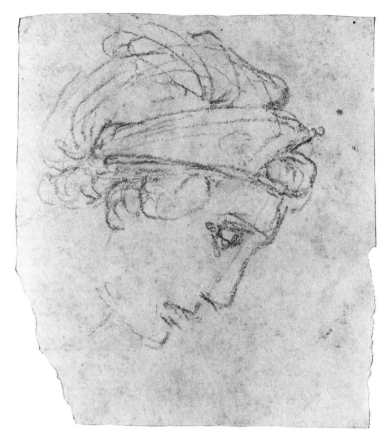

98 Study for the Woman of
Samaria, Geneva, M. Bodmer
Foundation.

99 Nicolas Beatrizet after
Michelangelo, *Christ and the
Woman of Samaria*.

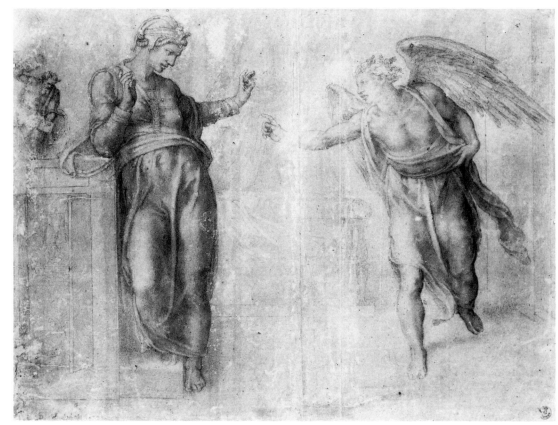

100 *The Annunciation*, Florence, Uffizi.

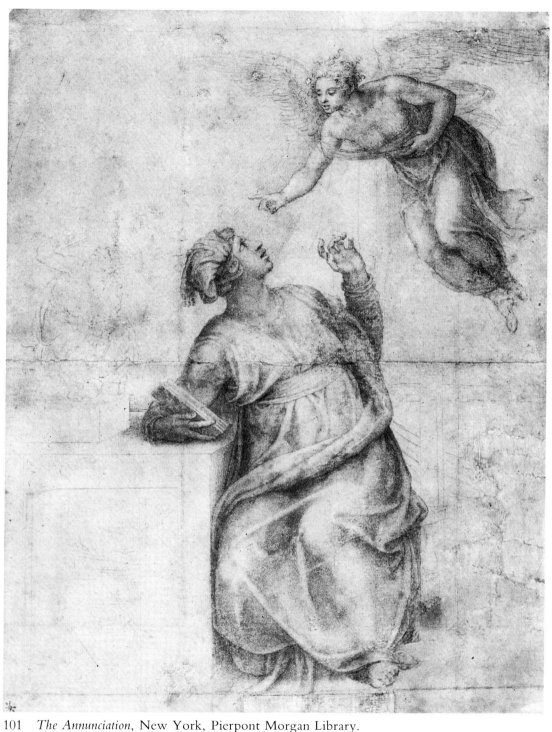

101 *The Annunciation*, New York, Pierpont Morgan Library.

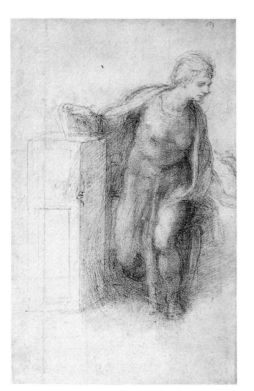

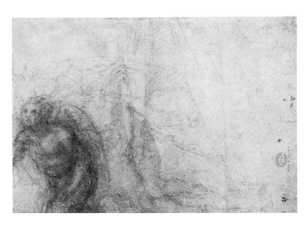

102 *The Annunciation*, London, British Museum.

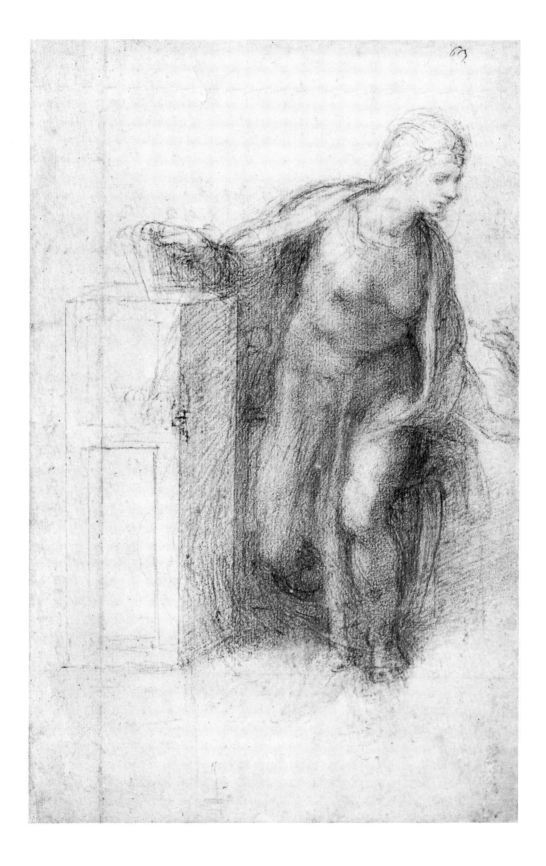

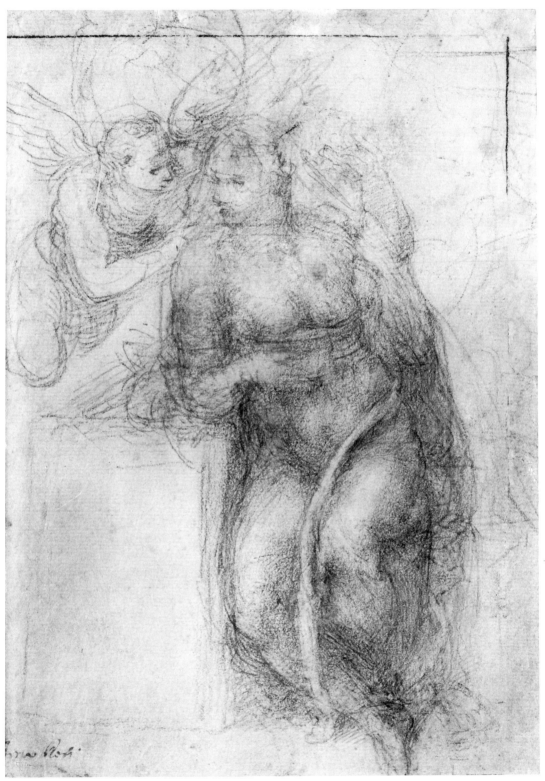

104 The Annunciate Virgin, London, British Museum.

105 The Annunciate Virgin, London, British Museum.

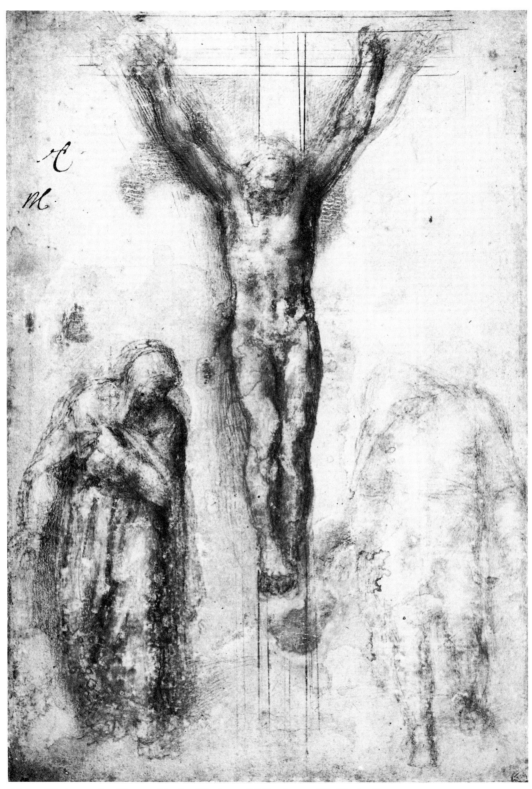

106 *Christ on the Cross with the Virgin and Nicodemus* (?), Paris, Louvre.

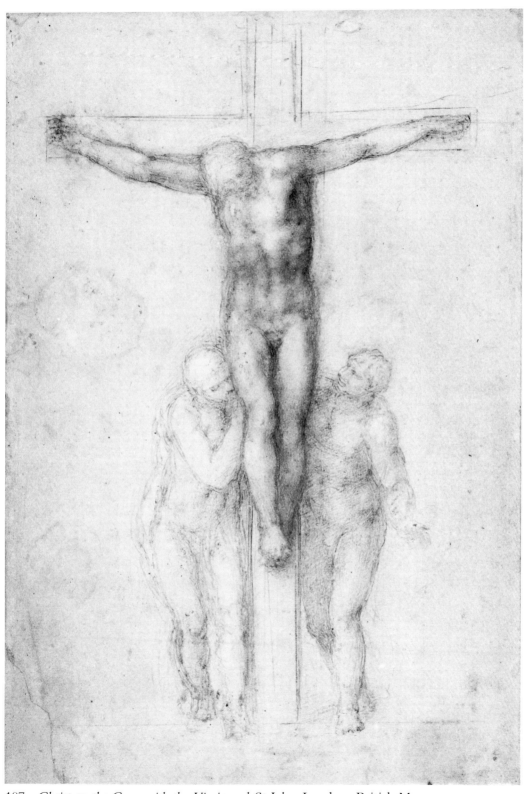

107 *Christ on the Cross with the Virgin and St John*, London, British Museum.

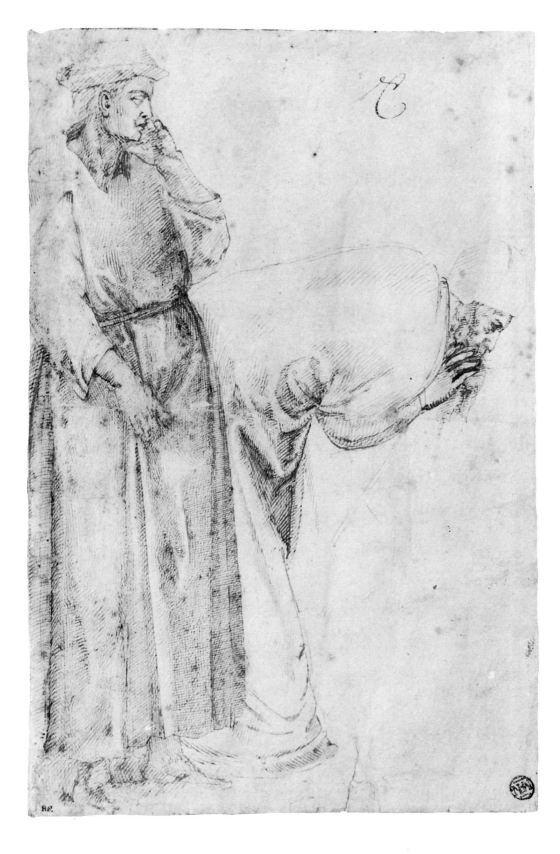

109 Giotto, *Ascension of St John* (detail), Florence, S. Croce, Peruzzi Chapel.

108 (facing page) Study after Giotto, Paris, Louvre.

110 Florentine School, *Funeral of St Stephen* (detail), Prato, Cathedral.

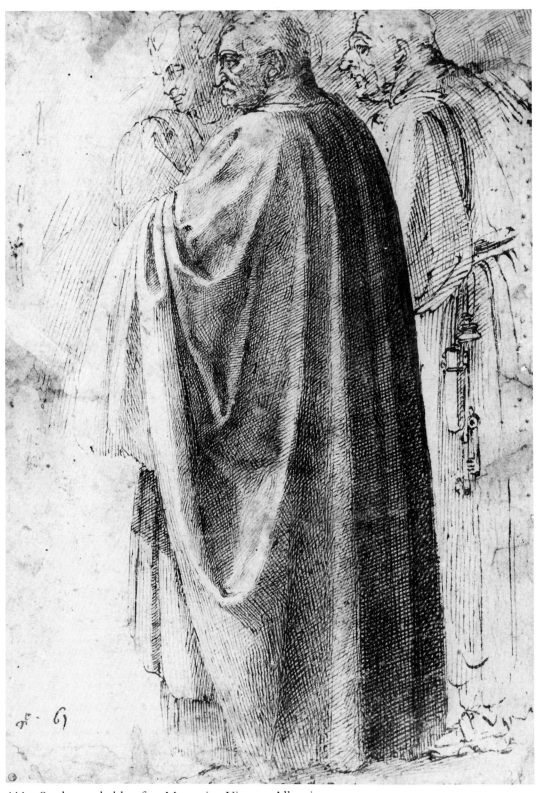

111 Study, probably after Masaccio, Vienna, Albertina.

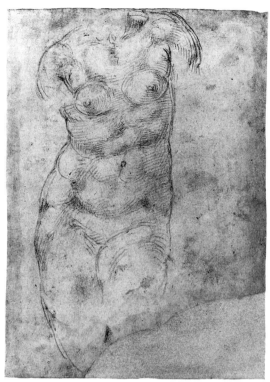

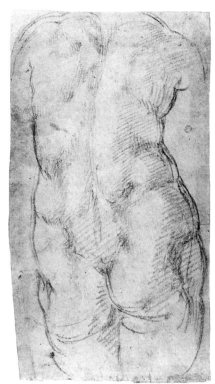

112 Study of an antique Venus, London, British Museum.

113 Study of an antique Venus, London, British Museum.

114 Studies of an antique Venus, Florence, Casa Buonarroti.

115 Study of an antique Venus, Florence, Casa Buonarroti.

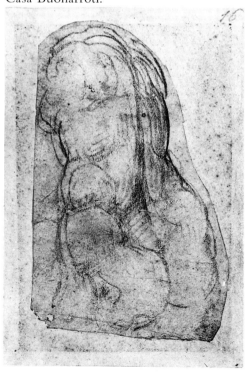

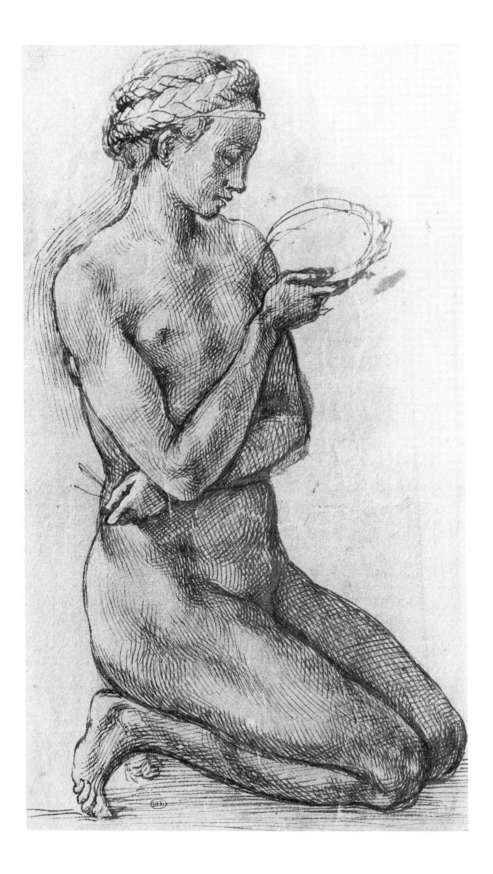

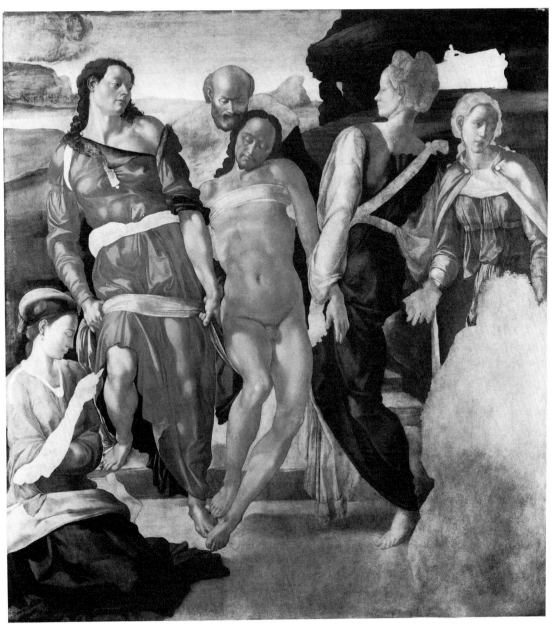

117 *Christ carried to the Tomb*, London, National Gallery.

116 A kneeling nude girl, Paris, Louvre.

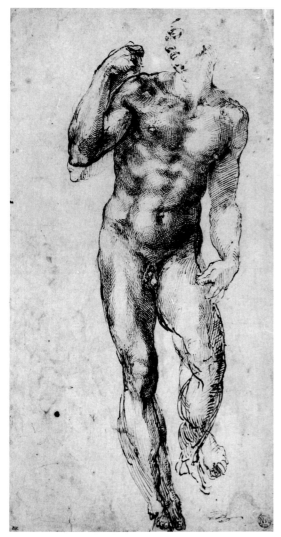

118 Study of a male nude, Paris, Louvre.

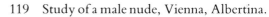

119 Study of a male nude, Vienna, Albertina.

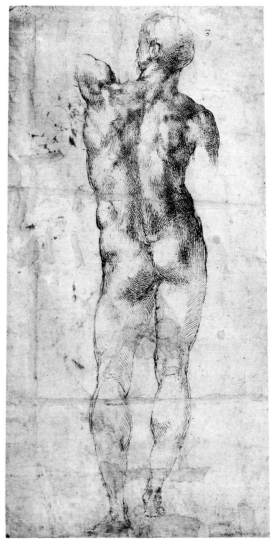

120 (facing page) Study of a male nude, Florence, Casa Buonarroti.

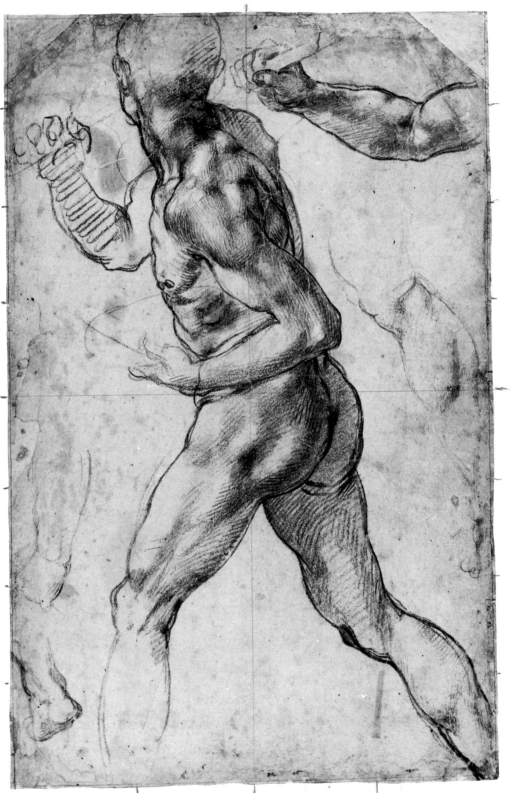

121 Figure study for the *Battle of Cascina*, Haarlem, Teylers Museum.

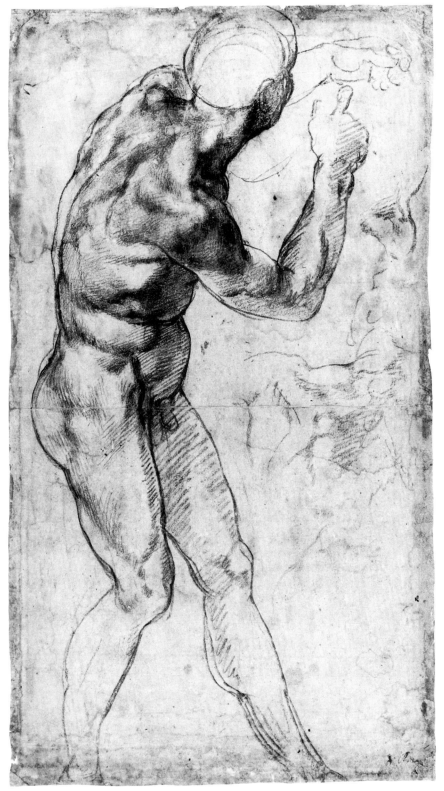

122 Figure study for the *Battle of Cascina*, Haarlem, Teylers Museum.

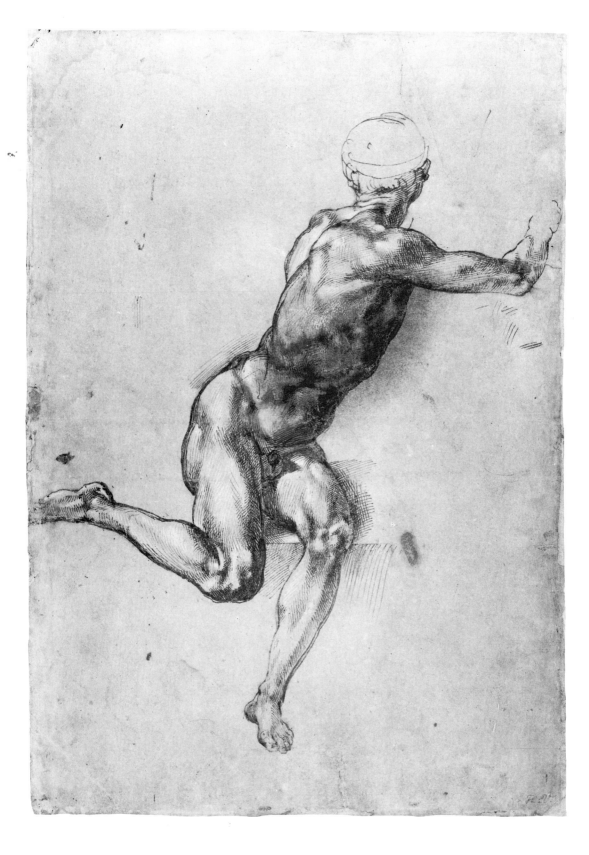

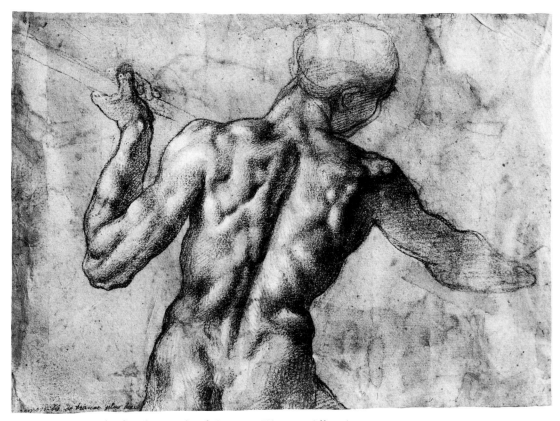

124 Figure study for the *Battle of Cascina*, Vienna, Albertina.

123 Figure study for the *Battle of Cascina*, London, British Museum.

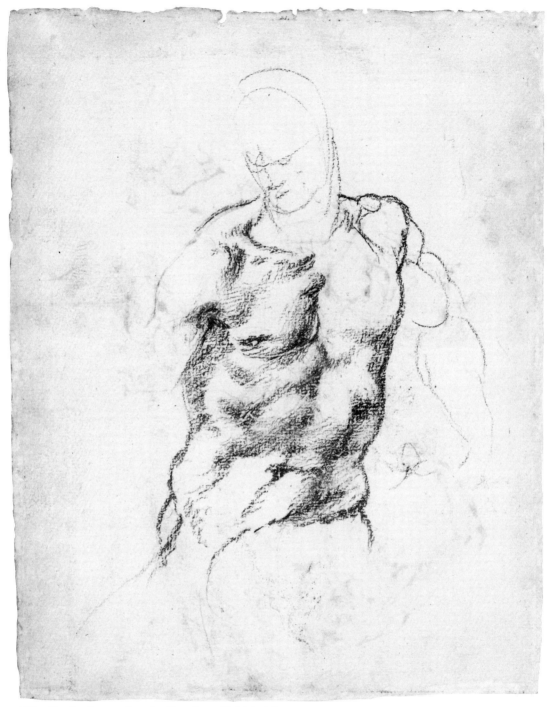

125 Study for an *Ignudo*, London, British Museum.

126 Study for an *Ignudo*, Paris, Louvre.

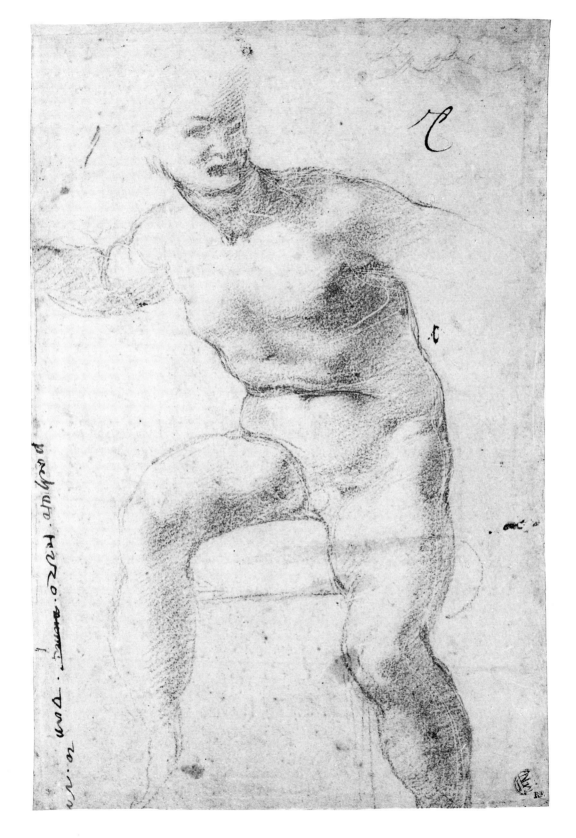

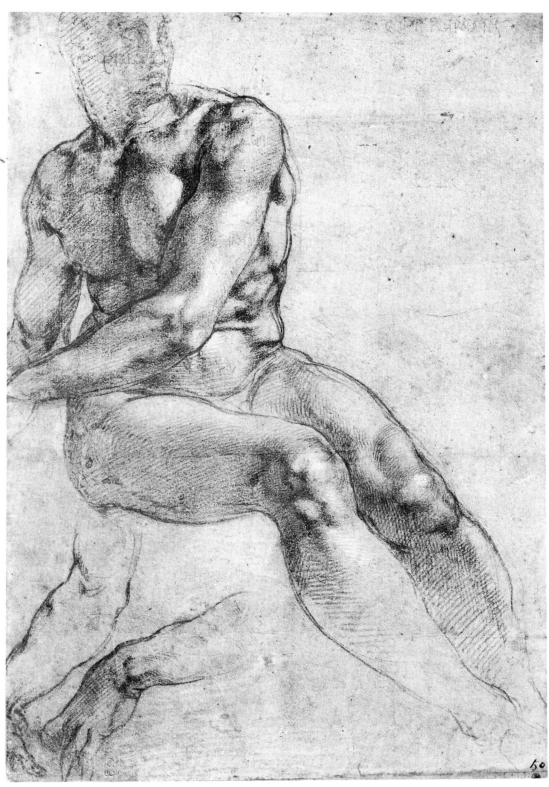

127 Study for an *Ignudo*, Vienna, Albertina.

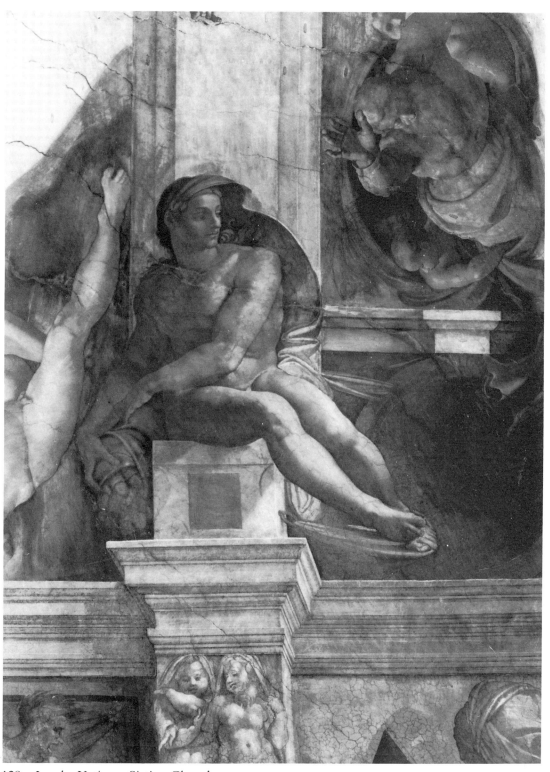

128 *Ignudo*, Vatican, Sistine Chapel.

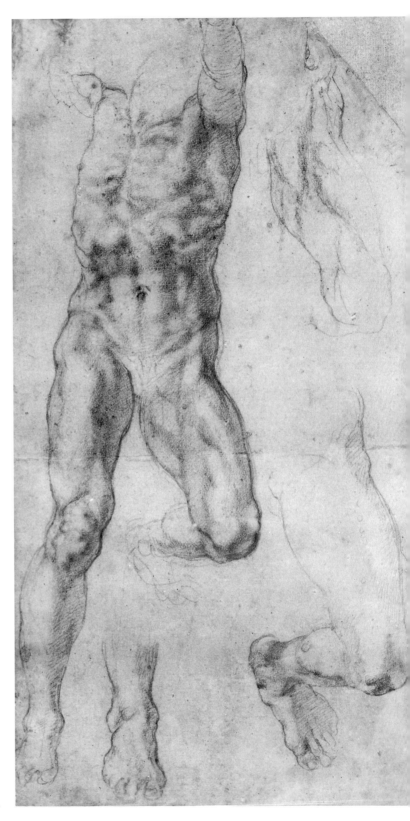

129 Studies for
Haman, London,
British Museum.

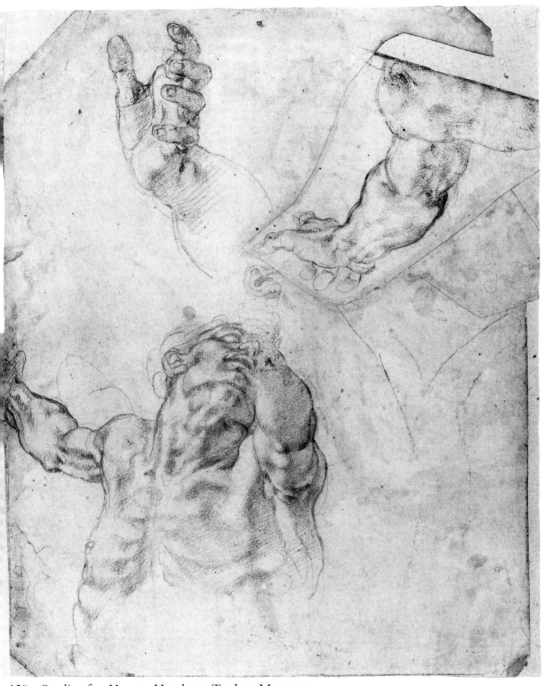

130 Studies for *Haman*, Haarlem, Teylers Museum.

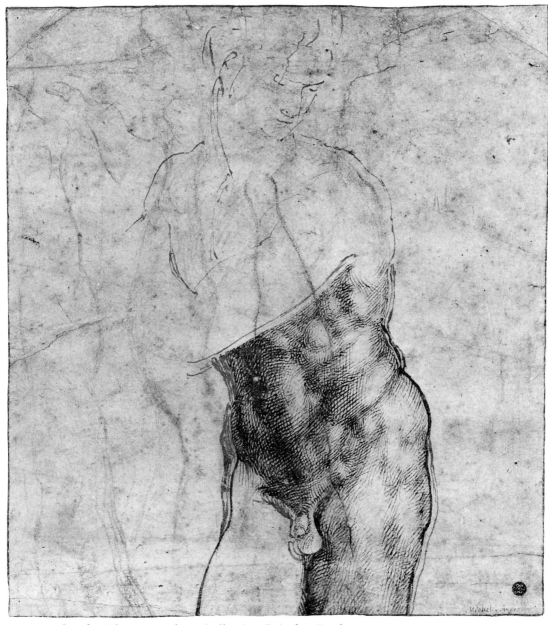

131 Studies for Christ, London, Collection Brinsley Ford.

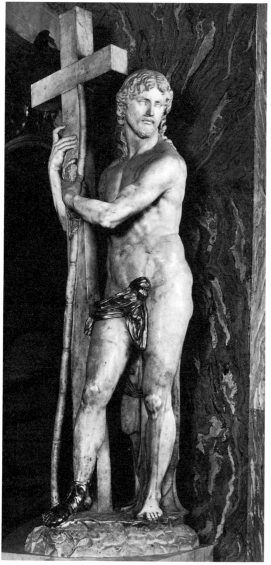 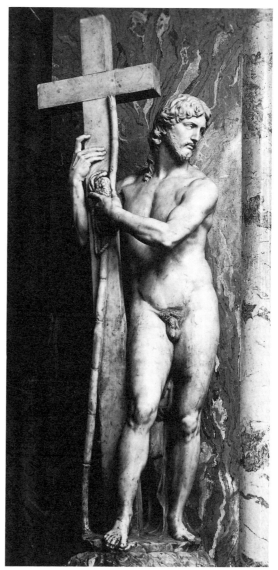

132 *Christ*, Rome, Santa Maria sopra Min-
erva.

133 *Christ*, Rome, Santa Maria sopra Min-
erva.

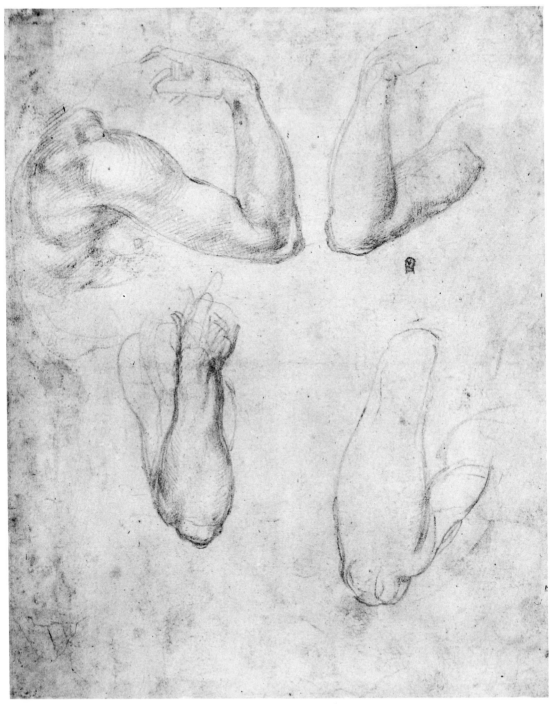

134 Studies for the right arm of *Night*, Oxford, Ashmolean Museum.

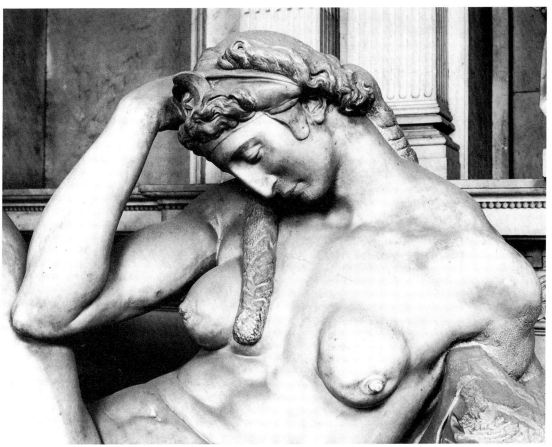

135 *Night* (detail), Florence, New Sacristy of San Lorenzo.

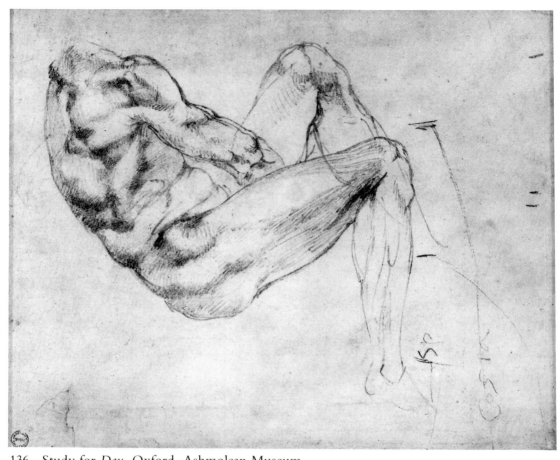

136 Study for *Day*, Oxford, Ashmolean Museum.

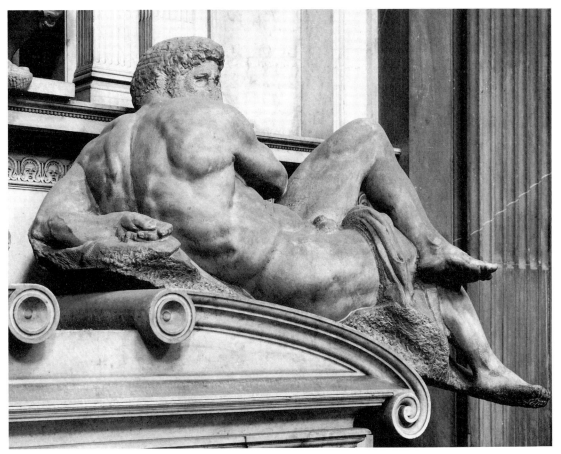
137 *Day*, Florence, New Sacristy of San Lorenzo.

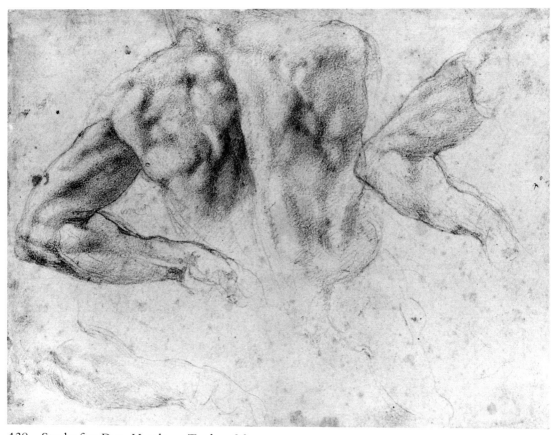

138 Study for *Day*, Haarlem, Teylers Museum.

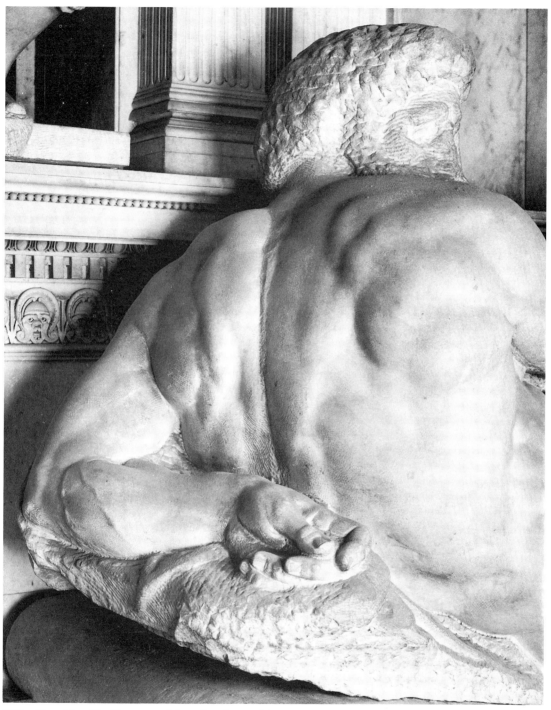

139 *Day* (detail). Florence, New Sacristy of San Lorenzo.

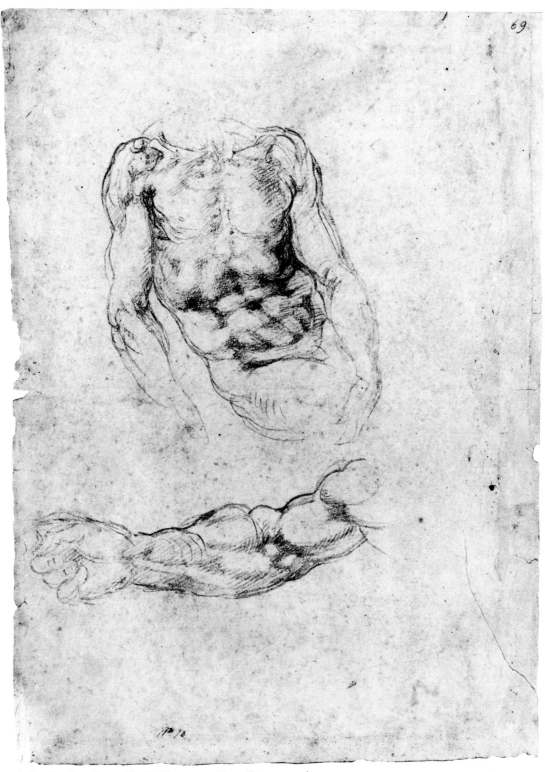

140 Studies for a Pietà, Florence, Casa Buonarroti.

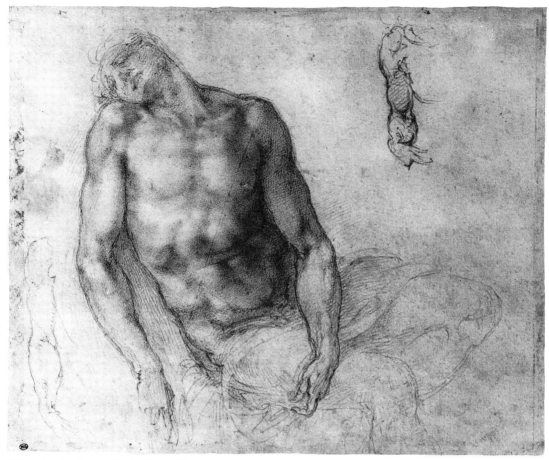

141 Study for a Pietà, Paris, Louvre.

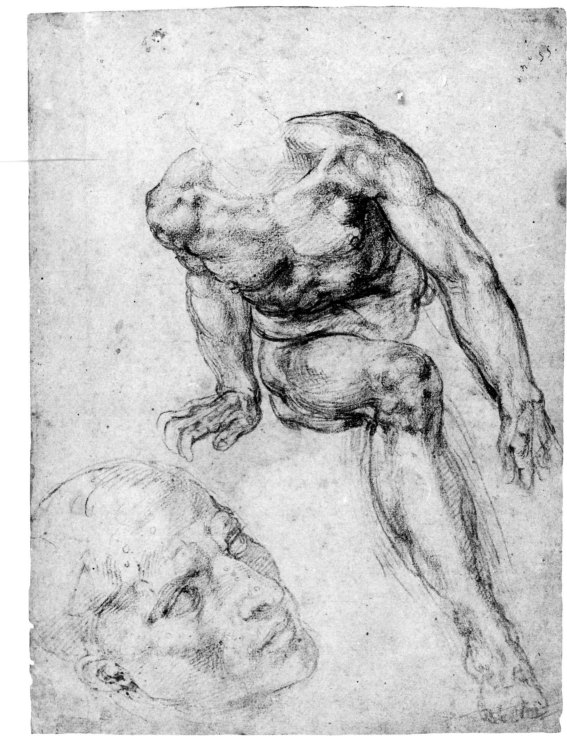

142 Study for St Lawrence, Haarlem, Teylers Museum.

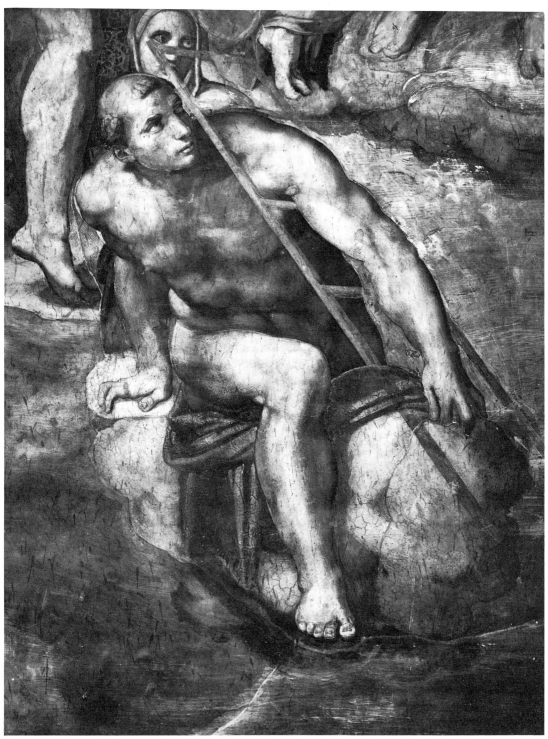

143 *St Lawrence*, Vatican, Sistine Chapel.

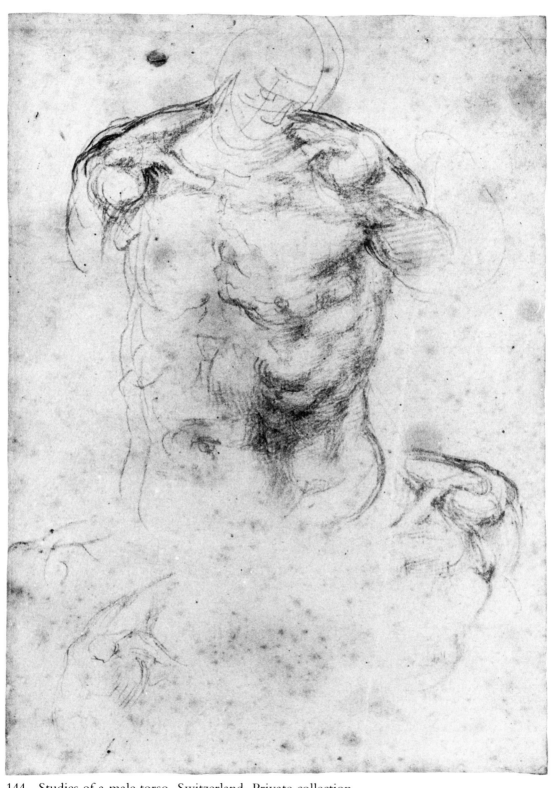

144 Studies of a male torso, Switzerland, Private collection.

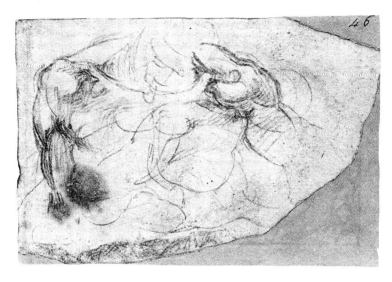

145 Study of a male torso,
Florence, Casa Buonarroti.

146 After Michelangelo,
Studies of an Entombment.

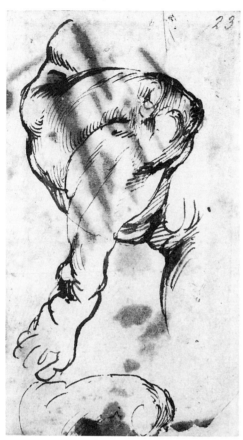

147 Study for the Doni tondo, Florence, Casa Buonarroti.

149 (facing page top) Study of a reclining figure, Florence, Casa Buonarroti.

150 (facing page bottom) Study of a reclining figure, Florence, Casa Buonarroti.

148 Two studies of legs, London, British Museum.

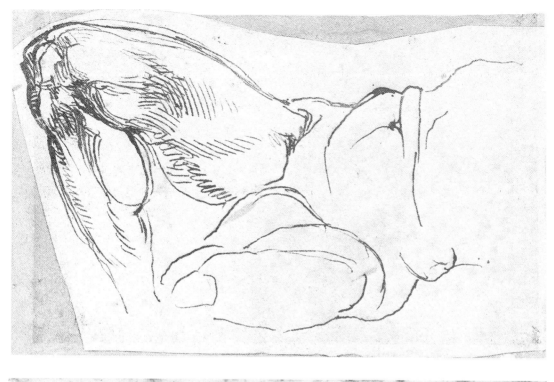

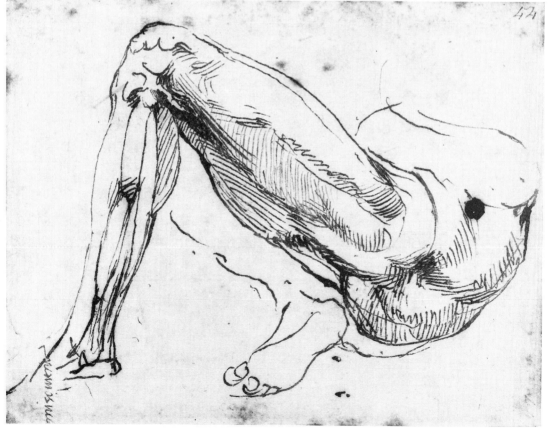

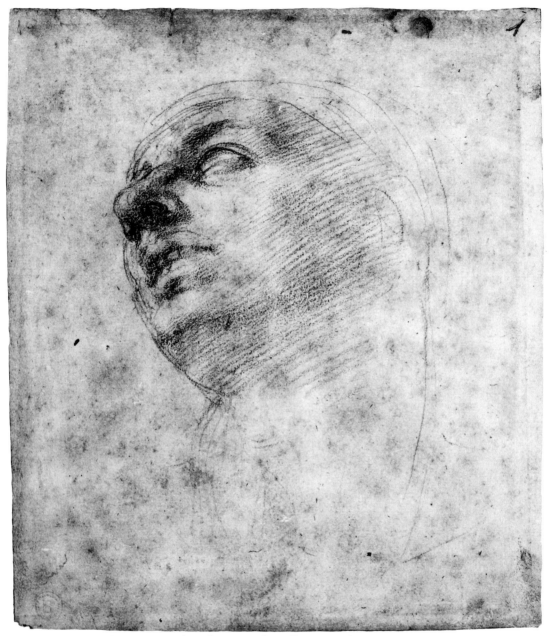

151 Study for the Doni tondo, Florence, Casa Buonarroti.

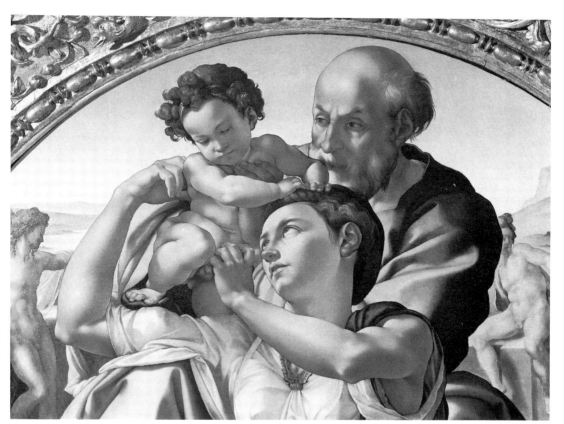

152 The Doni tondo (detail), Florence, Uffizi.

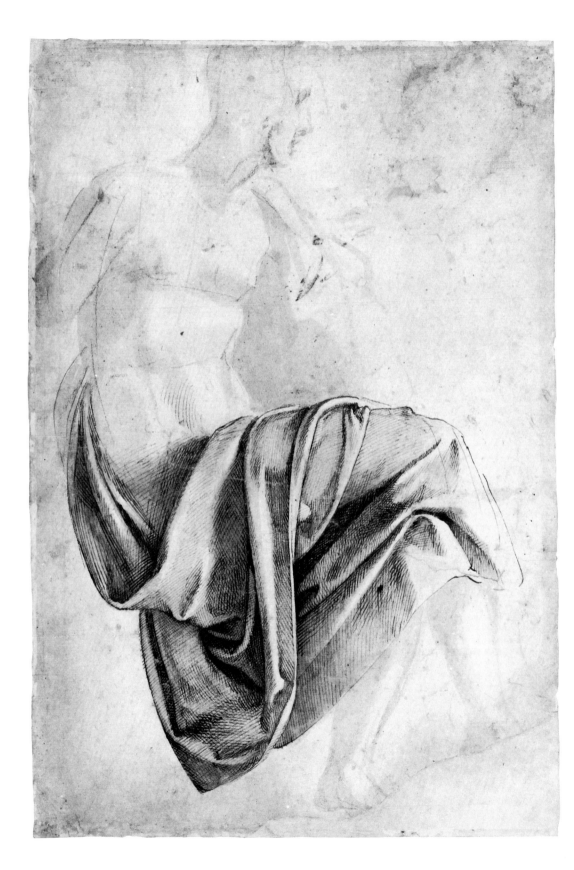

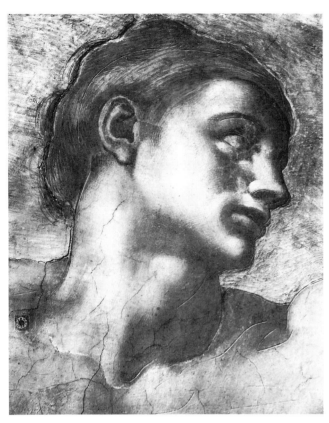

154 (left) *Creation of Adam* (detail), Vatican, Sistine Chapel.

153 (facing page) Study for the *Erythraean Sibyl*, London, British Museum.

155 (below left) Study for *Zechariah*, Florence, Uffizi.

156 (below right) Studies for the Sistine ceiling, Haarlem, Teylers Museum.

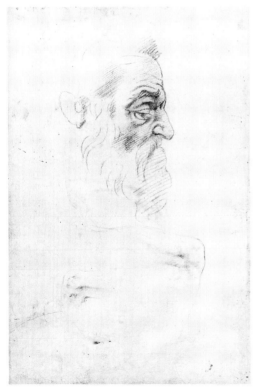

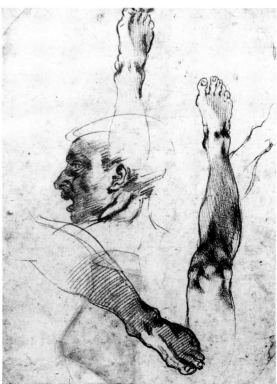

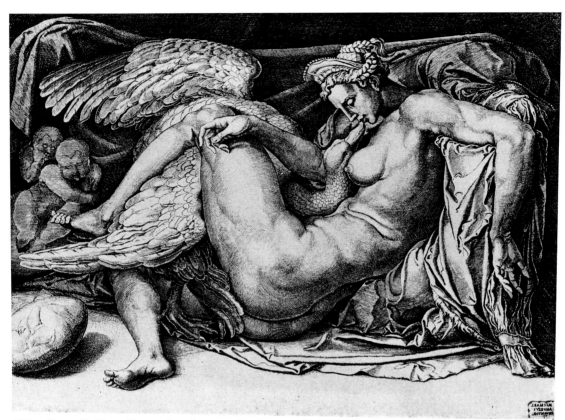

157 Cornelis Bos, Engraving (reversed) after Michelangelo's *Leda*.

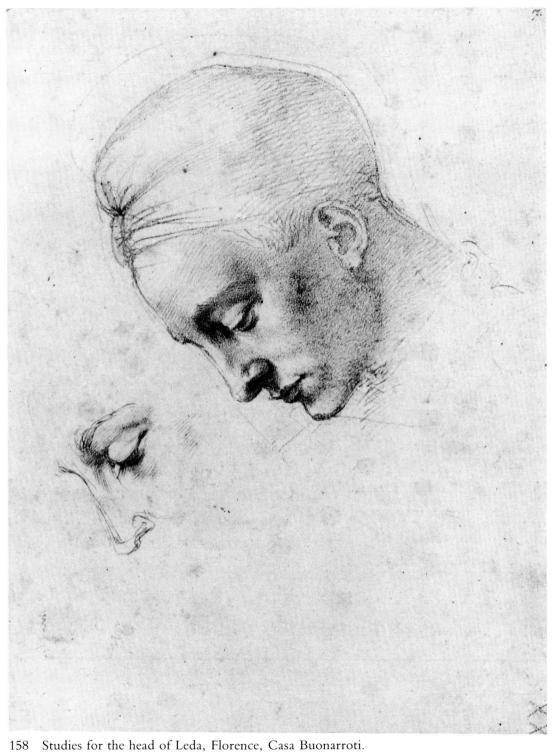

158 Studies for the head of Leda, Florence, Casa Buonarroti.

159 Grotesque head, Windsor, Royal Library.

161 (facing page) Design for a salt-cellar, London, British Museum.

160 Grotesque heads (detail), London, British Museum.

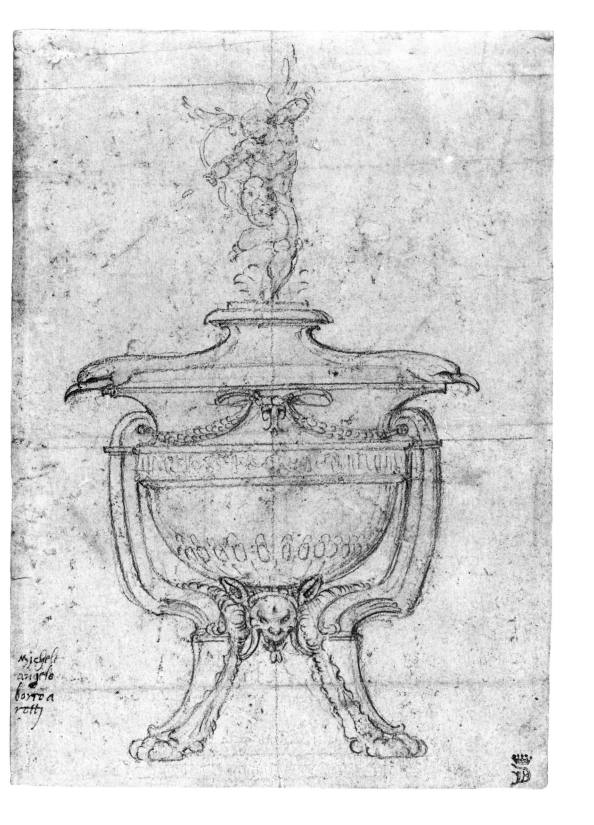

michel
angelo
bovoa
rotti

162 Drawings for the stone-cutters, London, British Museum.

163 Block drawings for the stone-cutters, Florence, Archivio Buonarroti.

164 Drawings of blocks for the San Lorenzo façade, Florence, Archivio Buonarroti.

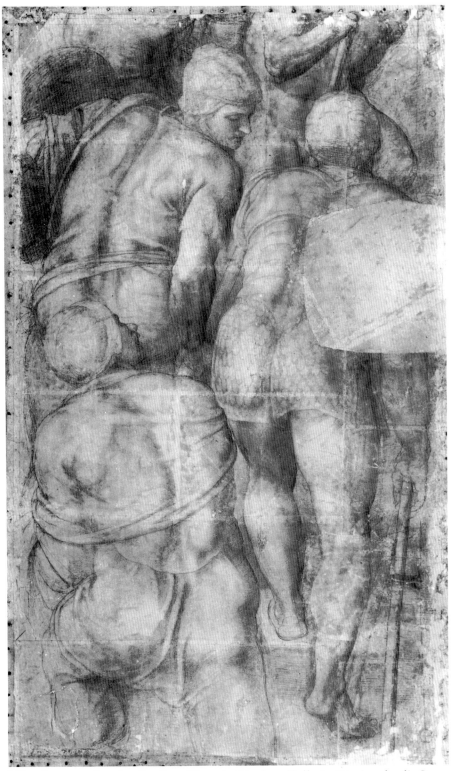

165 Cartoon for the Pauline Chapel, Naples, Galleria Nazionale di Capo-
dimonte.

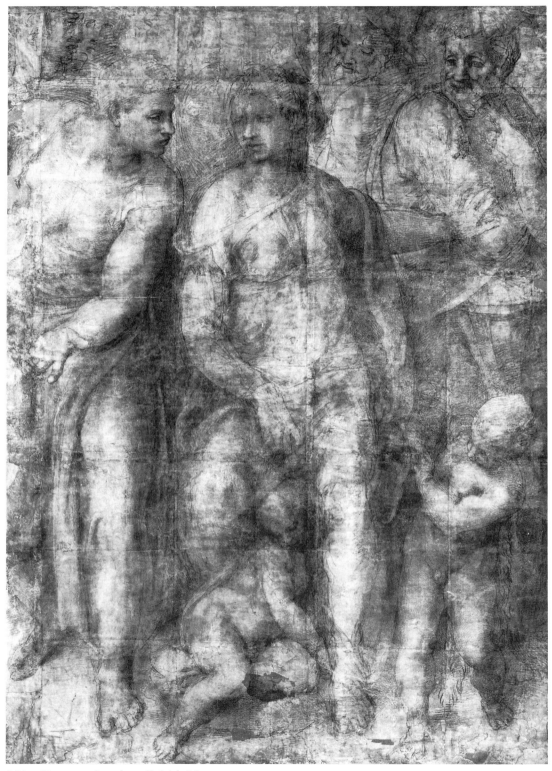

166 Cartoon, London, British Museum.

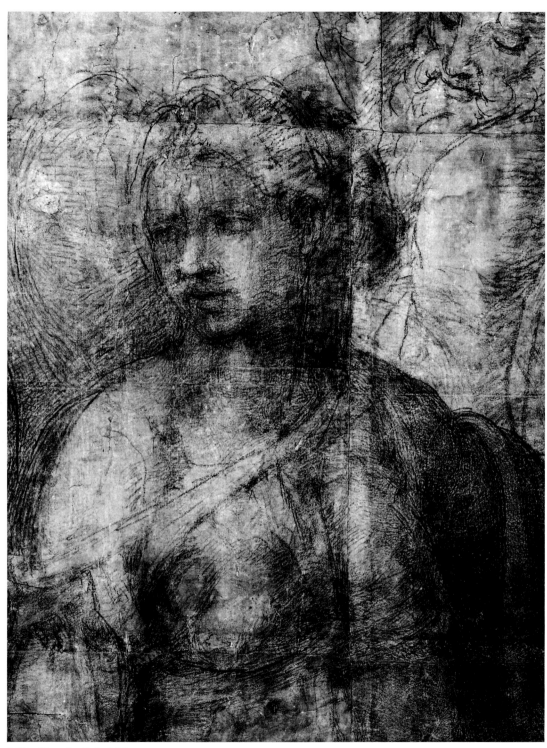

167 Detail of pl. 166.

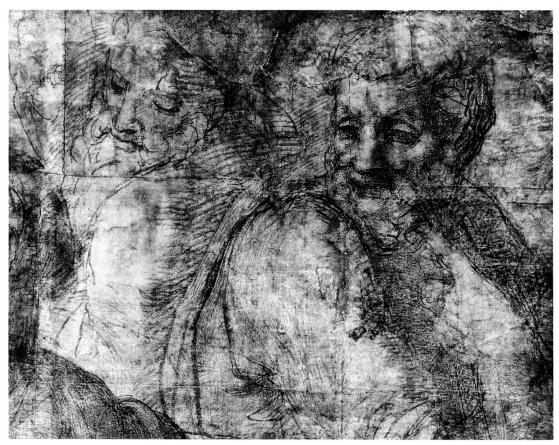

168 Detail of pl. 166.

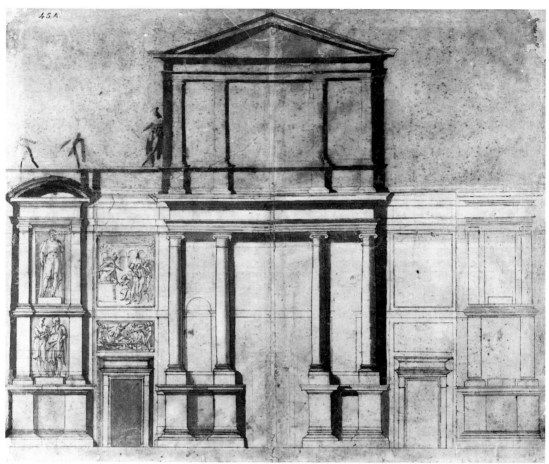

169 *Modello* for the San Lorenzo façade, Florence, Casa Buonarroti.

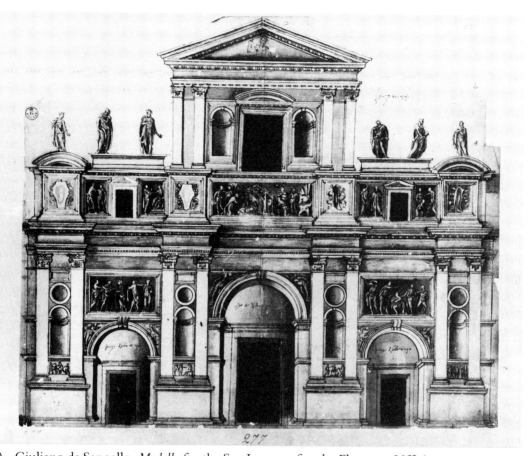

170 Giuliano da Sangallo, *Modello* for the San Lorenzo façade, Florence, Uffizi.

171 After Michelangelo, Design for the Tomb of Pope Julius II, East Berlin, Staatliche Museum.

173 (facing page) *Modello* for the Tomb of Pope Julius II, New York, Metropolitan Museum.

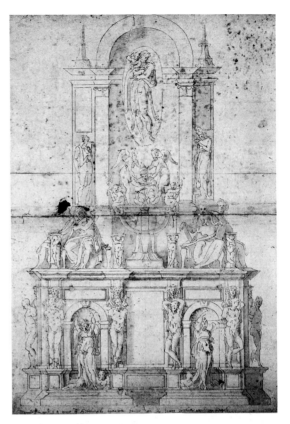

172 *Modello* for the Tomb of Pope Julius II (fragment), Florence, Uffizi.

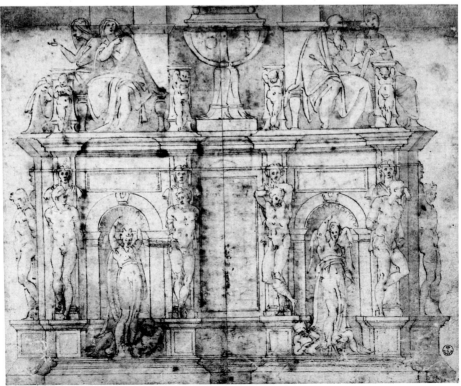

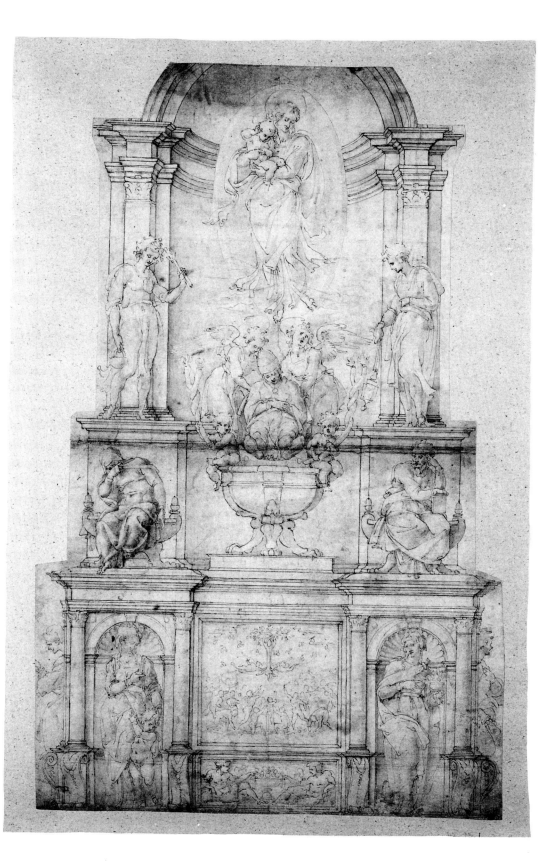

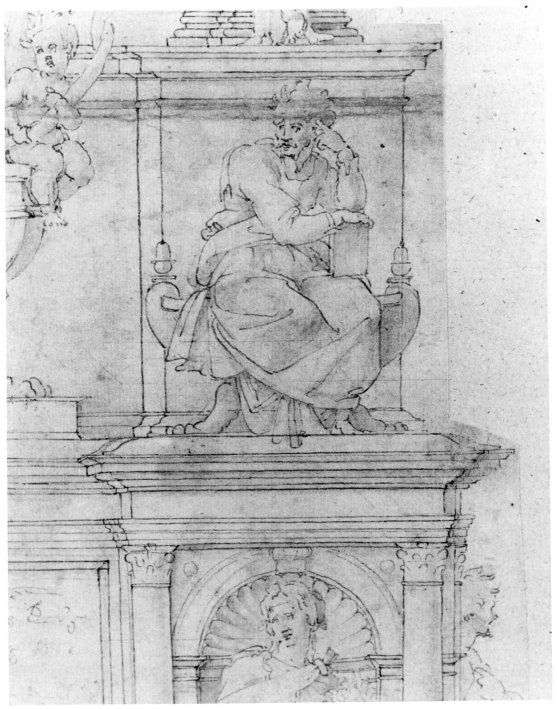

174 Detail of pl. 173.

175 Detail of pl. 172.

176 Study for a door, Florence, Casa Buonarroti.

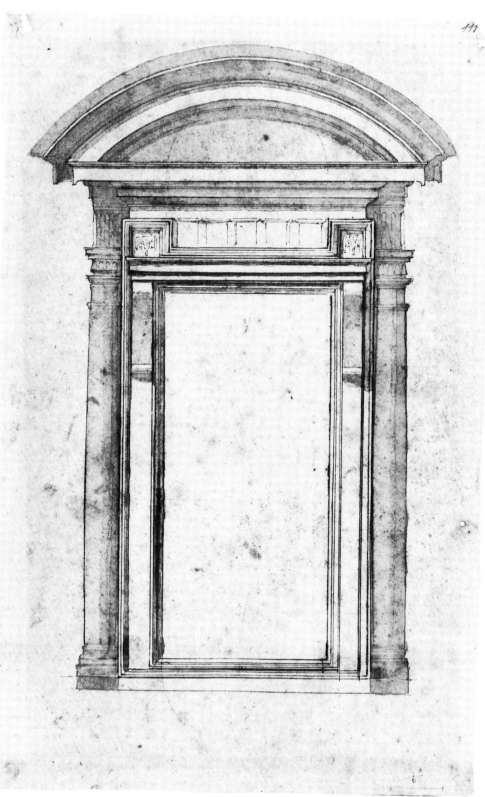

177 Study for a door, Florence, Casa Buonarroti.

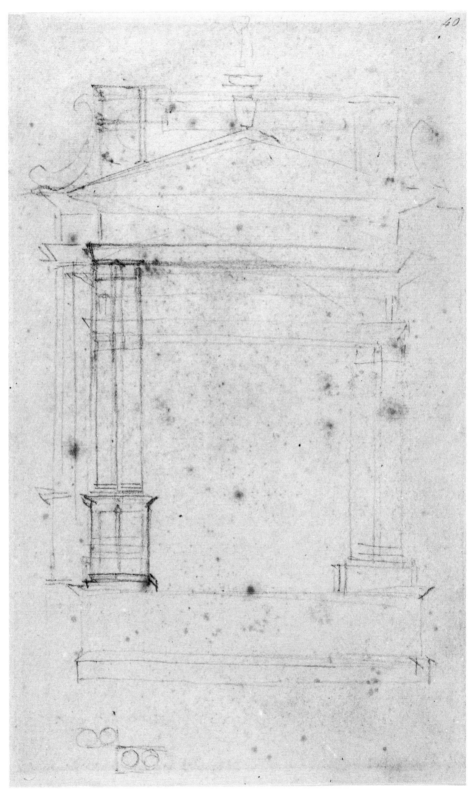

178 Architectural elevation and part of a plan, Florence, Casa Buonarroti.

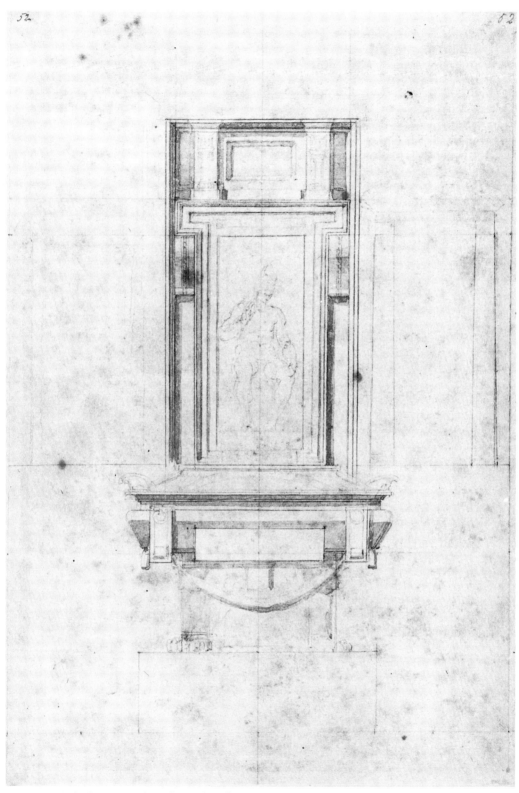

179 *Modello* for a papal wall tomb, Florence, Casa Buonarroti.

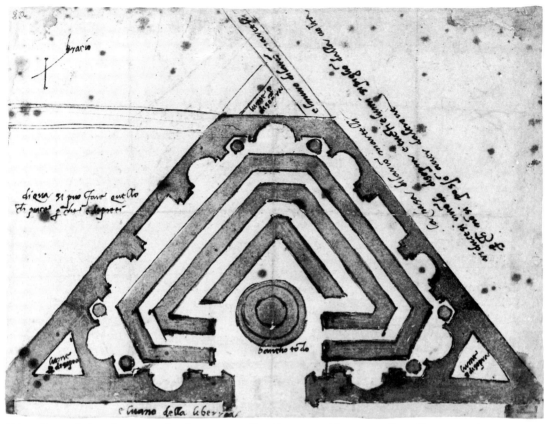

180 Groundplan for a rare-book room at San Lorenzo, Florence, Casa Buonarroti.

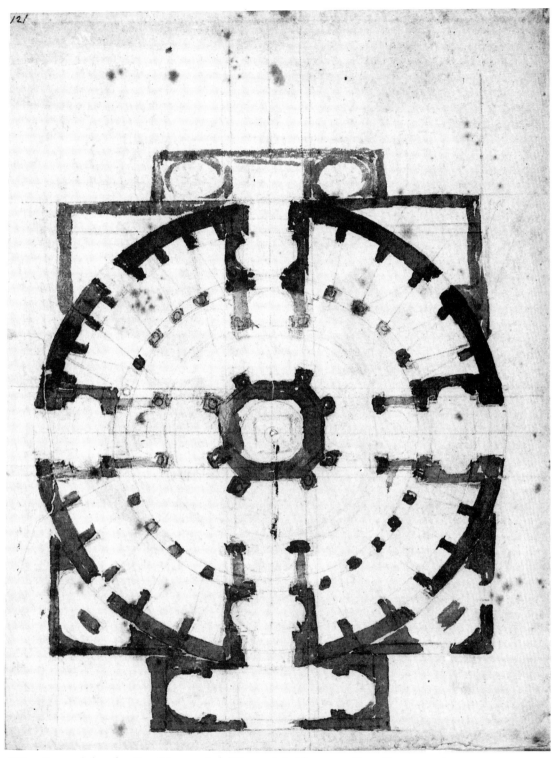

181 Groundplan for San Giovanni de'Fiorentini, Florence, Casa Buonarroti.

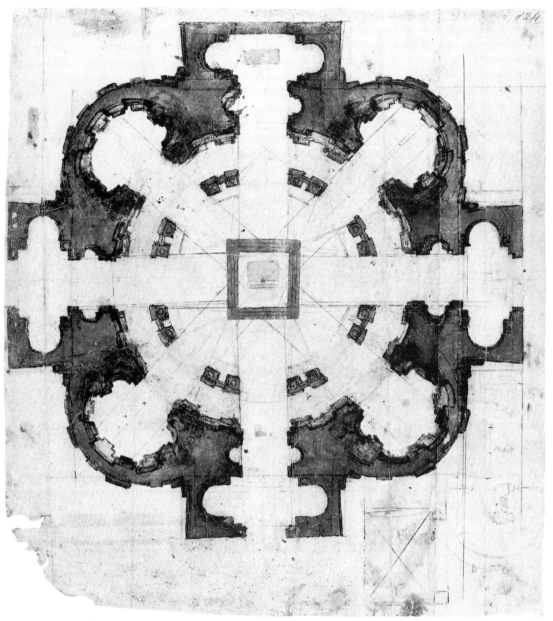

182 Groundplan for San Giovanni de'Fiorentini, Florence, Casa Buonarroti.

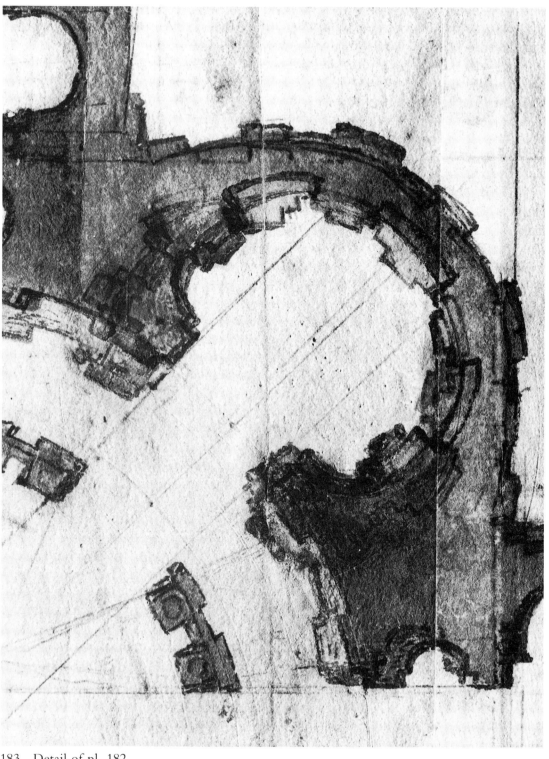

183 Detail of pl. 182.

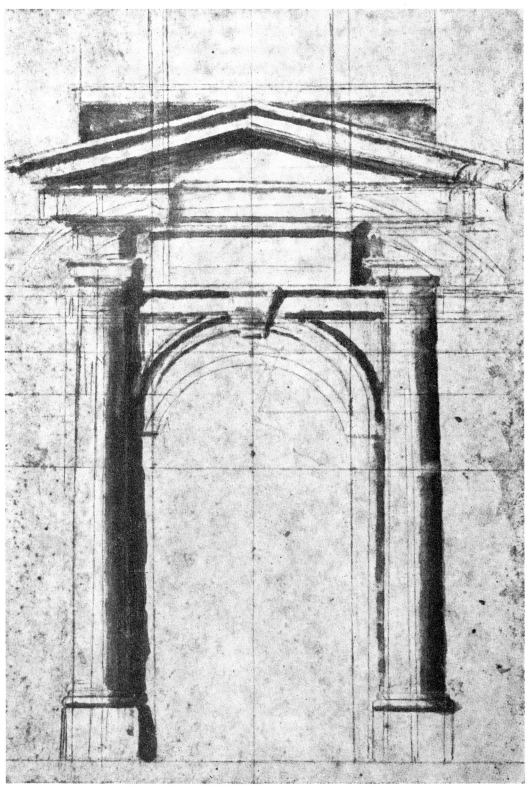

184 Study for the Porta Pia, Florence, Casa Buonarroti.

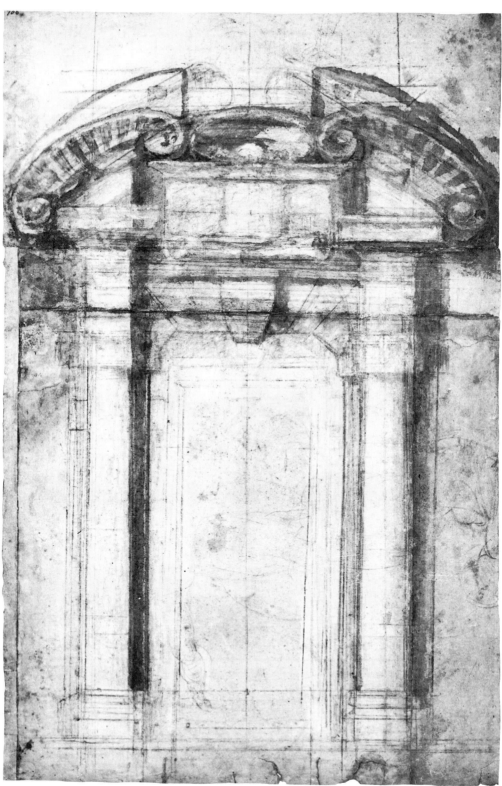

185　Study for the Porta Pia, Florence, Casa Buonarroti.

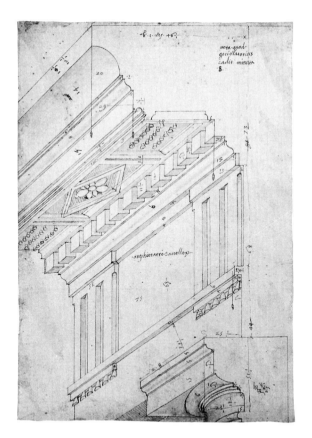

186 Bernardo della Volpaia, Study of antique architecture, Codex Coner, London, Soane Museum.

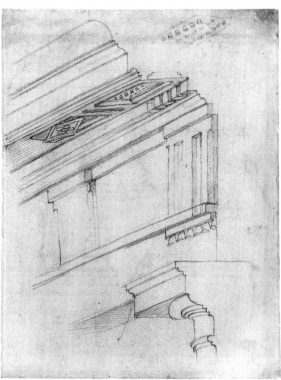

187 Copy after Bernardo della Volpaia, London, British Museum.

188 Bernardo della Volpaia, Studies of antique architecture, Codex Coner, London, Soane Museum.

189 Copies after Bernardo della Volpaia, Florence, Casa Buonarroti.

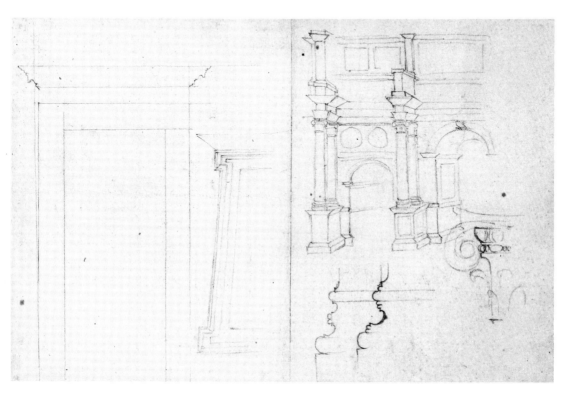

190 Site plan for the Library of San Lorenzo (left half), Florence, Casa Buonarroti.

191 Site plan for the Library of San Lorenzo (right half), Florence, Casa Buonarroti.

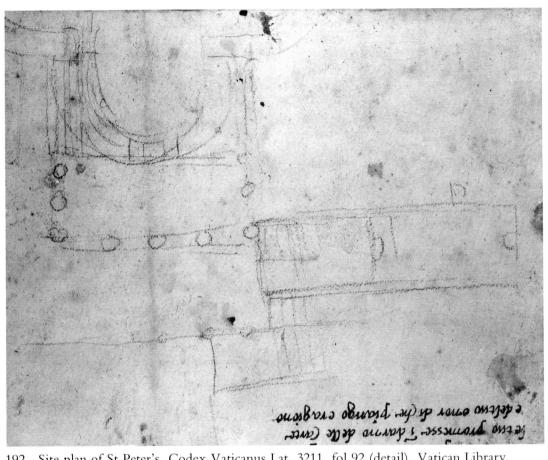

192 Site plan of St Peter's, Codex Vaticanus Lat. 3211, fol 92 (detail), Vatican Library.

193 Sketch plan for the façade of San Lorenzo, Florence, Archivio Buonarroti.

194 Sketch plan for the façade of San Lorenzo (detail), Florence, Casa Buonarroti.

196 Studies for attic of a ducal tomb, Florence, Casa Buonarroti.

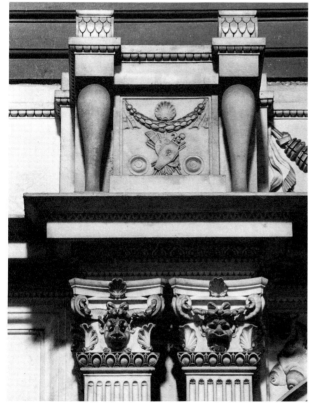

197 Attic of a ducal tomb (detail), Florence, New Sacristy of San Lorenzo.

195 (facing page) Plan and elevation of the San Lorenzo Library vestibule, Florence, Archivio Buonarroti.

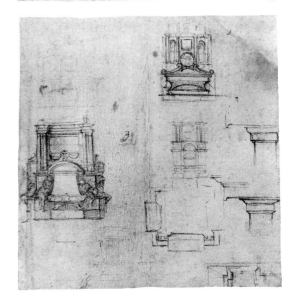

198 Designs for tombs, Florence, Casa
Buonarroti.

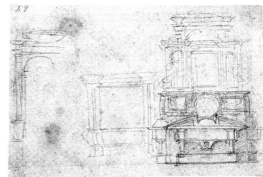

199 Designs for tombs, Florence, Casa
Buonarroti.

200 Designs for tombs, London, British
Museum.

8.5 cm

44.5 cm
60 cm

7 cm

201 Recon-
struction of the
versos of pls
198–200.

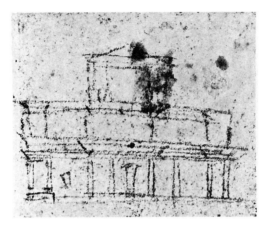

202 Sketch for the façade of San Lorenzo (detail), Florence, Casa Buonarroti.

203 Drawing for the façade of San Lorenzo (detail), Florence, Casa Buonarroti.

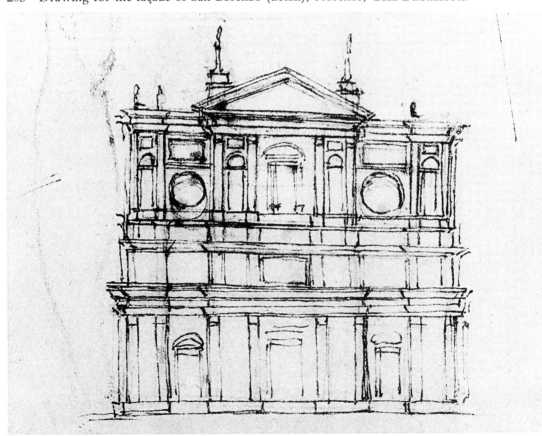

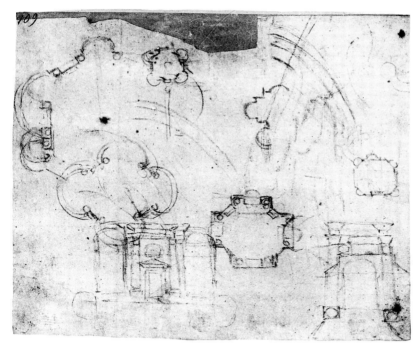

204 Architectural studies, Florence, Casa Buonarroti.

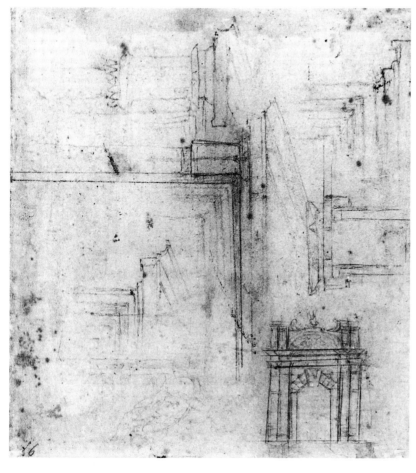

205 Architectural studies, Florence, Casa Buonarroti.

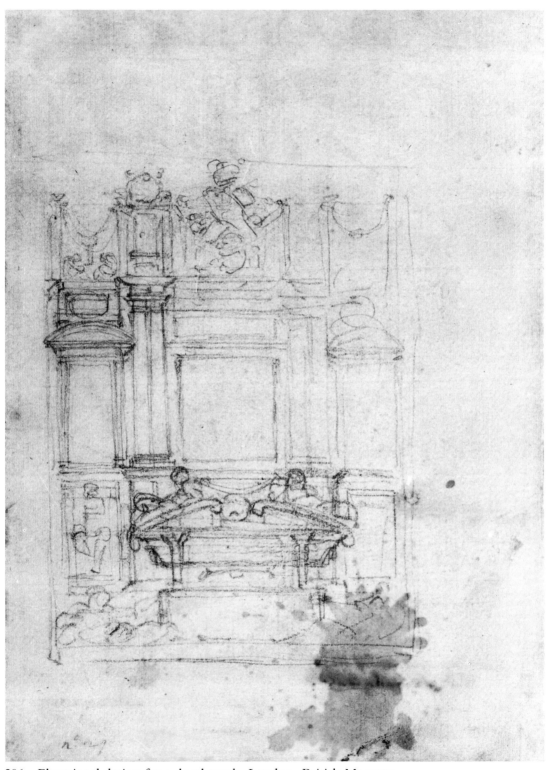

206 Elevational design for a ducal tomb, London, British Museum.

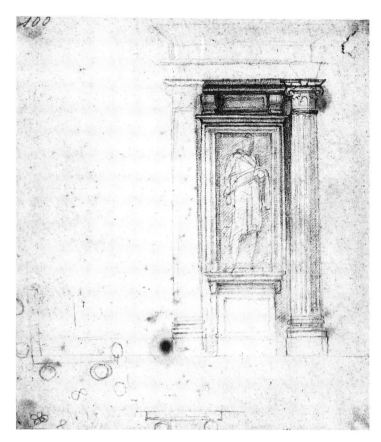

207 Study for the façade of San Lorenzo, Florence, Casa Buonarroti.

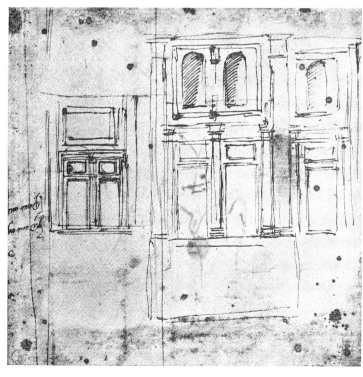

208 Sketch for wall elevation, Florence, Casa Buonarroti.

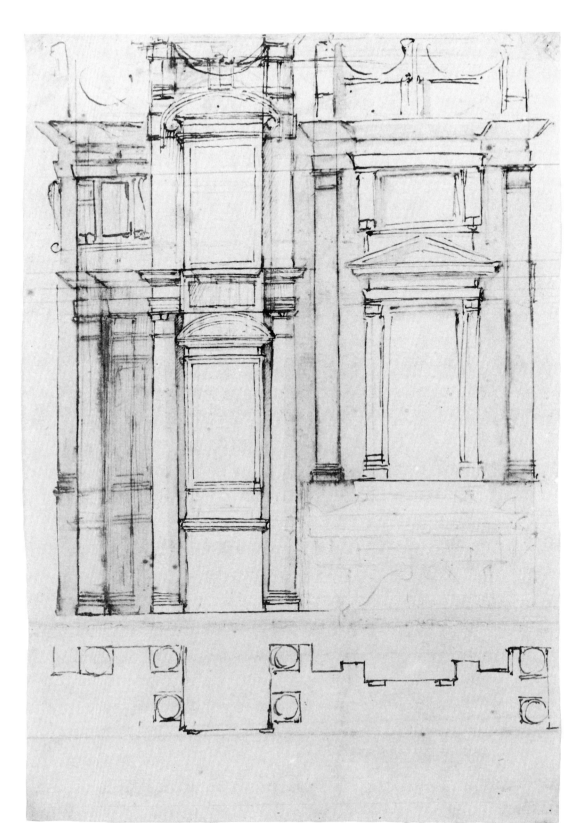

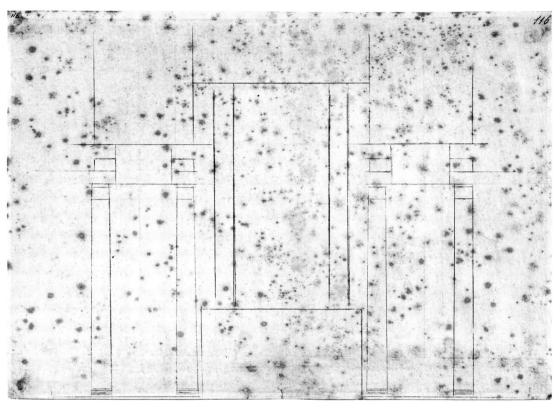

210 Elevation of a wall tomb, Florence, Casa Buonarroti.

209 Elevation and plan of a wall tomb, Florence, Casa Buonarroti.

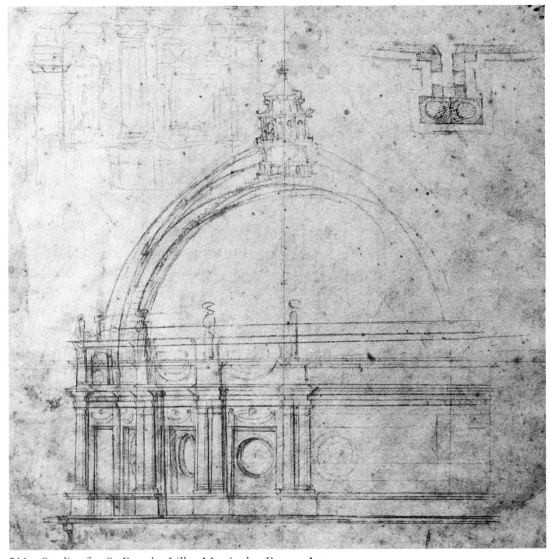

211 Studies for St Peter's, Lille, Musée des Beaux-Arts.

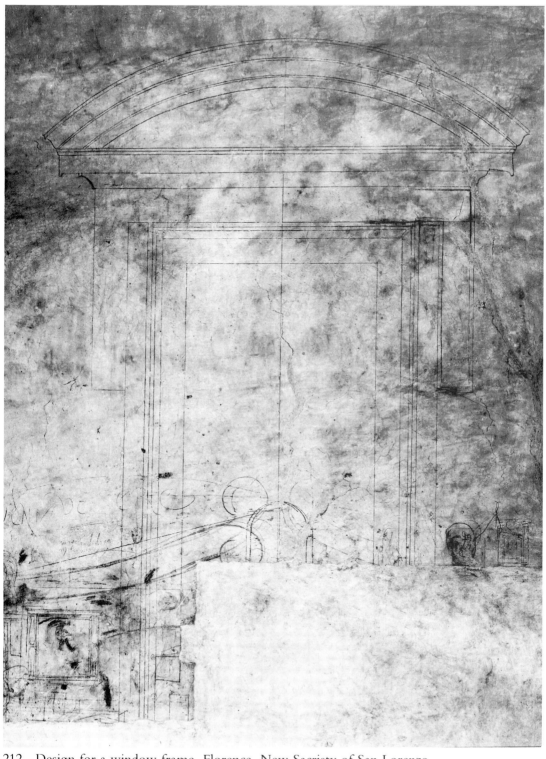

212 Design for a window frame, Florence, New Sacristy of San Lorenzo.

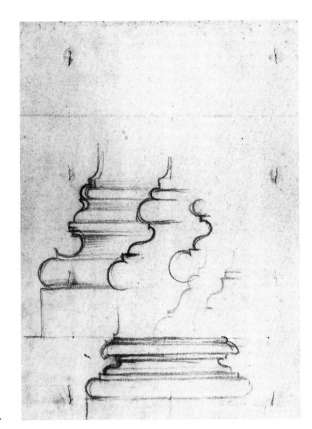

213 Studies of base
profiles and section,
Florence, Casa Buonarroti.

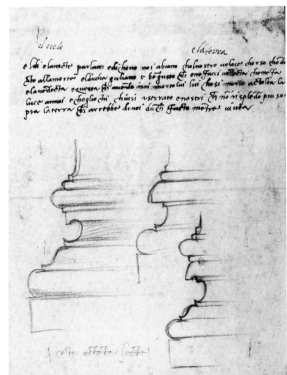

214 Studies of base
profiles, Florence, Casa
Buonarroti.

215 (facing page)
Template for base
moulding, Florence, Casa
Buonarroti.

il modano della colonna della se gubitura doppia di saguestri

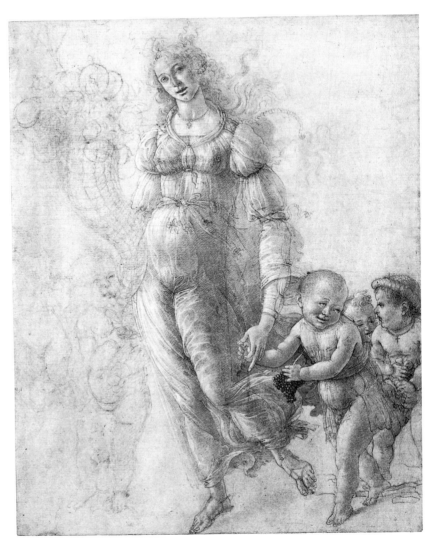

216 Sandro
Botticelli,
Abundance, London,
British Museum.

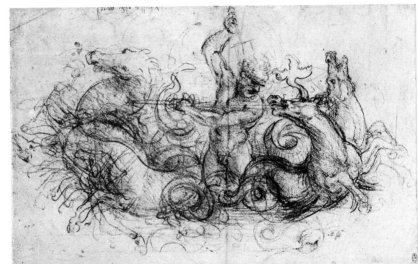

217 Leonardo da
Vinci, *Neptune with
Sea-Horses*,
Windsor, Royal
Library.

218 (facing page)
Three heads,
Florence, Uffizi.

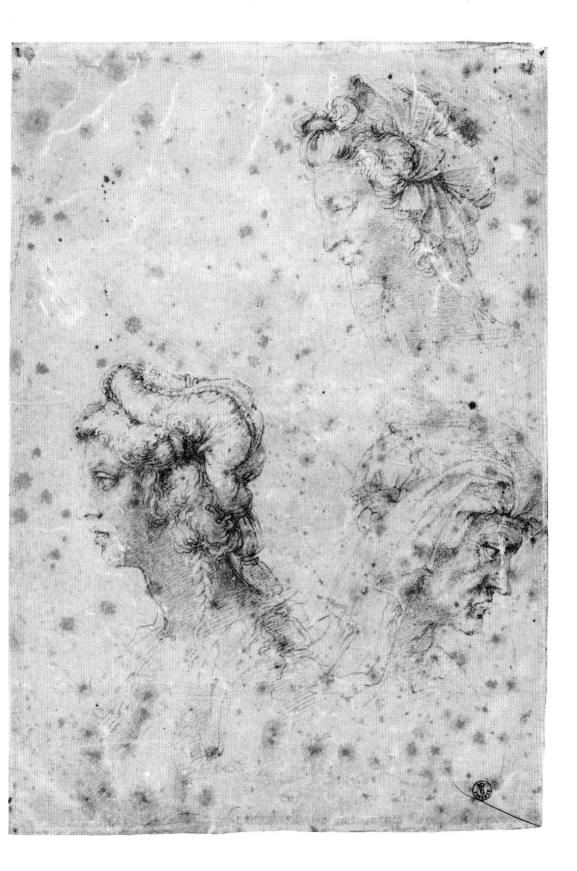

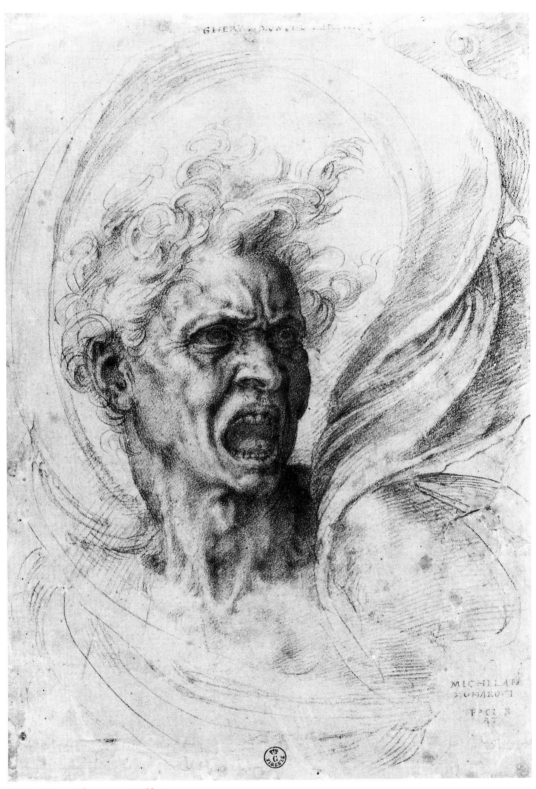

219 *Fury*, Florence, Uffizi.

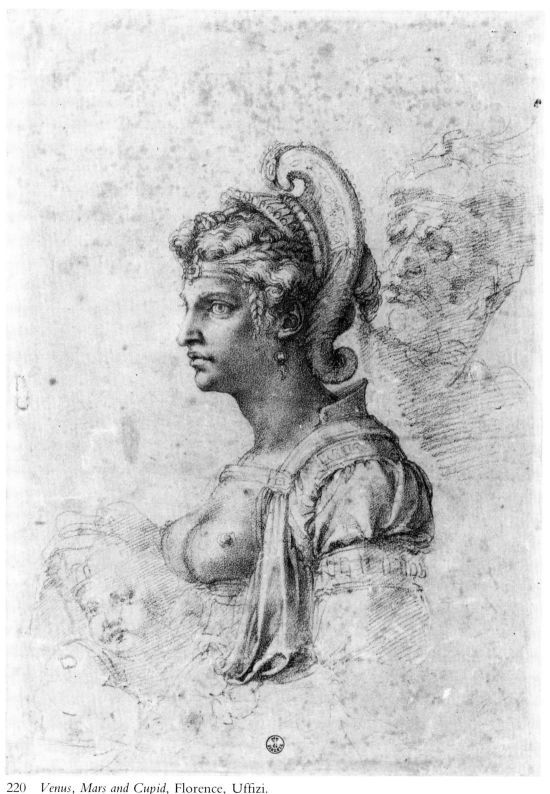

220 *Venus, Mars and Cupid,* Florence, Uffizi.

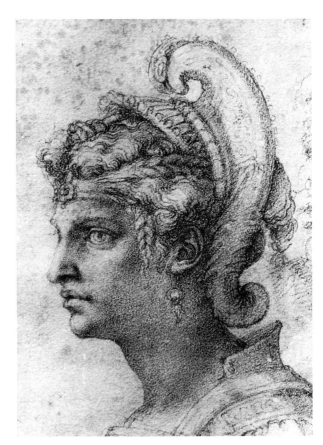

221 Detail of pl. 220.

222 Marco Zoppo,
Head, London, British
Museum.

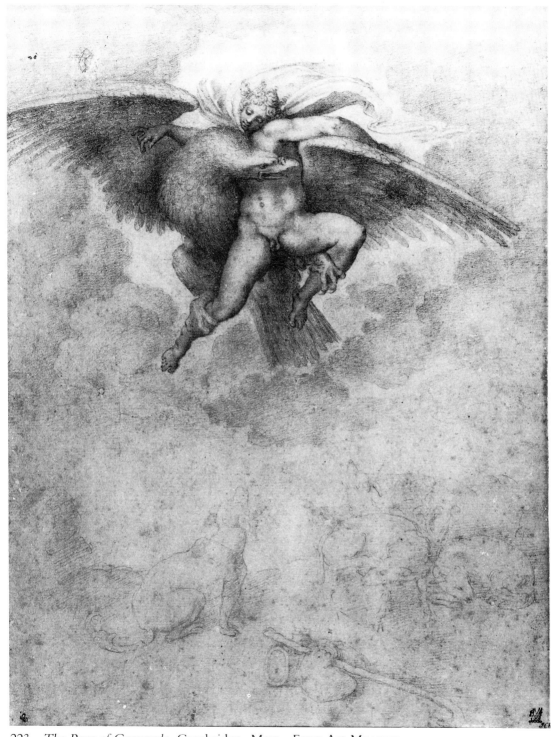

223 *The Rape of Ganymede*, Cambridge, Mass., Fogg Art Museum.

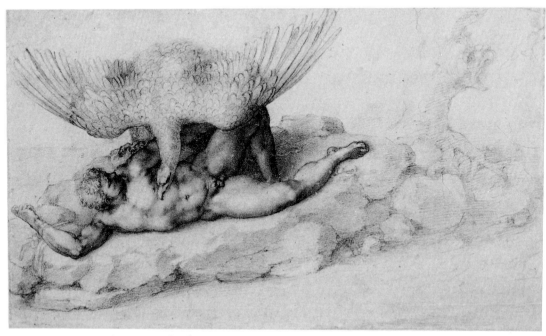

224 *Tityus*, Windsor, Royal Library.

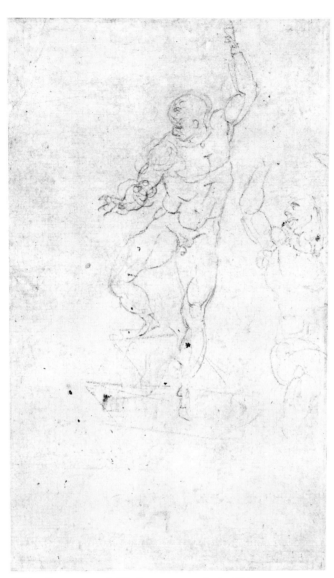

225 Resurrected Christ, verso of pl. 224.

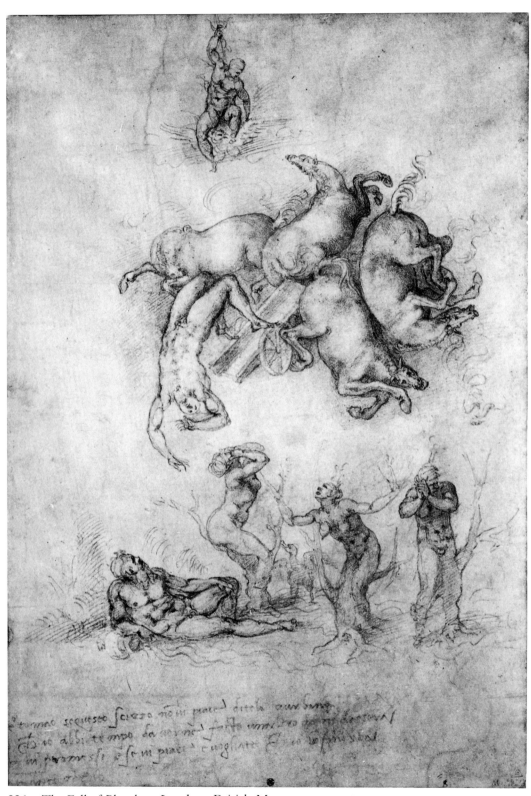

226 *The Fall of Phaethon*, London, British Museum.

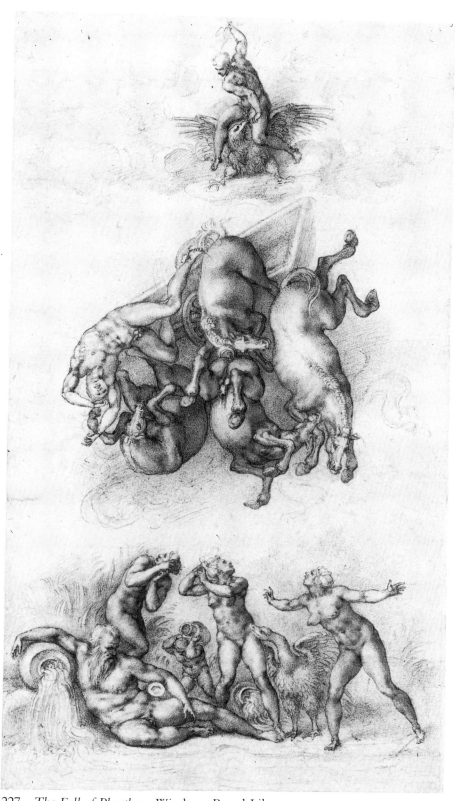

227 *The Fall of Phaethon*, Windsor, Royal Library.

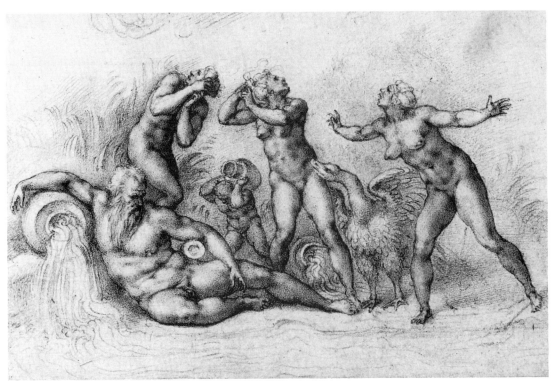

228 Detail of pl. 227.

230 (facing page) *The Fall of Phaethon*, Venice, Accademia.

229 Detail of pl. 230.

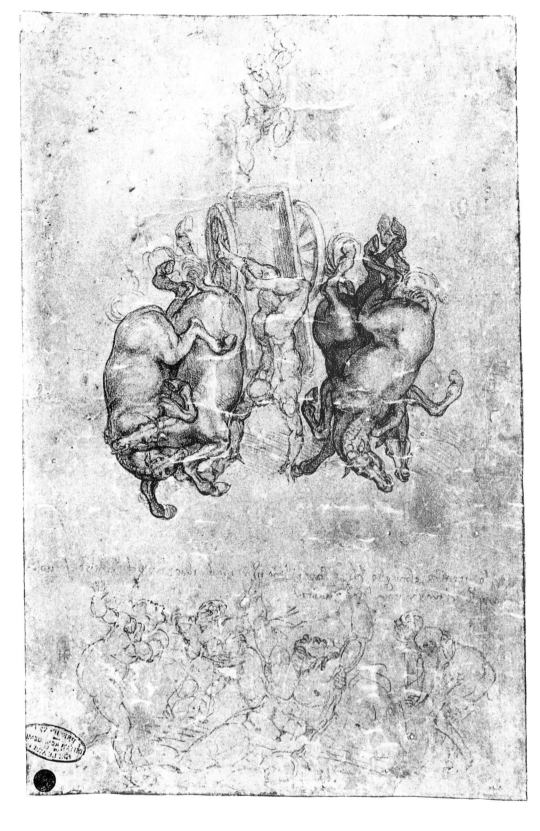

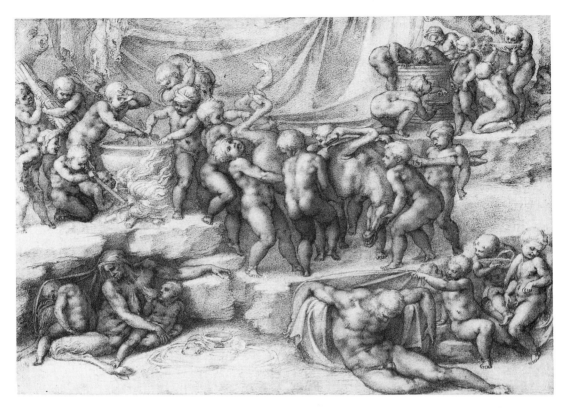

231 *Children's Bacchanal*, Windsor, Royal Library.

233 (facing page top) A reclining nude and putti around a wine vat, Bayonne, Musée Bonnat.

234 (facing page bottom) Detail of pl. 231.

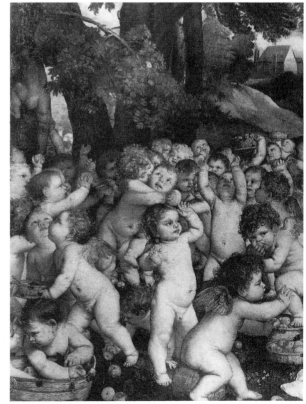

232 Titian, *Worship of Venus* (detail), Madrid, Prado.

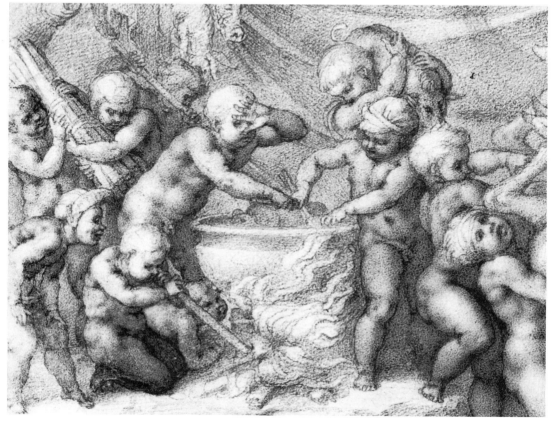

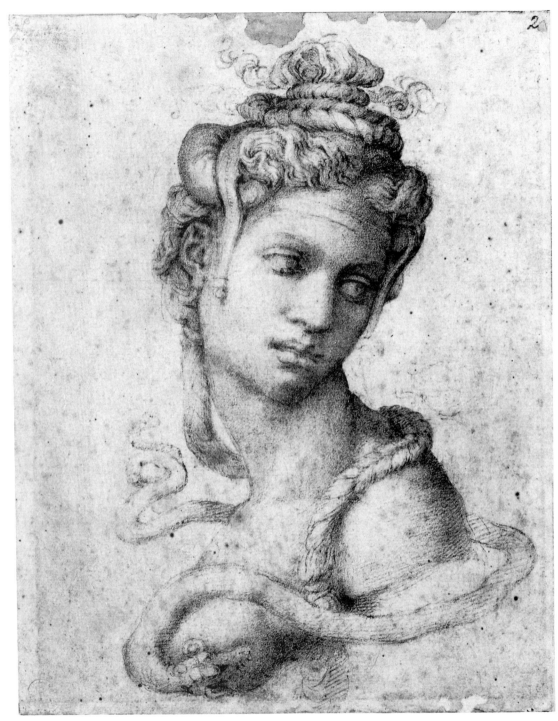

235 *Cleopatra*, Florence, Casa Buonarroti.

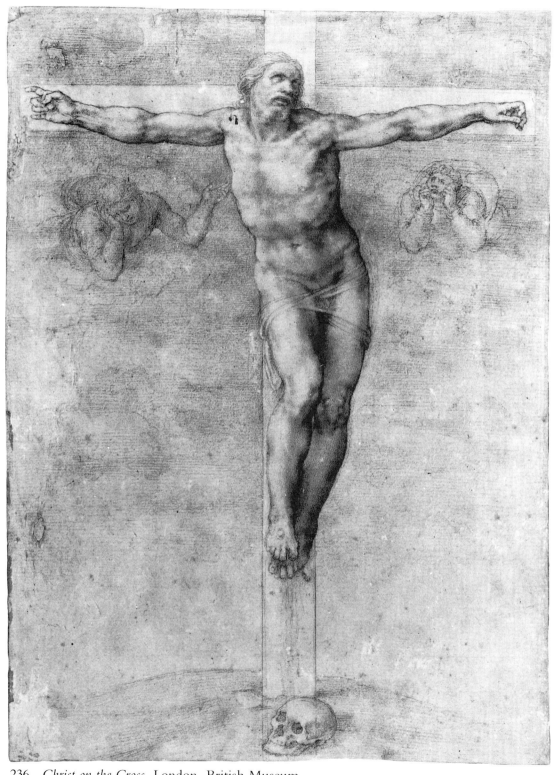

236 *Christ on the Cross*, London, British Museum.

237 Macrophotographic detail of pl. 231.

238 Macrophotographic detail of pl. 227.